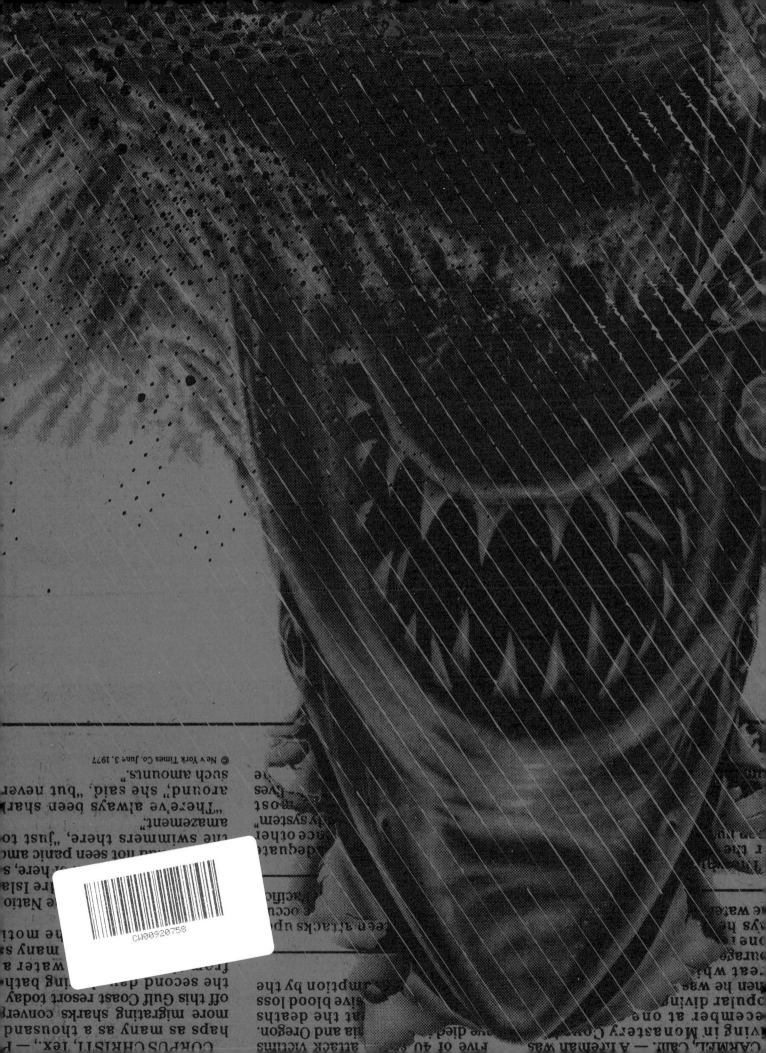

AD NAUSEAM

NEWSPRINT NIGHTMARES
FROM THE '70s & '80s

BY

MICHAEL GINGOLD

FOR SHEA

who has always saved
the important stuff.

CONTENTS

FOREWORD
MOVIE ADS!

Those irresistible siren calls to adventure and excitement yet to be experienced in the comfortable, popcorn-strewn confines of your neighborhood theater! All brought to you for a dime on newsprint that came off on your hands.

When I was growing up in New Jersey, there were countless daily newspapers in the New York/Metro area. Besides the still-active *Times*, *Daily News* and *Post*, there were the *Mirror*, the *World-Telegram and Sun*, the *Journal American* and others—and they all ran pages and pages of juicy ad mats for the latest releases, with the larger ones appearing on Wednesdays and Fridays when the programs changed. I dutifully cut them out and collected them in a shoebox, separating the double bills (*Plus! 2nd Big Co-Hit!*) so I could program my own "shows." The richest period was the late '50s-early '60s when the sci-fi/horror boom was in full swing, since they had the most lurid and bombastic ads. Eventually I outgrew this hobby, but I never lost my fascination with the art of ballyhoo, which stood me in good stead when I found myself concocting these same kinds of ads for my mentor Roger Corman at New World Pictures in the 1970s.

Michael Gingold's first edition of *Ad Nauseam* concentrated on the '80s, but the '70s were an especially anything-goes era, with a verve and dynamic all its own. Largely ushered in by the introduction of the MPAA rating system, an unprecedented torrent of adults-only movies full of hitherto unseen levels of violence and nudity began to supplant mainstream Hollywood fare in theaters across the nation. Freed from the strictures and mild titillation of nudie-cutie "art house" fare, hardcore sex began to dominate the movie pages, with long runs of *Deep Throat* and *Man and Wife* turning many neighborhood theaters into triple-X houses.

All this served to embolden us at New World, where hitherto impossible taglines accompanied our ad mats: "Wet dreams and open jeans!" (*Street Girls*), "They're always overexposed but they're never underdeveloped" (*Cover Girl Models*) and "Frank had the biggest cock in town—and what he did with it was illegal in 47 states!" (*Cockfighter*). You can return to this golden age of good-taste-is-timeless promotion by leafing through this latest treasury of the imagery that seared our formative brains so many years ago and still fascinates today.

JOE DANTE | Director
Piranha / The Howling / Gremlins / The 'Burbs

(Additional Joe Dante ads on pages 119, 183, 258-259, and 357.)

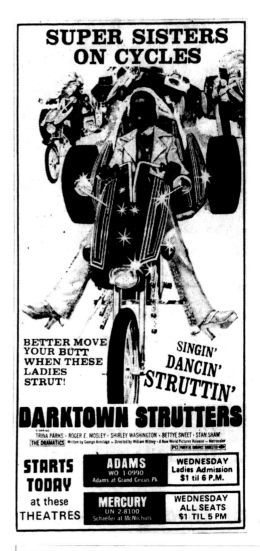

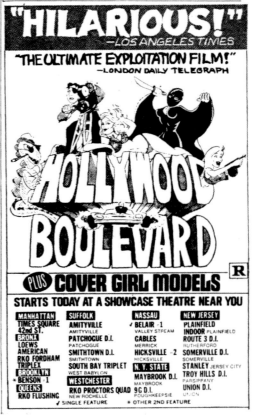

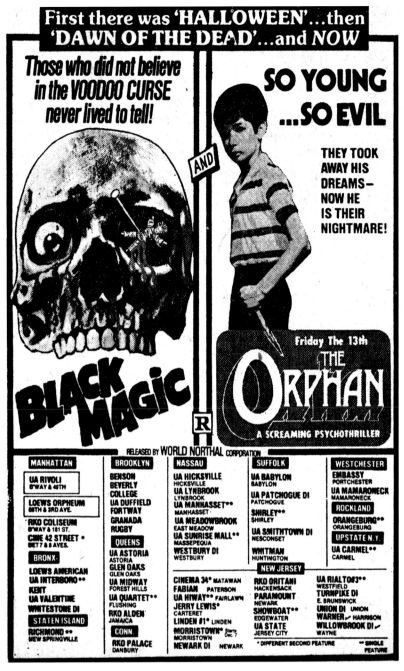

If this is your first time picking up *Ad Nauseam*, welcome to the wonderful world of vintage horror-film newspaper advertising! If you've already got the previous edition, I promise the double-dip will be worth it.

As I detailed in my intro to that first book, *Ad Nauseam* showcased hundreds of ads that I obsessively cut out of New York City newspapers beginning when I was a junior-high-school student, and continuing throughout the 1980s into my college years. They exemplify the now-lost art of illustrated ballyhoo used to lure prospective viewers to all manner of horror movies, from slashers to ghost stories to creature features and more. They teased us and tempted us with promises of all manner of terrifying and bloody sights—promises that were sometimes kept by the films, sometimes not. These ads were an art form unto themselves, and the positive response to the book from both those who also grew up seeing them and more recently minted fans was hugely gratifying. And there was one question a number of readers asked: "When are you going to do a book on the 1970s?"

The answer, at the time, was that this wouldn't be possible, as I started collecting the ads in 1979. (I continued through the 1990s and 2000s, which are covered in *Ad Nauseam II*.) But while the Internet was a key factor in the demise of newspaper advertising for movies, it also offers access to a wealth of past material in that very area. And so, with *Ad Nauseam* heading into its third printing, my publisher Matthew Chojnacki and I decided to expand the book to encompass the '70s as well. Digging through various online archives, I was able to come up with over 250 ads for a wide range of screen shockers, big and small.

The '70s represented a turning point for the horror genre, as it broke out beyond the drive-in circuit: *The Exorcist*, *Jaws*, *The Omen* and others became major-studio blockbusters by terrifying audiences. At the same time, the independent revolution spearheaded by 1968's *Night of the Living Dead* gave us *The Last House on the Left*, *The Texas Chainsaw Massacre*, *Halloween* and other trendsetters. And as bold and attention-grabbing as the ads could be in the '80s, they were even more so in the '70s. The imagery and the taglines were sometimes far more garish in the earlier decade; just compare, say, the '80s' *Prom Night* ("If you're not back by midnight...you won't be coming home!") and *My Bloody Valentine* ("There's more than one way to lose your heart...") to the '70s' *The Crimson Cult* ("Come face to face with naked fear on the altar of evil!") and *The Vampire Lovers* ("A bloodstained tale of terror and torture! An orgy of death was their ultimate love!"). Frequently, these ads are different—and more striking—than the films' one-sheet posters.

As it turned out, the decade's final year was a transitional one for both the genre and my perception of it. As noted above, 1979 was when I first started collecting the ads; having only been familiar with *The New York Times* up to that point, I discovered the *Daily News* and the *Post*, which ran far more horror/exploitation advertisements, and sometimes more explicit ones. This revelation dovetailed with a new boom in fright titles inspired by the success of 1978's *Halloween*; every week in '79 seemed to bring the release of either a new film or a reissued one. On one hand, there were major-studio and other conspicuous features such as *Alien*, *The Amityville Horror*, *Dawn of the Dead*, *Dracula*, *Phantasm* and *Prophecy*, while on the other, through the movie sections of all those papers, I learned of all kinds of smaller, bizarre stuff, like *Driller Killer* and *Last House on Dead End Street* and *The Watts Monster* (years before I became aware that credited *House* director "Victor Janos" was actually Roger Watkins and *Monster* was a retitling of *Dr. Black, Mr. Hyde*). A few indie movies I had heard of (like *The Hills Have Eyes* and *I Drink Your Blood*) returned to screens on double bills, but remained tantalizingly out of reach for my then-preteen self.

And so I began scouring the papers every Friday, clipping out any horror ads I could find, from full pages in the *Times* to the tiniest but still lurid mats in the *Daily News* and *Post*–along with stuff I'd find in

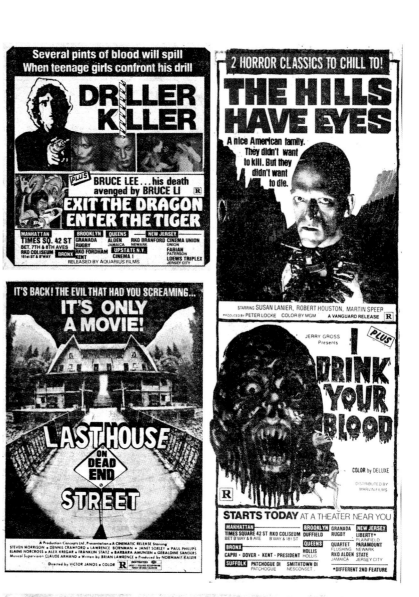

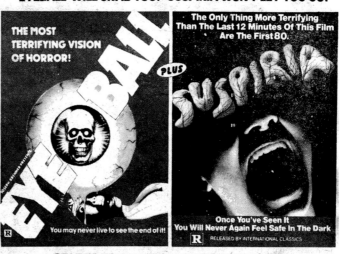

other cities during family vacations. For a few years, they were totems of movies I was too young to see in theaters. Then, after I discovered that my friends and I didn't necessarily have to be accompanied by a parent or adult guardian to get our under-17 selves into R-rated fare, the ads became mementos of the theatrical experience. These were my formative years, before my passion for scary movies became my vocation, and *Ad Nauseam*, in both its prior and current editions, is a celebration of a fandom fueled by black-and-white representations of the full-color nightmares dwelling at the local movie houses.

In keeping with my '80s collection, the '70s ads here are sourced from New York-area newspapers, with a few exceptions when necessary (as in fall 1978, when the city's key papers weren't publishing due to a pressman's strike) or to cover the patchy distribution history of a few key films. As such, they're arranged based on the years in which the movies opened in NYC, though several of them first played other cities the previous year. As in the '80s sections, I've thrown in variant ads for several titles, as campaigns changed after the films' opening weekends—sometimes to celebrate their success, and other times in the hopes of changing their fortunes. I've included more reviews, too, to give you an idea of how a number of key titles were critically received upon their initial releases. These are the opinions you won't find at Rotten Tomatoes, where '70s and '80s films are largely represented by online reviews that address them from a nostalgic or revisionist point of view. This is what the critics of the time thought of these pictures, and while their positive and negative reactions may be what you expect in some cases, others might surprise you.

Ad Nauseam is now a history of arguably the horror genre's two greatest decades in pictures and taglines, and whether this book represents nostalgia or discovery for you, I hope you'll enjoy taking in these dark and devious graphic delights as much as I enjoyed assembling them.

— MICHAEL GINGOLD

1970

9

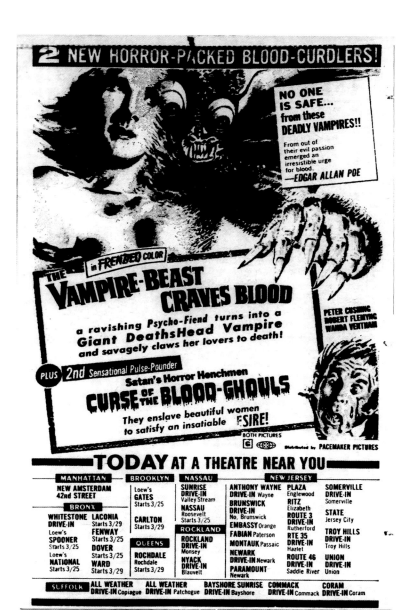

THE VAMPIRE-BEAST CRAVES BLOOD / CURSE OF THE BLOOD-GHOULS & WHIRLPOOL

"a ravishing Psycho-Fiend turns into a Giant DeathsHead Vampire and savagely claws her lovers to death!" "They enslave beautiful women to satisfy an insatiable DESIRE!" Sounds pretty shocking, and a bit risqué. Then you read the fine print: "Both Pictures [rated] G"! Other movies that initially received the MPAA's least restrictive rating, back in the very different era of the late '60s and early '70s, included Hammer's *The Devil Rides Out*, *Dracula Has Risen from the Grave* and *The Lost Continent*, the 1972 kindertrauma classic *The Legend of Boggy Creek*, and fairly heavy mainstream fare such as Michael Crichton's virus thriller *The Andromeda Strain* and the first three *Planet of the Apes* films.

Meanwhile, a large number of movies in all genres, from high-profile studio fare to arty independents, were freely released and advertised while bearing X ratings during the same period, before that designation fully gained the stigmatizing association with porn by the mid-'70s. Among them was *Whirlpool*, a sex-and-violence opus from first-time Spanish director José Ramón Larraz, whose name was Anglicized as "J.R. Larrath" in the ads.

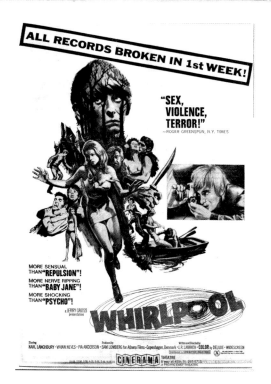

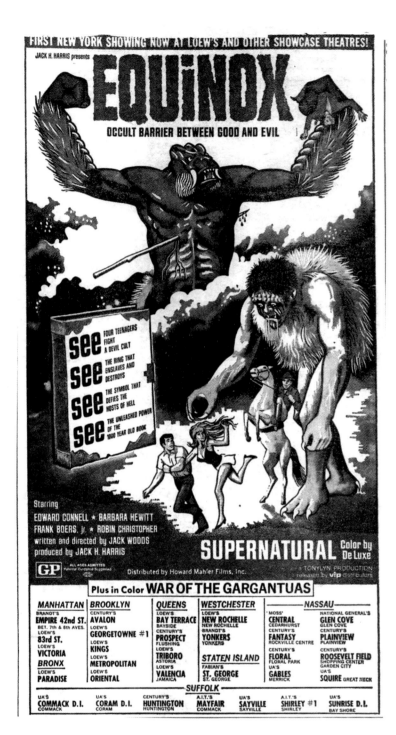

THE BIRD WITH THE CRYSTAL PLUMAGE

Speaking of ratings, *The Bird With the Crystal Plumage*, along with the next two films in Dario Argento's murder-happy "Animal Trilogy" (*Cat O'Nine Tails* and *Four Flies on Grey Velvet*), got away with GP, or PG, tags from the MPAA. Argento's premier *giallo* saw him receiving a certain amount of critical respect at the beginning of his fright career.

"In a dazzling directorial debut...Dario Argento displays such authority and imagination he makes the formula seem fresh and thoroughly engrossing."

— Kevin Thomas, *Los Angeles Times*

"The film moves briskly, and is helped immeasurably by you-are-there photography and a tinkling music score. To top things off, the plot has four—count 'em—four endings."

— JOE BALTAKE, *PHILADELPHIA DAILY NEWS*

"Director Dario Argento...sets a good, fast pace by wasting no time getting from one scene to another. He's aided by credible acting throughout, and as the terror builds, the audience responds audibly."

— Edward Knoblauch, *Asbury Park Press*

"The potential for some authentic chills are there, but director-writer Dario Argento works to develop the shock in a rather pedestrian manner... It's all rather contrived and hackneyed."

— John Bustin, *Austin American-Statesman*

"The mystery plot is about as substantial as soap bubbles and it's hardly mystifying.... Dario Argento, who wrote and directed the movie, is a former film critic. He's unfortunately seen too many of the wrong pictures."

— Stanley Eichelbaum, *San Francisco Examiner*

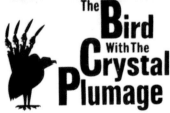

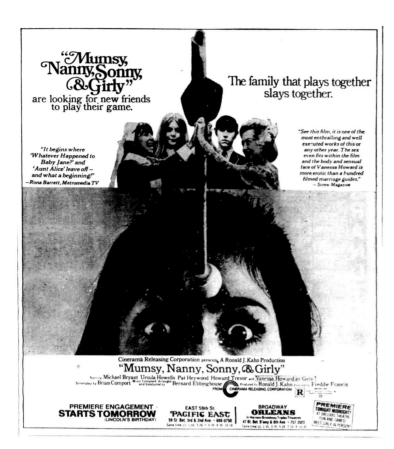

MUMSY, NANNY, SONNY, & GIRLY / GIRLY

Back in the days before home video, or even cable-TV movie channels, films of all kinds were routinely rereleased to theaters, sometimes mere months after their initial play. And sometimes they'd come back with different titles and ad campaigns, in attempts by distributors to win new audiences. One example is this passion project for British director and Hammer veteran Freddie Francis—a movie that fell victim to the media's moral panic over sexual cinema then raging in England, due to its hints of incest. In the States, it arrived in New York in February 1970 bearing its original title, with an ad oriented toward the strange games played by its central family. It then returned in November as the simplified *Girly*, positing Vanessa Howard's unbalanced, murderous young woman as its central figure.

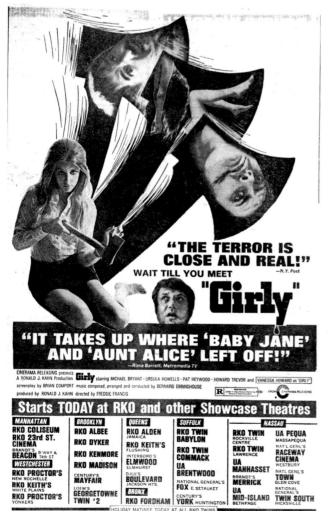

You'll feel four hands reaching for you— when the **twins** arrive Today!

I AM YOU WHEN I LOVE YOU LOVE

YOU ARE ME WHEN I KILL, YOU KILL

starring CINERAMA RELEASING presents A JOSEF SHAFTEL PRODUCTION
JUDY GEESON · MARTIN POTTER · ALEXIS KANNER
MICHAEL REDGRAVE

"GOODBYE GEMINI"

MIKE PRATT · FREDDIE JONES · EDMUND WARD · *screenplay by* Ask Agamemnon *from the novel* by JENNI HALL · *executive producer* JOSEF SHAFTEL

Original Soundtrack Available on DJM Records. · *produced by* PETER SNELL · *directed by* ALAN GIBSON · FROM CINERAMA RELEASING · COLOR · **R**

PREMIERE TODAY on B'way **Astor and RKO** and other theatres near you

15

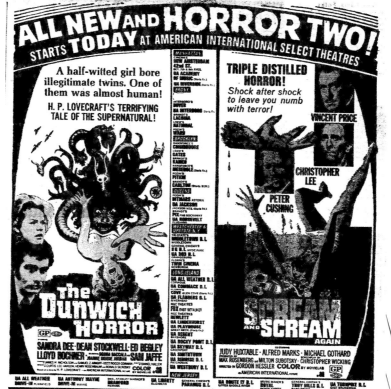

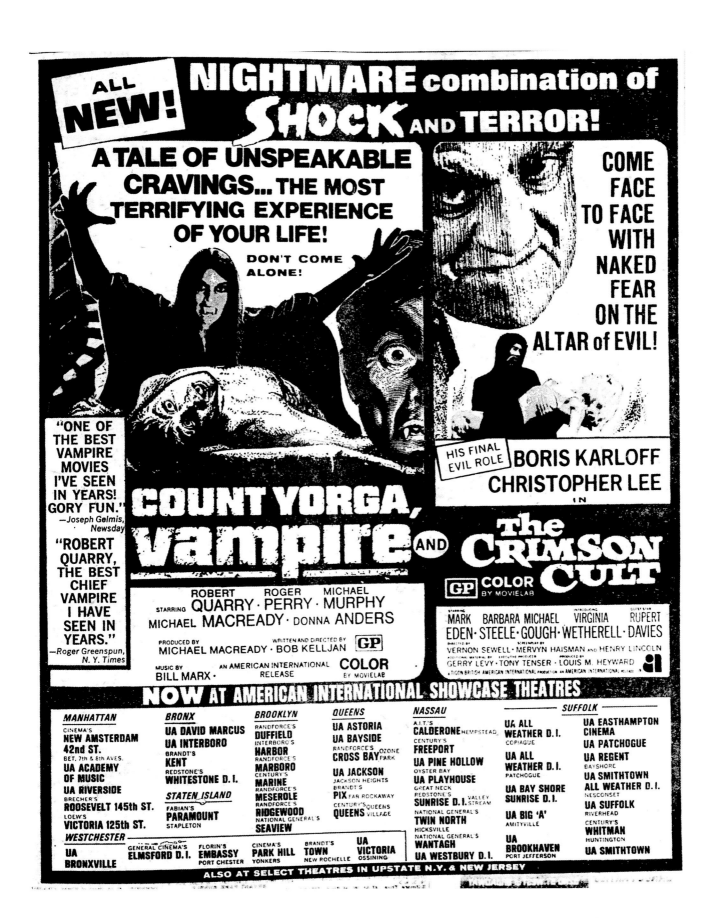

Heaven help whoever is...
and
"THE NEXT VICTIM"

GEMINI RELEASING CORPORATION and MARON FILMS LIMITED
Present an MLR FILMS, INC./LAURIE INTERNATIONAL RELEASE · COLOR

Under 17 must be accompanied by adult.

CHARLES BRONSON ANTHONY PERKINS

A doctor twists and perverts his patient's mind ...and creates his own personal executioner.

SOMEONE BEHIND THE DOOR

A GSF Release IN COLOR **GP** ALL AGES ADMITTED

NOW PLAYING AT A DIAMOND SHOWCASE THEATRE NEAR YOU!

MANHATTAN
CINEMA CIRCUIT'S
NEW AMSTERDAM
42nd STREET
CINEMA CIRCUIT'S
HARRIS
42nd STREET
UA'S **RIVIERA**
B'DWY & 97th ST

BRONX
READE'S **ALLERTON**
744 ALLERTON
BRANDT'S **EARL**
E. 161 ST.

BROOKLYN
UA'S **BENSON** CENTURY'S **MIDWOOD**
CENTURY'S
KINGS PLAZA SOUTH CENTURY'S **SHEEPSHEAD**

QUEENS
UA'S **CASINO** READE'S **CONTINENTAL**
RICHMOND HILL FOREST HILLS
CENTURY'S **COMMUNITY** READE'S **LITTLE NECK**
QUEENS VILLAGE LITTLE NECK
UA'S **QUARTET I** FLUSHING

STATEN ISLAND
FABIAN'S **ST. GEORGE**

NASSAU
CENTURY'S **ALAN** GG'S **BEACON**
NEW HYDE PARK PORT WASHINGTON
CENTURY'S **BALDWIN** CENTURY'S **FIVE TOWNS**
BALDWIN WOODMERE
AIT'S **BAR HARBOR** GG'S **OLD COUNTRY**
MASSAPEQUA PARK PLAINVIEW

SUFFOLK
UA'S **BROOKHAVEN** AIT'S **HAUPPAUGE**
PORT JEFFERSON
UA'S **COMMACK DI** UA'S **ISLIP**
COMMACK
UA'S **CORAM DI** UA'S **PLAZA**
 PATCHOGUL
CENTURY'S **YORK** HUNTINGTON

WESTCHESTER
UA'S **LARCHMONT**
LARCHMONT
READE'S **PIX**
WHITE PLAINS

UPSTATE NEW YORK
CINEMA II
PEEKSKILL
MALL CINEMA
MONTICELLO
VICTORIA
OSSINING

NEW JERSEY
ANTHONY WAYNE DI **SOMERVILLE DI**
WAYNE SOMERVILLE
EATONTOWN DI **STATE**
EATONTOWN (12-10-12) JERSEY CITY
HACKENSACK DI **TEANECK**
LITTLE FERRY TEANECK
MALL **TOWN**
HACKETTSTOWN LAKEWOOD
PARAMUS #1 **TROY HILLS DI**
PARAMUS PARSIPPANY
ROUTE 17 DI
UPPER SADDLE RIVER *Plays Dec. 15-21

STARTS **TODAY** CONTINUOUS PERFORMANCES
DOORS OPEN 10:30 AM

OBSESSED MYSTICISM
...a bewitching dimension of the occult!

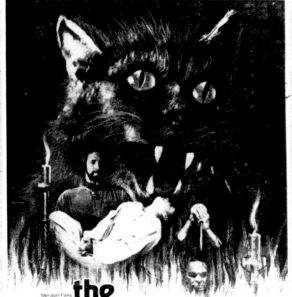

Meridian Films presents
the REINCARNATE

Starring JACK CRELEY · JAY REYNOLDS · TRUDY YOUNG
With HUGH WEBSTER · GENE TYBURN · TERRY DARTNALL · REX HAGON
Written and Produced by SEELEG LESTER · Directed by DON HALDANE
Executive Producer N.A. TAYLOR · A Tower Productions Release · COLOR

GP

NEW **PentHouse**
B'way & 47th St. 757-5450

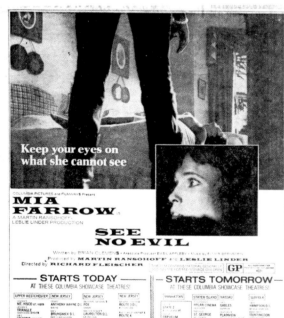

Keep your eyes on what she cannot see

COLUMBIA PICTURES and FILMWAYS Present

MIA FARROW in

A MARTIN RANSOHOFF · LESLIE LINDER Production

SEE NO EVIL

Written by BRIAN CLEMENS · Associate Producer BASIL APPLEBY · Music by ELMER BERNSTEIN
Produced by MARTIN RANSOHOFF and LESLIE LINDER
Directed by RICHARD FLEISCHER

GP

STARTS TODAY
AT THESE COLUMBIA SHOWCASE THEATRES!

STARTS TOMORROW
AT THESE COLUMBIA SHOWCASE THEATRES!

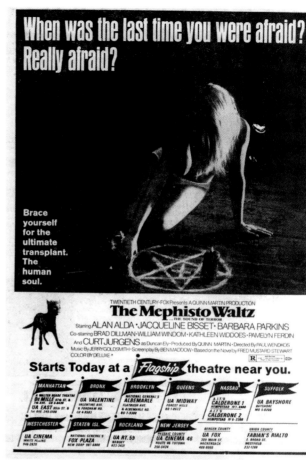

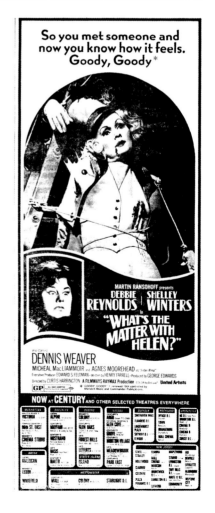

1971

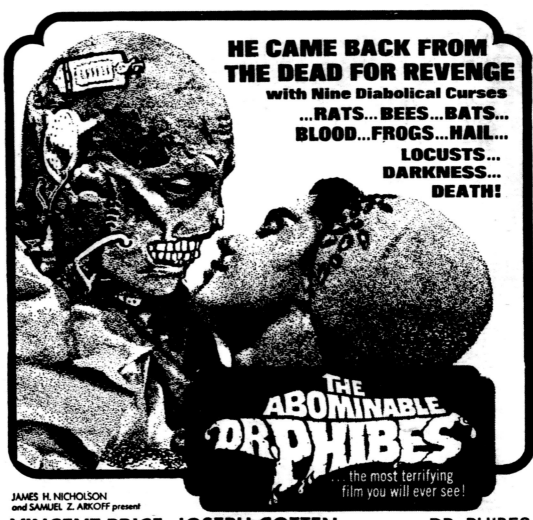

HE CAME BACK FROM THE DEAD FOR REVENGE
with Nine Diabolical Curses
...RATS...BEES...BATS...
BLOOD...FROGS...HAIL...
LOCUSTS...
DARKNESS...
DEATH!

THE abominable DR. PHIBES

...the most terrifying
film you will ever see!

JAMES H. NICHOLSON
and SAMUEL Z. ARKOFF present

VINCENT PRICE · JOSEPH COTTEN in the abominable **DR. PHIBES**
also starring **HUGH GRIFFITH** and **TERRY-THOMAS** presenting **VIRGINIA NORTH** as Vulnavia

MUSIC FROM THE SOUND TRACK AVAILABLE
ON AMERICAN INTERNATIONAL RECORDS

WRITTEN BY JAMES WHITON and WILLIAM GOLDSTEIN · PRODUCED BY LOUIS M. HEYWARD and RONALD S. DUNAS
EXECUTIVE PRODUCERS SAMUEL Z. ARKOFF and JAMES H. NICHOLSON · ORIGINAL MUSIC COMPOSED BY BASIL KIRCHIN · DIRECTED BY ROBERT FUEST

GP ALL AGES ADMITTED Parental Guidance Suggested **COLOR** BY MOVIELAB An **AMERICAN INTERNATIONAL** Picture

plus 2nd THRILL HIT! **YOG** MONSTER FROM SPACE **G COLOR** BY MOVIELAB An **AMERICAN INTERNATIONAL** Release

N.Y. PREMIERE TODAY at AMERICAN INTERNATIONAL SELECT THEATRES

21

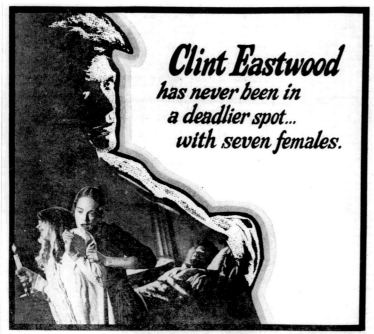

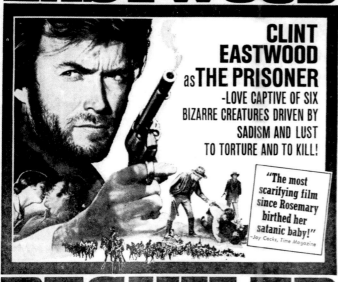

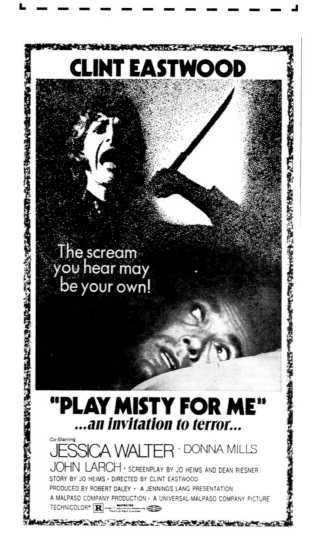

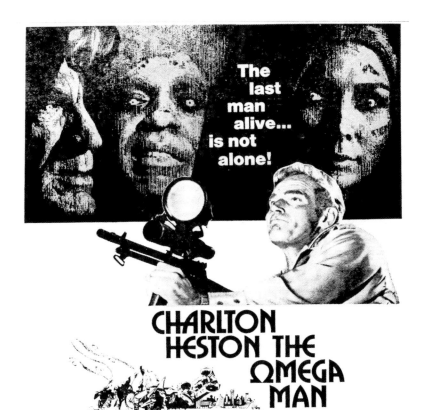

The
last
man
alive...
is not
alone!

CHARLTON HESTON THE ΩMEGA MAN

GP

A WALTER SELTZER PRODUCTION · ANTHONY ZERBE · ROSALIND CASH SCREENPLAY BY JOHN WILLIAM and JOYCE H. CORRINGTON
WALTER SELTZER · DIRECTED BY BORIS SAGAL · PANAVISION® · TECHNICOLOR® · FROM WARNER BROS. A Kinney Leisure Service

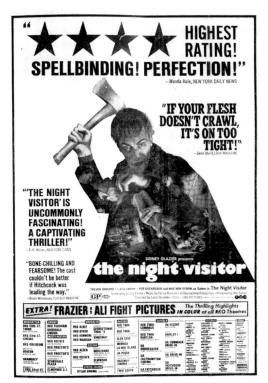

"★★★★ HIGHEST RATING!
SPELLBINDING! PERFECTION!"
—Wanda Hale, NEW YORK DAILY NEWS

"IF YOUR FLESH DOESN'T CRAWL, IT'S ON TOO TIGHT!"
—Gene Shalit, LOOK MAGAZINE

"'THE NIGHT VISITOR' IS UNCOMMONLY FASCINATING! A CAPTIVATING THRILLER!"
—A.H. Weiler, NEW YORK TIMES

"BONE-CHILLING AND FEARSOME! The cast couldn't be better if Hitchcock was leading the way."
—Bruce Williamson, PLAYBOY MAGAZINE

SIDNEY GLAZIER presents
the night visitor

TREVOR HOWARD · LIV ULLMANN · PER OSCARSSON and MAX VON SYDOW as Salem in The Night Visitor
Screenplay by Guy Elmes · Music by Henry Mancini · A Hemisphere Production · Produced by Mel Ferrer
Directed by Laslo Benedek · Onto · UMC PICTURES

GP

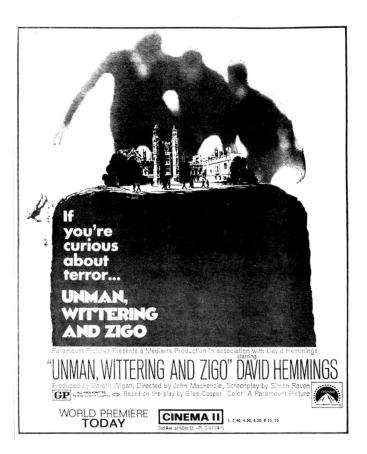

If you're curious about terror...
UNMAN, WITTERING AND ZIGO

Paramount Pictures Presents a Mediarts Production in association with David Hemmings
starring
"UNMAN, WITTERING AND ZIGO" DAVID HEMMINGS
Produced by Gareth Wigan, Directed by John Mackenzie, Screenplay by Simon Raven
GP Based on the play by Giles Cooper Color A Paramount Picture

WORLD PREMIERE TODAY CINEMA II
3rd Ave at 60th St · PL 3-0774-5
1, 2:40, 4:30, 6:20, 8:10, 10

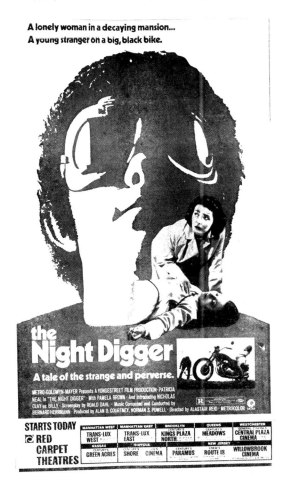

A lonely woman in a decaying mansion...
A young stranger on a big, black bike.

the Night Digger
A tale of the strange and perverse.

METRO-GOLDWYN-MAYER Presents A Youngstreet Film Production PATRICIA NEAL in "THE NIGHT DIGGER" with PAMELA BROWN · And introducing NICHOLAS CLAY as BILLY · Screenplay by ROALD DAHL · Music Composed and Conducted by BERNARD HERRMANN · Produced by ALAN D. COURTNEY, NORMAN S. POWELL · Directed by ALASTAIR REID · METROCOLOR R

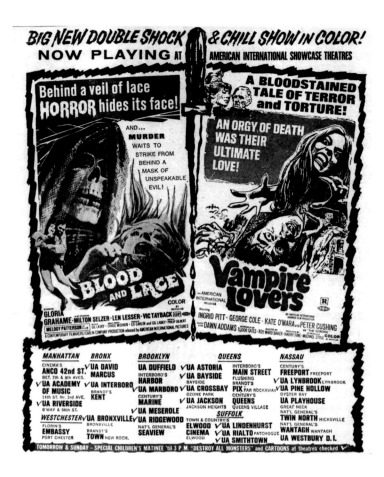

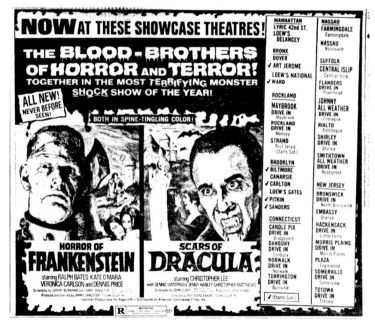

DAUGHTERS OF DARKNESS

Sapphism was the in thing for vampire movies in the early '70s, e.g. *The Vampire Lovers* at left. Arguably the most artful is Harry Kümel's *Daughters of Darkness*, with the exquisite Delphine Seyrig, an art-house darling thanks to Alain Resnais' *Last Year at Marienbad*, as the seductive Countess Bathory. She and her sultry companion Ilona (Andrea Rau) prey on a troubled couple (John Karlen and Danielle Ouimet) at an otherwise empty seaside hotel, while the ads emphasized a subsidiary surprise regarding the mother of Karlen's character. The film seduced a number of critics as well.

"Subtle, stately, stunningly colored and exquisitely directed by Belgium's young Harry Kumel...this is far and away the most artistic vampire shocker since the Franco-Italian *Blood and Roses* 10 years ago."

— Howard Thompson, *The New York Times*

"A testament to the film's quality is the fact that while one might imagine Miss Seyrig and the memories of her masterpiece role [in *Marienbad*] being cheapened in this association, the exact opposite is true."

— JOHN CRITTENDEN,
THE [HACKENSACK, NJ] *RECORD*

"[T]he film is a good off-beat thriller which manages to avoid the clichés of standard vampire shockers.... Director Harry Kumel keeps the pitch low-key at first, gradually building a subtle atmosphere of horror."

— George Kinnon, *The Boston Globe*

"The film suffers from some obviousness and several slow passages but the acting by the principals is strong, the settings exotic, the plot unusual, and the wispy, evil pleasures of vampirism are enough to dispel feelings of disbelief."

— Frank Daley, *The Ottawa Journal*

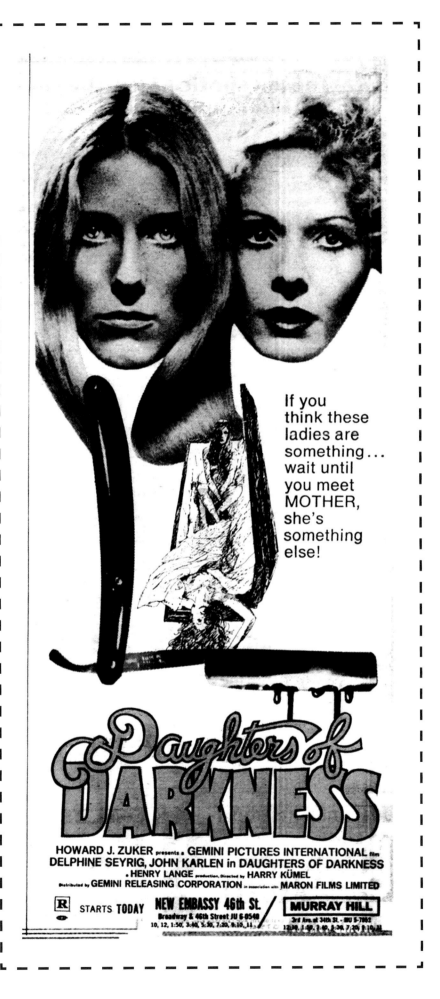

If you think these ladies are something... wait until you meet MOTHER, she's something else!

Daughters of DARKNESS

HOWARD J. ZUKER presents a GEMINI PICTURES INTERNATIONAL film
DELPHINE SEYRIG, JOHN KARLEN in DAUGHTERS OF DARKNESS
a HENRY LANGE production. Directed by HARRY KÜMEL
Distributed by GEMINI RELEASING CORPORATION in association with MARON FILMS LIMITED

R STARTS TODAY

NEW EMBASSY 46th St.
Broadway & 46th Street JU 6-0540
10, 12, 1:50, 3:40, 5:30, 7:20, 9:10, 11

MURRAY HILL
3rd Ave. at 34th St. - MU 5-7662
12:30, 1:40, 3:40, 5:30, 7:20, 9:10, 11

25

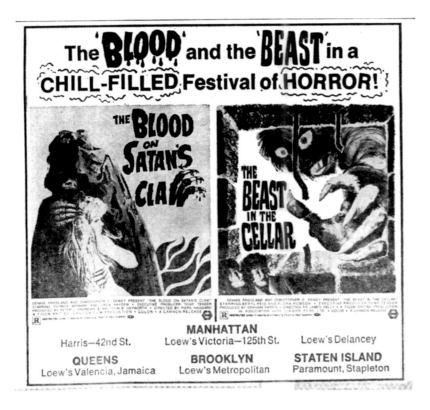

The 'BLOOD' and the 'BEAST' in a
CHILL-FILLED Festival of HORROR!

THE BLOOD ON SATAN'S CLAW

THE BEAST IN THE CELLAR

MANHATTAN
Harris—42nd St. Loew's Victoria—125th St. Loew's Delancey

QUEENS BROOKLYN STATEN ISLAND
Loew's Valencia, Jamaica Loew's Metropolitan Paramount, Stapleton

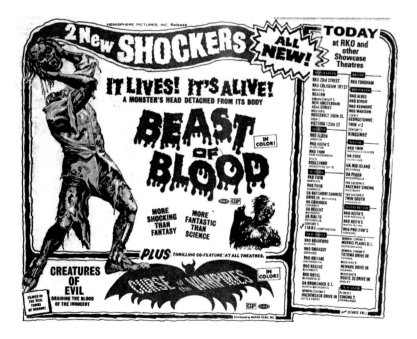

HEMISPHERE PICTURES, INC. Release

2 New SHOCKERS ALL NEW!

TODAY
at RKO and
other
Showcase
Theatres

IT LIVES! IT'S ALIVE!
A MONSTER'S HEAD DETACHED FROM ITS BODY

BEAST OF BLOOD

IN COLOR!

MORE SHOCKING THAN FANTASY MORE FANTASTIC THAN SCIENCE

PLUS THRILLING CO-FEATURE AT ALL THEATRES

CREATURES OF EVIL
DRAINING THE BLOOD OF THE INNOCENT

FILMED IN THE REAL TOWNS OF HORROR!

IN COLOR!

Distributed by MARVIN FILMS, INC.

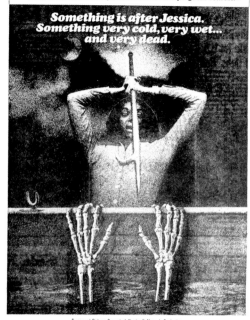

Something is after Jessica.
Something very cold, very wet...
and very dead.

Paramount Pictures Presents A Charles B. Moss, Jr. Production

"Let's Scare Jessica To Death"

Starring Zohra Lampert · Barton Heyman · Kevin O'Connor · Gretchen Corbett · Alan Manson and Mariclare Costello
Written by Norman Jonas and Ralph Rose · Produced by Charles B. Moss, Jr. · Directed by John Hancock · Color · A Paramount Picture

GP

World Premiere Today
CRITERION/JULIET I

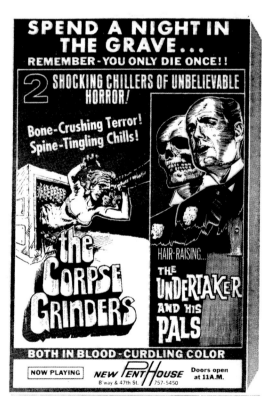

SPEND A NIGHT IN THE GRAVE...
REMEMBER - YOU ONLY DIE ONCE!!

2 SHOCKING CHILLERS OF UNBELIEVABLE HORROR!

Bone-Crushing Terror!
Spine-Tingling Chills!

the CORPSE GRINDERS

HAIR-RAISING...
THE UNDERTAKER AND HIS PALS

BOTH IN BLOOD-CURDLING COLOR

NOW PLAYING NEW PENTHOUSE Doors open at 11A.M.
B'way & 47th St. 757-5450

1971

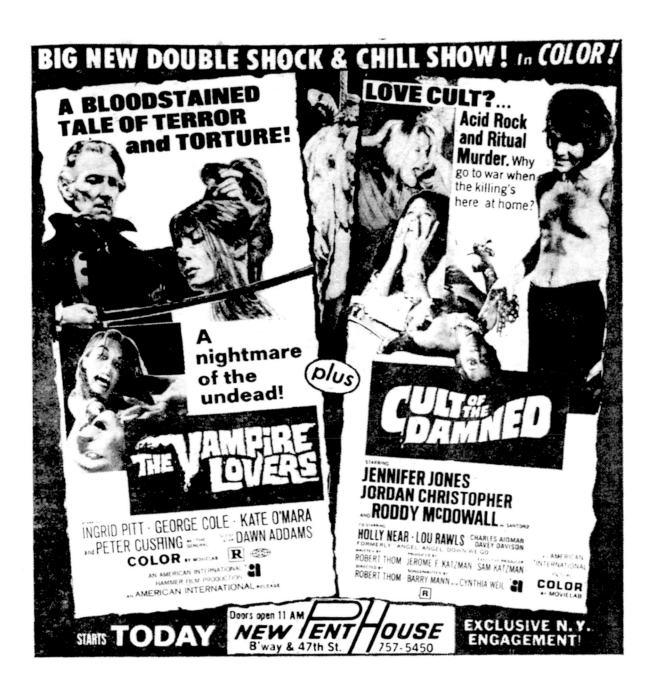

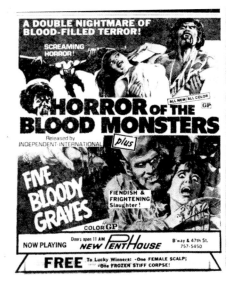

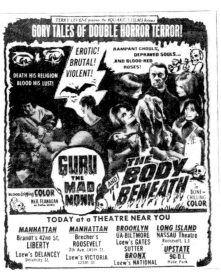

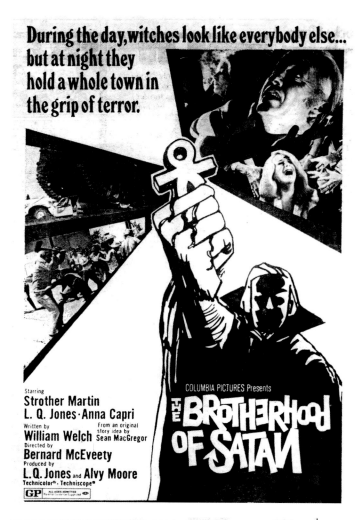

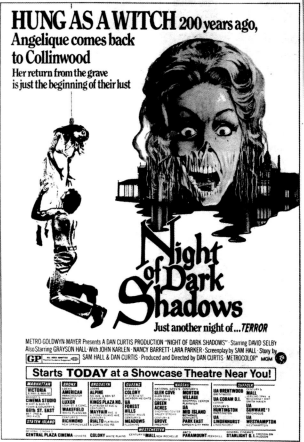

The Devils is not a film for everyone...

It is a true story, carefully documented,
historically accurate — a serious work by a distinguished
film maker. As such it is likely to be hailed
as a masterpiece by many. But because it is explicit
and highly graphic in depicting the bizarre
events that occurred in France in 1634, others will find it
visually shocking and deeply disturbing.

We feel a responsibility to alert you to this.
It is our hope that *only* the audience that will appreciate
THE DEVILS will come to see it.

VANESSA REDGRAVE~OLIVER REED
IN KEN RUSSELL'S FILM OF
THE DEVILS

A Robert H. Solo - Ken Russell Production · Screenplay by **Ken Russell**
Based on the play by John Whiting and "The Devils of Loudun" by Aldous Huxley · Directed by **Ken Russell**
Panavision' Technicolor· from **Warner Bros.** · A Kinney Leisure Service ⓧ

WORLD PREMIERE TODAY THE **Fine arts** A WALTER READE THEATRE 58th St. Bet. Park and Lexington · PL 5-6030 1, 3, 5, 7, 9, 11

"PSYCHO" THRILLERS

Alfred Hitchcock's 1960 classic about unbalanced mother love and unsafe showers continued to cast a long shadow in the 1970s. Numerous movie ads this decade pushed the comparison, including these four, all for overseas productions—the British *And Soon the Darkness* (which had a little trouble with the spelling) and *The House That Dripped Blood* (scripted by original *Psycho* author Robert Bloch), Dario Argento's Italian *giallo Cat O'Nine Tails* and *From Ear to Ear*, a French film originally titled *Les cousines*.

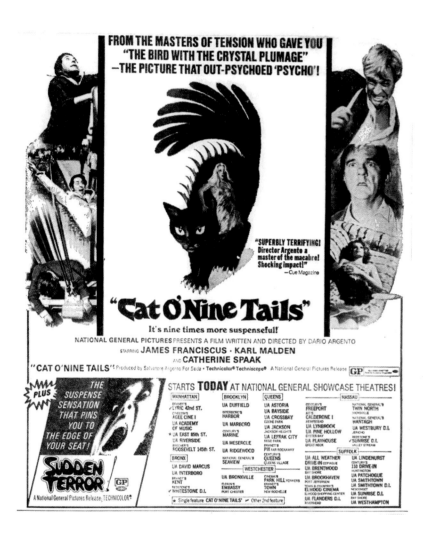

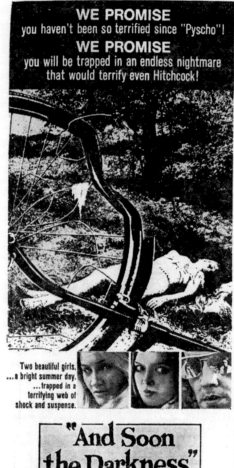

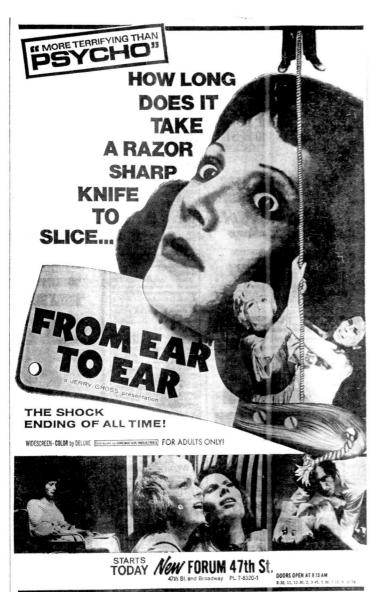
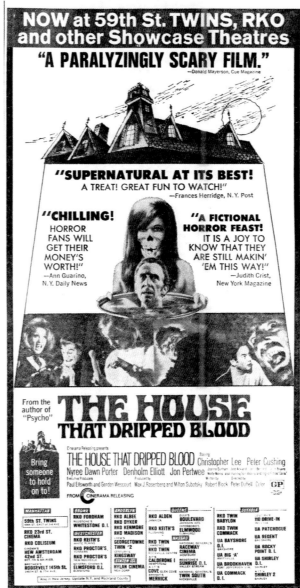

1972

TWIN TALES OF TERROR

The Black Belly of the Tarantula

with needles dipped in deadly venom the victims are paralyzed.

IN COLOR from MGM

At least they knew the butler didn't do it... his was the FIRST BODY they found!

WEEKEND MURDERS

STARTS TODAY AT A THEATRE NEAR YOU!

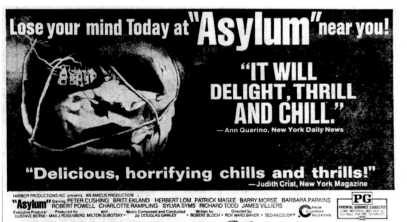

Lose your mind Today at "Asylum" near you!

"IT WILL DELIGHT, THRILL AND CHILL."
— Ann Guarino, New York Daily News

"Delicious, horrifying chills and thrills!"
— Judith Crist, New York Magazine

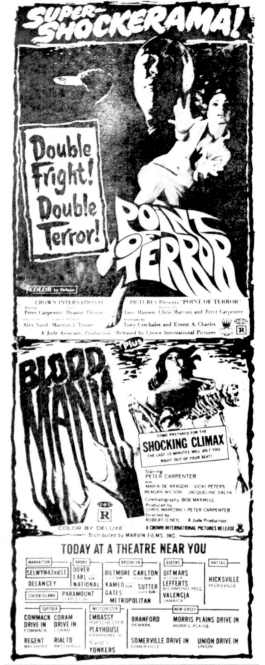

SUPER-SHOCKERAMA!

Double Fright! Double Terror!

POINT OF TERROR

COLOR by Deluxe

BLOOD MANIA PLUS

COME PREPARED FOR THE **SHOCKING CLIMAX** THE LAST 15 MINUTES WILL JOLT YOU RIGHT OUT OF YOUR SEAT!

Starring PETER CARPENTER

TODAY AT A THEATRE NEAR YOU

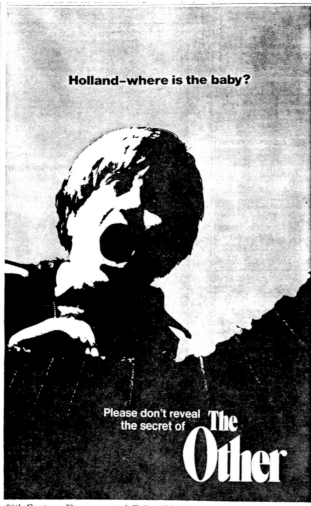

Holland—where is the baby?

Please don't reveal
the secret of The **Other**

20th Century-Fox presents A Robert Mulligan Production "The Other"
starring
Uta Hagen · Diana Muldaur · Chris and Martin Udvarnoky as the Perry Twins
Produced and Directed by Robert Mulligan · Executive Producer Thomas Tryon
Associate Producer Don Kranze · Screenplay by Thomas Tryon · Based upon his Novel
Music by Jerry Goldsmith · Color by De Luxe

The Shocking Best-Seller Becomes *The* Shocking Movie. PG PARENTAL GUIDANCE SUGGESTED

WORLD PREMIERE
TODAY THE **Coronet** A WALTER READE THEATRE
 59th St. at 3rd Ave. · EL 5-1663

SPECIAL NOTE: NO ONE ADMITTED AFTER THE FIRST TEN MINUTES.
SEE IT AT: 12:00, 2:00, 4:00, 6:00, 8:00, 10:00

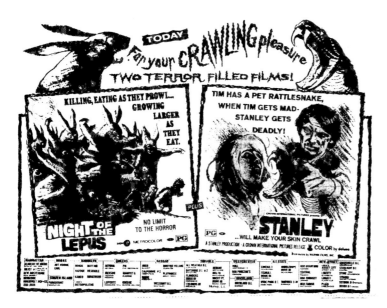

BLACULA

The title was a natural in the thick of the blaxploitation movie trend, though American International's African-American vampire opus could have descended into camp. But Shakespearean actor William Marshall, who did numerous interviews to promote the picture, fulfilled his stated ambition to bring sympathy and dignity to the title role. The movie was a hit, and the reviews generally fell into two camps: those who believed the movie complemented Marshall's performance, and those who felt it was *Blacula*'s only virtue.

"Would you believe it? *Blacula*, which makes one wince at the very sound of its exploitative title, is really lots of fun.... [F]ar less an exploitation film than it is a rip-roaring entertainment, done with lively spurt of suspense and clever twists of camp."

— Stanley Eichelbaum, *San Francisco Examiner*

"It would seem at the outset, another cheaply produced quickie... Because of the power and impressive stature of William Marshall's acting...and excellent technical values, the film turns into a suspenseful, heart pounding ghoul infested delight."

— BARBARA BLADEN,
THE [SAN MATEO, CA] *TIMES*

"Some of *Blacula*...is good, even scary; some of it is terrible; but almost all of it is funny. You may be laughing with it or at it, but you laugh, and these days, that's something.... William Marshall is an elegant and beautifully spoken Blacula."

— Bernard Drew, Gannett News Service

"The only thing that *Blacula* has going for it is William Marshall...whose mellifluous speaking voice makes the most inane dialogue sound rich. But Marshall, fine actor that he is, can deliver nothing more than a routine vampire."

— Barbara L. Wilson, *The Philadelphia Inquirer*

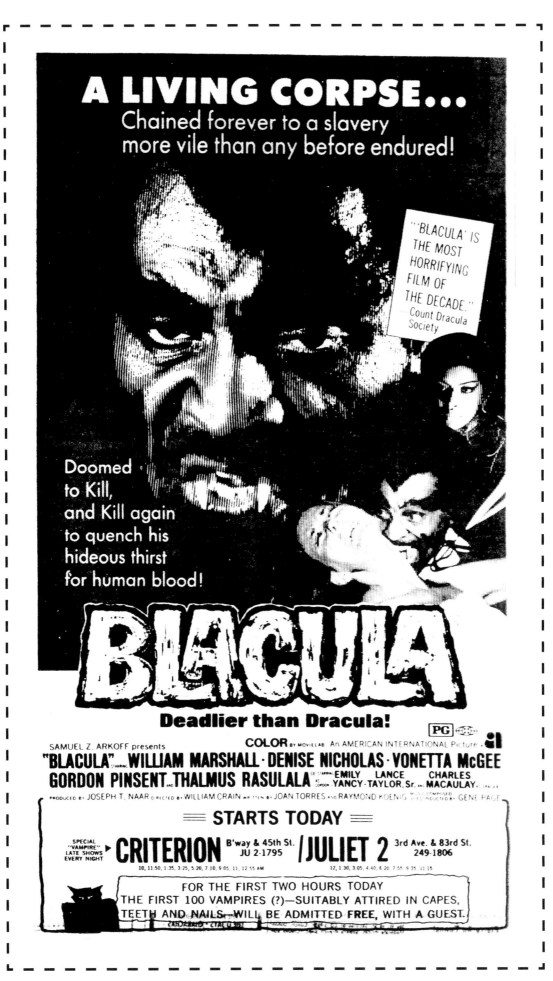

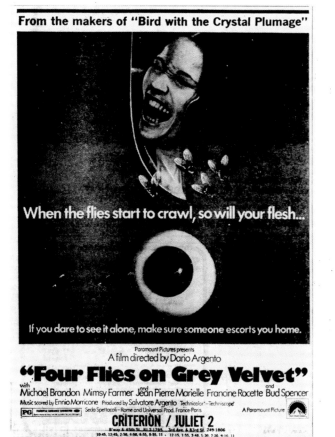

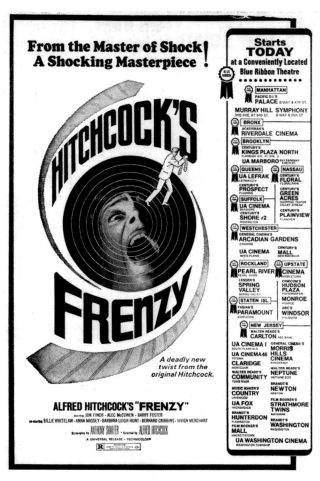

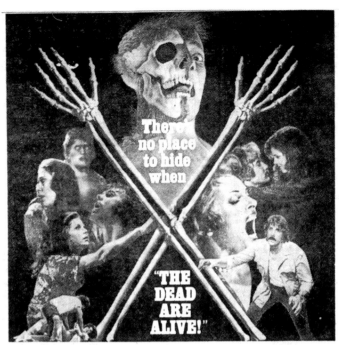

There's no place to hide when

"THE DEAD ARE ALIVE!"

NATIONAL GENERAL PICTURES Presents
ALEX CORD · SAMANTHA EGGAR · JOHN MARLEY THE DEAD ARE ALIVE
HORST FRANK and with NADJA TILLER Written by LUCIO BATTISTRADA and ARMANDO CRISPINO
Produced by MONDIAL TE. FL. Directed by ARMANDO CRISPINO Technicolor A NATIONAL GENERAL PICTURES RELEASE

NATIONAL GENERAL PICTURES PRESENTS
PLUS "Cat O'Nine Tails"
It's nine times more suspenseful!
PG Technicolor Technisope

STARTS TODAY AT A SHOWCASE THEATRE NEAR YOU.

HIS AND HER HORROR!

"DAUGHTERS OF SATAN" and "SUPERBEAST"

United Artists

MANHATTAN	BRONX	QUEENS	SUFFOLK
BRANDT'S **LYRIC 42nd St.** BET. 7TH & 8TH	INTERBORO'S **DOVER**	CENTURY'S **COMMUNITY** QUEENS VILLAGE	U.A.'S **REGENT** BAY SHORE
PODIN'S **WEST END**	BRANDT'S **KENT**	U.A.'S **BOULEVARD** JACKSON HEIGHTS	U.A.'S **RIALTO** PATCHOGUE
PODIN'S **SAN JUAN**	PODIN'S **NATIONAL**	U.A.'S **QUARTET 2** FLUSHING	**PATCHOGUE ALL-WEATHER D.I.**
U.A.'S **ACADEMY OF MUSIC** 14TH ST. NR. 3RD AVE.	PODIN'S **STAR**	**NASSAU**	
NEW JERSEY	PODIN'S **ART JEROME**	CENTURY'S **ARGO** ELMONT	U.A.'S **GREENPORT**
U.A.'S **PLAZA** ENGLEWOOD	BRANDT'S **WARD**	CENTURY'S **GROVE** FREEPORT	U.A.'S **BAY SHORE D.I.2**
GENERAL CINEMA'S **PARAMUS D.I.**	**BROOKLYN**	A.T.'S **CALDERONE 2** HEMPSTEAD	**WESTCHESTER**
STANLEY WARNER'S **RITZ** ELIZABETH	U.A.'S **DUFFIELD**		FLORIN'S **EMBASSY** PORTCHESTER

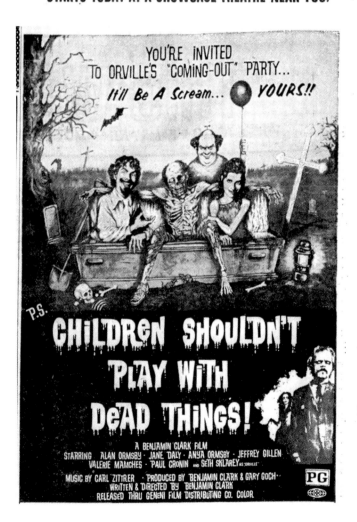

YOU'RE INVITED
TO ORVILLE'S "COMING-OUT" PARTY...
It'll Be A Scream... YOURS!!

P.S.
CHILDREN SHOULDN'T PLAY WITH DEAD THINGS!

A BENJAMIN CLARK Film
STARRING ALAN ORMSBY · JANE DALY · ANYA ORMSBY · JEFFREY GILLEN
VALERIE MAMCHES · PAUL CRONIN and SETH SKLAREY as ORVILLE
MUSIC BY CARL ZITTRER · PRODUCED BY BENJAMIN CLARK & GARY GOCH
WRITTEN & DIRECTED BY BENJAMIN CLARK
RELEASED THRU GENENI FILM DISTRIBUTING CO. COLOR.
PG

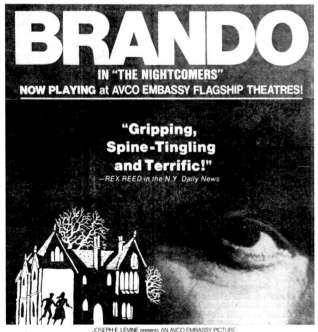

BRANDO

IN "THE NIGHTCOMERS"
NOW PLAYING at AVCO EMBASSY FLAGSHIP THEATRES!

"Gripping, Spine-Tingling and Terrific!"
—REX REED in the N.Y. Daily News

JOSEPH E. LEVINE presents AN AVCO EMBASSY PICTURE
MARLON BRANDO
In a MICHAEL WINNER Film
"THE NIGHTCOMERS"
Co-starring STEPHANIE BEACHAM · THORA HIRD and HARRY ANDREWS · Music by JERRY FIELDING · Written by MICHAEL HASTINGS
Produced and Directed by MICHAEL WINNER · An ELLIOTT KASTNER-JAY KANTER-ALAN LADD JR.-SCIMITAR PRODUCTION
R COLOR by Technicolor® Prints by Deluxe®
An Avco Embassy Release

THE WORMS ARE WAITING!

"The night Evelyn came out of the grave"

Starring ANTHONY STEFFEN · MARINA MALFATTI Also Starring ERICA BLANC
Directed By EMILIO P. MIRAGLIA · A PHASE ONE FILMS, INC. RELEASE
TECHNICOLOR® TECHNISCOPE® [R]

TWO DEADLY TALES OF TERROR!
FIRST N.Y. SHOWING NOW AT A THEATRE NEAR YOU

A severed hand beckons from an open grave as the Bloodiest Butchers in history turn the screen into a Slaughterhouse!

BLOOD FROM THE MUMMY'S TOMB

ANDREW KEIR · VALERIE LEON · JAMES VILLIERS
And HUGH BURDEN · GEORGE COULOURIS
Screenplay by CHRISTOPHER WICKING · HOWARD BRANDY · SETH HOLT
COLOR BY DE LUXE® · EMI Film Productions Limited presents A Hammer Production

this film is filled with SHOCK AFTER SHOCK AFTER SHOCK!

WARNING!
THE TRANSFORMATION OF DR. JEKYLL INTO SISTER HYDE WILL ACTUALLY TAKE PLACE BEFORE YOUR VERY EYES.

PARENTS: Be sure your children are sufficiently mature to witness the details of this film.

DR. JEKYLL AND SISTER HYDE
An American International Release

RALPH BATES · Co-Starring MARTINE BESWICK · Also Starring GERALD SIM · LEWIS FIANDER

Where "WILLARD" ended... BEN begins.

"Superior follow-up to 'Willard'. Imaginative and enormously effective."
—Mayerson, Cue

CINERAMA RELEASING presents BEN starring JOSEPH CAMPANELLA · ARTHUR O'CONNELL · MEREDITH BAXTER
and introducing LEE HARCOURT MONTGOMERY as Danny · Screenplay by GILBERT A. RALSTON · Based on characters created by WALTER SCHARF
"Ben's Song" & "Start the Day" by DON BLACK and WALTER SCHARF · CHARLES A. PRATT · MORT BRISKIN · PHIL KARLSON A BCP PRODUCTION A service of Cox Broadcasting Corp. In Color
[PG] "Ben's Song" sung by MICHAEL JACKSON on Motown Records

TODAY NEW PENTHOUSE/59th St.Twin #1/RKO 86th St.Twin #1

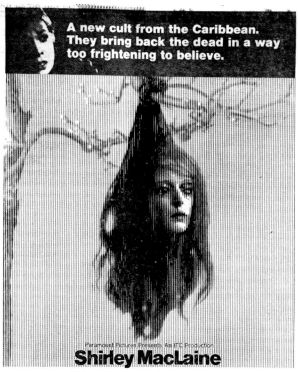

A new cult from the Caribbean. They bring back the dead in a way too frightening to believe.

Paramount Pictures Presents An ITC Production

Shirley MacLaine
The Possession of Joel Delaney

Based on the novel by Ramona Stewart · Screenplay by Matt Robinson and Grimes Grice
Directed by Waris Hussein · Music Scored and conducted by Joe Raposo · In Color · A Paramount Picture
[R]

World Premiere Today
Criterion | RKO 59th St. Twin #2 | Paramount

1972

Today at Allied Artists Showcase Theatres

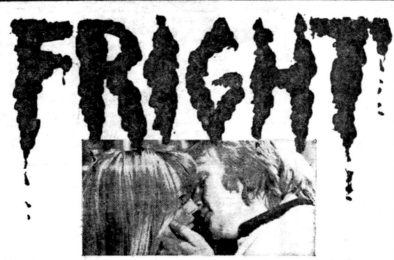

Just another normal night of babysitting ...with a few exceptions.

See him give her the biggest shock of her life!

SUSAN GEORGE · HONOR BLACKMAN · IAN BANNEN · JOHN GREGSON

FRIGHT

Written by Tudor Gates · Produced by Harry Fine and Michael Style · Directed by Peter Collinson
EastmanColor a Lion International film · Distributed by Allied Artists **PG**

MANHATTAN
ABC EASTERN'S
JULIET #1
3rd AVE. & 83rd ST.
BRANDT'S
SELWYN 42nd ST.
BET B WAY & 8th AVE.
UA ACADEMY OF MUSIC
14TH. ST. NR. 3RD. AVE.

BRONX
POZIN'S
BAINBRIDGE
UA INTERBORO
BRANDT'S
KENT
AIDALA'S
PALACE

BROOKLYN
UA DUFFIELD
CENTURY'S
MAYFAIR
UA MESEROLE
CENTURY'S
NOSTRAND
UA OASIS
CENTURY'S
RIALTO
NAT'L GENERAL'S
SEAVIEW

QUEENS
UA ASTORIA
GG'S
BOULEVARD
JACKSON HTS.
CENTURY'S
COMMUNITY
QUEENS VILLAGE
UA CROSSBAY
OZONE PARK
UA QUARTET III
FLUSHING

NASSAU
CENTURY'S
ALAN NEW HYDE PARK
CENTURY'S
ARGO ELMONT
CENTURY'S
BALDWIN BALDWIN
CENTURY'S
FIVE TOWNS
WOODMERE
UA GABLES
MERRICK
GG'S
OLD COUNTRY
PLAINVIEW
UA PLAYHOUSE
GREAT NECK

SUFFOLK
UA ALL WEATHER D. I.
COPIAGUE
UA ART PORT JEFFERSON
TOWN & COUNTRY'S
ELWOOD CINEMA
UA PLAZA PATCHOGUE
UA REGENT BAY SHORE
UA ROCKY POINT D.I.
ROUTE 25A ROCKY POINT
**UA SMITHTOWN
ALL WEATHER D. I.**
NESCONSET
UA SHIRLEY D. I.
UA SUFFOLK RIVERHEAD
CENTURY'S
WHITMAN HUNTINGTON

WESTCHESTER
ABC'S
PARAMOUNT
PEEKSKILL
MUSIC MAKERS'
RYE RIDGE
PORTCHESTER

UPSTATE N.Y.
UA CARMEL 1
Carmel
Film Booker's
CINEMA 3
Highland Falls
Walter Reade's
COMMUNITY
Kingston (6/2-4)
Tri State's
MAYBROOK D.I.
Maybrook (6/3-6)
Tri State's
MIDDLETOWN D.I.
Middletown
ABC's
PARAMOUNT
Middletown
Lesser's
RIALTO
Monticello
UA ROCKLAND D.I.
Monsey
Tri State's
TRI STATE D.I.
Matamoras, Pa

NEW JERSEY
Florin's
ADAMS Newark
UA BRUNSWICK D.I.
North Brunswick
Music Maker's
CINEMA 34 Matawan
Walter Reade's
EATONTOWN D.I.
Brandt's
✱ **HUNTERDON**
Flemington
Brandt's
✱ **NEWTON** Newton
UA PLAINFIELD D.I.
Plainfield
UA PLAZA Englewood
LOEWS ROUTE 18
East Brunswick
Film Booker's
STATE Boonton
Brandt's
✱ **STRAND** Hackettstown
Music Maker's
TOWN Lakewood

✱ SINGLE FEATURE

PLUS 2ND FEATURE AT MOST THEATRES!

39

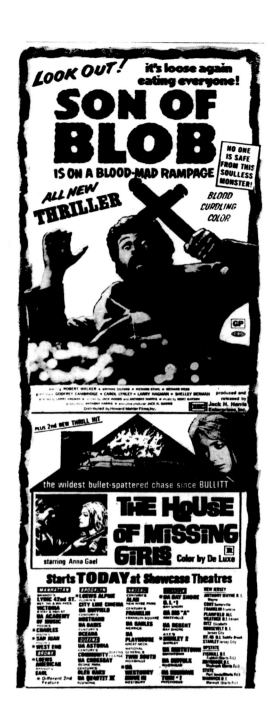

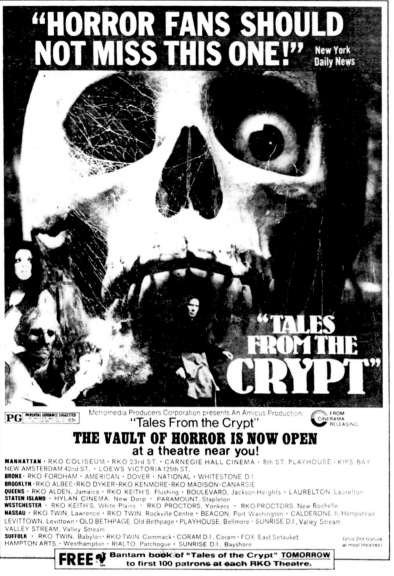

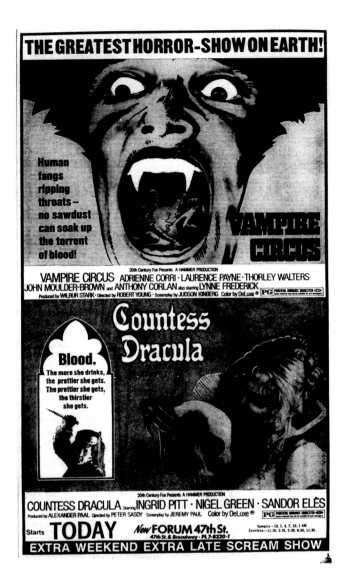

THE GREATEST HORROR-SHOW ON EARTH!

Human fangs ripping throats — no sawdust can soak up the torrent of blood!

VAMPIRE CIRCUS

20th Century Fox Presents A HAMMER PRODUCTION

VAMPIRE CIRCUS · ADRIENNE CORRI · LAURENCE PAYNE · THORLEY WALTERS
JOHN MOULDER-BROWN and ANTHONY CORLAN also starring LYNNE FREDERICK **PG**
Produced by WILBUR STARK · Directed by ROBERT YOUNG · Screenplay by JUDSON KINBERG · Color by DeLuxe ®

Countess Dracula

Blood. The more she drinks, the prettier she gets. The prettier she gets, the thirstier she gets.

20th Century Fox Presents A HAMMER PRODUCTION

COUNTESS DRACULA starring INGRID PITT · NIGEL GREEN · SANDOR ELÈS
Produced by ALEXANDER PAAL Directed by PETER SASDY Screenplay by JEREMY PAUL Color by DeLuxe ® **PG**

Starts **TODAY** *New* **FORUM 47th St.**
47th St. & Broadway · PL 7-8320-1
Vampire—10, 1, 4, 7, 10, 1 AM
Countess—11:20, 2:25, 5:30, 8:30, 11:30.

EXTRA WEEKEND EXTRA LATE SCREAM SHOW

SHE'S THE GIRL WITH THE POWER ...TO TURN YOU ON!...TO TURN YOU OFF!

She'll curl your mind!

the Virgin Witch **R**

Joseph Brenner presents ANN MICHELLE as the "Virgin Witch" with PATRICIA HAINES · NEIL HALLETT
KEITH BUCKLEY · JAMES CHASE · VICKI MICHELLE · Screenplay by KLAUS VOGEL · Produced by RALPH SOLOMONS · Directed by RAY AUSTIN
A UNIVISTA PRODUCTION, LTD. · In Eastmancolor · RELEASED BY JOSEPH BRENNER ASSOCIATES INC.

PLUS

"MOST REMARKABLE .." —NEW YORK TIMES

LEE RESSEL Presents **The Minx R** —exactly what you think she is

STARTS TODAY AT A SHOWCASE THEATRE NEAR YOU!

MANHATTAN	BROOKLYN	NASSAU	SUFFOLK
BRANDT'S **APOLLO 42nd ST.** BET. 7TH & 8TH AVES.	LIGHTSTONE'S **BENSON** FLORIN'S	CENTURY'S **ARGO** ELMONT	* **UA ALL WEATHER DRIVE-IN** PATCHOGUE
UA ACADEMY OF MUSIC	**CITY LINE CINEMA**	AIT'S **CALDERONE #2** HEMPSTEAD	**UA AMITYVILLE** AMITYVILLE
BRANDT'S **ESSEX**	**UA DUFFIELD**	CENTURY'S **GROVE** FREEPORT	**UA ART** PORT JEFFERSON
UA RIVERSIDE	INTERBORO'S **HARBOR** CENTURY'S	INTERBORO'S **LIDO** LONG BEACH	**UA BAY SHORE DRIVE-IN**
WESTCHESTER	**HOSTRAND**	**UA MID ISLAND** BETHPAGE	* **UA CORAM D.I.** CORAM
LESSER'S **CINEMA 2** PEEKSKILL	**UA OASIS** NAT'L GENERAL'S **SEAVIEW**	CENTURY'S **MORTON VILLAGE** PLAINVIEW	**UA REGENT** BAY SHORE
TRIANGLE'S **PICKWICK** DOBBS FERRY	QUEENS	MARMO'S **STUDIO 1** LYNBROOK	**UA SUFFOLK** RIVERHEAD
	CENTURY'S **ASTORIA**	NAT'L GENERAL'S **WANTAGH**	**UA SUNWAVE TWIN CINEMA** PATCHOGUE
	COMMUNITY QUEENS VILLAGE	INTERBORO'S **PARSONS** FLUSHING	
	UA JACKSON JACKSON HEIGHTS	SHORE'S **PIX** FAR ROCKAWAY	* Different 2nd Feature
	UA LEFFERTS RICHMOND HILL	**UA QUARTET III** FLUSHING	Also Playing at Theatres in New Jersey and Upstate New York

ALL NEW! DOUBLY DEADLY!

YORGA IS BACK FROM THE GRAVE and with him a horde of nameless horrors

Edgar Allan Poe's masterpiece of the grotesque...

A SIGH...A GASP...A SCREAM! THESE ARE THE SOUNDS OF...

THE RETURN OF COUNT YORGA

GP

the return of count yorga
robert quarry · mariette hartley · roger perry · yvonne wilder
edward walsh · george macready · walter brooke

Murders IN THE Rue Morgue

GP

JASON ROBARDS in "Murders In The Rue Morgue"
CHRISTINE KAUFMANN · HERBERT LOM
ADOLFO CELI · MICHAEL DUNN · LILLI PALMER

NOW PLAYING at RKO and other Showcase Theatres

MANHATTAN	BROOKLYN	QUEENS	NASSAU	SUFFOLK	UPSTATE N.Y.	NEW JERSEY
BRANDT'S **LYRIC 42nd ST.**	**RKO ALBEE**	**RKO ALDEN** JAMAICA	**RKO TWIN** LAWRENCE	**RKO TWIN BABYLON**	QUICKWAY CINEMA	ORITANI ELIZABETH
RKO 23rd ST. CINEMA	**RKO DYKER**	**RKO KEITH'S** FLUSHING	ROCKVILLE CENTRE	BABYLON	TWIN CINEMA I	**RITZ** ELIZABETH
RKO COLISEUM	**RKO KENMORE**	CO'S	**BEACON** PORT WASHINGTON	**RKO TWIN COMMACK**	Newburgh	**ROOSEVELT D.I.** Jersey City
BRONX	**RKO MADISON**	**BOULEVARD** JACKSON HTS.	CO'S	COMMACK	NEW JERSEY	**STATE** New Brunswick
RKO FORDHAM	CENTURY'S **AVALON**		**CALDERONE #2** HEMPSTEAD	NAT'L GENERAL'S **FOX** EAST	AMBOYS D.I. Sayreville	**TROY HILLS D.I.** Parsippany
STATEN ISLAND	WESTCHESTER		**PLAYHOUSE** GREAT NECK	SETAUKET	BAKER D.I.	WELLMONT
FABIAN'S **PARAMOUNT** STAPLETON	**RKO KEITH'S** WHITE PLAINS		**RACEWAY CINEMA** WESTBURY	**CINEMA #2** BAY SHORE	BRANFORD NEW D.I.	EMBASSY Orange
	RKO PROCTOR'S NEW ROCHELLE		NAT'L GENERAL'S **TWIN SOUTH**	NAT'L GENERAL'S **HO D.I.** HUNTINGTON	CINEMA #2 Morristown	**FABIAN** Paterson
	RKO PROCTOR'S PARAMOUNT PEEKSKILL			**RIALTO** PATCHOGUE	EMBASSY	**TABAN**
					ALCONQUIN	**MALL** Chester

41

GIMMICKS AND GIVEAWAYS

With so much scary stuff all over the screens, certain distributors came up with extra bonuses to help lure butts into seats. One of the most notorious was the "Distress Aid"—i.e. an airplane-style vomit bag emblazoned with the movie's logo/art—provided by Hallmark Releasing to help viewers handle the more revolting aspects of *Mark of the Devil*. Warner Bros. released Hammer's *Dracula A.D. 1972* accompanied (albeit not in all theaters, according to reports from the time) by a featurette in which a bloodsucker played by *The Night Stalker*'s Barry Atwater led the audience to take an oath to join the Count Dracula Society. This was an actual organization headed by Dr. Donald A. Reed, who would found The Academy of Science Fiction, Fantasy and Horror Films, bestowers of the Saturn Awards, the same year. And the first 100 attendees of Palomar Pictures International's double bill of Amicus' *What Became of Jack and Jill?* and Jack Starrett's *The Strange Vengeance of Rosalie* were promised "Scream Suppressors." What those suppressors were, this writer has not been able to uncover.

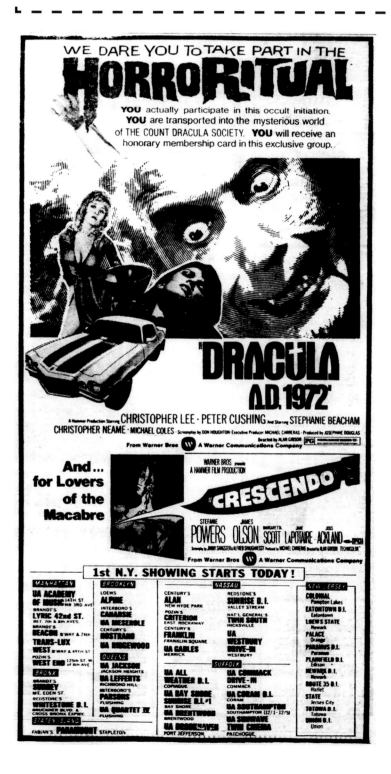

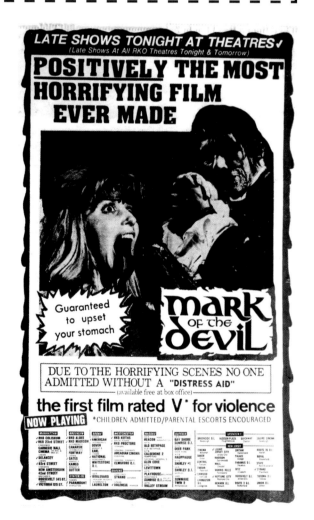

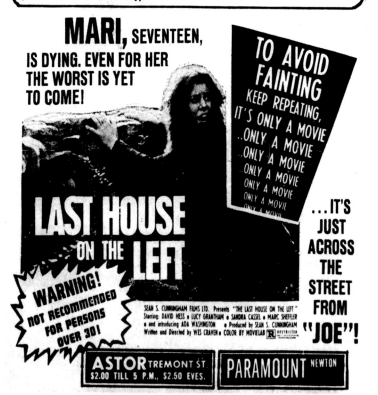

MARI, SEVENTEEN, IS DYING. EVEN FOR HER THE WORST IS YET TO COME!

TO AVOID FAINTING KEEP REPEATING, IT'S ONLY A MOVIE ..ONLY A MOVIE ..ONLY A MOVIE ..ONLY A MOVIE ONLY A MOVIE ONLY A MOVIE ONLY A MOVIE

...IT'S JUST ACROSS THE STREET FROM "JOE"!

LAST HOUSE on the LEFT

WARNING! NOT RECOMMENDED FOR PERSONS OVER 30!

SEAN S. CUNNINGHAM FILMS LTD. Presents "THE LAST HOUSE ON THE LEFT" Starring: DAVID HESS • LUCY GRANTHAM • SANDRA CASSEL • MARC SHEFFLER • and introducing ADA WASHINGTON • Produced by SEAN S. CUNNINGHAM Written and Directed by WES CRAVEN • COLOR BY MOVIELAB [R] RESTRICTED

ASTOR TREMONT ST. $2.00 TILL 5 P.M., $2.50 EVES. PARAMOUNT NEWTON

THE LAST HOUSE ON THE LEFT

It seems like there were just as many letters to the editor regarding Wes Craven's debut shocker in the newspapers as there were reviews. Concerned citizens wrote in about this "disgusting" and "pornographic" "trash" (to cite just three of the descriptors) infesting their local theaters, with many walking out and some complaining to those movie houses. Distributor Hallmark Releasing, always looking for a good gimmick, took full advantage of the dissent, positing *Last House* as an important cautionary tale, not a violent exploitation film, in some advertisements. Others quoted a positive review from a source that might surprise some, and stood in contrast to the bulk of the other notices, which echoed the thoughts of those letter-writers.

"I don't want to give the impression...that this is simply a good horror movie. It's horrifying, all right, but in ways that have nothing to do with the supernatural... Wes Craven's direction never lets us out from under almost unbearable dramatic tension."
— Roger Ebert, *Chicago Sun-Times*

"In many ways it comes closer to succeeding than the several movies from which it liberally borrows ideas... This movie is so powerful that it touches the very roots of fears other movies only titillate."
— JIM HOPWOOD, [DECATUR, IL] *HERALD AND REVIEW*

"How healthy and noble those simple Swedish sex romps of a few years ago now seem when compared to the pornography of violence we find in repulsive films like this."
— George Anderson, *Pittsburgh Post-Gazette*

"Compared to this standard [of *Straw Dogs*], writer-director Wes Craven shows the imagination of a burned-out light bulb, the intelligence of a carrot, and the sensitivity of a dead snail."
— Brian Nelson, *The* [Moline, IL] *Daily Dispatch*

1972

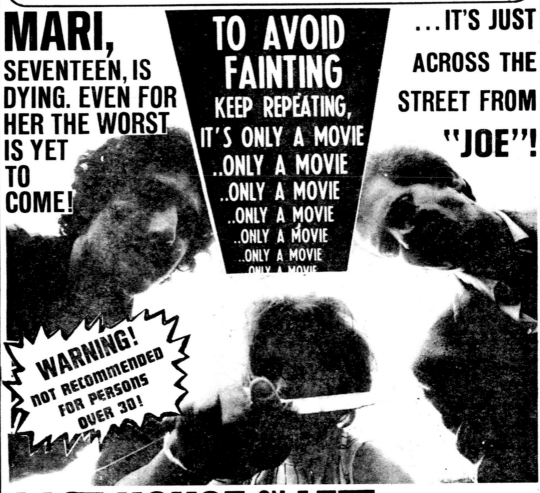
45

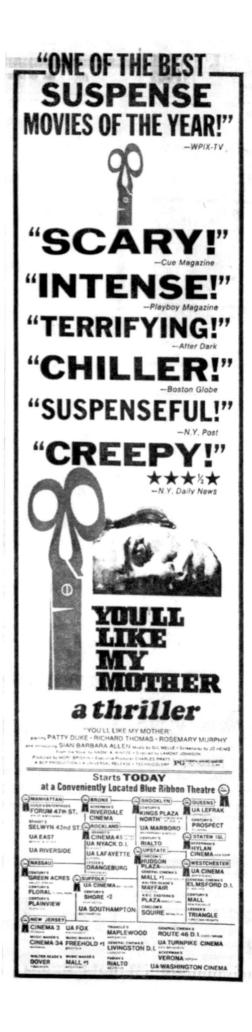

1972

If You Dare!

See this Heart-Stopping Blood-Chilling double bill!

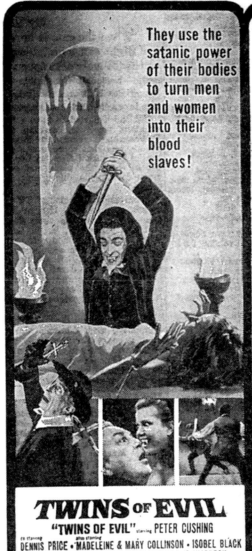

They use the satanic power of their bodies to turn men and women into their blood slaves!

TWINS OF EVIL

"TWINS OF EVIL" starring PETER CUSHING

co starring DENNIS PRICE • MADELEINE & MARY COLLINSON • ISOBEL BLACK
KATHLEEN BYRON • DAMIEN THOMAS • DAVID WARBECK

Screenplay by TUDOR GATES Produced by HARRY FINE and MICHAEL STYLE Directed by JOHN HOUGH In Color

A HAMMER PRODUCTION
A UNIVERSAL RELEASE **R**

Starts **TODAY** at Universal Showcase Theatres

MANHATTAN
CINEMA CIRCUIT'S
NEW AMSTERDAM 42nd STREET
UA RIVERSIDE

BROOKLYN
LOEW'S
ALPINE
CENTURY'S
BROOK
UA DUFFIELD
UA MESEROLE
CENTURY'S
SHEEPSHEAD

BRONX
POZIN'S
ART JEROME
BRANDT'S POZIN'S
EARL WARD

QUEENS
UA JACKSON
JACKSON HEIGHTS
UA LEFFERTS
RICHMOND HILL,
UA QUARTET #2
FLUSHING
CENTURY'S
QUEENS
QUEENS VILLAGE

STATEN ISLAND FABIAN'S
PARAMOUNT
STAPLETON

NASSAU
CENTURY'S
FRANKLIN
FRANKLIN SQ,
CENTURY'S
FREEPORT
FREEPORT
UA MID ISLAND
BETHPAGE

UA PLAYHOUSE
GREAT NECK
MARMO'S
STUDIO #1
LYNBROOK
UA WESTBURY D.I.
WESTBURY

SUFFOLK
UA AMITYVILLE
AMITYVILLE
UA BAYSHORE
D.I. #2 BAYSHORE
UA COPIAGUE D-I
COPIAGUE
UA FLANDERS
RIVERHEAD

UA PATCHOGUE
PATCHOGUE
UA ROCKY PT. D-I
ROCKY POINT
UA SMITHTOWN
SMITHTOWN
CENTURY'S
WHITMAN
HUNTINGTON

WESTCHESTER
EMBASSY
PORTCHESTER
GENERAL CINEMA'S
HOLLOWBROOK D-I
PEEKSKILL
ABC EASTERN'S
PARAMOUNT
PEEKSKILL

ROCKLAND
UA 303 D.I.
ORANGEBURG

N.Y. STATE
TRI-STATE'S
FAIR OAKS D-I
FAIR OAKS
CINECOM'S
FISHKILL D-I
FISHKILL
GENERAL CINEMA'S
9-6 D-I HYDE PARK
ABC PARAMOUNT'S
PARAMOUNT
MIDDLETOWN

NEW JERSEY
UA LIBERTY
ELIZABETH
GENERAL CINEMA'S
MORRIS PLAINS D-I
MORRIS PLAINS
WALTER READE'S
BAY D.I. ISLAND
HEIGHTS
GENERAL CINEMA'S
PALACE CINEMA
ORANGE

UA PLAINFIELD D-I
NORTH PLAINFIELD
GENERAL CINEMA'S
ROUTE 3 D-I
RUTHERFORD
UA STATE
JERSEY CITY
UA TURNPIKE D-I
EAST BRUNSWICK

THE HANDS OF JACK THE RIPPER LIVE AGAIN...as his fiendish daughter kills again...

"Hands of the Ripper"

"HANDS OF THE RIPPER" starring Eric Porter • Jane Merrow
guest star Dora Bryan also starring Angharad Rees • Derek Godfrey
Screenplay by L. W. DAVIDSON • From an original story by EDWARD SPENCER SHEW
Produced by AIDA YOUNG • Directed by PETER SASDY
A HAMMER PRODUCTION
A UNIVERSAL RELEASE In COLOR **R**

47

1973

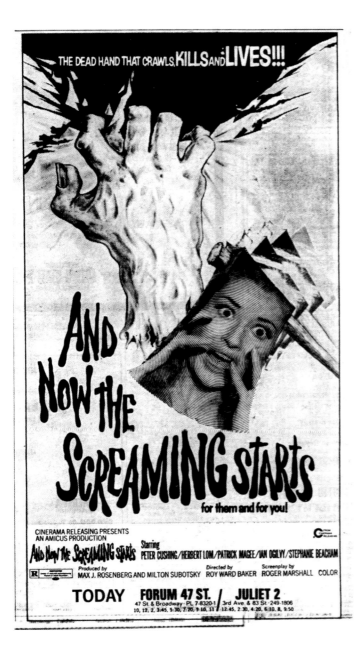

THE DEAD HAND THAT CRAWLS, KILLS AND LIVES!!!

AND NOW THE SCREAMING STARTS

for them and for you!

CINERAMA RELEASING PRESENTS
AN AMICUS PRODUCTION

AND NOW THE SCREAMING STARTS

Starring
PETER CUSHING / HERBERT LOM / PATRICK MAGEE / IAN OGILVY / STEPHANIE BEACHAM

R

Produced by
MAX J. ROSENBERG AND MILTON SUBOTSKY

Directed by
ROY WARD BAKER

Screenplay by
ROGER MARSHALL COLOR

TODAY FORUM 47 ST. / JULIET 2
47 St & Broadway · PL 7-8320-1 3rd Ave & 83 St · 249-1806
10, 12, 2, 3:45, 5, 30, 7, 20, 9, 10, 11 12:45, 2, 30, 4, 20, 6, 10, 8, 9:50

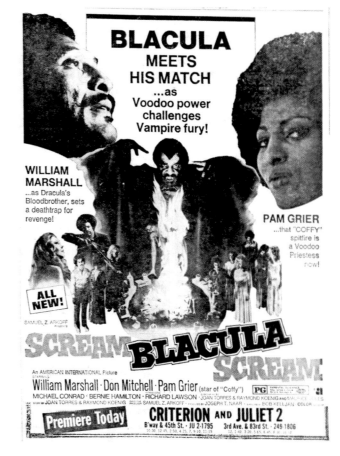

BLACULA
MEETS HIS MATCH
...as Voodoo power challenges Vampire fury!

WILLIAM MARSHALL
...as Dracula's Bloodbrother, sets a deathtrap for revenge!

PAM GRIER
...that "COFFY" spitfire is a Voodoo Priestess now!

ALL NEW!

SAMUEL Z. ARKOFF Presents

SCREAM BLACULA SCREAM

An AMERICAN INTERNATIONAL Picture

STARRING
William Marshall · Don Mitchell · Pam Grier (star of "Coffy") PG

MICHAEL CONRAD · BERNIE HAMILTON · RICHARD LAWSON · JOAN TORRES & RAYMOND KOENIG and MAURICE JULES
Story by JOAN TORRES & RAYMOND KOENIG Produced by SAMUEL Z. ARKOFF Directed by JOSEPH T. NAAR Music by BOB KELLJAN COLOR

Premiere Today CRITERION AND JULIET 2
B'way & 45th St. · JU 2-1795 3rd Ave. & 83rd St. · 249-1806

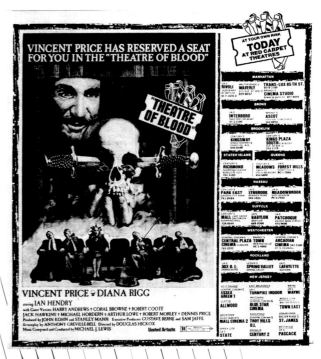

VINCENT PRICE HAS RESERVED A SEAT FOR YOU IN THE "THEATRE OF BLOOD"

"THEATRE OF BLOOD"

VINCENT PRICE · DIANA RIGG

starring IAN HENDRY
with Guest Victims HARRY ANDREWS · CORAL BROWNE · ROBERT COOTE
JACK HAWKINS · MICHAEL HORDERN · ARTHUR LOWE · ROBERT MORLEY · DENNIS PRICE
Produced by JOHN KOHN and STANLEY MANN Executive Producers GUSTAVE BERNE and SAM JAFFE
Screenplay by ANTHONY GREVILLE-BELL Directed by DOUGLAS HICKOX R
Music Composed and Conducted by MICHAEL J. LEWIS United Artists

AT YOUR OWN RISK
TODAY
AT RED CARPET THEATRES

MANHATTAN
RIVOLI
WALTER READE'S WAVERLY TRANS-LUX 85TH ST.
CINEMA STUDIO

BRONX
INTERBORO BRANDT'S ASCOT

BROOKLYN
CENTURY'S KINGSWAY CENTURY'S KINGS PLAZA SOUTH

STATEN ISLAND
CENTURY'S RICHMOND QUEENS
CENTURY'S MEADOWS CENTURY'S FOREST HILLS

NASSAU
CENTURY'S PARK EAST LYNBROOK MEADOWBROOK

SUFFOLK
CENTURY'S MALL CENTURY'S BABYLON PATCHOGUE

WESTCHESTER
CENTRAL PLAZA CINEMA BRANDT'S TOWN BRANDT'S ARCADIAN CINEMA

ROCKLAND
303 D.I. SPRING VALLEY LAFAYETTE

NEW JERSEY
ESSEX GREEN 1 TURNPIKE INDOOR WAYNE
ALLWOOD BLUE STAR CINEMA TOWN EAST
MALL CINEMA 2 TROY HILLS ST. JAMES
STATE CENTURY 2 PASCACK

49

THE CRAZIES

George A. Romero's first true horror film since *Night of the Living Dead* had its initial release in New York City, where it unfortunately received negative reviews and disappointing box-office returns. Financier/distributor Cambist Films quickly pulled *The Crazies*, retitled it *Code Name Trixie* and sent it around the U.S. drive-in circuit on double bills with *The Minx* and *Vampyres/Daughters of Dracula*, with notably chintzy ads. It did screen as the opening attraction at 1973's Edinburgh International Film Festival, resulting in much stronger notices from the UK papers; Romero reported in 1974 that two other distributors had offered to buy the rights, but Cambist wouldn't let the movie go. Finally, in 1976, Romero got the movie away from them and booked it under its original title into specialty houses in a number of cities, including New York (where he made personal appearances at occasional showings), Boston, Los Angeles, San Francisco and others.

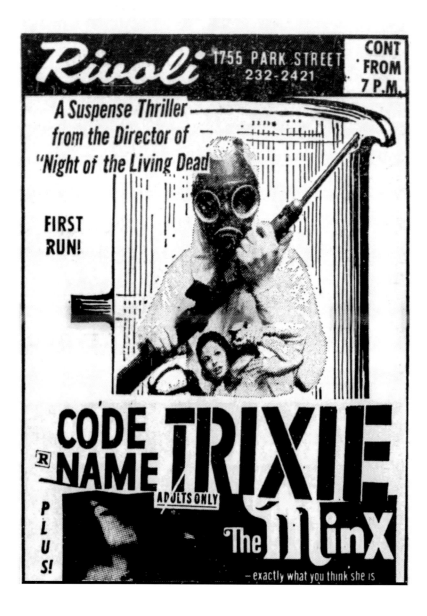

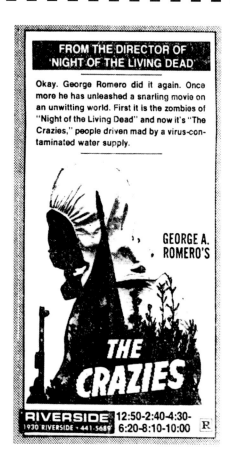

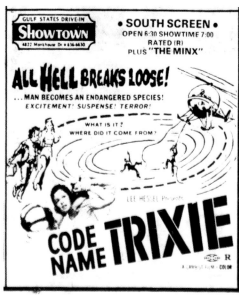

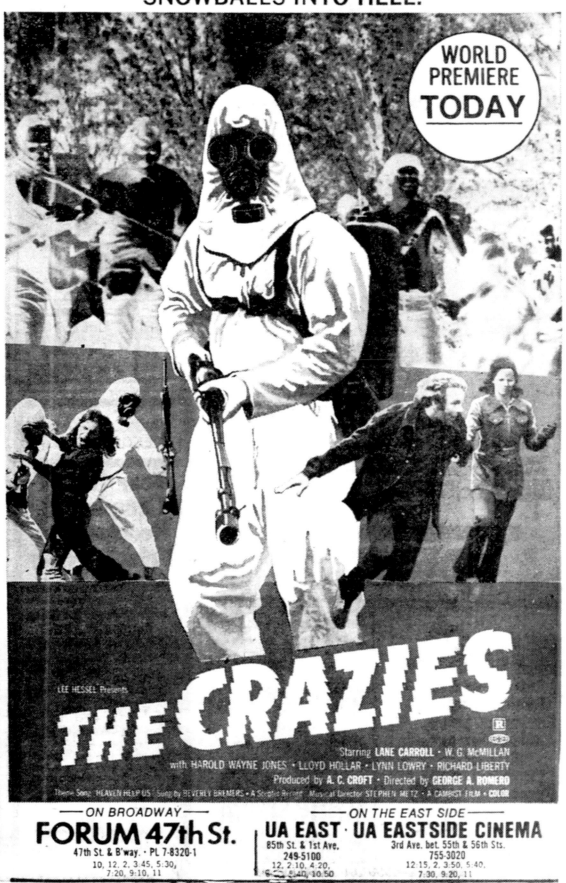

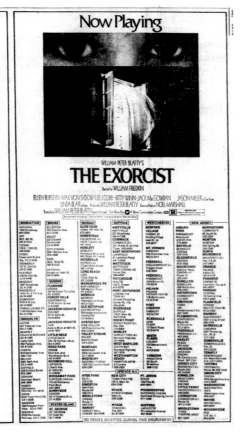

THE EXORCIST

William Friedkin and William Peter Blatty's game-changing possession saga first opened in limited bookings in December 1973, and spread throughout the country over the following months. Very quickly, the crowds lining up to see the film, and their extreme reactions to it, became a story in and of themselves. *The New York Times*, among others, interviewed people waiting to see *The Exorcist* (including a young drama student named Bill Hurt) about their anticipation for it, and Warner Bros. even took out ads assuring the public that there were seats to be had. The movie's explicit horrors also became a point of discussion and contention, with rumors spreading that the film would be cut for its wider release—which the studio also addressed in the advertising. Other ads touted the raves *The Exorcist* had received from many critics, though a few were not as enthusiastic.

"*The Exorcist* is the scariest Class Act horror movie I've ever seen, and some of its most frightening sequences are filled with terrors so shocking and unspeakable they cannot be described in a family newspaper.... It is still giving me nightmares."

— Rex Reed, New York *Daily News*

"*The Exorcist* is one of the best movies of its type ever made; it not only transcends the genre of terror, horror, and the supernatural, but it transcends such serious, ambitious efforts in the same direction as Roman Polanski's *Rosemary's Baby*."

— ROGER EBERT, *CHICAGO SUN-TIMES*

"For all of the meticulous work involved, I not only did not believe the story or the characters, I never felt the fusion of reality and mysticism Friedkin tried so hard to create."

— Bernard Drew, Gannett News Service

"In its uncompromised treatment of its theme, *The Exorcist* becomes quite as much a movie landmark as, say, *Who's Afraid of Virginia Woolf* did in its year for its own reasons. It is strong and frequently revolting stuff."

— Charles Champlin, *Los Angeles Times*

1973

WILLIAM PETER BLATTY'S

THE EXORCIST

Directed by WILLIAM FRIEDKIN

ELLEN BURSTYN · MAX VON SYDOW · LEE J. COBB
KITTY WINN · JACK MacGOWRAN JASON MILLER as Father Karras
LINDA BLAIR as Regan · Produced by WILLIAM PETER BLATTY
Executive Producer NOEL MARSHALL · Screenplay by WILLIAM PETER BLATTY based on his novel
From Warner Bros. A Warner Communications Company R RESTRICTED Under 17 requires accompanying Parent or Adult Guardian

WORLD PREMIERE TODAY **CINEMA I** 3rd Ave. at 60th St. PL 3-6022
12:10, 2:20, 4:35, 6:50, 9, 11:15

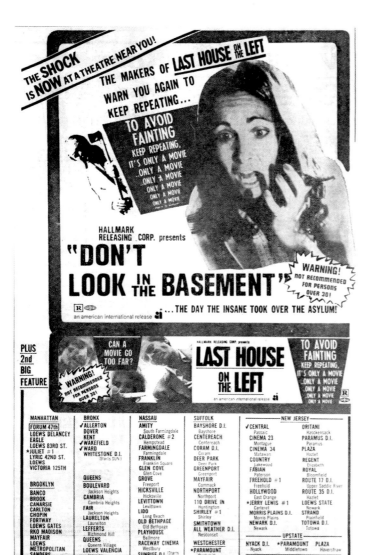
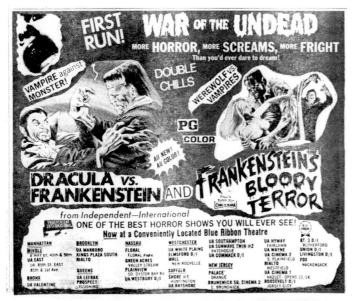
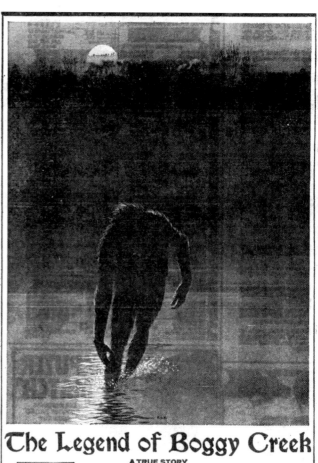

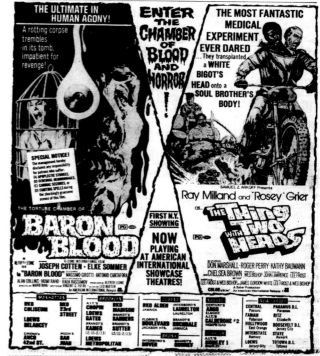

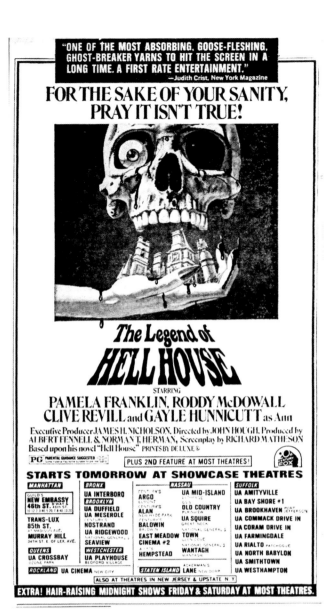
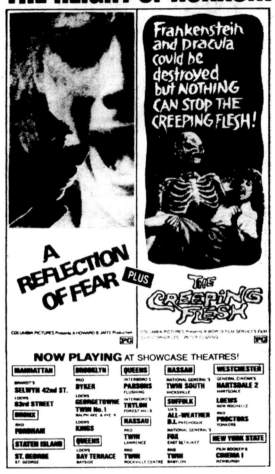
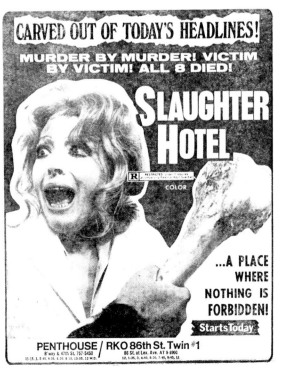
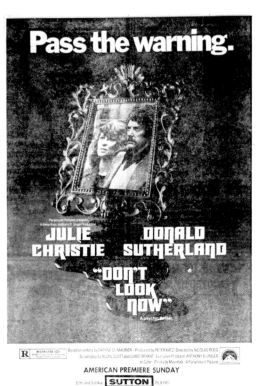

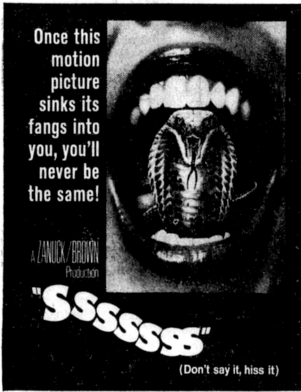

Once this
motion
picture
sinks its
fangs into
you, you'll
never be
the same!

A ZANUCK/BROWN
Production

"SSSSSS"

(Don't say it, hiss it)

CO-STARRING STROTHER MARTIN DIRK BENEDICT HEATHER MENZIES

Screenplay by: HAL DRESNER From a story by: DAN STRIEPEKE Directed by: BERNARD L. KOWALSKI Produced by: DAN STRIEPEKE

Executive Producers: RICHARD D. ZANUCK and DAVID BROWN A UNIVERSAL PICTURE TECHNICOLOR® PG

AND

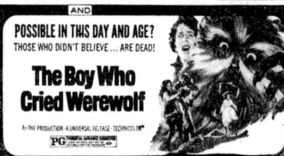

POSSIBLE IN THIS DAY AND AGE?
THOSE WHO DIDN'T BELIEVE... ARE DEAD!

The Boy Who
Cried Werewolf

An RKF PRODUCTION · A UNIVERSAL RELEASE · TECHNICOLOR® PG

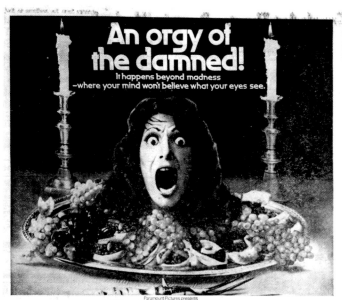

An orgy of
the damned!

It happens beyond madness
—where your mind won't believe what your eyes see.

Paramount Pictures presents

Tales that
Witness Madness

A World Film Services Limited Production

starring and (in alphabetical order):
Kim Novak Joan Collins Jack Hawkins Donald Houston Michael Jayston
Suzy Kendall Peter McEnery Michael Petrovitch Donald Pleasence

written by Jay Fairbank produced by Norman Priggen directed by Freddie Francis In Color · A Paramount Picture

R RESTRICTED

STARTS TODAY at
PARAMOUNT PRESENTATION SHOWCASE THEATRES!

MANHATTAN	BROOKLYN	QUEENS	NASSAU	SUFFOLK	NEW JERSEY
GOULD'S FORUM 47th St. 47TH ST. & BROADWAY	RKO ALBEE UA BEVERLY	CENTURY'S COMMUNITY QUEENS VILLAGE	MANN'S BAR HARBOUR MASSAPEQUA PARK	UA BAY SHORE SUNRISE D.I. #1	AMBOY'S D.I. Sayreville BRANFORD Newark
CINEMA'S HARRIS 42nd ST. BET. 7TH & 8TH AVES.	CREATIVE'S CHOPIN GRAHAM	CENTURY'S GLEN OAKS UNION TURNPIKE	CENTURY'S BALDWIN CREATIVE'S CALDERONE · 2	CREATIVE'S CINEMA 112 #2 PORT JEFFERSON	CIRCLE · 2 Brockton ROUTE 17 D.I.
RKO COLISEUM 181 ST. & BROADWAY	RKO MADISON	INTERBORO LAURELTON	TWIN SOUTH HICKSVILLE	UA COMMACK D.I. UA COLLEGE	COUNTRY Denville
HALLMARK'S JULIET 2 3rd AVE. & 83rd ST.	UPSTATE N.Y. BARDAVON Poughkeepsie	LOEWS VALENCIA JAMAICA	TWIN CINEMA 2 EAST MEADOW	PLAZA · 2 FARMINGVILLE	ROUTE 46 D.I. Saddle Brook TOWN
SYMPHONY 95th & B'WAY	MALL #2 Monticello	UA QUARTET II FLUSHING	WESTCHESTER	A.I.T.S. KINGS PARK	Montvale TURNPIKE D.I. East Brunswick
BRONX	SQUIRE (Starts Fri.) Great Neck		BRANDT'S CINEMA 22 BEDFORD VILLAGE	CREATIVE'S TWIN SHIRLEY 1	FREEHOLD #2 Freehold HOLLYWOOD East Orange
VALHALLA PALACE	303 D.I. Orangeburg		PROCTOR'S YONKERS	WEST ISLIP #2	STRATHMORE #2 Matawan LEDGEWOOD D.I. LOEWS Jersey City WAYNE MALL

Plus second feature at most theatres

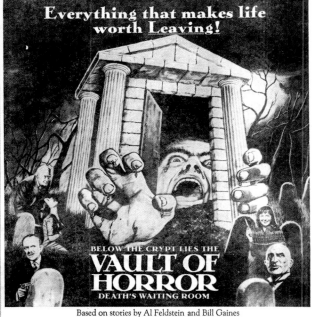

Everything that makes life
worth Leaving!

BELOW THE CRYPT LIES THE
VAULT OF
HORROR
DEATH'S WAITING ROOM

Based on stories by Al Feldstein and Bill Gaines

Metromedia Producers Corporation Presents An Amicus Production

"VAULT OF HORROR"

starring
DAWN ADDAMS | GLYNIS JOHNS | ANNA MASSEY
TOM BAKER | EDWARD JUDD | DANIEL MASSEY
MICHAEL CRAIG | CURT JURGENS | TERRY-THOMAS
DENHOLM ELLIOTT

Written by MILTON SUBOTSKY

Produced by MAX J. ROSENBERG and MILTON SUBOTSKY Executive Producer CHARLES FRIES

R Directed by ROY WARD BAKER In Color Soundtrack album available on Metromedia records

THE VAULT OPENS TODAY

NEW PENTHOUSE/RKO 86th St. Twin #1/MURRAY HILL
B'way & 47th St. 757-5450 | 86 St. at Lex. Ave. AT 9-8900 | 3rd Ave at 34th St. MU 5-7652

1973

57

GANJA & HESS / DOUBLE POSSESSION

Hired to write and direct a Black-themed vampire movie, to follow up on the big success of *Blacula*, by Kelly-Jordan Enterprises, Bill Gunn turned in an unusual, experimental, non-linear study of vampirism as addiction that eschewed commercial horror tropes. Even though it starred Duane Jones in his first screen role since *Night of the Living Dead* and played as part of Critics' Week at the Cannes Film Festival, *Ganja & Hess* received scant release under that title. In October 1975, it returned to New York City as *Double Possession*, in heavily recut form (one which had previously been released as *Blood Couple* in other cities), with ads that lied about both its content and its New York premiere status.

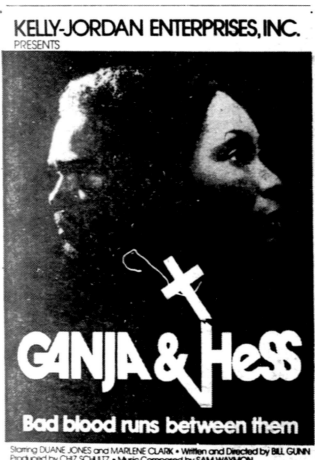

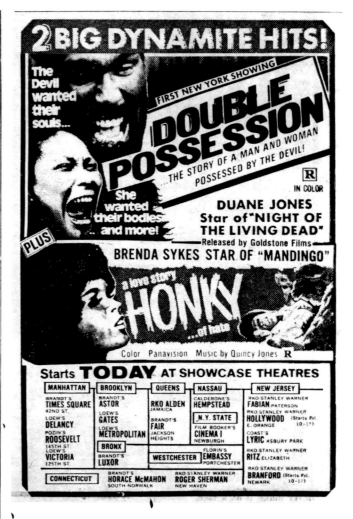

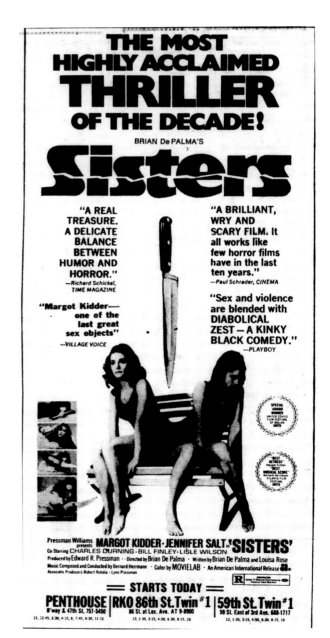

1974

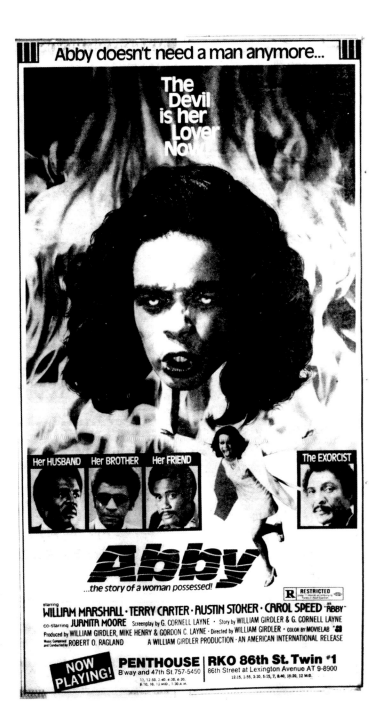

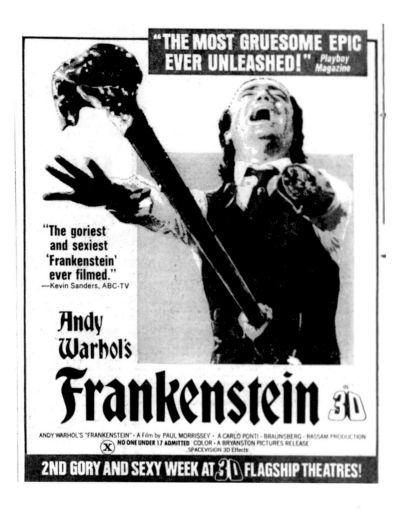

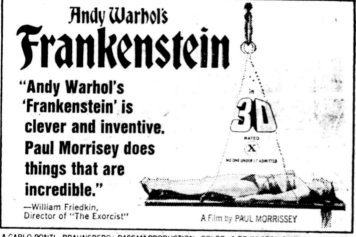

ANDY WARHOL'S FRANKENSTEIN

Today, the gory 3D variation on Mary Shelley's landmark is better known as Paul Morrissey's *Flesh for Frankenstein*. In 1974, the Andy Warhol connection (Morrissey was Warhol's in-house—or in-Factory—filmmaker) resulted in the pop artist getting the possessory. Despite the extra dimension and X rating, the first ads were relatively subtle before the later ones went for a more in-your-face approach. Subsequent ads quoted *The Exorcist*'s William Friedkin—though in New York, they got Morrissey's name wrong. (Those in at least one other city got Morrissey's spelling right but credited the quote to William "Friekin.") Such august journals as *Newsweek* and *New York* magazines also had positive things to say, while the reactions from the daily papers were widely mixed.

"[A] howlingly entertaining spin-off of the old horror story, except that you need an iron stomach, or a taste for necrophilia to get through it.... The comedy is apt and indicates, for once, that Morrissey wasn't relying on improvisation."

— Stanley Eichelbaum, *San Francisco Examiner*

"The film is the most sickeningly gory film ever to hit the screen. It also happens to be fun—if you like roller-coaster rides.... To a 3-D enthusiast the film is a must see."

— BILL CURRY, *THE PHILADELPHIA INQUIRER*

"[T]he film is a vomitous mixture of camp and guts... To compare this *Frankenstein* to any of the other versions, even the disgracefully cheap Hammer series, is to give the Warhol film a touch of class. It won't hold."

— Lou Cedrone, *The* [Baltimore] *Evening Sun*

"Is the acting dreadful, the whole film tacky and jerry-built? Well, you see, it's meant to be—that's the whole point! Does a Morrissey movie bore or nauseate? OF COURSE, silly—that's life! Get the idea?"

— Giles M. Fowler, *The Kansas City Star*

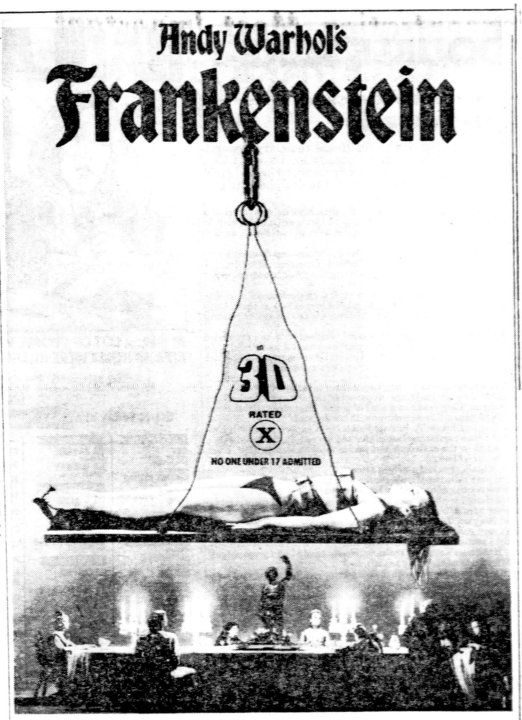

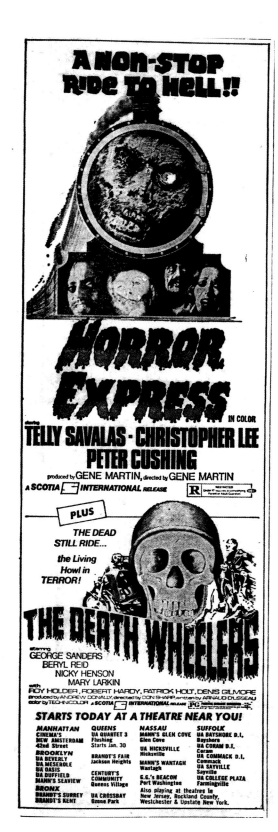

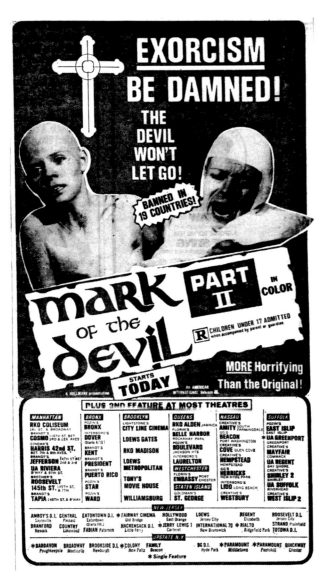
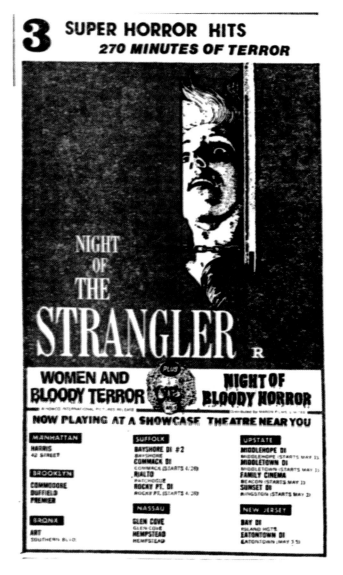
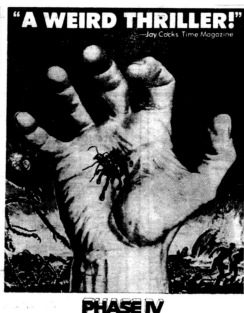
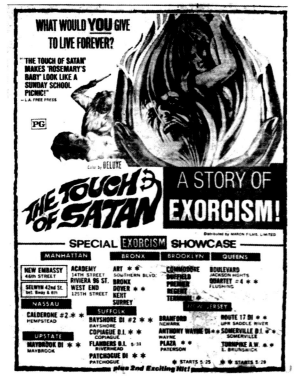
65

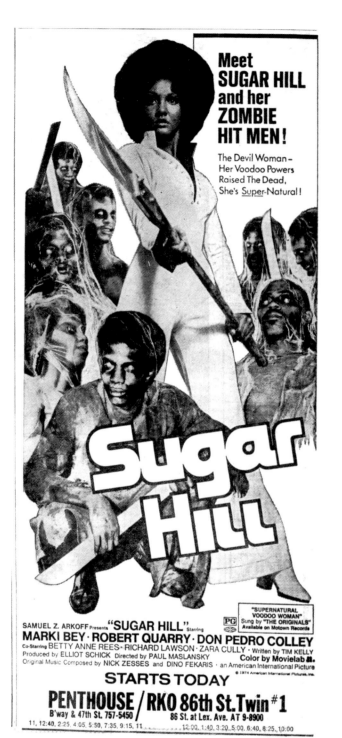

Meet
SUGAR HILL
and her
ZOMBIE
HIT MEN!

The Devil Woman -
Her Voodoo Powers
Raised The Dead,
She's Super-Natural!

Sugar Hill

"SUPERNATURAL
VOODOO WOMAN"
Sung by "THE ORIGINALS"
Available on Motown Records

SAMUEL Z. ARKOFF Presents "SUGAR HILL" Starring
MARKI BEY · ROBERT QUARRY · DON PEDRO COLLEY
Co-Starring BETTY ANNE REES · RICHARD LAWSON · ZARA CULLY · Written by TIM KELLY
Produced by ELLIOT SCHICK Directed by PAUL MASLANSKY **Color by Movielab**
Original Music Composed by NICK ZESSES and DINO FEKARIS · an American International Picture
© 1974 American International Pictures, Inc.

STARTS TODAY
PENTHOUSE / RKO 86th St. Twin #1
B'way & 47th St. 757-5450 86 St. at Lex. Ave. AT 9-8900
11, 12:40, 2:25, 4:05, 5:50, 7:35, 9:15, 11 12:00, 1:40, 3:20, 5:00, 6:40, 8:25, 10:00

PHANTOM OF THE PARADISE

20th Century Fox paid $2 million for the $1.3-million *Phantom of the Paradise*, setting a record for a studio acquisition of an independently made film. Brian De Palma's combination sendup of the music industry and hyperstylized update of *...Opera* received splashy openings in New York and Los Angeles, but sadly, the target youth audience didn't come out for it. Producer Edward R. Pressman, who had previously encouraged American International to give De Palma's initially unsuccessful *Sisters* another chance, did the same with Fox and *Phantom*, which began playing midnight shows in 1975 and was given another wide New York break in 1976. Today, *Phantom* is an enduring cult favorite, and like most such movies, it received the full breadth of critical response upon its first release.

"There is enough camp for a Boy Scout jamboree in *Phantom of the Paradise*, a gorgeously funny movie that successfully manages to combine a satire of the disparate worlds of rock music and horror films."

— Desmond Ryan, *The Philadelphia Inquirer*

"[I]t seems amazing that a film conceived and developed with such sophisticated filmic artistry could indulge in so much broad, even coarse humor. But there's no denying that *Phantom of the Paradise* is a visual triumph with much exciting music."
— KEVIN THOMAS, *LOS ANGELES TIMES*

"It is frequently funny, often not, and sometimes just plain strident. But it should amuse those who go for the wacky film world of the Beatles."

— Frances Herridge, *New York Post*

"De Palma gets off a lot of flashy and fascinating imagery, bolstered by a quadraphonic soundtrack... Ultimately, the director delivers more ideas than concept, and what triumphs over all is not good, not evil, but garish sophomorism."

— Will Jones, *Minneapolis Tribune*

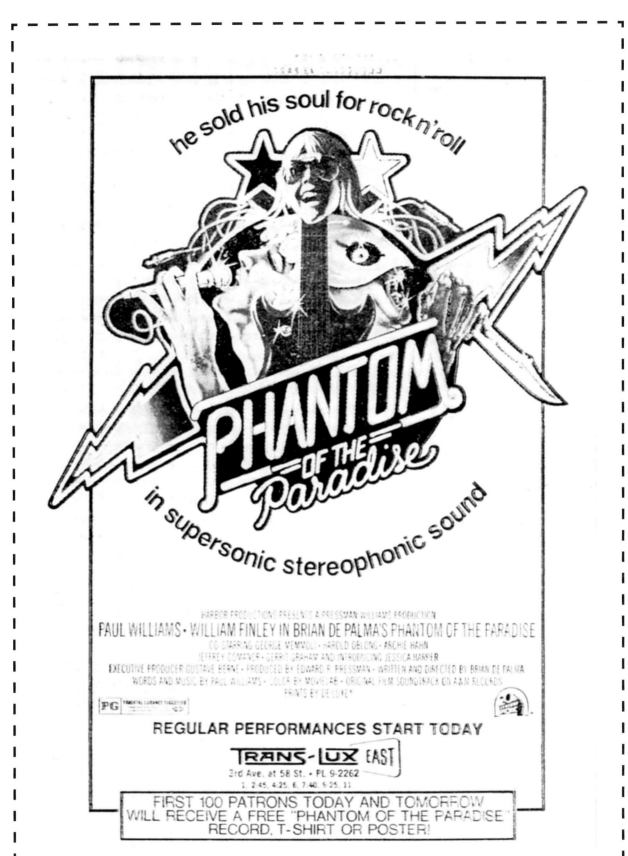

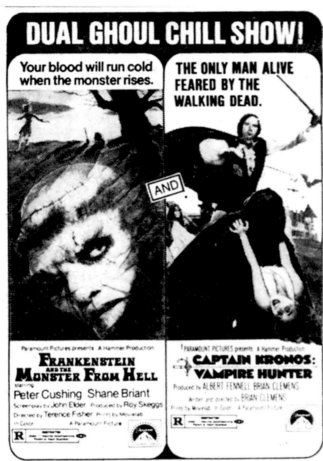
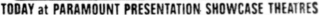
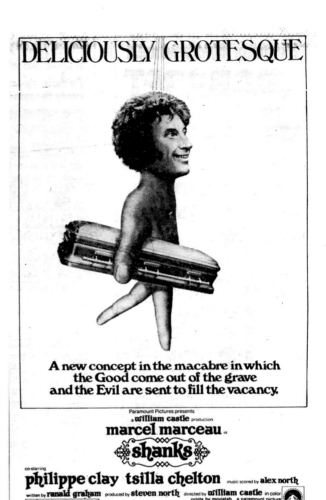

1974

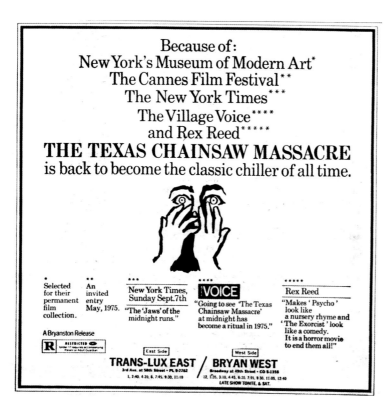

THE TEXAS CHAINSAW MASSACRE

Right from the start, Tobe Hooper's homegrown, down-and-dirty shocker was a hit at drive-ins and, going into 1975, in midnight shows. *Massacre* then started getting noticed by tonier venues, to the point where distributor Bryanston Pictures sold it like an art film later in '75. Certain critics appreciated it right from the beginning too, most of them comparing it favorably to that previous indie trendsetter, George A. Romero's *Night of the Living Dead*. Overall, the opinions spanned both extremes, even within the film's home state.

"If *Chainsaw*'s creators intended to challenge *Night of the Living Dead* for sheer sustained terror, they have succeeded.... [I]t is hardly the technical achievement of *The Exorcist*. But in the perverse sensibilities of horror movies, it's a lot more fun."

— Patrick Taggart, *The Austin American-Statesman*

"This film is positively ruthless in its attempt to drive you right out of your mind and it accomplishes everything it sets out to do with brilliance and unparalleled terror. [It] makes *Psycho* look like a nursery rhyme and *The Exorcist* like a comedy."

— REX REED, NEW YORK *DAILY NEWS*

"If you can get past the gore and the inept camera work and the fact that it was based on a Wisconsin crime, not a Texas case, this one isn't a total waste of time. On second thought: Yes, it is.... *Massacre* is just plain bad."

— Perry Stewart, *Fort Worth Star-Telegram*

"Torture and gruesome death through a filtered lens are still ugly and obscene. Craziness handled without sensitivity is a degrading, senseless misuse of film and time."

— Linda Gross, *Los Angeles Times*

71

1975

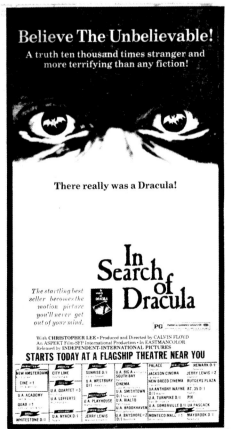
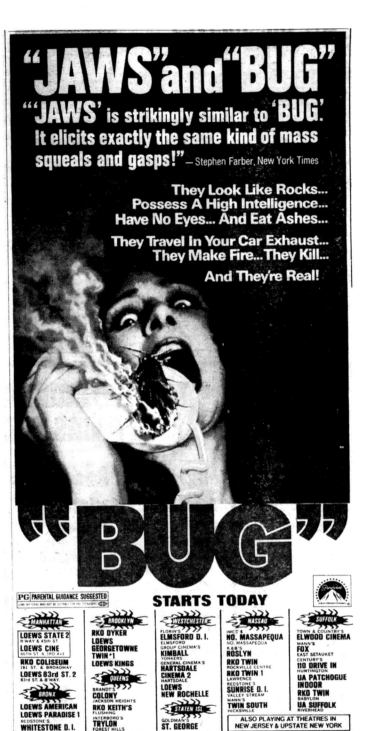
73

ANDY WARHOL'S DRACULA

When Paul Morrissey's second take on a horror standard first opened in New York City in early 1975, it was X-rated and sold in lush Gothic terms. It returned to theaters there in 1977 with an R rating and a more broadly comic pitch, billed as *Andy Warhol's Young Dracula*. Could a certain Mel Brooks hit have had anything to do with that?

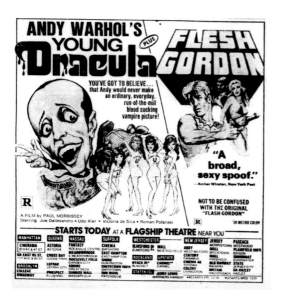

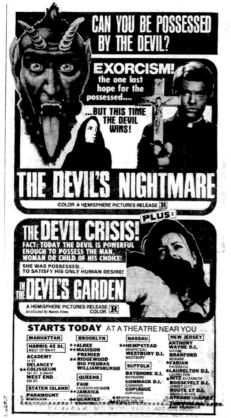

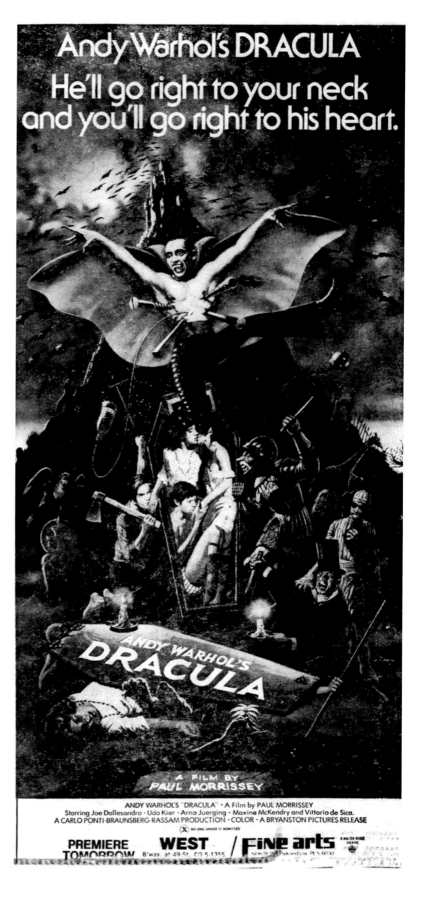

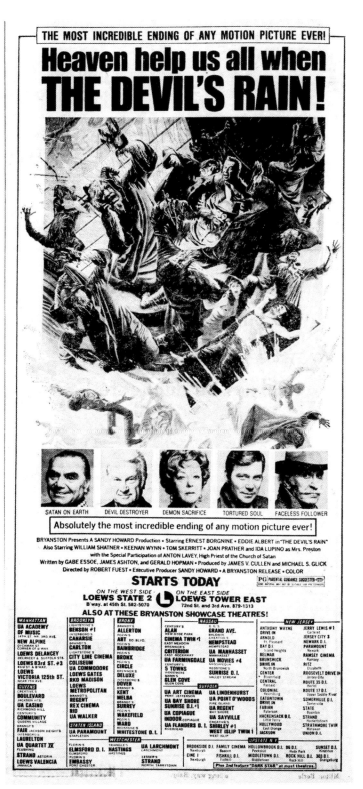

75

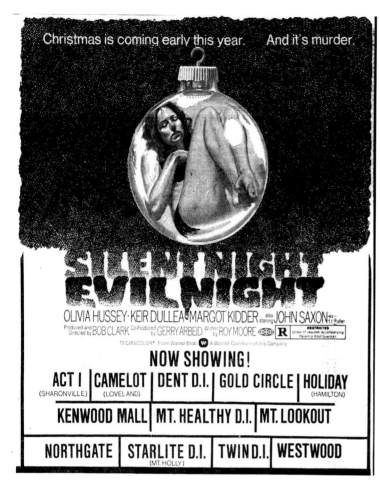

Christmas is coming early this year. And it's murder.

SILENT NIGHT EVIL NIGHT

OLIVIA HUSSEY · KEIR DULLEA · MARGOT KIDDER also starring JOHN SAXON as Lt. Fuller

Produced and Directed by BOB CLARK Co-Produced by GERRY ARBEID Written by ROY MOORE R RESTRICTED Under 17 requires accompanying Parent or Adult Guardian

TECHNICOLOR® From Warner Bros. W A Warner Communications Company

NOW SHOWING!

ACT I (SHARONVILLE)	CAMELOT (LOVELAND)	DENT D.I.	GOLD CIRCLE	HOLIDAY (HAMILTON)

KENWOOD MALL	MT. HEALTHY D.I.	MT. LOOKOUT

NORTHGATE	STARLITE D.I. (MT. HOLLY)	TWIN D.I.	WESTWOOD

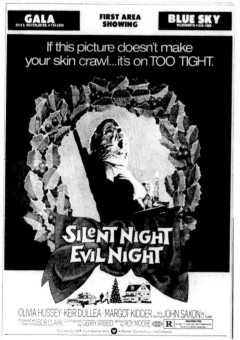

GALA 2219 E. WATERLOO RD. • 733-2354 FIRST AREA SHOWING BLUE SKY WADSWORTH • 334-1895

If this picture doesn't make your skin crawl...it's on TOO TIGHT.

SILENT NIGHT EVIL NIGHT

OLIVIA HUSSEY · KEIR DULLEA · MARGOT KIDDER and starring JOHN SAXON as Lt. Fuller

Produced and Directed by BOB CLARK Co-Produced by GERRY ARBEID Written by ROY MOORE R RESTRICTED Under 17 requires accompanying Parent or Adult Guardian

TECHNICOLOR® From Warner Bros. W A Warner Communications Company

8 DAYS TO **Black Christmas**

BLACK CHRISTMAS

Bob Clark's Yuletide chiller first opened as *Black Christmas* in its native Canada in fall 1974. U.S. distributor Warner Bros., which had released *Shaft*, *Super Fly* and a number of other blaxploitation films, was concerned that the movie might be misidentified by potential viewers as part of that genre, and retitled it *Silent Night, Evil Night* for its first U.S. bookings the following summer. Midway through the run, the campaign adopted a new tagline and art, and by the time of its August Los Angeles opening and then its October New York debut, it was back to *Black Christmas*—though Tim A. Janes' review excerpted below referred to the movie throughout as *Dark Christmas*. His was among the relatively few pans for the otherwise well-received movie, which Warners teased with whimsically evil little ads ahead of opening day.

"[It's] the best chiller of the year, a creepy, murderous horror with an ending guaranteed to rattle what's left of your sensibilities after the movie's hour-and-45-minute onslaught."

— Kevin Kelly, *The Boston Globe*

"[P]roducer-director Bob Clark and scriptwriter Roy Moore have gone Gothic with considerable success. Their [film] is a neat balancing act— kiddingly yet genuinely a hair-raiser."

— JEAN DIETRICH, *THE* [LOUISVILLE, KY] *COURIER-JOURNAL*

"[*Black Christmas*] is like a trip through a haunted house. It doesn't amount to much other than some terrifyingly tense scenes and a few screams, but there's a great deal of entertainment within those limitations."

— Bob Keaton, *Fort Lauderdale News*

"As a mystery the film doesn't work because the script by Roy Moore pushes its one red herring forward with all the finesse of a steam roller. Thanks to Bob Clark's mechanical direction, the film also fails as a straight thriller."

— Tim A. Janes, *Arizona Daily Star*

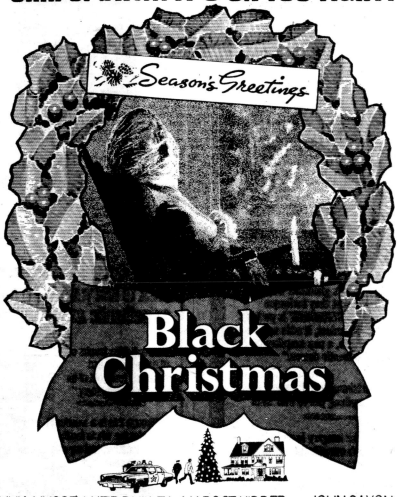

If this movie doesn't make your skin crawl... IT'S ON TOO TIGHT!

Season's Greetings

Black Christmas

OLIVIA HUSSEY · KEIR DULLEA · MARGOT KIDDER *also starring* JOHN SAXON *as Lt. Fuller*

Produced and Directed by BOB CLARK · Co-Produced by GERRY ARBEID · Written by ROY MOORE

R RESTRICTED Under 17 requires accompanying Parent or Adult Guardian

TECHNICOLOR® From Warner Bros. A Warner Communications Company

Starts TODAY at a FLAGSHIP theatre near you.

BREAKFAST AT THE MANCHESTER MORGUE / DON'T OPEN THE WINDOW

Jorge Grau's Spanish-Italian zombie standout has had practically as many titles as countries where it played. Most popularly known as *The Living Dead at Manchester Morgue* and *Let Sleeping Corpses Lie*, it first opened Stateside in 1975 under the odd title *Breakfast at the Manchester Morgue*. ("Break bread with the living dead!" proclaimed ads in other cities.) A year after this one-theater only NYC booking, the film returned to New York in a much wider break as *Don't Open the Window*, an even more meaningless moniker apparently intended by distributor Hallmark Releasing (under the Newport banner) to recall its previous *Don't Look in the Basement*, with the "It's Only a Movie" copy it had used with both *Basement* and *The Last House on the Left*.

THEY TAMPERED WITH NATURE - NOW THEY MUST PAY THE PRICE...

TO AVOID FAINTING KEEP REPEATING IT'S ONLY A MOVIE ONLY A MOVIE ONLY A MOVIE ONLY A MOVIE

"DON'T OPEN THE WINDOW"
WHAT EVER'S OUT THERE WILL WAIT !

STARTS TODAY AT A THEATRE NEAR YOU!

THEY TAMPERED WITH NATURE - NOW THEY MUST PAY THE PRICE...

TO AVOID FAINTING KEEP REPEATING, IT'S ONLY A MOVIE ONLY A MOVIE ONLY A MOVIE ONLY A MOVIE ONLY A MOVIE ONLY A MOVIE

"DON'T OPEN THE WINDOW"
WHAT EVER'S OUT THERE WILL WAIT !

NOW PLAYING AT A THEATRE NEAR YOU!

DOUBLE PREMIERE ENGAGEMENT
180 Minutes Of Murder And Madness!

WHEN THE MOON IS FULL
THE BEAST MUST DIE!

AND

The Executioner... The Queen of Evil... The Dwarf... Their only purpose is the breath-stopping panic of

SEIZURE!

Calvin Lockhart is the Brother who's stalking the Beast!

AN AMICUS PRODUCTION
CALVIN LOCKHART · PETER CUSHING "THE BEAST MUST DIE"

NOW PLAYING AT A SHOWCASE THEATRE NEAR YOU!

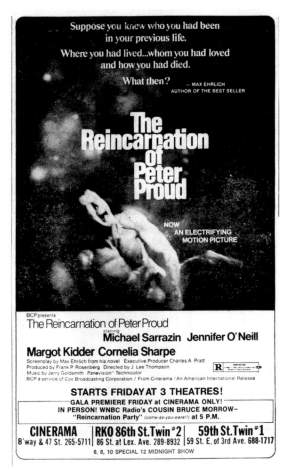

Suppose you knew who you had been in your previous life.
Where you had lived...whom you had loved and how you had died.
What then?
— MAX EHRLICH AUTHOR OF THE BEST SELLER

The Reincarnation of Peter Proud

NOW AN ELECTRIFYING MOTION PICTURE

BCP presents
The Reincarnation of Peter Proud
starring
Michael Sarrazin Jennifer O'Neill
Margot Kidder Cornelia Sharpe

Screenplay by Max Ehrlich from his novel Executive Producer Charles A. Pratt
Produced by Frank P. Rosenberg Directed by J. Lee Thompson
Music by Jerry Goldsmith Panavision· Technicolor
BCP a service of Cox Broadcasting Corporation / From Cinerama / An American International Release

STARTS FRIDAY AT 3 THEATRES!
GALA PREMIERE FRIDAY at CINERAMA ONLY!
IN PERSON! WNBC Radio's COUSIN BRUCE MORROW-
"Reincarnation Party" (come-as-you-were!!) at 5 P.M.

CINERAMA	RKO 86th St.Twin #2	59th St.Twin #1
B'way & 47 St. 265-5711	86 St. at Lex. Ave. 289-8932	59 St. E. of 3rd Ave. 688-1717

6, 8, 10 SPECIAL 12 MIDNIGHT SHOW

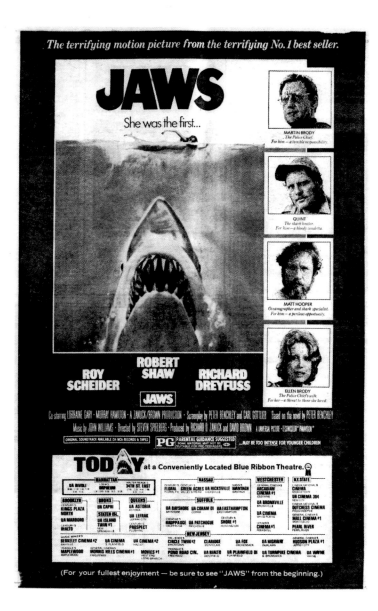

JAWS

The movie that first defined the summer blockbuster (with ads touting the repeat viewings that would continue well past Labor Day) still stands among the most magnificently well-crafted cinematic scream machines in history. It's also a model of adapting and improving on the source novel, and showcases some of director Steven Spielberg's all-time best work with actors. So...just for fun, I've gone back and picked out a selection of reviews that greeted the movie's first release with something less than overwhelming enthusiasm.

"[W]hat this movie is about, and where it succeeds best, is the primordial level of fear. The characters, for the most part, and the nonfish elements in the story are comparatively weak and not believable."

— Gene Siskel, *Chicago Tribune*

"[I]t enriches the viewer about as much as a haunted house ride at an amusement park. Perhaps it magnifies one's fear of sharks...but no feelings about anything else are changed. It has little to offer aside from cheap thrills."

— JOHN CRITTENDEN, *THE* [HACKENSACK, NJ] *RECORD*

"Young Steven Spielberg...shows as he has before an uncommon flair for handling big action. He, and the script, are much less successful in the man-to-man confrontations than in the man-to-shark meetings.... The ending is pulp story hokum."

— Charles Champlin, *Los Angeles Times*

"*Jaws* has everything going for it as excellent entertainment. It is suspenseful, humorous, exciting and gripping.... But that ending.... Instead of leaving the theater with one's suspension of disbelief intact, one leaves with it in tatters."

— Tony Macklin, The [Dayton, OH] *Journal Herald*

1975

How many times have you seen 'JAWS'?

LOIS BELFIORE
Long Island
(2 TIMES)
"I've never seen another movie more than once, but 'Jaws' was so exciting! The second time was as thrilling as the first."

JOSEPH J. CRESCI
Brooklyn
(6 TIMES)
"'Jaws' was the most fantastic movie I've seen. I even plan to see it a couple of more times. It was great."

THOMAS OSBORNE
Manhattan
(3 TIMES)
"Anything as exciting as 'Jaws' has to be seen more than once."

CHRISTINE KUPLESKI
Manhattan
(2 TIMES)
"A terrific experience! I won't soon forget it!"

SUSAN LEVINE
Brooklyn
(4 TIMES)
"It's the most exciting movie I've ever seen. The end was stimulating and kept me glued to my seat."

JACK GABIN
Long Island
(4 TIMES)
"Even after the 4th time seeing 'Jaws', I'm still holding onto the seat, enjoying every second of it."

HEIDI DAVIS
Manhattan
(3 TIMES)
"'Jaws' is the best movie I ever saw. I saw it three times and I want to see it three more times."

MICHAEL MILTZ
Queens
(2 TIMES)
"It's the best movie I've seen in years and I'll probably go to see it again."

ROXANNE VEZZA
Queens
(2 TIMES)
"This movie is one of a kind and I hope many people get to see it. It was very suspenseful and kept you on the edge of your seat."

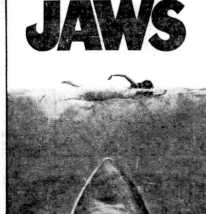

JAWS

A UNIVERSAL PICTURE · TECHNICOLOR® PANAVISION®

ORIGINAL SOUNDTRACK AVAILABLE ON MCA RECORDS & TAPES

PG PARENTAL GUIDANCE SUGGESTED
SOME MATERIAL MAY NOT BE SUITABLE FOR PRE-TEENAGERS
...MAY BE TOO INTENSE FOR YOUNGER CHILDREN

LINDA SESSA
Brooklyn
(2 TIMES)
"I thought that the picture was great. What I liked about it was it was real . . . It can happen in real life."

JUANITA RICHARDSON
Manhattan
(3 TIMES)
"The shark in 'Jaws' was incredible. It was a pleasure being frightened and yet be very safe in my seat."

BENEDETTE DIAFERIA
Manhattan
(2 TIMES)
"'Jaws' is the greatest thriller I ever saw. I talked about the movie all week."

JOSEPH REGINA
Bronx
(2 TIMES)
"I was so impressed by this movie that I viewed it again, in the same week, and I must say it was terrifyingly realistic."

ROBERT DONUS
Long Island
(2 TIMES)
"A suspensefully thrilling film. In no way, however, was I reluctant to take my children to see the picture."

ROCHELLE BIRNBAUM
Westchester
(2 TIMES)
"The most exciting movie I've seen in a long time. I had to see it a second time in order to watch the parts I was afraid to see the first time."

PRINCE A. DAVID
New York City
(4 TIMES)
"It is a classic. I saw it 4 times and I feel sure I'll see it again."

AMY SENNESH
Queens
(2 TIMES)
"The first time I was terrified by it, and the second time I loved watching the technical effects."

JODI BINN
Brooklyn
(3 TIMES)
"It's incredible. I've already seen it 3 times and could see it another 3 times."

JEFFREY SHIELDS
Manhattan
(2 TIMES)
"The thrills are there no matter how many times you see it."

The most popular film of our time!
See it Today!

Now in its 8th Record Week at Conveniently Located Blue Ribbon Theatres

(For your fullest enjoyment — be sure to see "JAWS" from the beginning.)

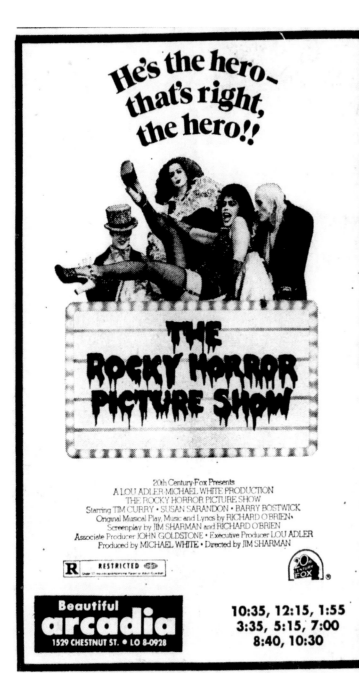

THE ROCKY HORROR PICTURE SHOW

The Jim Sharman-directed film version of Richard O'Brien's outrageous stage concoction of sex, monsters and rock and roll didn't actually open in New York City in 1975. Following up on successful runs in London and Los Angeles, the play opened at Broadway's Belasco Theatre in March of that year, and 20th Century Fox and producer Lou Adler agreed to hold the movie back in the Big Apple so as not to compete with it. The Belasco production lasted less than a month, and a Halloween '75 Manhattan opening was planned for the film, but disappointing returns in other cities led that to be cancelled. Then Fox began sending *Rocky Horror* out on the midnight circuit the following April, beginning at Greenwich Village's Waverly theater, and the rest is history. The ads seen here are from Los Angeles and Philadelphia, and in critical circles, not all were enamored of the film's brand of hedonistic free-spiritedness and excess—some comparing it to another specialist in that approach.

"[It's] simply too exuberant and too funny to be seriously decadent. Indeed, there's an underlying quality of tenderness and even innocence in this loving send-up of horror and sci-fi flicks and celebration of post-graduate sexuality."
— Kevin Thomas, *Los Angeles Times*

"It is demented, gross, absurd, vile, perverse and strangely appealing... [T]he cast's enthusiasm and energy manages to sustain a fairly constant level of entertainment."
— CARL ARRINGTON, *DETROIT FREE PRESS*

"The lunatic piece cries out for tricky cinematic (even Ken Russellish) effects. But Sharman's style is tame and plodding, cutting down on the enjoyment of a generally efficient and energetic cast."
— Stanley Eichelbaum, *San Francisco Examiner*

a different set of jaws

THE ROCKY HORROR PICTURE SHOW

20th Century-Fox Presents
A LOU ADLER · MICHAEL WHITE PRODUCTION
THE ROCKY HORROR PICTURE SHOW
Starring TIM CURRY · SUSAN SARANDON · BARRY BOSTWICK
Original Musical Play, Music and Lyrics by RICHARD O'BRIEN · Screenplay by JIM SHARMAN and RICHARD O'BRIEN
Associate Producer JOHN GOLDSTONE · Executive Producer LOU ADLER · Produced by MICHAEL WHITE
Directed by JIM SHARMAN · Production Services by RUBY SERVICE COMPANY

 R RESTRICTED ⊖⊜⊖
Under 17 requires accompanying Parent or Adult Guardian

STARTS FRIDAY-UA WESTWOOD
Lindbrook at Westwood Blvd. 477-0575
SHOWS FRIDAY AT 6:30, 8:30 (SOLD OUT), 10:30 & MIDNIGHT

1976

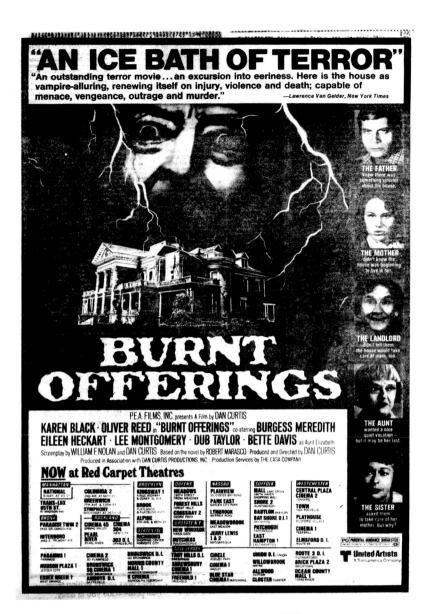
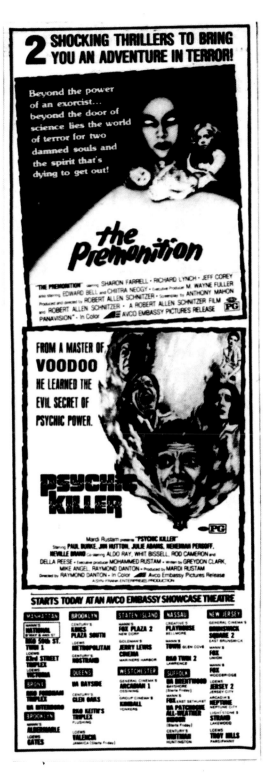
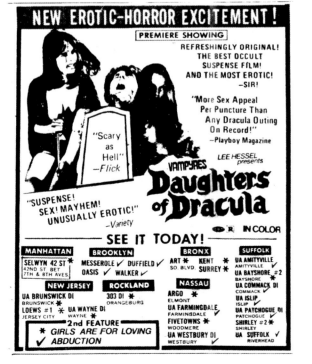

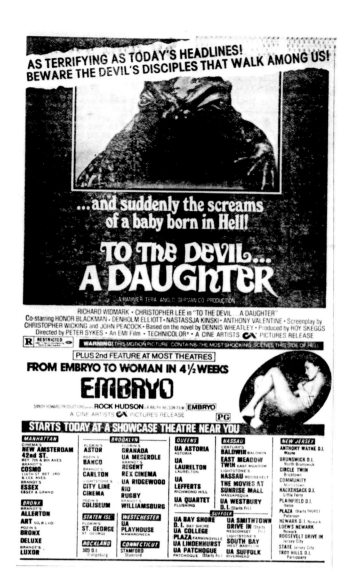

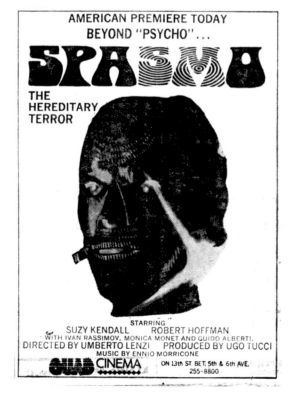

CARRIE

Carrie is one of history's few horror films whose marketing was centered on its final-reel action; essentially, the campaign was one big spoiler. (The previous year's *The Devil's Rain* is another example.) Even if they hadn't read Stephen King's popular novel, most people sitting down to see the movie knew it ended with its eponymous teenage heroine wreaking havoc at her high-school prom. Not that it mattered; *Carrie* was a sizable hit, winning stars Sissy Spacek and Piper Laurie rare Oscar nominations for acting in a horror film, elevating King's stature and taking director Brian De Palma's career to the next level. It also won the filmmaker some of his strongest reviews yet, even if not all of the critics were in assent.

"Brian De Palma's brilliantly directed *Carrie* is a new horror classic guaranteed to leave your nerve ends vibrating far into the night. *Carrie* is the most astute, skillful and satisfying thriller... since *Jaws*."

— Gary Arnold, *The Washington Post*

"*Carrie* is an absolutely spellbinding horror movie, with a shock at the end that's the best thing along those lines since the shark leaped aboard in *Jaws*. It's also (and this is what makes it so good) an observant human portrait."
— ROGER EBERT, *CHICAGO SUN-TIMES*

"The regrettable thing about *Carrie* is not only that its visual beauties and its persuasive acting are squandered on a preposterous and sometimes unsavory script, but the apparent eagerness of the director to manipulate... young minds."

— Malcolm L. Johnson, *The Hartford Courant*

"*Carrie* is a cinematic enigma—a well-acted, well-filmed and decidedly grisly psychic sight show that might just as well be missed.... [It] is a totally engrossing film that conversely is not the least bit entertaining."

— Ray Finocchiaro,
Wilmington, DE *Evening Journal*

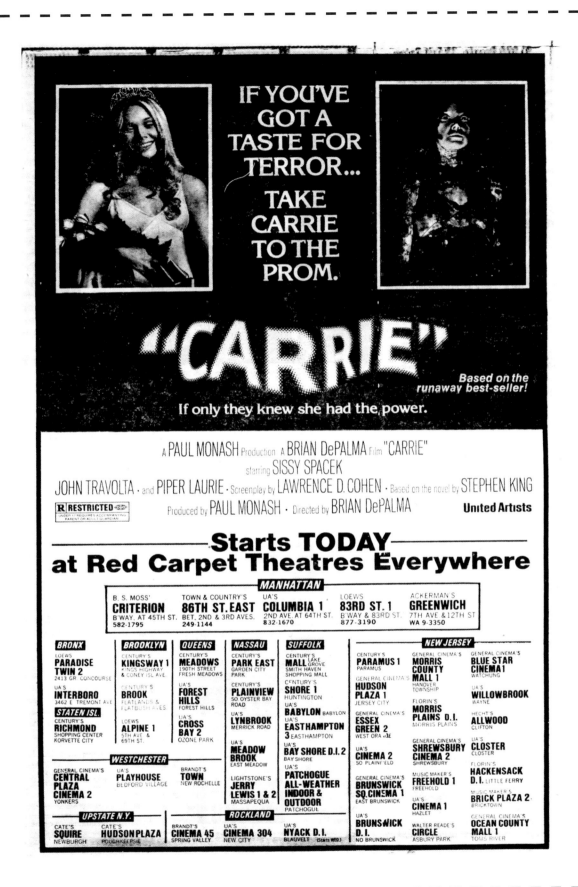

87

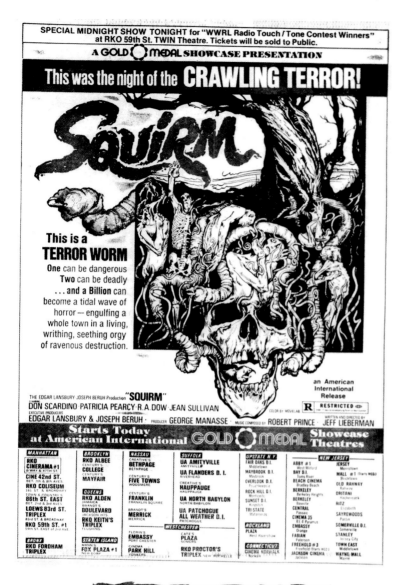

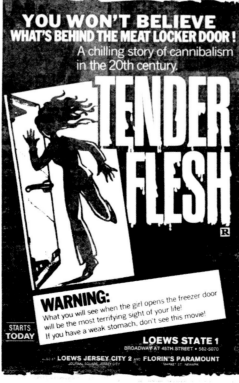

THE FOOD OF THE GODS

Filmmaker Bert I. Gordon earned the sobriquet "Mr. B.I.G." from *Famous Monsters of Filmland*'s Forrest J Ackerman for his series of 1950s thrillers about giant animals (*Earth vs. the Spider*, *Beginning of the End*) and people (*The Amazing Colossal Man*, *War of the Colossal Beast*). Two decades later, he returned to the theme with *The Food of the Gods*, in which the titular substance bubbles up from beneath the Earth's surface and causes everything from rats to chickens to become oversized and human-hungry. Despite classic science fiction author H.G. Wells' place of prominence in the ads, some critics noted the movie is only based on, and deviates significantly from, a small portion of Wells' same-titled novel. And that wasn't the only thing they objected to.

"The movie is an update of H.G. Wells' tale of terror of the same name. With that respectable genesis and some outstanding visual effects, *Food* is certain to please animal horror buffs."

— Bill von Maurer, *The Miami News*

"This *Food* is not very well done. The dialogue is stilted and abrupt, the story is thin—just enough to kill time between rats gnawing on Ida Lupino (fiction) and rats being brutally destroyed (for real), and the entire thing too predictable."

— DON UNDERWOOD, SPRINGFIELD, MO *NEWS AND LEADER*

"The film is rated PG and is a classic example of a two-faced rating system... The only suitable punishment for parents who let preteens see *Food of the Gods* would be sitting through the thing themselves."

— Bob Woessner, *Green Bay Press-Gazette*

"The movie is far more repulsive than frightening. For the special effects are poor and Gordon wallows in tasteless imagery."

— Jeanne Miller, *San Francisco Examiner*

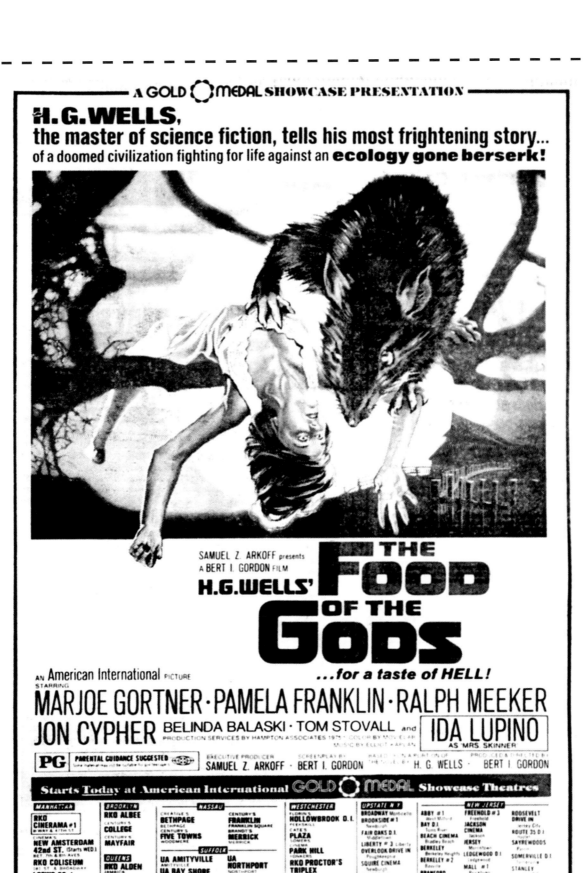

THE INCREDIBLE TORTURE SHOW & SNUFF

Joel M. Reed's carnival of misogynistic grotesqueries is so well-known by its alternate title *Bloodsucking Freaks* (applied by Troma when it picked the film up in the early '80s), it's easy to overlook the movie's initial opening under a just slightly less blatant title. Despite its X rating and seamy nature, *The Incredible Torture Show* played respectable Manhattan movie houses and got sizable ads in some of the local papers. Also carrying the X was *Snuff*, notorious at the time for featuring footage of an allegedly real murder, now notorious for having faked that setpiece. With all the controversy and outrage over its release (quite a bit of it manufactured by distributor Allan Shackleton), the ads didn't require any sensationalistic imagery, just the title.

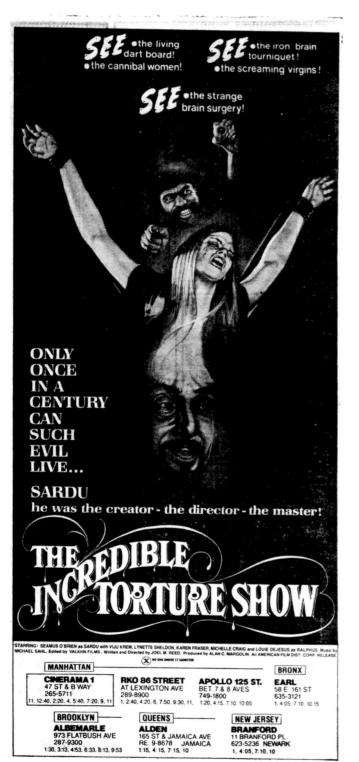

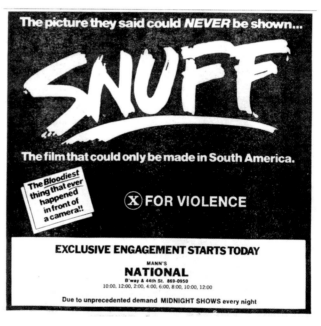

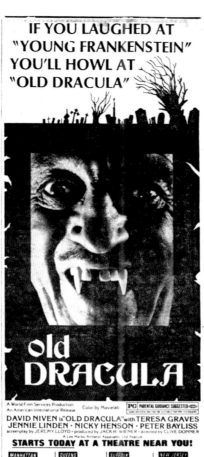

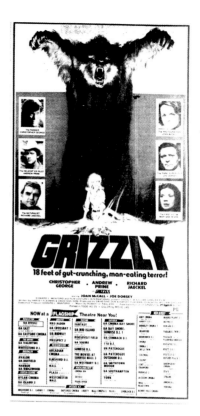

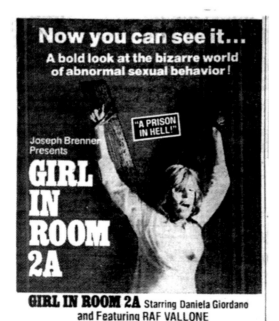

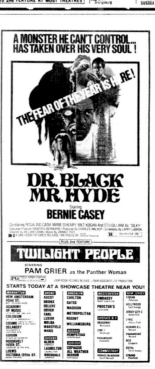

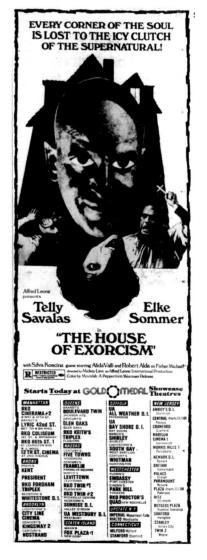

1976

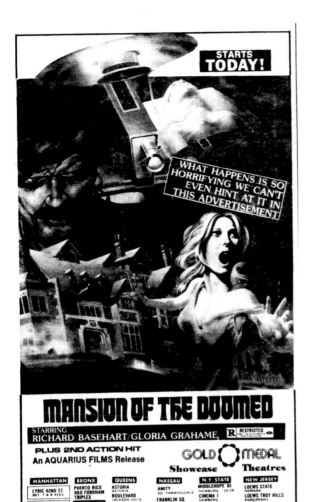

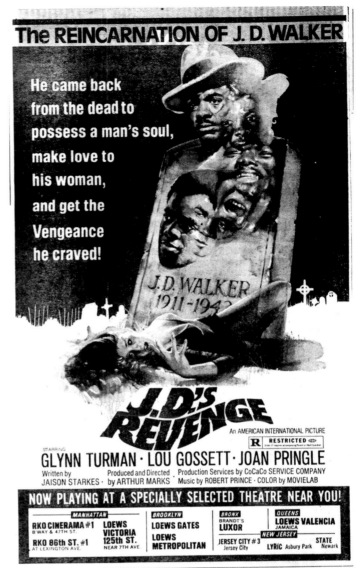

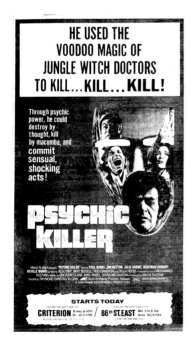

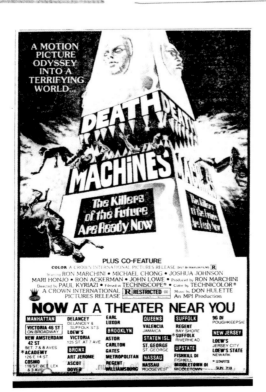

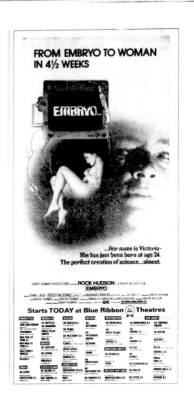

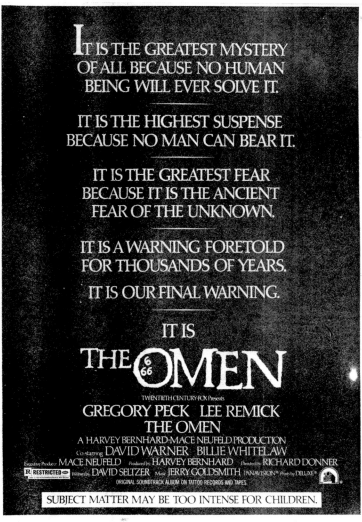

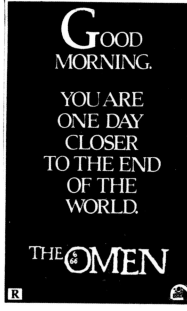

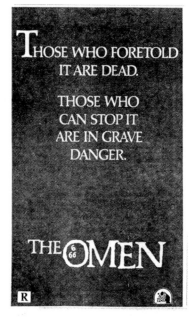

THE OMEN

20th Century Fox needed a hit in the summer of 1976, and got one big time with a theological shocker that spawned a franchise and inextricably tied the number "666" (an integral part of the title logo and advertising) to satanic evil in the public consciousness. An extensive pre-release campaign including multiple sneak previews and numerous teaser ads helped *The Omen* set an opening-weekend box-office record for Fox; unusually for a horror film, the print marketing emphasized copy over images. It seemed that two and a half years after *The Exorcist*, the devil still held a fascination for audiences, and a few reviewers felt *The Omen* was the superior movie. But not all...

"[I]t's better than *The Exorcist*, though less sensational. It is directed by Richard Donner with a fine sense of eeriness, eliciting maximum suspense without resorting to cheap tricks, and it is written with intelligence by David Seltzer."
— Bernard Drew, Gannett News Service

"*The Omen* is a movie that avoids every pitfall implied in the genre and exploits the opportunities with visceral effect. It inevitably invites comparison with *The Exorcist* and it is, in every regard I can think of, superior."
— DESMOND RYAN,
THE PHILADELPHIA INQUIRER

"Screenwriter Seltzer has a lot of things to answer for, in the way of mumbo-jumbo he has concocted from Revelations, but director Richard Donner probably deserves congratulations for giving mumbo-jumbo the appearances of the macabre."
— Dick Shippy, *Akron* [OH] *Beacon Journal*

"Thriller audiences may be the most willing suspenders of disbelief, but *The Omen* repeatedly blows the good will with rank implausibilities, farfetched horrors...and unintentional jokes."
— Tom Shales, *The Washington Post*

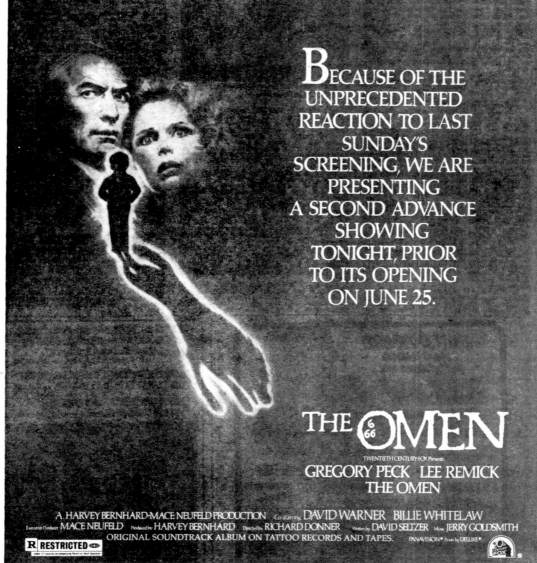

1977

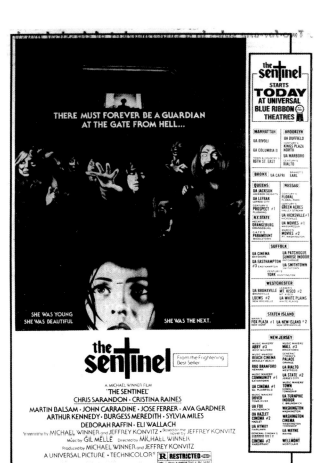

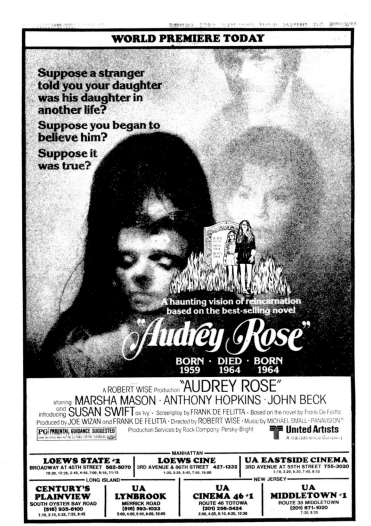

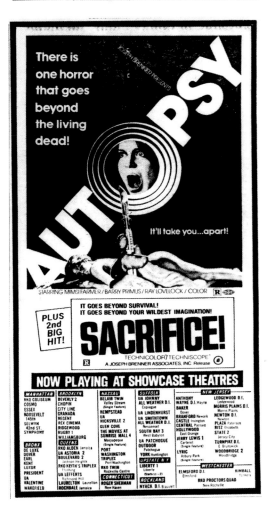

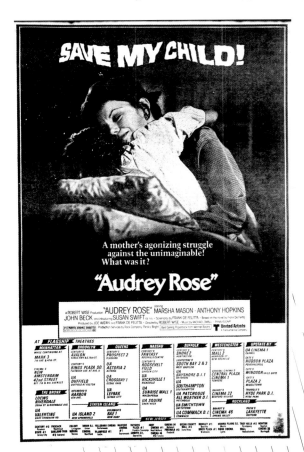

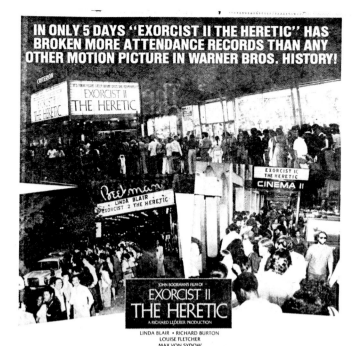

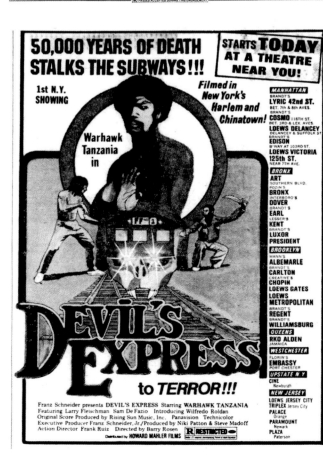

EXORCIST II: THE HERETIC

At the start of his no-stars review, the *Chicago Tribune*'s Gene Siskel noted, "My life was threatened Saturday night following a screening of *Exorcist II: The Heretic*... [A man] walked up to me and yelled, 'If you say one nice thing about that lousy movie, I'm going to burn your paper, kick in my television set, and then I'm coming after you!' He was kidding, and his embarrassed wife smiled weakly and said, 'Don't mind him; he's just upset.' He should be. *Exorcist II* is the worst major motion picture I've seen in almost eight years on the job." Many other critics agreed with Siskel, and so did the public; after huge opening-weekend grosses touted by Warner Bros.' ads, the box office subsequently plummeted.

"*The Heretic* isn't all that bad. In fact, it's a stimulating and novel film, a far cry from the original *Exorcist*, but a movie that can stand on its own conception. And that conception may be precisely what's gotten *The Heretic* into trouble."
— Dale Pollock, *Santa Cruz Sentinel*

"*Exorcist II* displays moments of taut suspense and credible horror, but a long silly scene near the beginning so undermines the tension the audience is lost through a wave of giggles and the filmmakers never get their complete serious attention again."
— BOB CURTRIGHT, *WICHITA BEACON*

"This is a citizen's arrest. This citizen knows gibberish, claptrap and gobbledygook are not charges that go by the legal book, but he can sure as hell recognize them when he sees them."
— Dean Johnson, [Orlando, FL] *Sentinel Star*

"One didn't have to believe in Satan to be fascinated by parts of *The Exorcist*. This follow-up, however, should embarrass even cult worshipers.... [T]he special effects are about as spectacular as a flag-raising ceremony."
— Don Frederick, *The* [Santa Fe] *New Mexican*

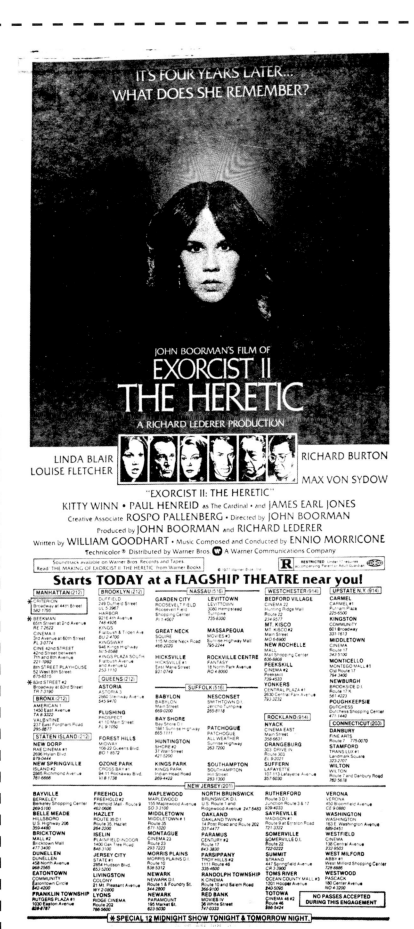

ORCA-THE KILLER WHALE!

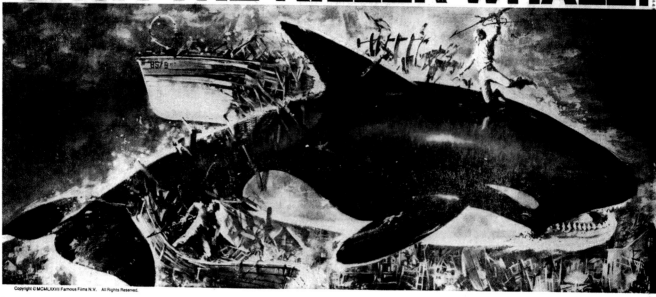

Orca—the killer whale, is one of the most intelligent creatures in the universe. Incredibly, he is the only animal other than man who kills for revenge.

He has one mate, and if she is harmed by man, he will hunt down that person with a relentless, terrible vengeance— across seas, across time, across all obstacles.

DINO DE LAURENTIIS PRESENTS

STARRING **RICHARD HARRIS** AND **CHARLOTTE RAMPLING**

WILL SAMPSON · BO DEREK ORIGINAL STORY AND SCREENPLAY BY LUCIANO VINCENZONI AND SERGIO DONATI PRODUCED BY LUCIANO VINCENZONI DIRECTED BY MICHAEL ANDERSON MUSIC COMPOSED AND CONDUCTED BY ENNIO MORRICONE A FAMOUS FILMS, N.V. PRODUCTION

PG PARENTAL GUIDANCE SUGGESTED A PARAMOUNT RELEASE TECHNICOLOR · PANAVISION

Starts Friday at a theatre near you!

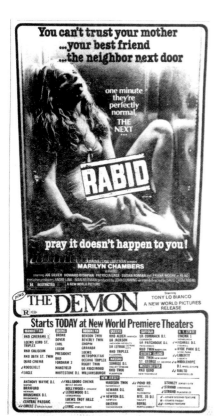

You can't trust your mother
...your best friend
...the neighbor next door

one minute they're perfectly normal, THE NEXT ...

RABID

pray it doesn't happen to you!

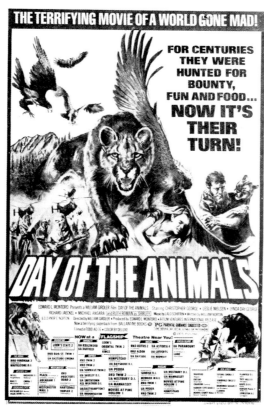

THE TERRIFYING MOVIE OF A WORLD GONE MAD!

FOR CENTURIES THEY WERE HUNTED FOR BOUNTY, FUN AND FOOD... NOW IT'S THEIR TURN!

DAY OF THE ANIMALS

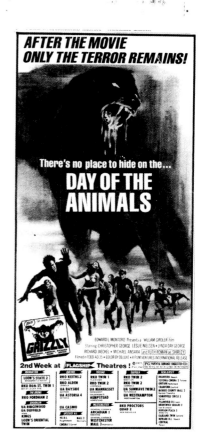

AFTER THE MOVIE ONLY THE TERROR REMAINS!

There's no place to hide on the...
DAY OF THE ANIMALS

1977

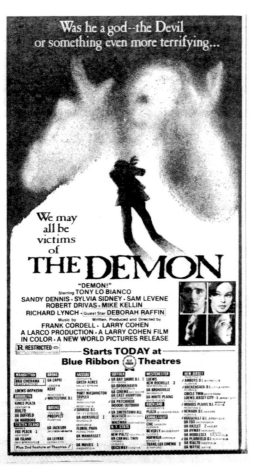

Was he a god--the Devil or something even more terrifying...

We may all be victims of

THE DEMON

"DEMON!"

Starring TONY LO BIANCO
SANDY DENNIS · SYLVIA SIDNEY · SAM LEVENE
ROBERT DRIVAS · MIKE KELLIN
RICHARD LYNCH · Guest Star DEBORAH RAFFIN
Music by FRANK CORDELL · Written, Produced and Directed by
LARRY COHEN
A LARCO PRODUCTION · A LARRY COHEN FILM
IN COLOR · A NEW WORLD PICTURES RELEASE

R RESTRICTED

Starts TODAY at Blue Ribbon Theatres

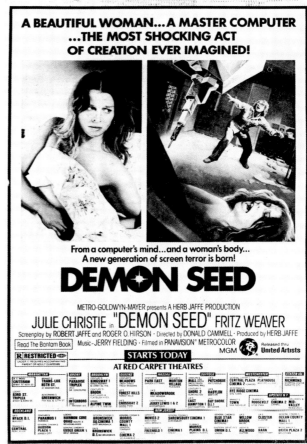

A BEAUTIFUL WOMAN...A MASTER COMPUTER ...THE MOST SHOCKING ACT OF CREATION EVER IMAGINED!

From a computer's mind...and a woman's body...
A new generation of screen terror is born!

DEMON SEED

METRO-GOLDWYN-MAYER presents A HERB JAFFE PRODUCTION
JULIE CHRISTIE in "DEMON SEED" FRITZ WEAVER
Screenplay by ROBERT JAFFE and ROGER O. HIRSON · Directed by DONALD CAMMELL · Produced by HERB JAFFE
Read The Bantam Book Music-JERRY FIELDING · Filmed in PANAVISION® METROCOLOR MGM Released thru United Artists

R RESTRICTED

STARTS TODAY AT RED CARPET THEATRES

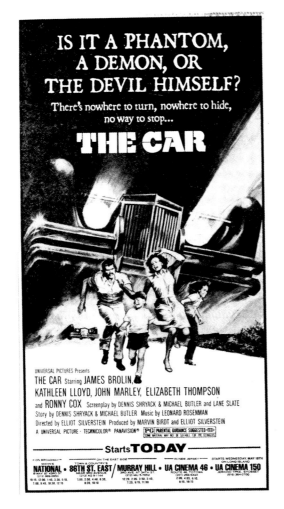

IS IT A PHANTOM, A DEMON, OR THE DEVIL HIMSELF?

There's nowhere to turn, nowhere to hide, no way to stop...

THE CAR

UNIVERSAL PICTURES Presents
THE CAR Starring JAMES BROLIN,
KATHLEEN LLOYD, JOHN MARLEY, ELIZABETH THOMPSON
and RONNY COX Screenplay by DENNIS SHRYACK & MICHAEL BUTLER and LANE SLATE
Story by DENNIS SHRYACK & MICHAEL BUTLER Music by LEONARD ROSENMAN
Directed by ELLIOT SILVERSTEIN Produced by MARVIN BIRDT and ELLIOT SILVERSTEIN
A UNIVERSAL PICTURE · TECHNICOLOR® PANAVISION® **PG** PARENTAL GUIDANCE SUGGESTED

Starts TODAY

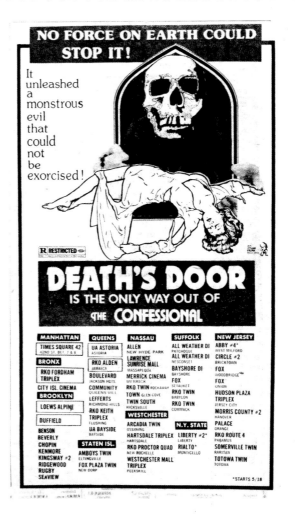

NO FORCE ON EARTH COULD STOP IT!

It unleashed a monstrous evil that could not be exorcised!

R RESTRICTED

DEATH'S DOOR

IS THE ONLY WAY OUT OF the CONFESSIONAL

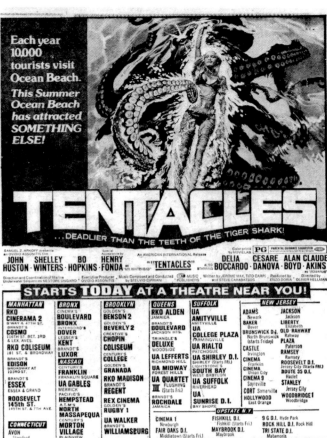

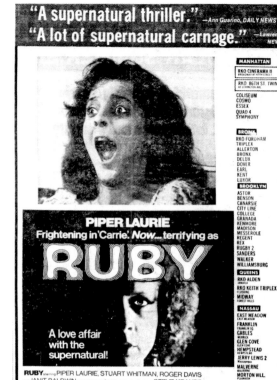

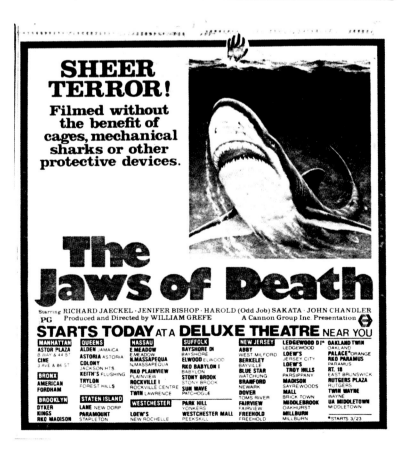

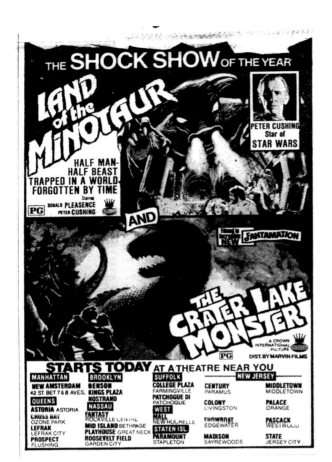
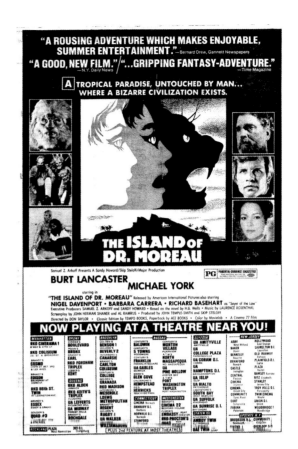
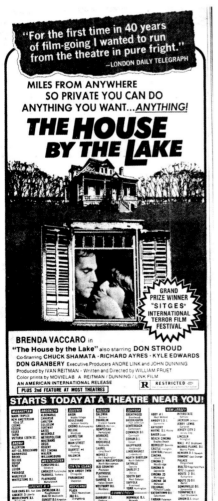
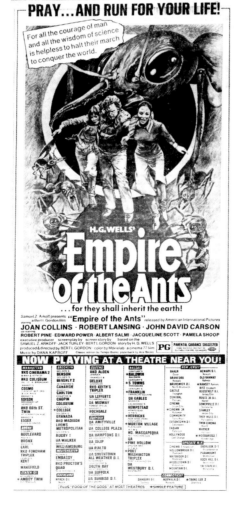
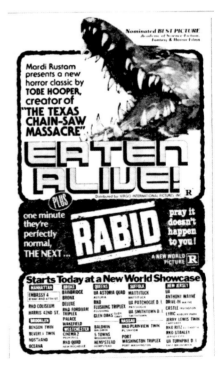

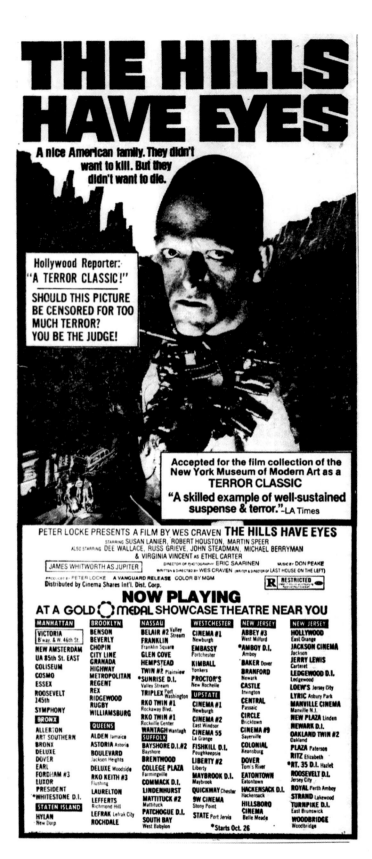

IT'S ALIVE

Larry Cohen's shocker about a mutant baby was initially given negligible openings in Los Angeles, Chicago and other cities by Warner Bros. in 1974. After a regime change at Warners, Cohen convinced them to give *It's Alive* another chance in 1976 (just before New World's release of his next film *God Told Me To*, a.k.a. *Demon*), and it received an upgraded ad campaign and healthier breaks, arriving in New York the following year. The result: a sleeper hit for the studio, though reviews ranged from qualified praise to outright pans.

"Despite patches of risible dialogue and other ludicrous bits and pieces it holds attention and even manages to be pretty scary.... [Cohen] directs with power and authority, developing and expressing ideas and emotions vividly but with not much grace."

— Kevin Thomas, *Los Angeles Times*

"Despite an obscure cast and a low-budget look, the latest 'monster' to emerge from Hollywood's nightmare factory creeps across the screen to provide sustained terror and finally even a certain pathos."

— MALCOLM L. JOHNSON, *THE HARTFORD COURANT*

"*It's Alive!* is not precisely the greatest horror flick of all time but it is a sinewy, moody, true-to-its-own-ground rules chiller.... Cohen delivers both with style and a certain touch of black humor."

— Roger Grooms, *The Cincinnati Enquirer*

"Admittedly, the film's final sequences, when the outraged husband develops compassion for the pitiful offspring he has fathered, are moving and sad. But by that time, a viewer is so turned off by the ugliness and carnage that it becomes difficult to empathize."

— Jeanne Miller, *San Francisco Examiner*

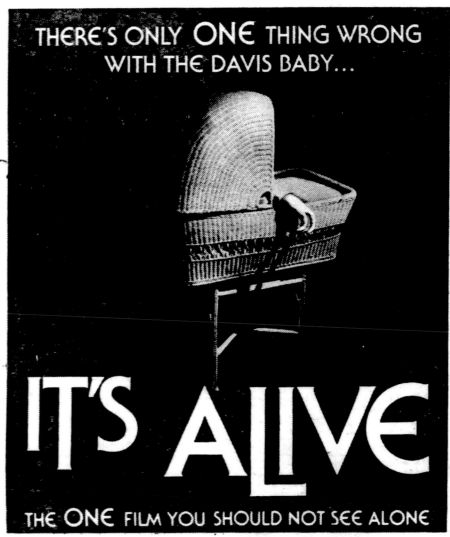

THERE'S ONLY **ONE** THING WRONG
WITH THE DAVIS BABY...

IT'S ALIVE

THE **ONE** FILM YOU SHOULD NOT SEE ALONE

A LARRY COHEN FILM · "IT'S ALIVE" · A LARCO PRODUCTION
starring JOHN RYAN · SHARON FARRELL · ANDREW DUGGAN · GUY STOCKWELL
JAMES DIXON · MICHAEL ANSARA · music by BERNARD HERRMANN
TECHNICOLOR® · written, produced and directed by LARRY COHEN
from Warner Bros. ⓦ A Warner Communications Company PG

— Starts **TODAY** at a FLAGSHIP THEATRE Near You! —

MANHATTAN	BROOKLYN	NASSAU	NASSAU	SUFFOLK
RIVOLI	AVALON	**BETHPAGE** MID ISLAND	**ROCKVILLE CENTRE**	**EAST HAMPTON**
B'WAY & 49TH ST.	DUFFIELD	**GARDEN CITY**	FANTASY	EAST HAMPTON 1
CINE 42nd ST.	GRANADA	ROOSEVELT FIELD	**VALLEY STREAM**	**HUNTINGTON**
EASTSIDE CINEMA	HARBOR	**GREAT NECK**	SUNRISE D.I.	SHORE 2
BRONX	KINGS PLAZA SOUTH	SQUIRE		**NESCONSET**
PALACE	**QUEENS**	**JERICHO**	**SUFFOLK**	SMITHTOWN
VALENTINE	**ASTORIA** ASTORIA	WESTBURY D.I.	**BAYSHORE**	INDOOR
WHITESTONE DRIVE IN	**FLUSHING** PROSPECT 2	**MASSAPEQUA**	CINEMA	**PATCHOGUE**
STATEN ISLAND	**JAMAICA** VALENCIA	THE MOVIES AT	**COPIAGUE**	PATCHOGUE
NEW DORP RAE TWIN 2	**LEFRAK CITY** CINEMA	SUNRISE MALL 4	ALL WEATHER	INDOOR
NEW SPRINGVILLE	**OZONE PARK**			
ISLAND 2	.CROSS BAY 1			

ALSO AT THEATRES IN WESTCHESTER, UPSTATE N.Y., NEW JERSEY & CONNECTICUT

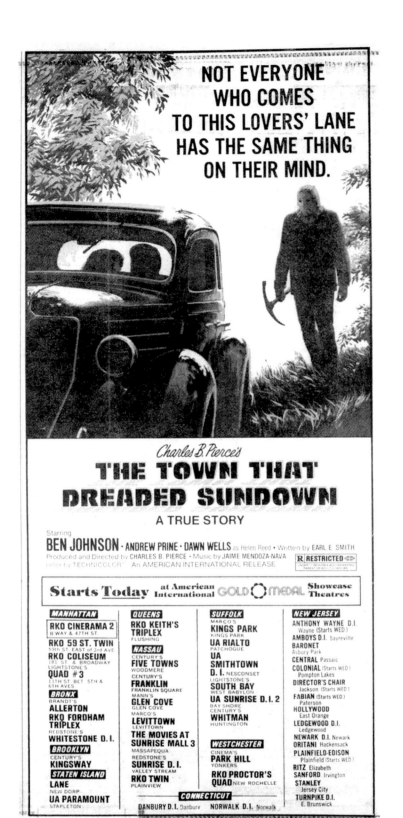

SUSPIRIA

That tagline, as some onlookers have noted, suggests that the final act of *Suspiria* isn't as scary as what has gone before, which many of its fans would debate. (They'll also note that the total of 92 minutes indicates trimming from the original running time of 98 to achieve an R rating.) Distributor 20th Century Fox was certainly scared off from releasing the movie under its own imprimatur, and thus created the "International Classics" brand to bring Dario Argento's most aggressively stylish horror film yet to U.S. theaters. The tone of the reviews largely had to do with whether that style complemented or overwhelmed the story.

"Fox has nothing to be ashamed of. Rather, by all rights, it should have been embarrassed by the likes of *Fire Sale* and *The Silver Streak* [*sic*].... *Suspiria* is...stylish, blood-spattered and genuinely gripping."

— Joe Baltake, *Philadelphia Daily News*

"The film transcends its formula plot in that Argento's visual style is positively florid. His compositions convey a relentlessly sinister and forbidding atmosphere, while his bizarre use of colored lights adds to the nightmarish qualities."

— PAUL BEUTEL, *THE AUSTIN AMERICAN-STATESMAN*

"There is something fiendishly irresponsible about enjoying such a garish, perverse, and brutal film, but *Suspiria* could have been much worse: it could have been boring.... [A]t least *Suspiria* does deliver the scares it promises."

— David Edelstein, *The Hartford Courant*

"If it had evidenced any intention of telling a cogent story, *Suspiria* would have failed. But Argento is clearly so absorbed by all of the weird lighting, outrageous sets and savage sounds that he transcends the pitfalls of story-telling."

— Scott Hammen, *The* [Louisville, KY] *Courier-Journal*

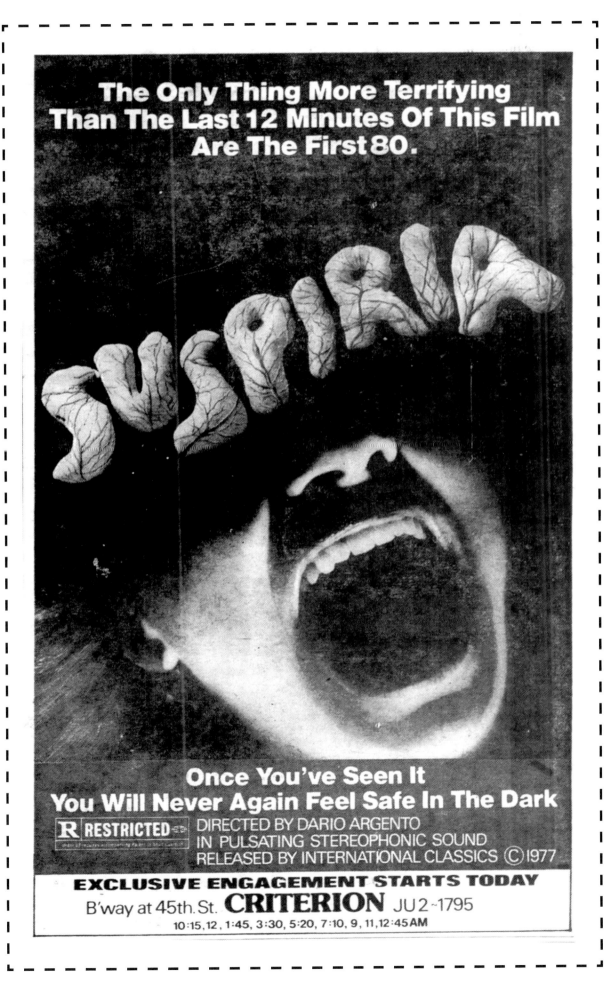

1978

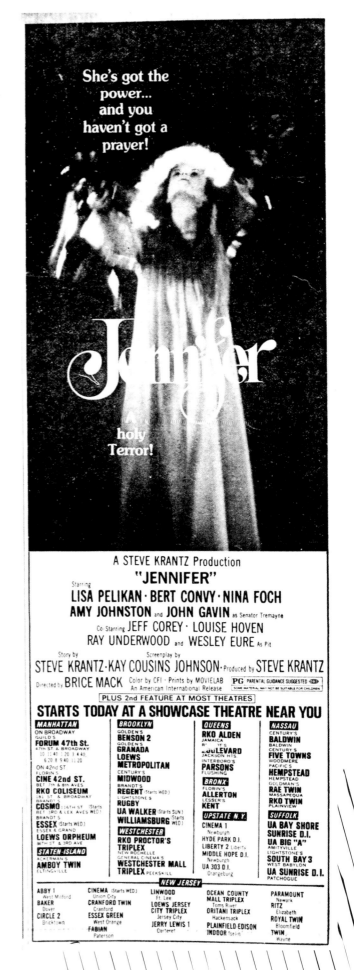

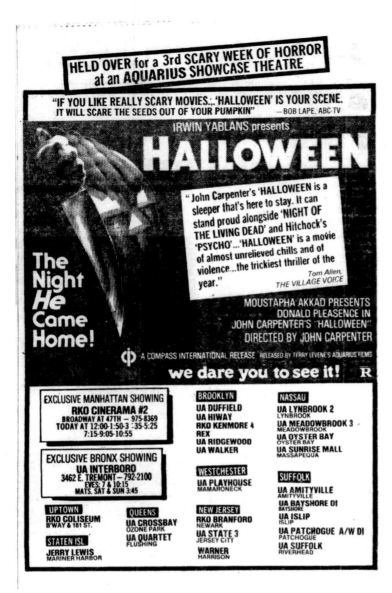

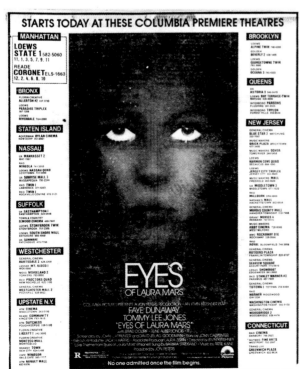

HALLOWEEN

When John Carpenter's ode to All Hallow's horrors began its regional release in October 1978, a pressman's strike had shuttered New York's *Times* and *Daily News*. Yet unlike many a low-budget, independent chiller, *Halloween* lasted more than a week or two and was still hanging in there when the strike was settled and the Big Apple papers came back in early November. The independent *The Village Voice*, unaffected by the walkout, was among many journals to laud Carpenter's scream machine, though there were critics who felt it was more a trick than a treat.

"It is a beautifully made thriller—more shocking than bloody—that will have you screaming with regularity... More than once during the movie I looked around just to make sure that no one weird was sitting behind me. It's that kind of movie."
— Gene Siskel, *Chicago Tribune*

"If you're at all interested in being frightened by a movie, this is the shock-show for you. It's as unrelenting as a white-knuckle midway ride jammed on DANGEROUS—OUT OF CONTROL!"
— GLENN LOVELL, *FORT LAUDERDALE NEWS AND SUN-SENTINEL*

"The screenplay...leaves more gaps and inconsistencies than a mobster on the witness stand, but Carpenter directs it with such frequent flare [*sic*] that it's enough to give viewers a bad case of the creeps."
— Jim Wright, *The* [Bergen County, NJ] *Record*

"With his cinematic flair, Carpenter...knows how to generate fear (rather than suspense) and how to make us feel like voyeurs (which makes the film a complete turn-off about halfway through). So what, then, is the point of all this realistically depicted slaughter and terror?"
— Kevin Thomas, *Los Angeles Times*

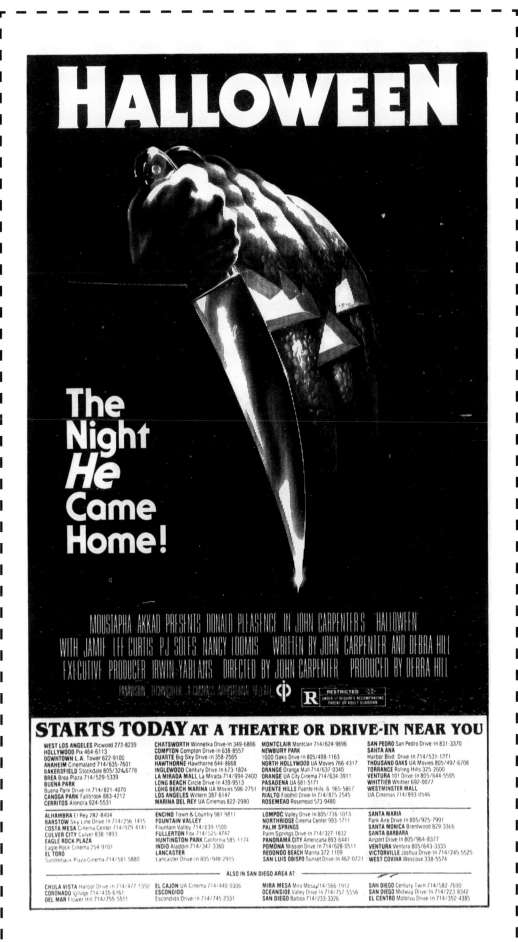

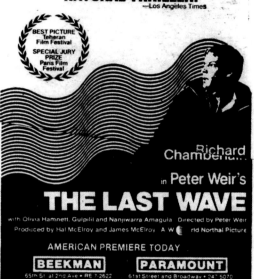
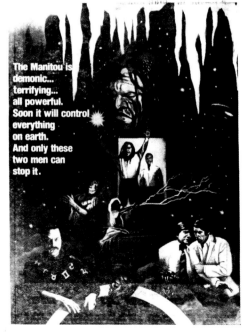
1978

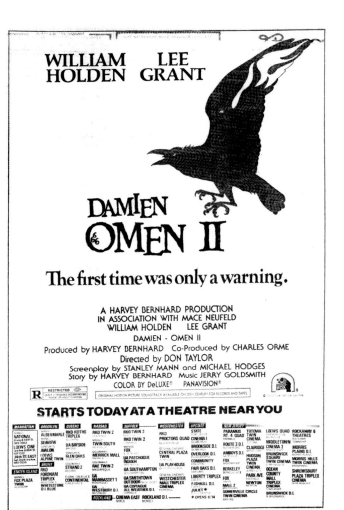

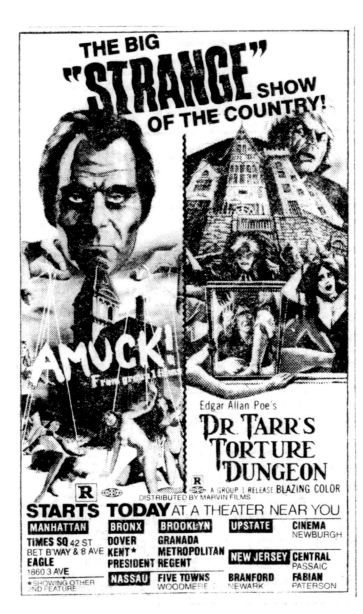

INVASION OF THE BODY SNATCHERS

Made for under $3.5 million, a low budget even in 1978, Philip Kaufman's remake of Don Siegel's 1956 classic opened rather incongruously during Christmastime 1978, and box office was initially soft. Yet word of mouth and excellent reviews turned the film into a sleeper hit; in *The New Yorker*, the esteemed Pauline Kael wrote, "It may be the best movie of its kind ever made," and *Invasion* wound up on a number of year-end 10-best lists. For all the praise, though, not all critics were as enthusiastic about this new take on Jack Finney's novel.

"*Invasion of the Body Snatchers* is one of the finest science fiction horror films ever made.... [I]t provides a shattering emotional experience while intellectually satirizing the decay in our culture."

— Richard Freedman, Newhouse News Service

"It is by all odds the scariest movie of the year, the most suspenseful and the most ingenious. Its horrors are not the ghastly shocks of eviscerations and dismemberments but the frights of the unexplainable and uncombatable."

— CHARLES CHAMPLIN,
LOS ANGELES TIMES

"It comes up from behind and catches you off-guard. It is entertaining, involving and frightening, but it isn't until *afterwards* that you're hit by its humor and its haunting, almost hallucinatory creativity."

— No author credited, *Philadelphia Daily News*

"[D]espite a few creepy moments and some fascinating special effects, the remake of *Invasion of the Body Snatchers* is a disappointment.... [W]hat cannot be accepted is the number of miscalculations made by director Philip Kaufman and scriptwriter W.D. Richter."

— Joe Leydon, *The Shreveport Times*

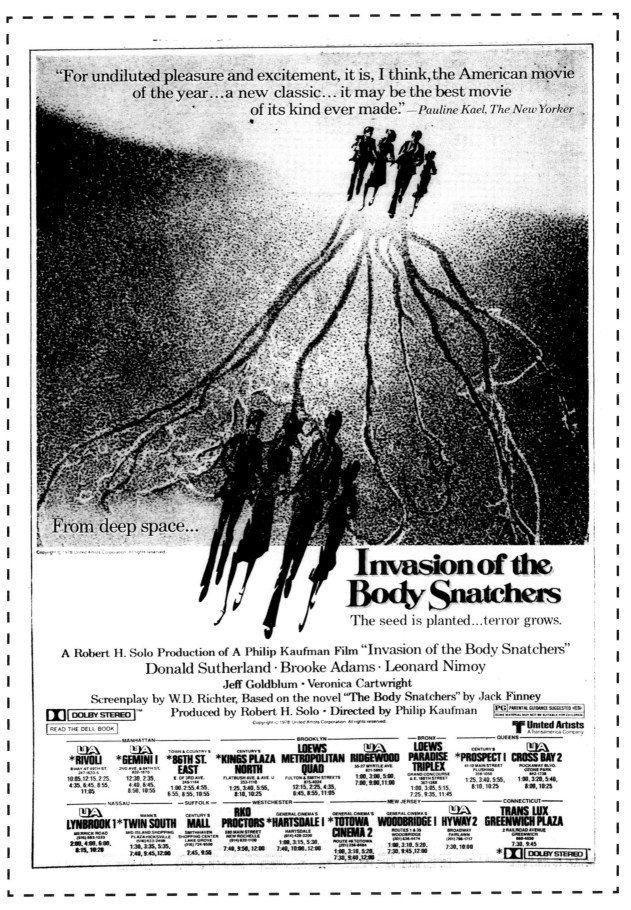

MARTIN

George A. Romero's is-he-or-isn't-he-a-vampire? drama first received a specialty release in New Jersey in December of 1976—the same year the filmmaker was finally able to give the mishandled *The Crazies* some significant bookings. He hoped that Libra Films would do better with *Martin*, but the distributor couldn't seem to settle on how to sell it. *Martin* was advertised in various cities as a romantic thriller, an art-house film and—as in New York, when it hit a handful of screens in December 1978—an exploitation picture with the extended title *Martin the Blood Lover*. (*Martin* also began a lengthy midnight run at the Waverly theater earlier that year.) Like *The Crazies*, *Martin* eventually found an appreciative audience thanks to video exposure and revival screenings.

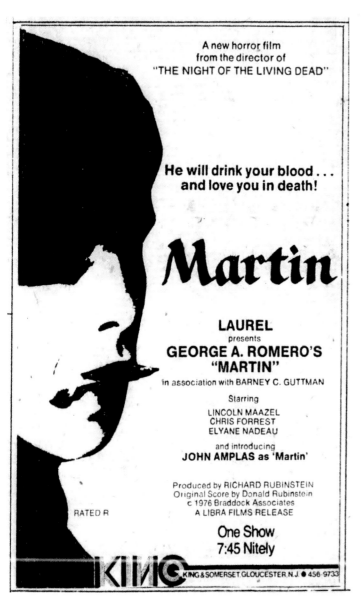

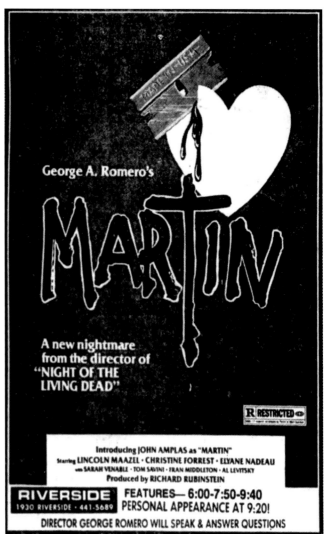

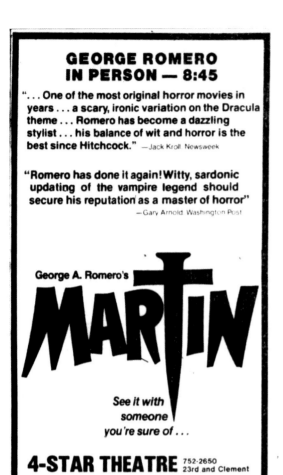

GEORGE ROMERO IN PERSON — 8:45

"...One of the most original horror movies in years ... a scary, ironic variation on the Dracula theme ... Romero has become a dazzling stylist ... his balance of wit and horror is the best since Hitchcock." —Jack Kroll, Newsweek

"Romero has done it again! Witty, sardonic updating of the vampire legend should secure his reputation as a master of horror" —Gary Arnold, Washington Post

George A. Romero's MARTIN

See it with someone you're sure of . . .

4-STAR THEATRE 752-2650
23rd and Clement

A Terrifying Love Story

MAGIC

JOSEPH E. LEVINE PRESENTS
MAGIC
ANTHONY HOPKINS · ANN-MARGRET
BURGESS MEREDITH · ED LAUTER
EXECUTIVE PRODUCER C.O. ERICKSON
MUSIC BY JERRY GOLDSMITH
SCREENPLAY BY WILLIAM GOLDMAN, BASED UPON HIS NOVEL
PRODUCED BY JOSEPH E. LEVINE AND RICHARD P. LEVINE
DIRECTED BY RICHARD ATTENBOROUGH
PRINTS BY DELUXE® TECHNICOLOR® R

EXCLUSIVE ENGAGEMENT STARTS TODAY

——Manhattan——

Mann's **NATIONAL**
Broadway at 44th St.
869-0950
11:00, 1:00, 3:00, 5:00,
7:00, 9:00, 11:00

BEEKMAN
65th St. & 2nd Ave.
737-2622
12:00, 2:00, 4:00,
6:00, 8:00, 10:00

PARAMOUNT
61st & Broadway
247-5070
12:00, 2:00, 4:00,
6:00, 8:00, 10:00

GRAMERCY
Lexington Ave. at 23rd St.
GR 5-1660
12:00, 2:00, 4:00,
6:00, 8:00, 10:00

——Westchester——

B.S. MOSS **MOVIELAND**
2500 Central Park Ave.
Yonkers
(914) 793-0002
2:00, 4:00, 6:00,
8:00, 10:00

——New Jersey——

Mann's **FOX WOODBRIDGE**
US #1 near Gills Lane
Woodbridge, N.J.
(201) 634-0044
1:00, 3:00, 5:00, 7:00,
9:00, 10:00, 11:10

RKO PARAMUS
Route 4
Paramus, N.J.
(201) 487-7909
1:30, 3:35, 5:50,
8:00, 10:10

——Long Island——

LOEWS NASSAU QUAD
Nassau Mall—Levittown
3585 Hempstead Tpke.
(516) 731-5400
8:10, 10:10

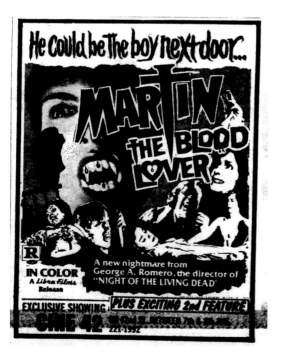

He could be the boy next door...

MARTIN THE BLOOD LOVER

R IN COLOR
A Libra Films Release

A new nightmare from George A. Romero, the director of "NIGHT OF THE LIVING DEAD"

EXCLUSIVE SHOWING
CINE 42

PLUS EXCITING 2nd FEATURE

NOT SINCE "VILLAGE OF THE DAMNED"

DEVIL TIMES FIVE

R
Starring
SHELLY MORRISON
SORREL BOOKE
GENE EVANS

HAS DEATH BECOME SO SAVAGE... OR SURVIVAL SO HOPELESS!

Executive Producer
JORDAN WANK
A BARRISTER PRODUCTION

PLUS SNUFF

Distributed by MARKFILM

NOW PLAYING AT A THEATER NEAR YOU

MANHATTAN
LIBERTY 42 ST.
BET 7 & 8 AVES
COSMO
116 ST BET LEX & 3 AVES
ESSEX
OFF COR GRAND & ESSEX

BRONX
DOVER
FORDHAM
KENT
PRESIDENT

BROOKLYN
GRANADA
REGENT
REX
RUGBY
WILLIAMSBURG

UPSTATE CINEMA I *
NEWBURGH

NEW JERSEY
CENTRAL
PASSAIC
CINEMA †
UNION CITY
FABIAN
PATERSON
9G DI
POUGHKEEPSIE
* STARTS 7 14
SHOWING OTHER 2ND FEATURE

LIBERTY
ELIZABETH
LOEWS
JERSEY CITY
PARAMOUNT
NEWARK
ROYAL
PERTH AMBOY

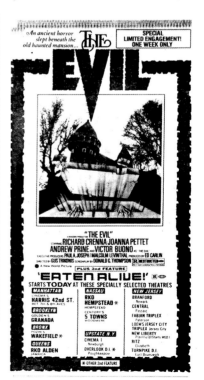

An ancient horror slept beneath the old haunted mansion...

SPECIAL LIMITED ENGAGEMENT! ONE WEEK ONLY

THE EVIL

"THE EVIL"
RICHARD CRENNA · JOANNA PETTET
ANDREW PRINE · VICTOR BUONO
Executive Producers PAUL A. JOSEPH / MALCOLM LEVINTHAL Produced by ED CARLIN
Directed by GUS TRIKONIS Screenplay by DONALD G. THOMPSON R
A New World Picture

PLUS 2nd FEATURE
'EATEN ALIVE!' R

STARTS TODAY AT THESE SPECIALLY SELECTED THEATRES

MANHATTAN
HARRIS 42nd ST.
BET 7th & 8th AVES
BROOKLYN
GOLDEN'S
GRANADA
BRONX
POZIN'S
WAKEFIELD *
QUEENS
RKO ALDEN
JAMAICA

NASSAU
RKO
HEMPSTEAD *
HEMPSTEAD
CENTURY'S
5 TOWNS
WOODMERE
CINEMA I
Newburgh
OVERLOOK D.I. *
Poughkeepsie

NEW JERSEY
BRANFORD
Newark
CENTRAL
Passaic
FABIAN TRIPLEX
Paterson
LOEWS JERSEY CITY
TRIPLEX Jersey City
NEW LIBERTY
Plainfield (Starts WED)
BITZ
Elizabeth
TURNPIKE D.I.
East Brunswick

* OTHER 2nd FEATURE

117

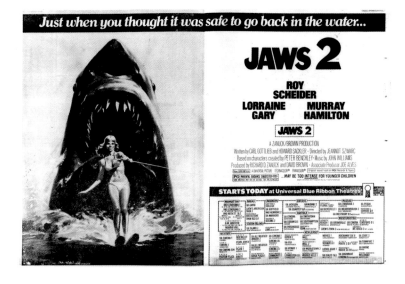

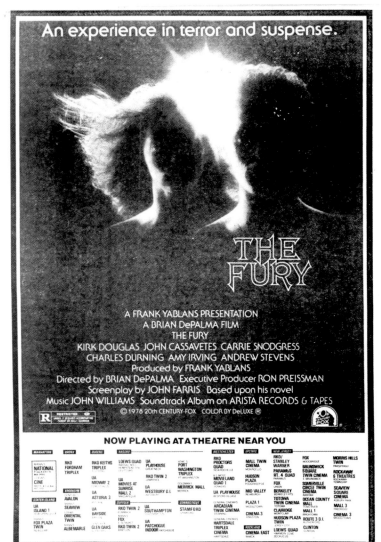

PIRANHA

"They're eating the guests, sir." That line, delivered by an underling (Shawn Nelson) to water park owner Buck Gardner (Dick Miller) as the killer fish attack, was cited by numerous reviews of Joe Dante's satirical nature-amok opus. Armed with a clever script by John Sayles and a great cast of character actors, Dante crafted the best of the *Jaws* knockoffs, which generated a sequel, a remake and imitations of its own. A hit for Roger Corman's New World Pictures, *Piranha* also inspired a number of positive critical notices.

"The only real difference between *Jaws* or *Jaws 2* and *Piranha* is the size of their budgets and teeth.... *Piranha*, at what I'm sure was a fraction of the cost of the big ones, succeeds very nicely, thank you."

— Charles Champlin, *Los Angeles Times*

"[T]o the movie's credit, the suspense is well-sustained, the acting credible, and the whole venture sickeningly feasible.... Keeping *Piranha* on course and continually interesting are the main characters, convincingly played."

— CANDICE RUSSELL, *THE MIAMI HERALD*

"Because we start believing in the characters and the fragility of their relationships, the horror of the attacks and their political implications become real and genuinely powerful."

— Peter Travers, Gannett Westchester Newspapers

"It's successful because it doesn't take itself very seriously and because it delivers exactly what its intended audience wants—oddball sadistic humor and plenty of gore."

— Joe Baltake, *Philadelphia Daily News*

"It's extremely easy to dislike such a shabby confection as this Roger Corman mini-Jaws... But beneath all the sloppy technique and poor writing, it seems director Joe Dante was at least able to wring humor out of his dismal budget."

— Patrick Taggart, *Austin American-Statesman*

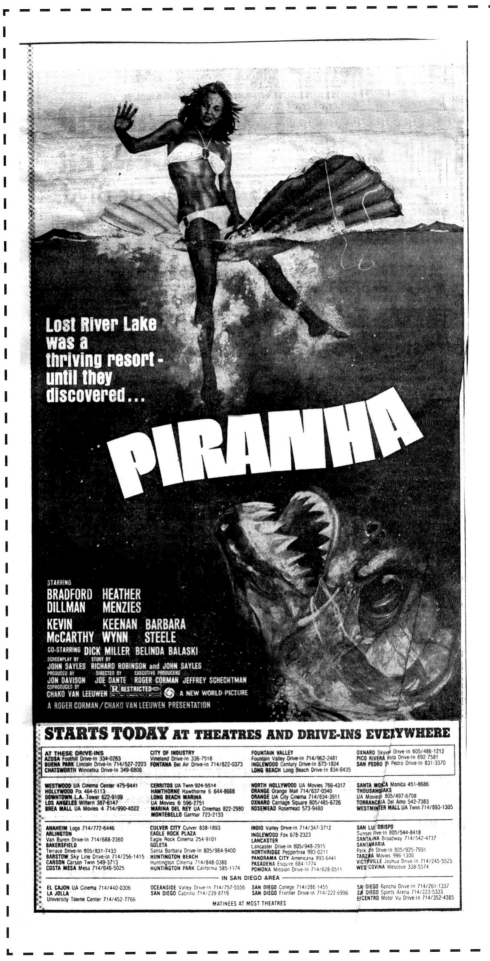

Lost River Lake was a thriving resort - until they discovered...

PIRANHA

STARRING
BRADFORD DILLMAN **HEATHER MENZIES**

KEVIN McCARTHY **KEENAN WYNN** **BARBARA STEELE**

CO-STARRING **DICK MILLER** **BELINDA BALASKI**

SCREENPLAY BY **JOHN SAYLES** STORY BY **Richard Robinson** and **JOHN SAYLES**

PRODUCED BY **JON DAVISON** DIRECTED BY **Joe Dante** EXECUTIVE PRODUCERS **Roger Corman** **Jeffrey Schechtman**

COPRODUCED BY **CHAKO VAN LEEUWEN** [R] RESTRICTED ⊙ A NEW WORLD PICTURE

A ROGER CORMAN / CHAKO VAN LEEUWEN PRESENTATION

STARTS TODAY AT THEATRES AND DRIVE-INS EVERYWHERE

AT THESE DRIVE-INS
AZUSA Foothill Drive-In 334-0263
BUENA PARK Lincoln Drive-In 714/527-2223
CHATSWORTH Winnetka Drive-In 349-6806

CITY OF INDUSTRY Vineland Drive-In 336-7518
FONTANA Bel Air Drive-In 714/822-0373

FOUNTAIN VALLEY Fountain Valley Drive-In 714/962-2481
INGLEWOOD Century Drive-In 673-1824
LONG BEACH Long Beach Drive-In 834-6435

OXNARD Skyview Drive-In 805/486-1212
PICO RIVERA Vista Drive-In 692-7581
SAN PEDRO San Pedro Drive-In 831-3370

WESTWOOD UA Cinema Center 475-9441
HOLLYWOOD Pix 464-6113
DOWNTOWN L.A. Tower 622-9109
LOS ANGELES Wiltern 387-6147
BREA MALL UA Movies 4 714/990-4022

CERRITOS UA Twin 924-5514
HAWTHORNE Hawthorne 6 644-8668
LONG BEACH MARINA UA Movies 6 596-2751
MARINA DEL REY UA Cinemas 822-2980
MONTEBELLO Garmar 723-2133

NORTH HOLLYWOOD UA Movies 766-4317
ORANGE Orange Mall 714/637-0340
ORANGE UA City Cinema 714/634-3911
OXNARD Carriage Square 805/485-6726
ROSEMEAD Rosemead 573-9480

SANTA MONICA Monica 451-8686
THOUSAND OAKS UA Movies 805/497-6708
TORRANCE UA Del Amo 542-7383
WESTMINSTER MALL UA Twin 714/893-1305

ANAHEIM Loge 714/772-6446
ARLINGTON Van Buren Drive-In 714/688-2360
BAKERSFIELD Terrace Drive-In 805/831-7433
BARSTOW Sky Line Drive-In 714/256-1415
CARSON Carson Twin 549-3713
COSTA MESA Mesa 714/646-5025

CULVER CITY Culver 838-1893
EAGLE ROCK PLAZA Eagle Rock Cinema 254-9101
GOLETA Santa Barbara Drive-In 805/964-9400
HUNTINGTON BEACH Huntington Cinema 714/848-0388
HUNTINGTON PARK California 585-1174

INDIO Valley Drive-In 714/347-3712
INGLEWOOD Fox 678-2323
LANCASTER Lancaster Drive-In 805/948-2915
NORTHRIDGE Peppertree 993-0211
PANORAMA CITY Americana 893-6441
PASADENA Esquire 684-1774
POMONA Mission Drive-In 714/628-0511

SAN LUIS OBISPO Sunset Five-In 805/544-8418
SANTA ANA Broadway 714/542-4737
SANTA MARIA Park Re Drive-In 805/925-7991
TARZANA Movies 996-1300
VICTORVILLE Joshua Drive-In 714/245-5525
WEST COVINA Wescove 338-5574

IN SAN DIEGO AREA

EL CAJON UA Cinema 714/440-0306
LA JOLLA University Towne Center 714/452-7766

OCEANSIDE Valley Drive-In 714/757-5556
SAN DIEGO Cabrillo 714/239-8719

SAN DIEGO College 714/286-1455
SAN DIEGO Frontier Drive-In 714/222-6996

SAN DIEGO Rancho Drive-In 714/261-1337
SAN DIEGO Sports Arena 714/223-5333
EL CENTRO Motor Vu Drive-In 714/352-4385

MATINEES AT MOST THEATRES

119

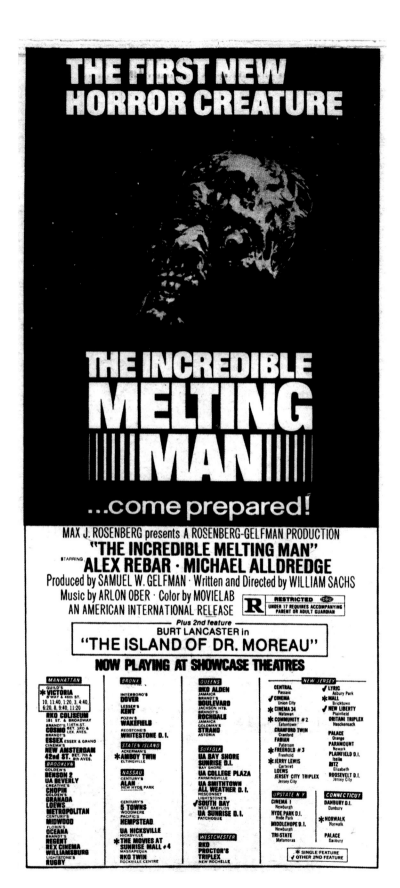

THE SWARM

Based on the rep of "Master of Disaster" Irwin Allen, the producer of the blockbusters *The Poseidon Adventure* and *The Towering Inferno* also assuming the director's chair here, U.S. exhibitors took *The Swarm* sight unseen, booking it into over 1,400 theaters—a record at the time. And yet, Warners would not screen this major summer release in advance for critics—clearly anticipating the deafening chorus of pans that greeted *The Swarm*. Bee-oriented plays on words were common ("It's the audience that gets stung," "Buzz off," etc.) among the many ways reviewers found to register their displeasure.

"Irwin Allen's latest disaster is so bad that one senses more than mere cynical greed in its production and release; there is a contempt for its audience implicit in nearly every scene. *The Swarm* is easily the worst big-budget movie I have ever seen."

— Bill Cosford, *The Miami Herald*

"It's not the subject matter that makes *The Swarm* such an irredeemably appalling picture. What's absolutely numbing about this two hour bugbite is the rank amateurishness of the filmmaking."

— JOSEPH GELMIS, NEW YORK *NEWSDAY*

"*The Swarm* may not be the worst movie ever made. I'd have to see them all to be sure. It's certainly as bad as any I've seen so far.... All the actors involved in this fiasco should be ashamed."

— Richard Velt, *Wilmington Morning Star*

"[M]ost disaster films are about as original as a salad bar.... The plot [of *The Swarm*] is even simpler than a salad bar—a baloney sandwich is a better analogy."

— Daniel Ruth, *The Tampa Tribune*

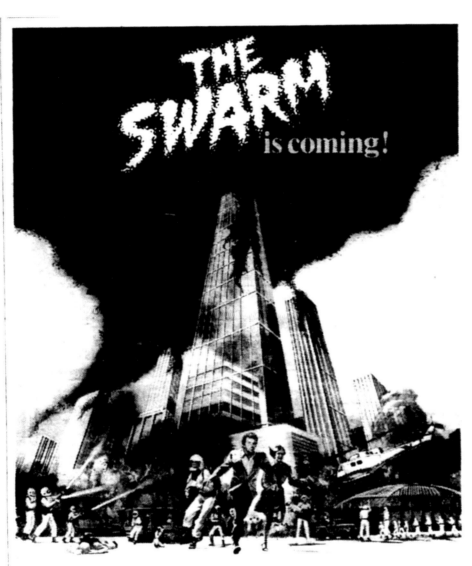

1979

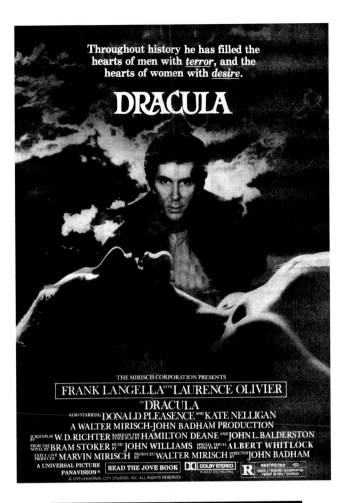

Throughout history he has filled the hearts of men with *terror*, and the hearts of women with *desire*.

DRACULA

THE MIRISCH CORPORATION PRESENTS

FRANK LANGELLA WITH LAURENCE OLIVIER
IN "DRACULA"
ALSO STARRING DONALD PLEASENCE AND KATE NELLIGAN
A WALTER MIRISCH-JOHN BADHAM PRODUCTION
SCREENPLAY BY W.D. RICHTER BASED ON THE STAGE PLAY BY HAMILTON DEANE AND JOHN L. BALDERSTON
FROM THE NOVEL BY BRAM STOKER MUSIC BY JOHN WILLIAMS SPECIAL VISUAL EFFECTS BY ALBERT WHITLOCK
EXECUTIVE PRODUCER MARVIN MIRISCH PRODUCED BY WALTER MIRISCH DIRECTED BY JOHN BADHAM
A UNIVERSAL PICTURE PANAVISION® READ THE JOVE BOOK DOLBY STEREO IN SELECTED THEATRES R RESTRICTED UNDER 17 REQUIRES ACCOMPANYING PARENT OR ADULT GUARDIAN
© 1979 UNIVERSAL CITY STUDIOS, INC. ALL RIGHTS RESERVED

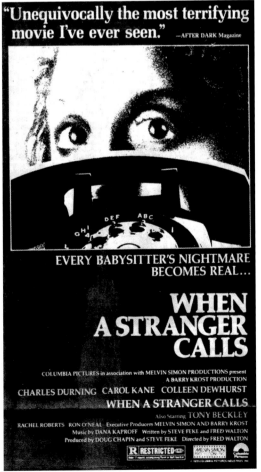

"Unequivocally the most terrifying movie I've ever seen."
—AFTER DARK Magazine

EVERY BABYSITTER'S NIGHTMARE BECOMES REAL...

WHEN A STRANGER CALLS

COLUMBIA PICTURES in association with MELVIN SIMON PRODUCTIONS present A BARRY KROST PRODUCTION

CHARLES DURNING CAROL KANE COLLEEN DEWHURST

WHEN A STRANGER CALLS
Also Starring TONY BECKLEY
RACHEL ROBERTS RON O'NEAL Executive Producers MELVIN SIMON AND BARRY KROST
Music by DANA KAPROFF Written by STEVE FEKE and FRED WALTON
Produced by DOUG CHAPIN and STEVE FEKE Directed by FRED WALTON

R RESTRICTED
© 1979 COLUMBIA PICTURES INDUSTRIES, INC.

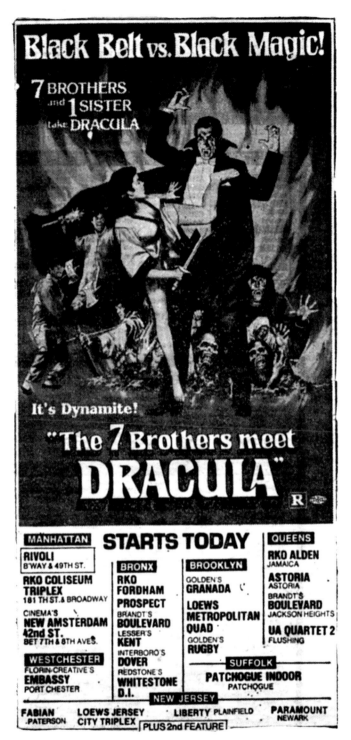

Black Belt vs. Black Magic!

7 BROTHERS and 1 SISTER take DRACULA

It's Dynamite!

"The 7 Brothers meet DRACULA" R

MANHATTAN	STARTS TODAY		QUEENS
RIVOLI B'WAY & 49TH ST.	**BRONX**	**BROOKLYN**	**RKO ALDEN** JAMAICA
RKO COLISEUM TRIPLEX 181 TH ST. & BROADWAY	RKO FORDHAM	GOLDEN'S GRANADA	ASTORIA ASTORIA
CINEMA'S NEW AMSTERDAM 42nd ST. BET 7TH & 8TH AVES.	PROSPECT BRANDT'S BOULEVARD LESSER'S KENT	LOEWS METROPOLITAN QUAD GOLDEN'S RUGBY	BRANDT'S BOULEVARD JACKSON HEIGHTS UA QUARTET 2 FLUSHING
WESTCHESTER FLORIN-CREATIVE'S EMBASSY PORT CHESTER	INTERBORO'S DOVER REDSTONE'S WHITESTONE D.I.	**SUFFOLK** PATCHOGUE INDOOR PATCHOGUE	
	NEW JERSEY		
FABIAN PATERSON	LOEWS JERSEY CITY TRIPLEX	LIBERTY PLAINFIELD PLUS 2nd FEATURE	PARAMOUNT NEWARK

123

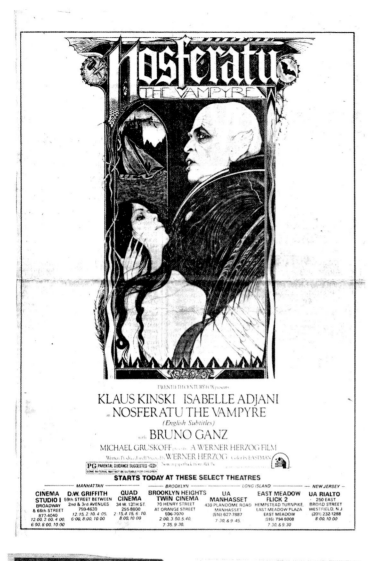

TWENTIETH CENTURY FOX presents

KLAUS KINSKI · ISABELLE ADJANI
in **NOSFERATU THE VAMPYRE**
(English Subtitles)
with **BRUNO GANZ**

MICHAEL GRUSKOFF presents A WERNER HERZOG FILM
Written, Produced and Directed by WERNER HERZOG · Color by EASTMAN

PG PARENTAL GUIDANCE SUGGESTED

STARTS TODAY AT THESE SELECT THEATRES

MANHATTAN			BROOKLYN	LONG ISLAND		NEW JERSEY
CINEMA STUDIO I BROADWAY & 66th STREET 877-4040 12:00, 2:00, 4:00, 6:00, 8:00, 10:00	D.W. GRIFFITH 59th STREET BETWEEN 2nd & 3rd AVENUES 759-4630 12:15, 2:10, 4:05, 6:00, 8:00, 10:00	QUAD CINEMA 34 W. 13TH ST. 255-8800 2:15, 4:15, 6:10, 8:00, 10:00	BROOKLYN HEIGHTS TWIN CINEMA 70 HENRY STREET AT ORANGE STREET 596-7070 2:00, 3:50, 5:40, 7:35, 9:30.	UA MANHASSET 430 PLANDOME ROAD MANHASSET (516) 627-7887 7:30 & 9:45.	EAST MEADOW FLICK 2 HEMPSTEAD TURNPIKE, EAST MEADOW PLAZA EAST MEADOW (516) 794-8008 7:30 & 9:30	UA RIALTO 250 EAST BROAD STREET WESTFIELD, N.J. (201) 232-1288 8:00, 10:00

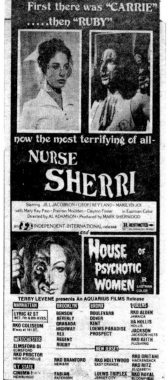

First there was "CARRIE"
.....then "RUBY"

now the most terrifying of all—

NURSE SHERRI

Starring JILL JACOBSON · GEOFFREY LAND · MARILYN JOI
with Mary Kay Pass · Prentiss Moulden · Clayton Foster in Eastman Color
Directed by AL ADAMSON · Produced by MARK SHERWOOD

an INDEPENDENT INTERNATIONAL release **R** RESTRICTED

and

HOUSE of PSYCHOTIC WOMEN

R EASTMAN COLOR

TERRY LEVENE presents An AQUARIUS FILMS Release

MANHATTAN	BROOKLYN	BRONX	QUEENS
LYRIC 42 ST BET. 7th & 8th AVES.	BENSON BEVERLY GRANADA HIGHWAY REX REGENT RUGBY	BOULEVARD DOVER KENT LOEWS PARADISE PROSPECT	RKO ALDEN JAMAICA UA HOLLIS HOLLIS JACKSON JACKSON HGTS RKO KEITH FLUSHING
RKO COLISEUM B'way at 181 ST.			
WESTCHESTER		NEW JERSEY	
ELMSFORD DI ELMSFORD			
RKO PROCTOR NEW ROCHELLE	RKO BRANFORD NEWARK	RKO HOLLYWOOD EAST ORANGE	RKO ORITANI HACKENSACK RKO RITZ ELIZABETH
N.Y. STATE			
CINEMA 1 NEWBURGH	FABIAN PATERSON	LOEWS TRIPLEX JERSEY CITY	RKO ROYAL BLOOMFIELD

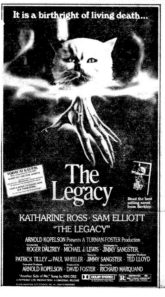

It is a birthright of living death...

TODAY AT 6:15 P.M.

Read the best selling novel from Berkley.

The Legacy

KATHARINE ROSS · SAM ELLIOTT
"THE LEGACY"

ARNOLD KOPELSON Presents A TURMAN-FOSTER Production
Starring ROGER DALTREY · Music by MICHAEL J. LEWIS · Screenplay by JIMMY SANGSTER
PATRICK TILLEY and PAUL WHEELER · Story by JIMMY SANGSTER · Associate Producer TED LLOYD
Executive Producer ARNOLD KOPELSON · Produced by DAVID FOSTER · Directed by RICHARD MARQUAND

"Another Side of Me" Sung by KIKI DEE **DOLBY STEREO** A PETHURST LTD. PRODUCTION A UNIVERSAL RELEASE **R**

THE AMITYVILLE HORROR

Lords of the drive-in for decades, American International Pictures had a mainstream blockbuster with its adaptation of Jay Anson's best-selling and allegedly fact-based haunted-house saga. *The Amityville Horror* was one of the biggest hits of 1979 (outdoing *Alien*, among many others), but despite that success and the high grosses of its Dracula comedy *Love at First Bite* the same summer, AIP would be purchased by and folded into Filmways within a year. Meanwhile, the movie jumpstarted debate about the veracity of the horrific claims made by the Lutz family about the events at 112 Ocean Avenue (some of them teased in advance ads), but the reviews were largely in agreement that the cinematic treatment didn't convince.

"[I]t stands high on the list in Hollywood's present preoccupation with supernatural escapades. The fact that it claims to be true adds to its fascination, and while no monsters are revealed, they are not missed. The unknown is always more terrifying."
— Bob Freund, *Fort Lauderdale News*

"What credibility the book did have is further dissipated by the movie.... *The Amityville Horror* is frequently eerie but more often inane. "
— JIM WRIGHT, *THE* [HACKENSACK, NJ] *RECORD*

"So many horror-movie clichés have been assembled under the roof of a single haunted house that the effect is sometimes mind-bogglingly messy. There is apparently very little to which the director, Stuart Rosenberg, will not resort."
— Janet Maslin, *The New York Times*

"The titles, which announce 'The First Day...the 7th Day...the 12th Day...' etc., have an uncanny way of underlining the plodding continuity.... What a relief it is to see 'The Last Day...'"
— Gary Arnold, *The Washington Post*

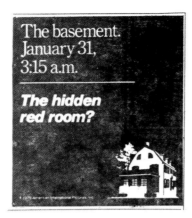
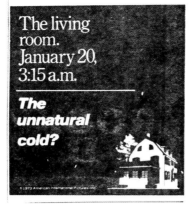
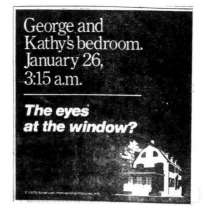
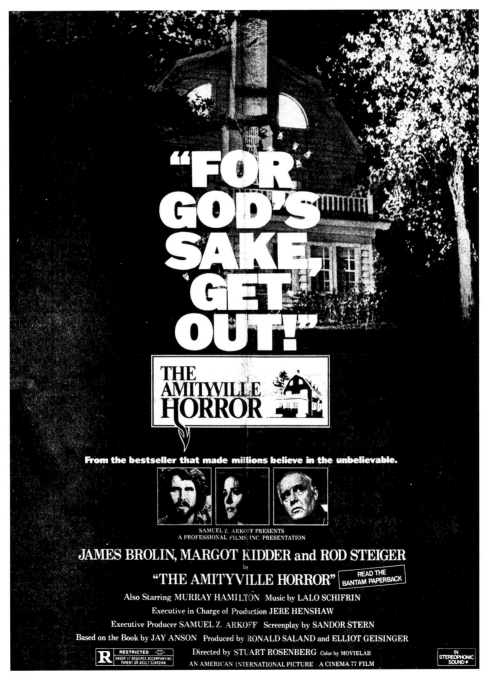
125

DAWN OF THE DEAD

Knowing that an X rating would be a given for the film's parade of bloody makeup illusions, George A. Romero and United Film Distribution started a genre trend by releasing *Dawn of the Dead* without a rating, imposing their own "No one under 17 will be admitted" tag. And while some critics praised Romero's combination of compelling horror-drama and pointed social satire, others were appalled. A few even copped to walking out on the film, most notoriously *The New York Times*' Janet Maslin, who departed after 15 minutes. (She apologized on Twitter in 2020, calling it "an unprofessional and stupid thing to do... It's a mistake I never made again.")

"It is gruesome, sickening, disgusting, violent, brutal and appalling. It is also (excuse me for a second while I find my other list) brilliantly crafted, funny, droll, and savagely merciless in its satiric view of the American consumer society. Nobody ever said art had to be in good taste."
— Roger Ebert, *Chicago Sun-Times*

"[L]ike most great sequels, this one makes no attempt whatsoever to recreate its predecessor.... The original was gothic grotesque; its sequel is an incredible social comment on American consumerism run rampant."
— ELEANOR RINGEL, *THE ATLANTA CONSTITUTION*

"George A. Romero has managed to put together a fright flick that has audiences screaming and quaking in their seats one minute and rolling with laughter the next. And the guffaws and chuckles tend to be at ourselves—a bit ashamedly at that."
— Bill Prescott, *Tallahassee Democrat*

"The redundant scenes of slaughter lack even a hint of subtle horror film stylism, and the film emerges as little more than an obscenely gruesome bloodbath, like seeing the ending of *Taxi Driver* replayed for two hours."
— Bruce Westbrook, *The Daily Oklahoman*

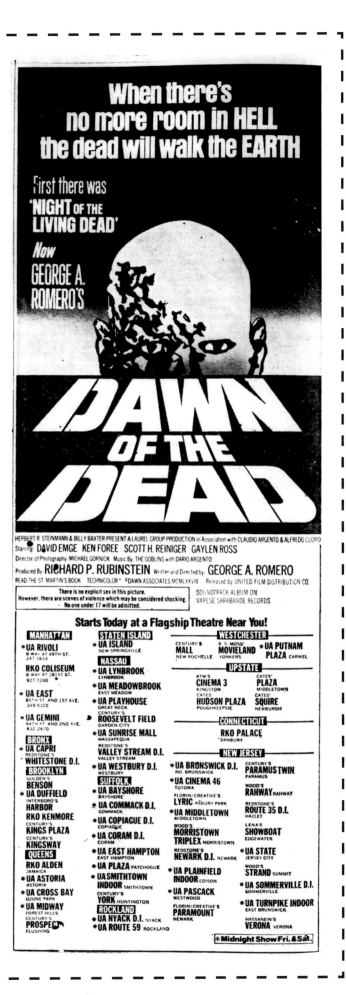

PHANTASM

Back in the 1970s, the major studios would routinely hold sneak previews of their upcoming movies, and indie Avco Embassy Pictures, which had gone through a fallow period in the mid-'70s, also did so with Don Coscarelli's nightmarish horror-fantasy. These advance showings, along with a very effective ad campaign and significant in-theater ballyhoo, helped make *Phantasm* the first in a string of high-profile horror successes for Avco Embassy. The film found approval from a number of critics (including Charles Champlin, a longtime Coscarelli supporter) as well.

"It's as real and foreboding as a cemetery after dark... There is no comforting rational explanation for the story's dark events. The tingles linger on, but you can't help laughing; it helps to steady the nerves."

— Charles Champlin, *Los Angeles Times*

"If you like gore, you'll love *Phantasm*. And even if you don't, you'll come away from the film with admiration for the perverse energy of writer/director Don Coscarelli."

— BILL COSFORD, *THE MIAMI HERALD*

"[A]n impressive entrant into the world of horror.... Coscarelli has borrowed a little bit from many spooky elements of old and inserted a couple of fascinating new ones of his own to lift *Phantasm* a grade above the standard fare."

— Joseph Bensoua, San Pedro, CA *News Pilot*

"Never mind that *Phantasm*'s story line ultimately makes as much sense as an IRS 1040 form. Coscarelli...knows how to prey on audiences' emotions, if not their intellects, by mixing rude terror with humor."

— Jim Wright, *The* [Hackensack, NJ] *Record*

"[D]espite haphazard editing and only a passing interest in continuity, Coscarelli manages to inject a fresh and funny tone into his film that make it more effective than many recent industry attempts [at horror]."

— Marylynn Uricchio, *Pittsburgh Post-Gazette*

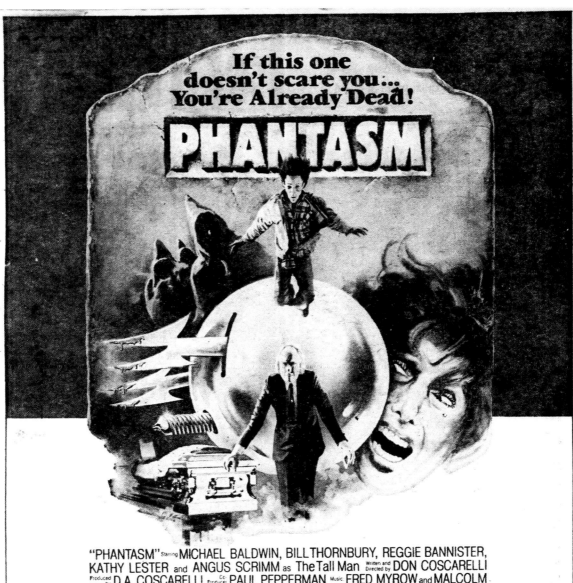

If this one doesn't scare you... You're Already Dead!

PHANTASM

"PHANTASM" Starring MICHAEL BALDWIN, BILL THORNBURY, REGGIE BANNISTER, KATHY LESTER and ANGUS SCRIMM as The Tall Man Written and Directed by DON COSCARELLI Produced by D.A. COSCARELLI Co Producer PAUL PEPPERMAN Music FRED MYROW and MALCOLM SEAGRAVE Prints by CFI SOUNDTRACK AVAILABLE ON VARESE SARABANDE RECORDS △AVCO EMBASSY PICTURES Release

RESTRICTED R

Starts Today at 'PHANTASM' Showcase Theatres

VAMPIRE HOOKERS (OF HORROR)

When subdistributing Caprican Three, Inc.'s *Vampire Hookers* in NYC, Aquarius Films apparently felt the title wasn't enough of an attention-grabber, adding *of Horror* in the ads (even though the film is more of a comedy). Yet at the same time, they were either inclined or obligated to tone down the original tagline: "Warm blood isn't all they suck!"

1979

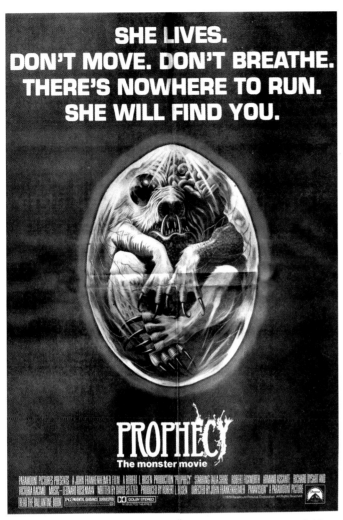

SHE LIVES.
DON'T MOVE. DON'T BREATHE.
THERE'S NOWHERE TO RUN.
SHE WILL FIND YOU.

PROPHECY
The monster movie

STARTS FRIDAY AT A THEATRE NEAR YOU

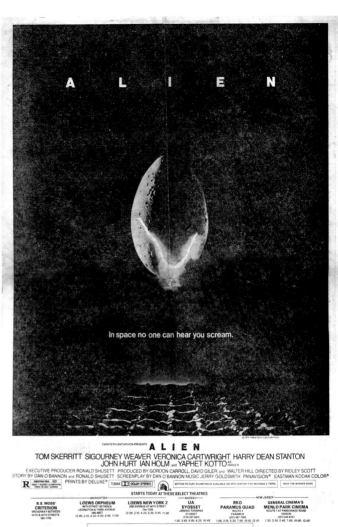

A L I E N

In space no one can hear you scream.

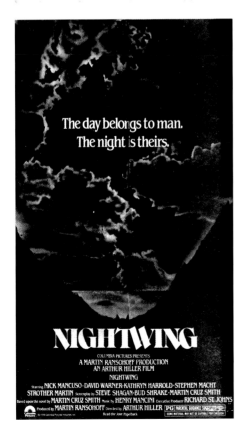

The day belongs to man.
The night is theirs.

NIGHTWING

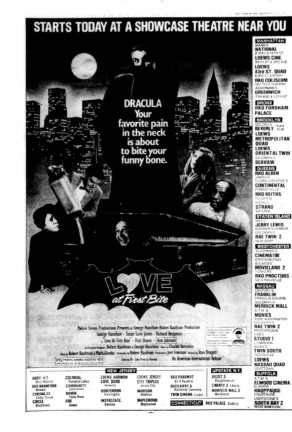

STARTS TODAY AT A SHOWCASE THEATRE NEAR YOU

DRACULA
Your favorite pain in the neck is about to bite your funny bone.

LOVE at First Bite

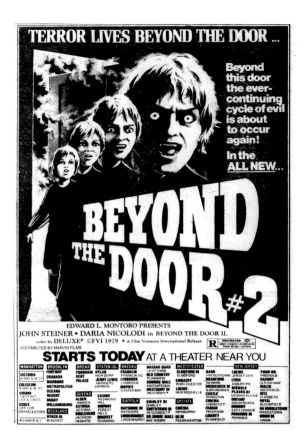

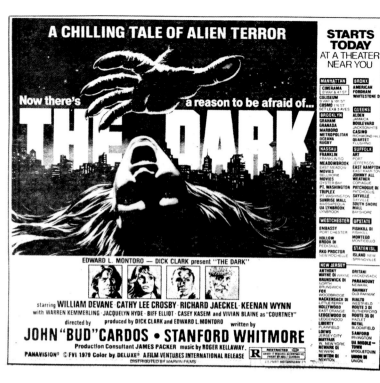

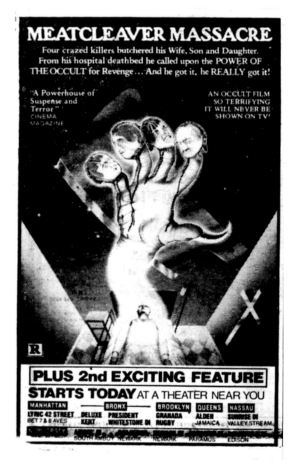

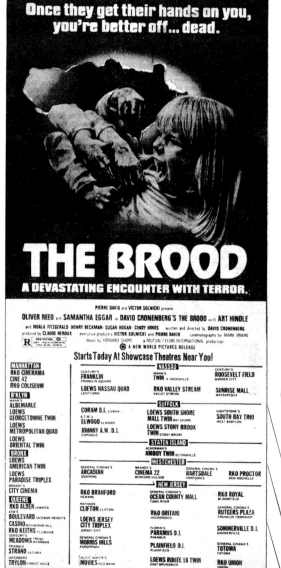

DOUBLE-FEATURE REISSUES

As horror became a hot commodity in the wake of *Halloween*, distributors began pulling fright films from throughout the '70s off the shelf and sending them out on paired bills in the New York area and elsewhere. These included *Last House Part II*, a duplicitous retitling of Mario Bava's *A Bay of Blood* (a.k.a. *Twitch of the Death Nerve*). Soon enough, there would be plenty of new scary movies to fill screens, and the '80s horror boom would begin...

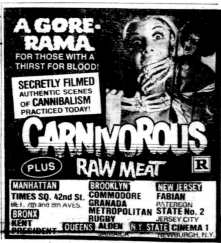

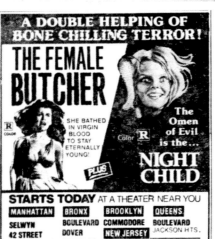

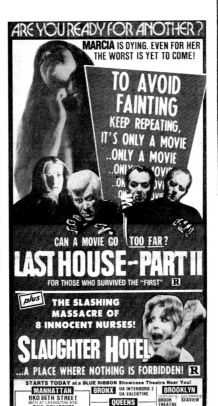

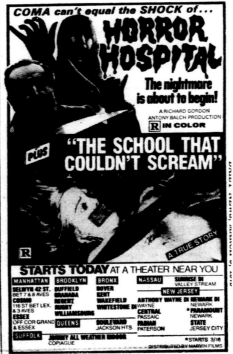

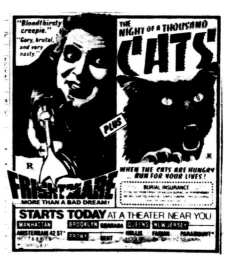

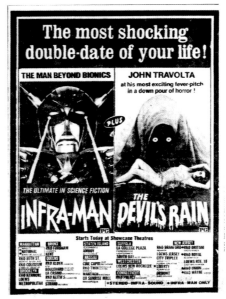

1980

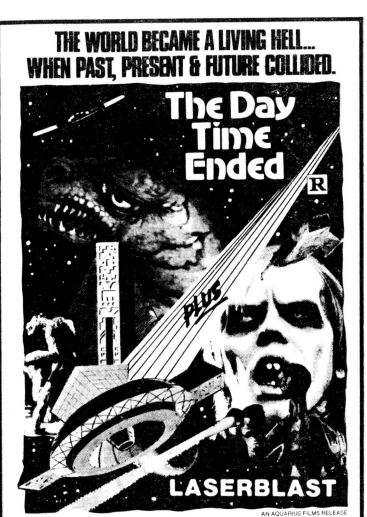
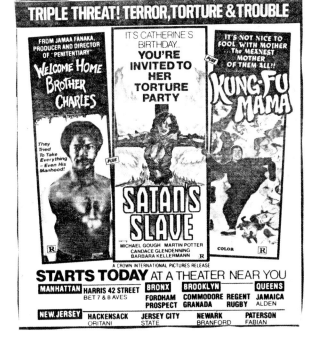
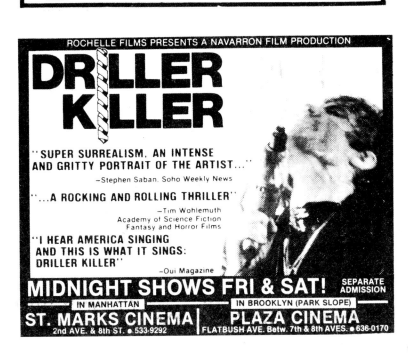
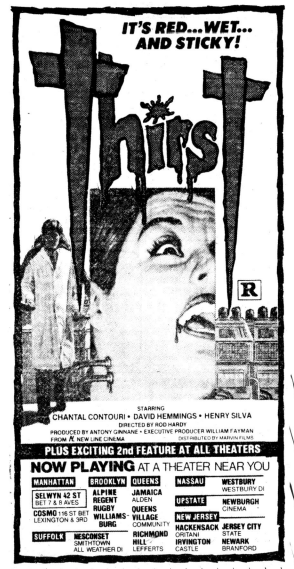
135

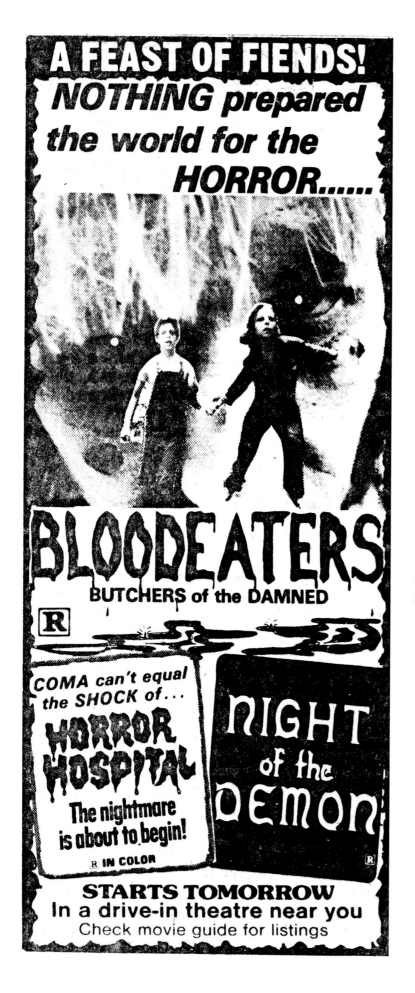

A FEAST OF FIENDS!
NOTHING prepared the world for the HORROR......

BLOODEATERS
BUTCHERS of the DAMNED

R

COMA can't equal the SHOCK of...
HORROR HOSPITAL
The nightmare is about to begin!
R IN COLOR

NIGHT of the DEMON

R

STARTS TOMORROW
In a drive-in theatre near you
Check movie guide for listings

FRIDAY THE 13TH

Up until spring 1980, low-budget slasher films (even John Carpenter's hit *Halloween*) had been regionally released independent productions. *Friday the 13th* changed all that, as it was sent to over 1000 theaters nationwide by big studio Paramount Pictures. Some critics expressed outrage that a major distributor would put out such a bloodbath, and most found many other things to object to as well. Amidst all the attacks, however, a few reviewers praised the shocking impact of *Friday*, which went on to be a box-office sleeper — one of the few hits of that summer.

"People in horror movies are always dumb... But in *Friday the 13th*, stupidity reaches a new level... [It] is proof positive that it takes more than a bucket of fake blood and a screeching soundtrack to make a horror film."
— Jeff Borden, *Columbus Evening Dispatch*

"I will make no moral arguments for *Friday the 13th*; it is crude, cheap, and revolting enough to zap a zombie into a double coma. The film has no purpose except to freeze your veins, which it does with evil expertise."
— PETER TRAVERS, *GANNETT NEWS SERVICE*

"...*Friday the 13th* is a film singularly lacking in suspense, directorial skill, tension, or even humor. Director Sean S. Cunningham strings together a series of grisly murders...with all the infectious enthusiasm of a Hong Kong sweatshop laborer stringing beads for tourists."
— Joe Leydon, *The Dallas Morning News*

"The test of a horror film is whether it scares you. *Friday the 13th* succeeds in this goal, even though it has a silly plot and generally poor performances and has obviously borrowed most of its plot elements from *Halloween*. So why is it effective? Principally because it preys of everyone's natural fear of mutilation and painful death."
— Robert C. Trussell, *The Kansas City Star*

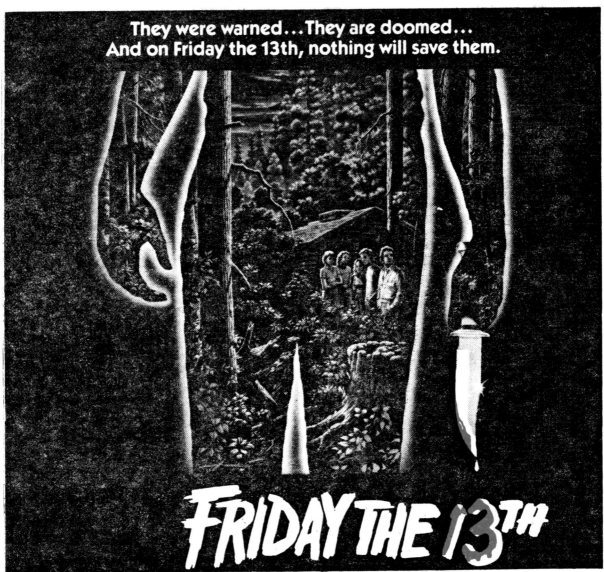

They were warned...They are doomed...
And on Friday the 13th, nothing will save them.

FRIDAY THE 13TH

A 24 hour nightmare of terror.

PARAMOUNT PICTURES PRESENTS A SEAN S. CUNNINGHAM FILM FRIDAY THE 13TH WRITTEN BY VICTOR MILLER PRODUCED AND DIRECTED BY SEAN S. CUNNINGHAM
A GEORGETOWN PRODUCTIONS INC. PRODUCTION

© MCMLXXX BY PARAMOUNT PICTURES CORPORATION
ALL RIGHTS RESERVED A PARAMOUNT RELEASE

STARTS TODAY

MANHATTAN
LOEWS ASTOR PLAZA
B'way & 44th St. 869-8340
Fri, Sat & Sun: 12, 1:50, 3:40, 5:30, 7:20, 9:10, 11
LOEWS ORPHEUM
86th St. & 3rd Ave. 289-4607
Fri & Sat: 12:15, 2:05, 3:55, 5:45, 7:35, 9:25, 11:15
Sun: 1, 2:45, 4:30, 6:15, 8:05, 9:50
Walter Reade's
34th STREET EAST
Near 2nd Ave. 683-0255
Fri & Sat: 12, 1:50, 3:40, 5:30, 7:20, 9:10, 11
Sun: 12:50, 2:40, 4:30, 6:20, 8:10, 10

BRONX
LOEWS AMERICAN TWIN
CITY CINEMA
LOEWS PARADISE TRIPLEX
WHITESTONE D.I. RED

BROOKLYN
ALBEMARLE
LOEWS
GEORGETOWNE TWIN
LOEWS
METROPOLITAN QUAD
OCEANA 1
LOEWS ORIENTAL TWIN

QUEENS
BOULEVARD 1
JACKSON HEIGHTS
LOEWS ELMWOOD
TWIN ELMHURST
RKO KEITHS
FLUSHING
LITTLE NECK
LITTLE NECK
Century's
MEADOWS 1
FRESH MEADOWS

NASSAU
Century's
FLORAL
FLORAL PARK
RKO LAWRENCE
LAWRENCE
THE MOVIES AT SUNRISE MALL 7
MASSAPEQUA
Century's
ROOSEVELT FIELD 2
GARDEN CITY
SUNRISE
SIXPLEX CINEMAS
VALLEY STREAM
TWIN SOUTH
HICKSVILLE
WESTBURY D.I.
TRIPLEX 2
JERICHO

SUFFOLK
CORAM D.I.
CORAM
EAST HAMPTON 4
EAST HAMPTON
ELWOOD
ELWOOD
JOHNNY
ALL WEATHER D.I.
OUTDOOR
COPIAGUE
SOUTH BAY TRIO 1
WEST BABYLON
LOEWS
SOUTH SHORE
TWIN
BAYSHORE
LOEWS
STONYBROOK
TRIPLEX
STONYBROOK
SUNWAVE
TWIN 1
PATCHOGUE

STATEN ISLAND
ISLAND 1
NEW
SPRINGVILLE
RAE TWIN 1
NEW DORP

UPSTATE N.Y.
CARMEL
UA CINEMA 1
FISHKILL
FISHKILL D.I.
KINGSTON
KINGSTON
TRIPLEX 3
LIBERTY
LIBERTY TRIPLEX 2
MIDDLETOWN
MIDDLETOWN D.I.
MONTICELLO
MALL 1
NEWBURGH
MIDDLE HOPE D.I.
NEWBURGH
SQUIRE 1
POUGHKEEPSIE
DUTCHESS
WARWICK
WARWICK D.I

CONNECTICUT
PLAYHOUSE
NEW CANAAN
TRANS LUX 2
STAMFORD

ROCKLAND
NANUET MOVIES 3
NEW CITY TOWN
NYACK NYACK D.I.

BLOOMFIELD
RKO ROYAL
BRICKTOWN
BRICK PLAZA 2
CLIFTON
CLIFTON TWIN 1
EAST BRUNSWICK
LOEWS ROUTE 18 TWIN
EDGEWATER
SHOWBOAT
FLEMINGTON
HUNTERDON
FREEHOLD
POND ROAD
HAZLET
ROUTE 35 D.I.
JERSEY CITY
LOEWS
JERSEY CITY TRIPLEX
LITTLE FERRY
HACKENSACK D.I.
LIVINGSTON
LIVINGSTON D.I.
MIDDLETOWN
CINEMA 1

ARCADIAN 2
OSSINING

CINEMA 2
HARTSDALE

NEW JERSEY
MORRISTOWN
MORRISTOWN
TRIPLEX 3
NEWARK
NEWARK D.I.
NEWTON
NEWTON TWIN 2
NORTH
BRUNSWICK
BRUNSWICK D.I.
PARAMUS
RKO ROUTE 4
PARSIPPANY
MORRIS HILLS 1
RARITAN
SOMERVILLE 3
RIDGEWOOD
RKO WARNER
RUTHERFORD
ROUTE 3 D.I.
SAYREVILLE
AMBOY
SIXPLEX
CINEMAS 1

SECAUCUS
LOEWS
HARMON COVE
QUAD
SHREWSBURY
CINEMA 3
TOMS RIVER
OCEAN COUNTY
MALL 1
TOTOWA
TOTOWA 2
UNION
RKO UNION
UNION
UNION D.I.
WATCHUNG
BLUE STAR 2
WEST END
THE MOVIES 1
WEST
ORANGE
ESSEX
GREEN 3
WOODBRIDGE
WOODBRIDGE 1

WESTCHESTER
CINEMA 22
BEDFORD VILLAGE
MOVIELAND 3
YONKERS
PARK HILL YONKERS

RKO PROCTORS
NEW ROCHELLE
WESTCHESTER
MALL TRIPLEX 2
PEEKSKILL

HALLOWEEN

When John Carpenter's terror-fest first opened in New York in October 1978, the city was in the midst of a three-month strike by newspaper pressmen, and neither *The New York Times* nor the *Daily News* were in print to cover it. However, many other dailies around the country, along with magazine and TV critics, raved about the film, and were quoted in ads for *Halloween*'s seasonal re-releases in 1979 and 1980.

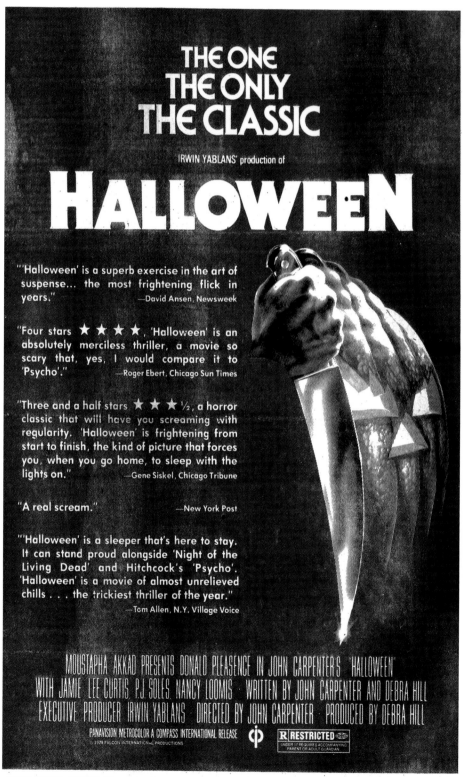

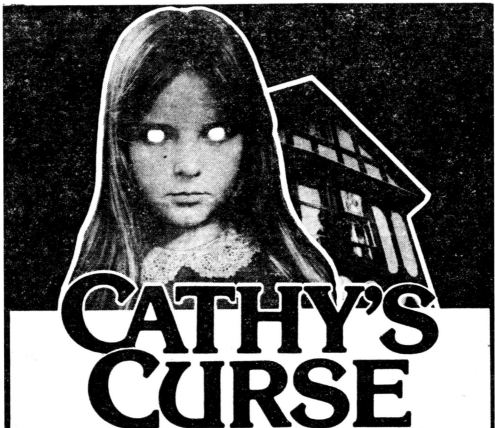

CATHY'S CURSE

SHE HAS THE POWER
...TO TERRORIZE.

Nicole Mathieu Boisvert and Eddy Matalon present "CATHY'S CURSE"
starring ALAN SCARFE BEVERLY MURRAY and RANDI ALLEN as CATHY

 Directed by EDDY MATALON
DISTRIBUTION Eastmancolor

STARTS TODAY AT A THEATRE NEAR YOU!

MANHATTAN	BRONX	QUEENS	SUFFOLK	YORK HUNTINGTON
CINE 42 42nd STREET (Betw. 7th & 8th Aves.) 221-1992	**MELBA**	**UA ASTORIA** ASTORIA	**LINDENHURST** LINDENHURST	**ENCORE** BAYSHORE
NOVA 3589 BROADWAY (Betw. 147th & 148th St.) 862-5728	**LOEW'S AMERICAN**	**KEITH'S #3** FLUSHING	**SMITHTOWN INDOOR A/W** SMITHTOWN	**SHIRLEY** SHIRLEY
RKO COLISEUM 181st ST. & B'WAY 927-7200	**LOEW'S PARADISE**	**LEFFERTS** RICHMOND HILL		**WESTCHESTER**
		ALDEN JAMAICA	**JOHNNY A/W D/I** COPIAGUE	**MALL** NEW ROCHELLE
	BROOKLYN REX RUGBY		***WILLIAMSBURG** *STARTS 8/8	**HOLLOWBROOK D/I** PEEKSKILL
NEW JERSEY				**EMBASSY** PORTCHESTER
LOEW'S JERSEY CITY JERSEY CITY	**ORITANI** HACKENSACK	**HOLLYWOOD** EAST ORANGE	**JERRY LEWIS** CARTERET	**UPSTATE**
	PLAZA PATERSON			**CINEMA NEWBURG** NEWBURG
	SANFORD IRVINGTON	**ISELIN** ISELIN	**PARAMUS D/I** PARAMUS	
BRANFORD NEWARK	**LIBERTY** PLAINFIELD	**BAY** BAYONNE	**UNION D/I** UNION	

139

DON'T ANSWER THE PHONE & DON'T GO IN THE HOUSE

"Don't" titles weren't new to the fright marketplace when these two hit screens; there had been the drive-in perennial *Don't Look in the Basement*, the TV movie favorite *Don't Be Afraid of the Dark*, and so on. These two were unusually nasty pictures, though, featuring some of the stalker genre's ugliest violence against women, which led some critics to inevitably give their readers a variation of the warning "Don't see this movie."

"*Phone* is a low-brow exploitation film that has a fixation on gore and on teasing shots of women in various stages of undress during assaults, but little interest in basics such as motivation and characterization."

—Ed Blank, *The Pittsburgh Press*

"The film strings its violence and prurience together in a dim programmer way that is marginally watchable for people who like this sort of stuff."

—Tom Dowling, *The Washington Star*

"The movie seems to say that feelings and psychology and women's liberation and so on are irksome nonsense… [and] that beating women and killing them is amusing and killing creeps is amusing."

—JOE ADCOCK, *PHILADELPHIA EVENING BULLETIN*

"Often it seems to be a sleazy excuse for bare breasts, shrill screams, and foul cursing. It is one of those killer-on-the-loose tales that is more maddening than suspenseful."

—Donna Chernin, *Cleveland Plain Dealer*

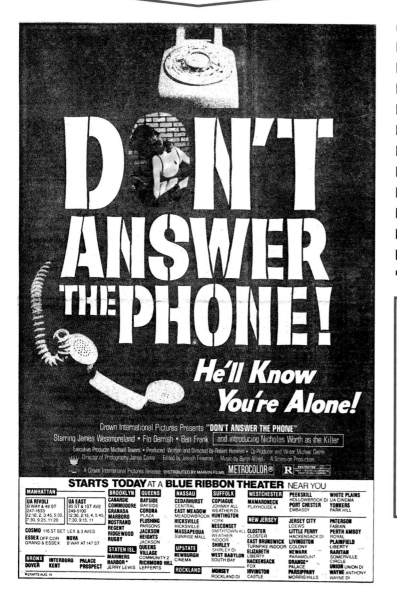

"The story has its perfunctory moral: Abused children become murderers. But to get that moral, all we need to do is follow the real-life news. None of us needs to see a movie this bad or this insulting."

— Robin Brown, *Wilmington (DE) Morning News*

"This alleged horror film is horrible only by virtue of an idiotic script (which required the efforts of three writers), amateurish performances, confused direction, and bargain-basement photography and sound recording. … [It] apparently was made by sadists for sadists."

— Robert C. Trussell, *The Kansas City Star*

"As entertaining horror, it falls somewhere between ghoulish Nazi archive footage and outtakes from *The Towering Inferno*. Too bad because director Ellen Hammill [sic] has a good eye for detail…and manages to sustain a fairly oppressive mood."

— GLENN LOVELL, *SAN JOSE MERCURY NEWS*

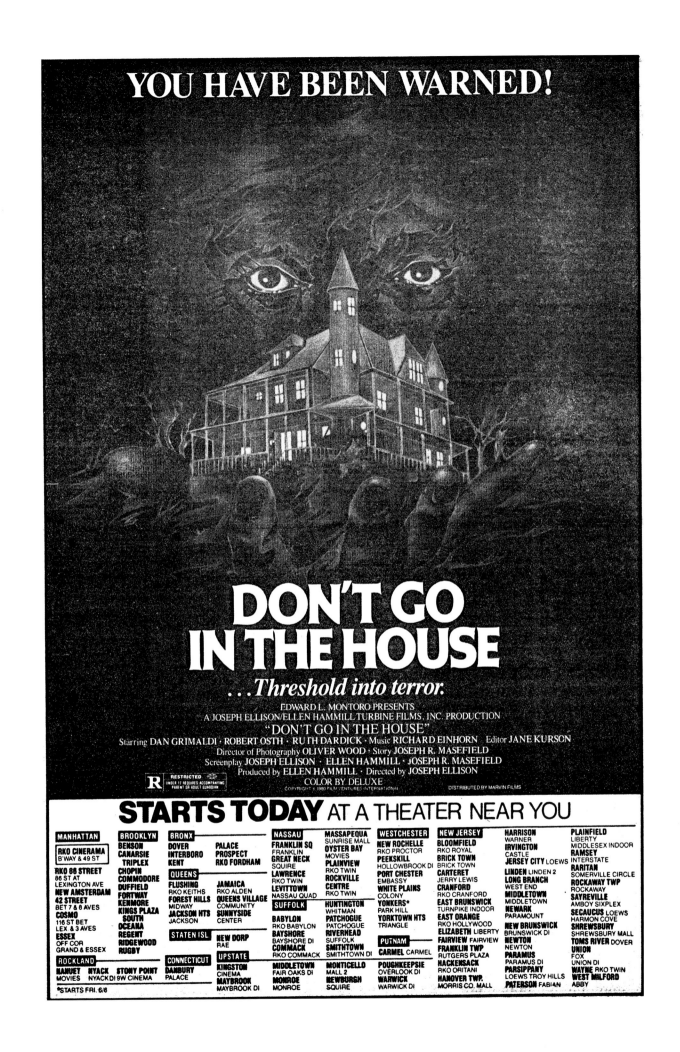

"I'm so proud of my boys — they never forget their mama."

CHARLES KAUFMAN'S

MOTHER'S DAY

"MOTHER'S DAY" • Produced by MICHAEL KRAVITZ & CHARLES KAUFMAN • Directed by CHARLES KAUFMAN
Starring NANCY HENDRICKSON • DEBORAH LUCE • TIANA PIERCE • HOLDEN McQUIRE • BILLY RAY McQUADE • ROSE ROSS
Executive Producer ALEXANDER BECK • Production Executive RAY SUNDLIN • Associate Producers LLOYD KAUFMAN & MICHAEL HERZ
Written by CHARLES KAUFMAN and WARREN D. LEIGHT • Music by PHIL GALLO and CLEM VICARI • Edited by DANIEL LOWENTHAL
Production Design SUSAN KAUFMAN • Director of Photography JOE MANGINE
Color by TVC • Equipment by Cinecam, Inc. • Released by United Film Distribution Co.

This picture contains scenes of a violent nature.
No one under 17 will be admitted unless accompanied by an adult.

STARTS FRIDAY, SEPTEMBER 19th

MANHATTAN

RIVOLI 247-1633
B'WAY & 49TH ST.

UA gemini 1
2ND AVE. & 64TH ST. 832-1670

UA EAST
85TH ST. & 1ST AVE. 249-5100

QUEENS

ASTORIA
Astoria

CROSS BAY
Ozone Park

RKO ALDEN
Jamaica

CENTURY'S
GLEN OAKS
Glen Oaks

MIDWAY
FOREST HILLS

BRONX

INTERBORO VALENTINE

BROOKLYN

CENTURY'S
KINGS PLAZA
DUFFIELD

CENTURY'S
KINGSWAY
MARBORO

STATEN ISLAND

ACKERMAN'S
LANE
NEW DORP

ISLAND
SPRINGVILLE

NASSAU

CENTURY'S
FANTASY
ROCKVILLE CENTRE

MEADOWBROOK
EAST MEADOW

CENTURY'S
ROOSEVELT FIELD
GARDEN CITY

SQUIRE
GREAT NECK

SUNRISE MALL
MASSAPEQUA

WESTBURY D.I.
WESTBURY

SUFFOLK

ALMI'S
BAY SHORE
BAY SHORE

EAST HAMPTON
EAST HAMPTON

JOHNNY ALL-WEATHER D.I.
COPIAGUE

PATCHOGUE
PATCHOGUE

CORAM D.I.
CORAM

COMMACK D.I.
COMMACK

CENTURY'S
SHORE
HUNTINGTON

SMITHTOWN INDOOR
NESCONSET

WESTCHESTER

UA CINEMA
PUTNAM PLAZA, CARMEL

ACKERMAN'S
CINEMA 100
WHITE PLAINS

B.S. MOSS'
MOVIE LAND
YONKERS

CENTURY'S
MALL
NEW ROCHELLE

UPSTATE

CATE'S
HUDSON PLAZA
POUGHKEEPSIE

FLORIN/CREATIVE'S
LIBERTY
LIBERTY

CATE'S
MID VALLEY
NEWBURGH

FLORIN/CREATIVE'S
MONTECO MALL
MONTICELLO

CATE'S
PLAZA
MIDDLETOWN

LESSER'S
TRIANGLE
YORKTOWN HEIGHTS

ROCKLAND

ROUTE 303 D.I.
ORANGEBURG

UA CINEMA 304
NEW CITY

ALSO STARTS SEPTEMBER 19 AT THEATRES IN NEW JERSEY

143

THE COED MURDERS

The retitling of Massimo Dallamano's *What Have They Done to Your Daughters?* (released in Italy in 1974) is a tad misleading, as the victims in this combination of *giallo* shocker and police procedural are not college coeds but high school girls involved in a prostitution ring. Surely a title like T*he High School Hooker Murders* would have been an even bigger grabber for exploitation audiences?

DRACULA AND SON

Christopher Lee delivered all of his lines in French for this Gallic vampire farce by Édouard Molinaro (who directed the 1978 art-house hit *La Cage aux Folles*), and initially dubbed an English version as well. Unfortunately, this U.S. theatrical edition belied its ad tagline by having someone else speak for Lee's character — in a generally obnoxious dub job to boot. The film was also hacked by nearly 20 minutes and scenes were reordered. As that ad copy makes clear, this release was intended to cash in on the success of the George Hamilton-starring 1979 hit *Love at First Bite*.

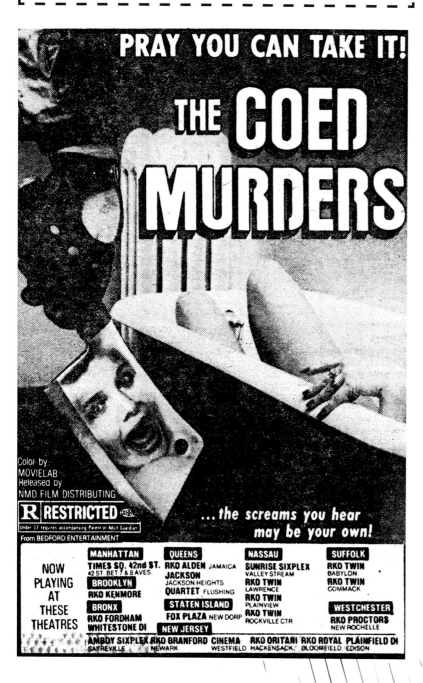

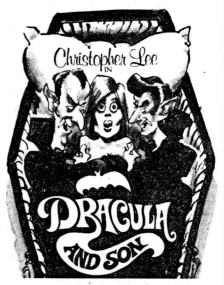

VAMPIRE PLAYGIRLS / EAGER BEAVERS

In the late 1970s and early 1980s, Motion Picture Marketing specialized in reissuing and retitling assorted exploitation films, often on double bills. In this case, *Vampire Playgirls* was actually the 1971 Belgian/Italian satanic shocker *The Devil's Nightmare*, and *Eager Beavers* was a 1975 psychothriller originally titled *The Swinging Barmaids*. Other movies to get new MPM monikers were Jack Hill's *Switchblade Sisters* (*Playgirl Gang*) and *The Swinging Cheerleaders* (*Locker Room Girls*), and the Paul Naschy picture *Count Dracula's Great Love* (*Cemetery Girls*).

THE HOLLYWOOD HILLSIDE STRANGLER

I found this ad during one of my Cape Cod summer trips, and at first thought it was a restyling of *Don't Answer the Phone*, which was originally called *The Hollywood Strangler*. Years later I learned that it was actually an obscure 1973 art film with horrific overtones, originally titled *Hollywood 90028*.

**They're not human.
But they hunt human women.
Not for killing.
For mating.**

HUMANOIDS
FROM THE DEEP

Starring DOUG McCLURE ANN TURKEL VIC MORROW
Screenplay by FREDERICK JAMES Story by FRANK ARNOLD and MARTIN B. COHEN
Produced by MARTIN B. COHEN Directed by BARBARA PEETERS A New World Picture

R RESTRICTED UNDER 17 REQUIRES ACCOMPANYING PARENT OR ADULT GUARDIAN Production services by Marketing Communications Production Company © 1980 New World Productions

Starts Today at a
"HUMANOID" Showcase Theatre Near You!

MANHATTAN
A CINEMA 5 THEATRE
NATIONAL
1500 B'WAY 869-0950
Fri. & Sat. – 12, 1:40, 3:20,
5, 6:40, 8:20, 10, 12 Mid.
Sun.-Thurs. – 12, 1:40, 3:20,
5, 6:40, 8:20, 10
RKO 86th ST.
86TH & LEX. AVE. 289-8900
Fri. & Sat. – 1, 2:35, 4:10,
5:50, 7:25, 9:05, 10:45
Sun.-Thurs. – 1, 2:30, 4, 5:30,
7, 8:40, 10:10
*NOVA
B'WAY & 147TH ST. 862-5728
Fri. – 4:00, 7:15, 10:45
Sat. & Sun. – 3:00, 6:45, 10:20
Mon.-Thurs. – 4:00, 5:45,
7:30, 9:20

BROOKLYN
GOLDEN'S
BENSON
GOLDEN'S
BEVERLY
CENTURY'S
COLLEGE
FLORIN/CREATIVE'S
CANARSIE
FLORIN CREATIVE'S
CHOPIN
GOLDEN'S
FORTWAY

STATEN ISLAND
A CINEMA 5 THEATRE
*FOX PLAZA NEW DORP

BRONX
LOEWS
PARADISE TRIPLEX
REDSTONE'S
*WHITESTONE D.I.

QUEENS
RKO ALDEN
JAMAICA
RKO KEITHS
FLUSHING
TRIANGLE
*STRAND ASTORIA

NASSAU
CENTURY'S
FRANKLIN
FRANKLIN SQUARE
RKO LAWRENCE
LAWRENCE
LESSER'S
MOVIES OYSTER BAY
RKO PLAINVIEW
PLAINVIEW
LIGHTSTONE'S
STUDIO LYNBROOK
A CINEMA 5 THEATRE
*WANTAGH
WANTAGH

SUFFOLK
RKO COMMACK
COMMACK
BRENNER'S
EAST ISLIP E. ISLIP
FLORIN'S
SHIRLEY SHIRLEY
LIGHTSTONE'S
SOUTH BAY WEST BABYLON

WESTCHESTER
MAXI'S
COLONY
WHITE PLAINS
ATM'S
*ELMSFORD D.I.
ELMSFORD
RKO PROCTORS
NEW ROCHELLE

UPSTATE
TRI-STATE'S
*FISHKILL D.I.
FISHKILL
TRI-STATE'S
*MIDDLETOWN D.I.
MIDDLETOWN
TRI-STATE'S
*MAYBROOK D.I.
MAYBROOK
FILM BOOKER'S
*CINEMA 1
NEWBURGH

ROCKLAND
*ROCKLAND D.I.
MONSEY

NEW JERSEY
MUSIC MAKER'S
ABBY WEST MILFORD
REDSTONE'S
AMBOY SIXPLEX
SAYREVILLE
*RKO BRANFORD
NEWARK
*BRUNSWICK D.I.
NEW BRUNSWICK
RKO CRANFORD
CRANFORD
MUSIC MAKER'S
DOVER TOMS RIVER
*EATONTOWN D.I.
EATONTOWN
A CINEMA 5 THEATRE
*FOX UNION
*RKO HOLLYWOOD
EAST ORANGE
MUSIC MAKER'S
INTERSTATE RAMSEY
FLORIN/CREATIVE'S
ISELIN ISELIN
LOEWS JERSEY CITY
TRIPLEX JERSEY CITY
MUSIC MAKER'S
MALL BRICK TOWN

MUSIC MAKER'S
MOVIES RED BANK
REDSTONE'S
*NEWARK D.I. NEWARK
*RKO ORITANI
HACKENSACK
FLORIN'S
*PARAMUS D.I.
PARAMUS
PLAINFIELD INDOOR
EDISON
FLORIN'S
PLAZA PATERSON
FLORIN/CREATIVE'S
RAHWAY RAHWAY
AMERICAN MULTI'S
ROCKAWAY No. 5
ROCKAWAY TOWNSHIP
REDSTONE'S
*RT. 35 HAZLET
FILM BOOKER'S
*ROYAL
PERTH AMBOY
RKO ROYAL
BLOOMFIELD
*RKO TWIN WAYNE
MUSIC MAKER'S
PLAZA HAZLET

CONNECTICUT
RKO PALACE
DANBURY
ATM'S
CINEMA NORWALK

***With 2nd Feature**

MOTEL HELL

Amidst all the single-minded slasher films dominating the horror scene in fall 1980, *Motel Hell* came along just before Halloween to inject a little black humor. As gruesome as the competition, it offered equal parts belly laughs and bodily mutilation scenes, as suggested by the ads. Unfortunately, not all critics got the joke.

"*Motel Hell* opens well, with some clever scene setting. … The rest of *Motel Hell* is pretty much revolting, however; what we have here is a horror movie aimed directly at the yahoo trade."

— Bill Cosford, *The Miami Herald*

"Arch is the word for *Motel Hell*, an oddball, bizarre and nearly successful bit of camp. … With a richer, fuller script, *Motel Hell* could be a deserving cult classic of horrordom. Chances are it will become a minor celebrity in the *Living Dead* mold anyway. There's just enough in the secret garden to warrant that."

— Fred LeBrun, *Albany Times Union*

"What Kevin Connor's movie would like to be is the *Airplane!* of the whole genre… Alas, no. It doesn't turn into anything but a silly mess with a few good satirical ideas kicking around (literally) in the middle of it."

— David Foil, *The Advocate (LA)*

"*Motel Hell* is a welcome change-of-pace; it's to *Chainsaw Massacre* as *Airplane!* is to *Airport*. It has some great moments…[that] illuminate the movie's basic and not very profound insight, which is that most of the sleazoids would be a lot more fun if they didn't take themselves with such gruesome solemnity."

— ROGER EBERT,
CHICAGO SUN-TIMES

147

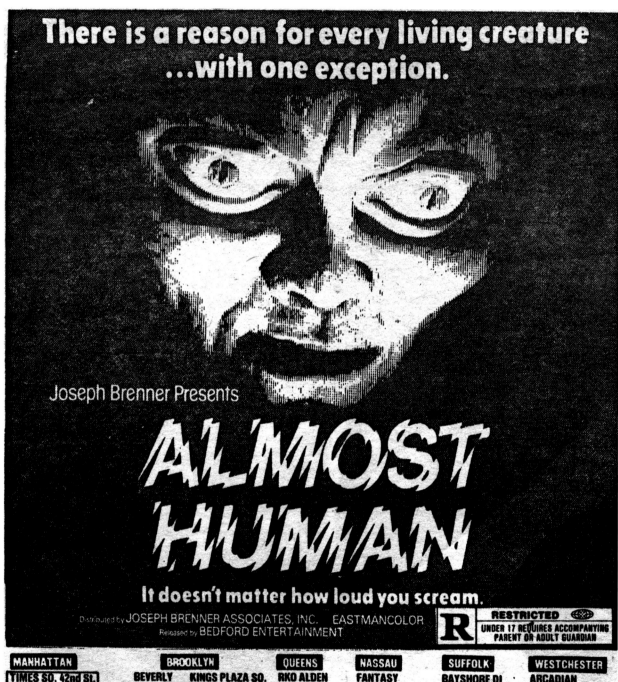

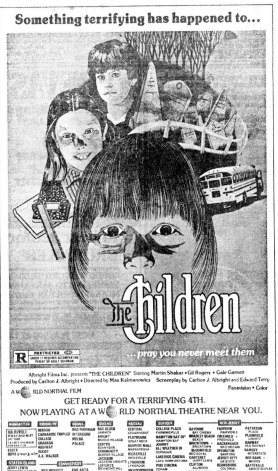

Something terrifying has happened to...

The Children

...pray you never meet them

RESTRICTED | R | UNDER 17 REQUIRES ACCOMPANYING PARENT OR ADULT GUARDIAN

Albright Films Inc. presents "THE CHILDREN" Starring Martin Shakar • Gil Rogers • Gale Garnett
Produced by Carlton J. Albright • Directed by Max Kalmanowicz • Screenplay by Carlton J. Albright and Edward Terry
A WORLD NORTHAL FILM Panavision • Color

GET READY FOR A TERRIFYING 4TH.
NOW PLAYING AT A WORLD NORTHAL THEATRE NEAR YOU.

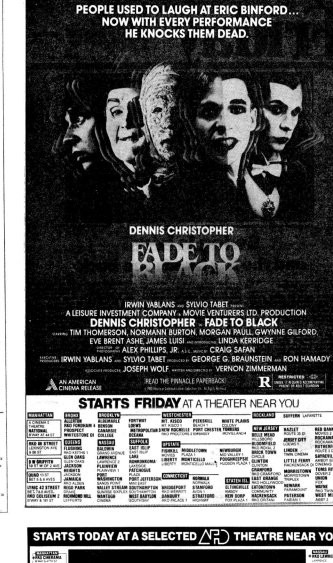

PEOPLE USED TO LAUGH AT ERIC BINFORD... NOW WITH EVERY PERFORMANCE HE KNOCKS THEM DEAD.

DENNIS CHRISTOPHER

FADE TO BLACK

IRWIN YABLANS and SYLVIO TABET PRESENT
A LEISURE INVESTMENT COMPANY & MOVIE VENTURERS LTD. PRODUCTION
DENNIS CHRISTOPHER in **FADE TO BLACK**
STARRING TIM THOMERSON, NORMANN BURTON, MORGAN PAULL, GWYNNE GILFORD,
EVE BRENT ASHE, JAMES LUISI AND INTRODUCING LINDA KERRIDGE
DIRECTOR OF PHOTOGRAPHY ALEX PHILLIPS, JR. A.S.C. MUSIC BY CRAIG SAFAN
EXECUTIVE PRODUCERS IRWIN YABLANS AND SYLVIO TABET PRODUCED BY GEORGE G. BRAUNSTEIN AND RON HAMADY
ASSOCIATE PRODUCER JOSEPH WOLF WRITTEN AND DIRECTED BY VERNON ZIMMERMAN

AN AMERICAN CINEMA RELEASE READ THE PINNACLE PAPERBACK! RESTRICTED | R | UNDER 17 REQUIRES ACCOMPANYING PARENT OR ADULT GUARDIAN

STARTS FRIDAY AT A THEATER NEAR YOU

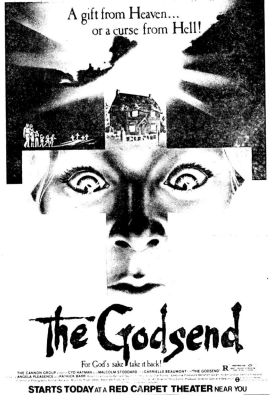

A gift from Heaven... or a curse from Hell!

The Godsend

For God's sake take it back!

THE CANNON GROUP presents CYD HAYMAN • MALCOLM STODDARD • GABRIELLE BEAUMONT's "THE GODSEND"
ANGELA PLEASENCE • PATRICK BARR RESTRICTED | R

STARTS TODAY AT A RED CARPET THEATER NEAR YOU

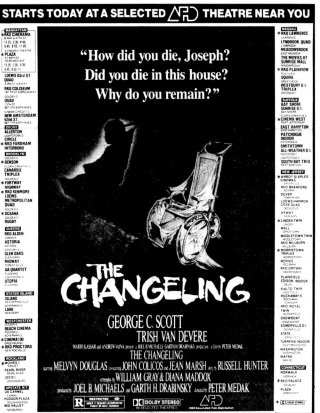

"How did you die, Joseph?
Did you die in this house?
Why do you remain?"

THE CHANGELING

GEORGE C. SCOTT
TRISH VAN DEVERE

MARIO KASSAR and ANDREW VAJNA present a JOEL B. MICHAELS GARTH H. DRABINSKY a film by PETER MEDAK
THE CHANGELING
STARRING MELVYN DOUGLAS co-starring JOHN COLICOS and JEAN MARSH story by RUSSELL HUNTER
screenplay by WILLIAM GRAY & DIANA MADDOX
produced by JOEL B. MICHAELS and GARTH H. DRABINSKY directed by PETER MEDAK

RESTRICTED | R | UNDER 17 REQUIRES ACCOMPANYING PARENT OR ADULT GUARDIAN DOLBY STEREO IN SELECTED THEATRES

STARTS TODAY AT A SELECTED AFD THEATRE NEAR YOU

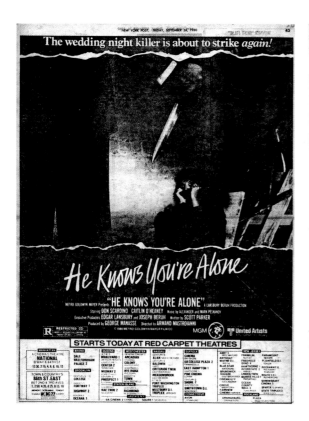
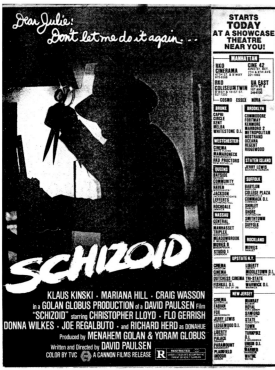
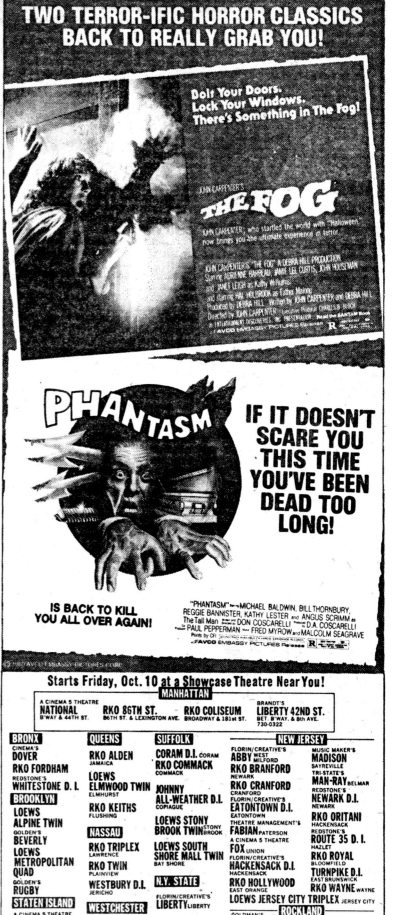
1980

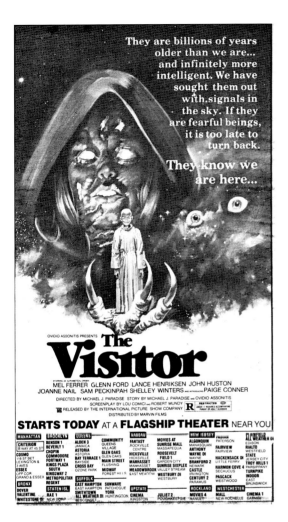

They are billions of years older than we are... and infinitely more intelligent. We have sought them out with signals in the sky. If they are fearful beings, it is too late to turn back.

They know we are here...

OVIDIO ASSONITIS PRESENTS

The VISITOR

MEL FERRER GLENN FORD LANCE HENRIKSEN JOHN HUSTON
JOANNE NAIL SAM PECKINPAH SHELLEY WINTERS and introducing PAIGE CONNER

DIRECTED BY MICHAEL J. PARADISE STORY BY MICHAEL J. PARADISE and OVIDIO ASSONITIS
SCREENPLAY BY LOU COMICI and ROBERT MUNDY
RELEASED BY THE INTERNATIONAL PICTURE SHOW COMPANY
DISTRIBUTED BY MARVIN FILMS

STARTS TODAY AT A FLAGSHIP THEATER NEAR YOU

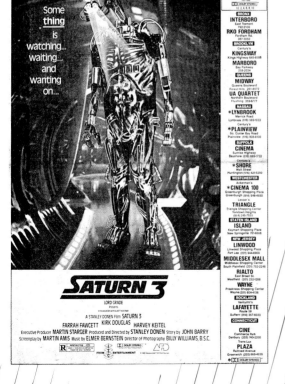

STARTS TODAY AT A SELECTED THEATRE NEAR YOU

Some thing is watching... waiting... and wanting on...

SATURN 3

LORD GRADE Presents

A STANLEY DONEN Film SATURN 3

FARRAH FAWCETT KIRK DOUGLAS HARVEY KEITEL

Executive Producer MARTIN STARGER Produced and Directed by STANLEY DONEN Story by JOHN BARRY
Screenplay by MARTIN AMIS Music by ELMER BERNSTEIN Director of Photography BILLY WILLIAMS, B.S.C.

FROM ENTERTAINMENT

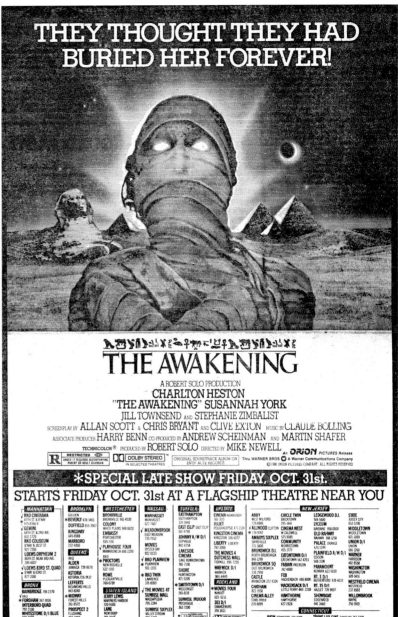

THEY THOUGHT THEY HAD BURIED HER FOREVER!

THE AWAKENING

A ROBERT SOLO PRODUCTION

CHARLTON HESTON
"THE AWAKENING" SUSANNAH YORK
JILL TOWNSEND and STEPHANIE ZIMBALIST
SCREENPLAY BY ALLAN SCOTT & CHRIS BRYANT AND CLIVE EXTON MUSIC BY CLAUDE BOLLING
ASSOCIATE PRODUCER HARRY BENN CO-PRODUCED BY ANDREW SCHEINMAN AND MARTIN SHAFER
TECHNICOLOR® PRODUCED BY ROBERT SOLO DIRECTED BY MIKE NEWELL An ORION PICTURES Release

ORIGINAL SOUNDTRACK ALBUM ON ENTR'ACTE RECORDS

Thru WARNER BROS A Warner Communications Company

★SPECIAL LATE SHOW FRIDAY, OCT. 31st.
STARTS FRIDAY OCT. 31st AT A FLAGSHIP THEATRE NEAR YOU

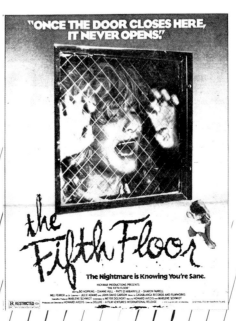

"ONCE THE DOOR CLOSES HERE, IT NEVER OPENS!"

the Fifth Floor

The Nightmare is Knowing You're Sane.

HICKMAR PRODUCTIONS PRESENTS THE FIFTH FLOOR
MEL FERRER starring BO HOPKINS · DIANNE HULL · PATTI D'ARBANVILLE · SHARON FARRELL
also starring JULIE ADAMS and JOHN DAVID CARSON music by CASABLANCA RECORDS AND FILMWORKS
Executive Producer MARLENE SCHMIDT Produced by HOWARD AVEDIS and MARLENE SCHMIDT
Associate Producer MARLENE SCHMIDT in DELUXE written by HOWARD AVEDIS and MARLENE SCHMIDT
Produced and Directed by HOWARD AVEDIS · A FILM VENTURES INTERNATIONAL RELEASE
DISTRIBUTED BY MARVIN FILMS

151

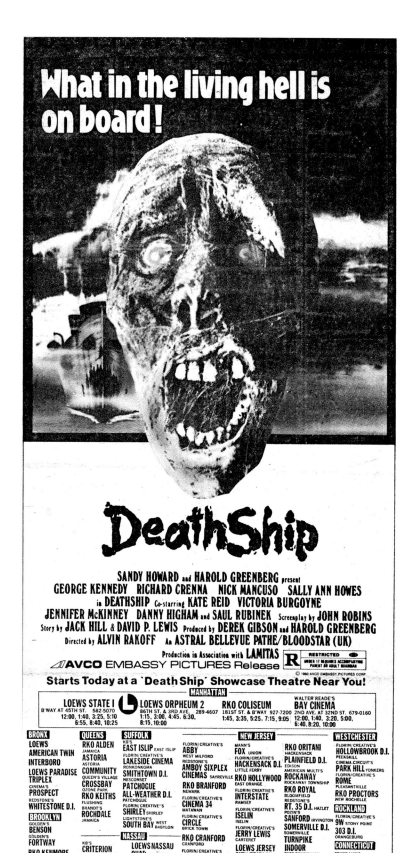

PROM NIGHT

Many early 1980s teen-kill chillers were criticized for their excessive violence. Conversely, a few reviewers of *Prom Night* noted audience dissatisfaction with the lack of sufficient onscreen bloodshed.

"The problem with *Prom Night*, as far as the crowd was concerned, was that it did not deliver what the television ads had promised. Instead of excessive blood-letting, director Paul Lynch and screenwriter William Gray provide a measure of subtlety to the killings. Instead of thoroughly bad acting – a hallmark of most blood and gore films – there are several stylish performances."
—*The Washington Star*, author unknown

"The most noteworthy thing about the movie is that, although the murders are ghoulish, Mr. Lynch chooses to underplay the bloody spectacle. ... This may or may not be the reason that the audience with which I saw the film yesterday booed at the end."
– VINCENT CANBY, *THE NEW YORK TIMES*

"The latest – and highly derivative – edition in a series of hack-and-dismember chillers is actually a worthy successor to John Carpenter's *Halloween*, with an emphasis on suspense and a minimum of gore. ... [It] is a bit slow-paced at times, particularly when director Paul Lynch is setting up the murders, but there are enough shocks to sate the genre's rather offbeat customers."
– Ray Finocchiaro, *Wilmington (DE) Morning News*

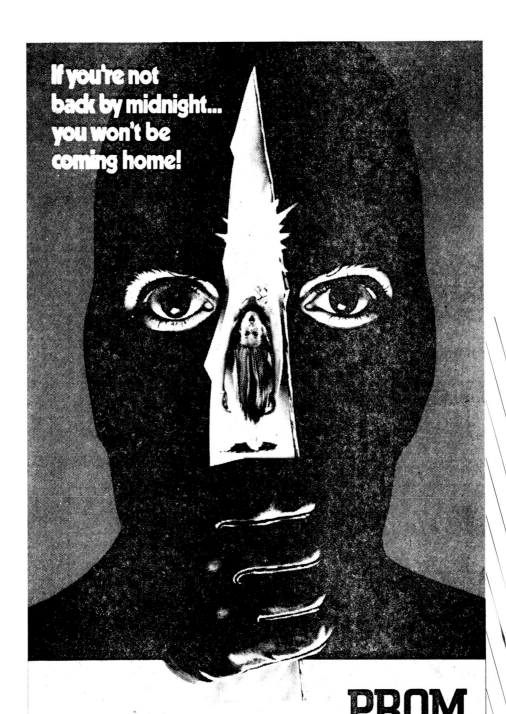

If you're not back by midnight... you won't be coming home!

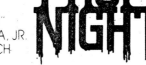

PROM NIGHT

A SIMCOM PRODUCTION
LESLIE NIELSEN • JAMIE LEE CURTIS IN "PROM NIGHT"
SCREENPLAY BY WILLIAM GRAY • STORY BY ROBERT GUZA, JR.
PRODUCED BY PETER SIMPSON • DIRECTED BY PAUL LYNCH
AVCO EMBASSY PICTURES Release R RESTRICTED UNDER REQUIRES ACCOMPANYING PARENT OR ADULT GUARDIAN

Starts Today
Boston Sack Saxon
and These Theaters and Drive-Ins!

BOSCOWEN NH	Sky Hi DI	LUNENBURG	Tritown DI	NEWINGTON NH	Newington DI	SALISBURY	Hiway DI
CANTON	Blue Hills	MALDEN	Granada	NORTH DARTMOUTH	Auto DI	SEEKONK	Seekonk DI
DORCHESTER	Neponsit DI	MANCHESTER NH	Bedford Grv DI	NORTHAMPTON NH	Seacoast DI	SHREWSBURY	Edgemere DI
GLOUCESTER	Gloucester DI	MEDFORD	Medford Triple DI	NORTH READING	Starlite	SOMERVILLE	Somerville
HAVERHILL	Riverview DI	MIDDLETOWN	Route 114 DI	QUINCY	Strand	SOMERSWORTH NH	Route 16 DI
HAVERHILL	Route 495 Cinema	MILFORD	DI	QUINEBAUG	Quinebaug DI	TEWKSBURY	Wamesit DI
HYANNIS (8/18-19)	DI	NASHUA NH	Studio	RAYNHAM	Route 24 Cinema	TYNGSBORO	Tyngsboro DI
HYDE PARK	Nu Pixie	NATICK	Flicks	RAYNHAM	Raynham DI	WEST ROXBURY	VFW DI
LEICESTER	DI	NEWBURYPORT	Studio	REVERE	Revere DI	WINCHESTER NH	Northfield DI

YARMOUTH (8/15-16) DI

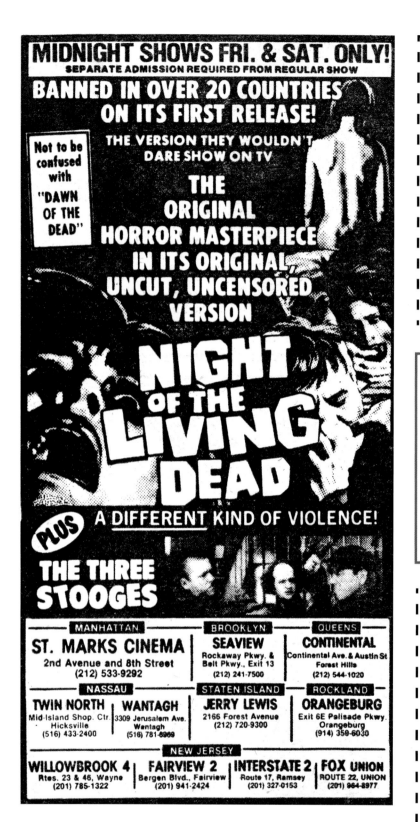

ZOMBIE

Apparently, the close-up of the "wormfaced" ghoul gracing *Zombie*'s theatrical poster was unfit for consumption by newspaper readers, so mainstream ads utilized less grotesque images. While New York critics left Lucio Fulci's bloody dish out of their review diet, several in other cities took a bite.

"...an ingenious, if unpleasant, cross between *The Island of Dr. Moreau* and every '40s zombie epic, with hints of voodooism thrown in to explain the unexplainable. ... While there isn't much that can pass for suspense here, there are a couple of outrageously sick moments."

— Glenn Lovell, *San Jose Mercury News*

"At least two important things should be said about *Zombie*... One is that it is disgusting, nauseating, phenomenally gory, fantastic, unoriginal, and probably an affront to decent people verywhere. The other is that, of its kind, it is excellent."

—TED MAHAR,
THE OREGONIAN

"...the rapid shifts in mood and tempo...that [George] Romero used to keep his slim situation going, are beyond the grasp of Fulci and his collaborators. ... [The film] slogs along at [a] pace slower than that of its graveyard gourmands."

— David Ehrenstein,
Los Angeles Herald Examiner

"...an Italian import that is so unbelievably absurd that it seems certain to instantly qualify for the Cultists' Hall of Fame. ... Name a stomach-churning scene and director Lucio Fulci provides it... ."

— Ray Finocchiaro, *Wilmington (DE) Morning News*

"This is another movie in which the makeup artist runs the show and the camera lingers on every gushing vein and wiggling worm. The overdubbing is atrocious, with actors' mouths racing frantically to catch up with the dialogue."

—Steve Rubenstein, *San Francisco Chronicle*

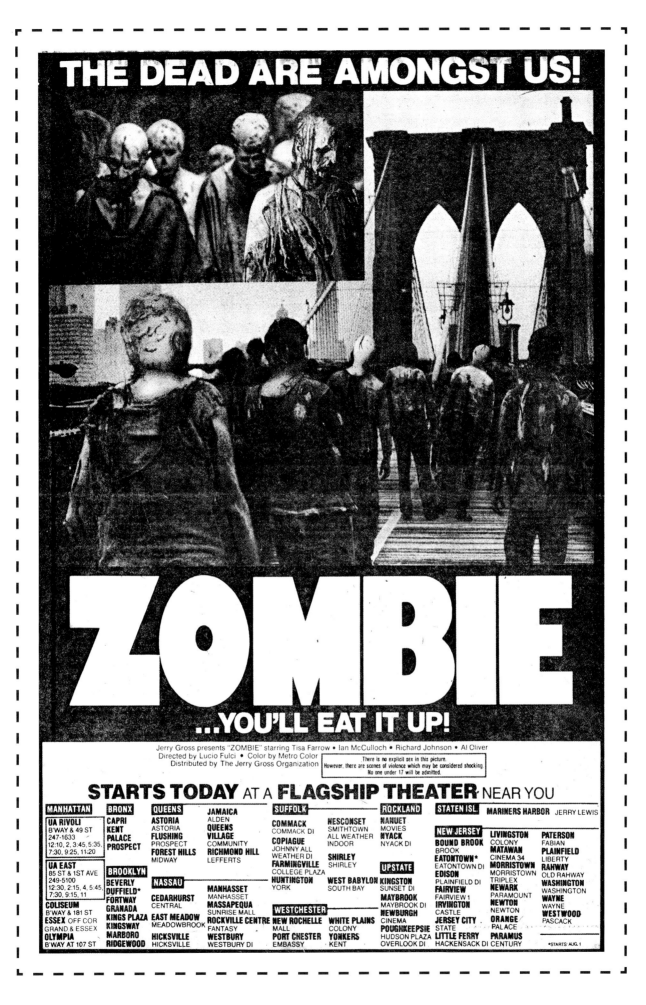

155

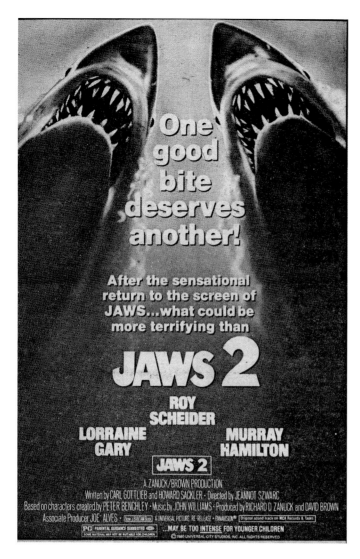

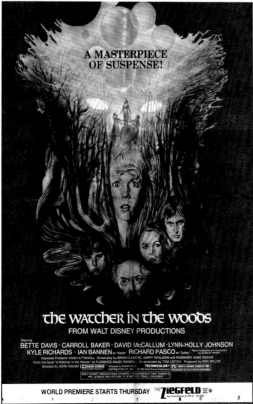

Jamie Lee Curtis' third horror film of 1980 boasted no less than Oscar winner John Alcott, cinematographer of the same year's *The Shining* and numerous other Stanley Kubrick films. The visual class he brought to the project, among other qualities, helped *Terror Train* to receive a greater percentage of positive notices than most of its stalk-and-kill brethren.

"Screenwriter T.Y. Drake and debuting director Roger Spottiswoode make excellent use of their cramped train setting. ... [The] script...is superior to most of what's passing for horror these days. Best of all, he catches us off guard in the end with the true identity of the killer."

— Glenn Lovell, *San Jose Mercury News*

"Shades of a stupefying quantity of movies of recent vintage, the passengers are slain. Without style. Without suspense. Without any interest in them personally."

— Ed Blank, *The Pittsburgh Press*

"[D]elivers with a well-mixed bag of seat's-edge trickery, a number of sympathetic characters, strong eerie atmosphere and nerve-jangling music."

— MATT DAMSKER,
PHILADELPHIA EVENING BULLETIN

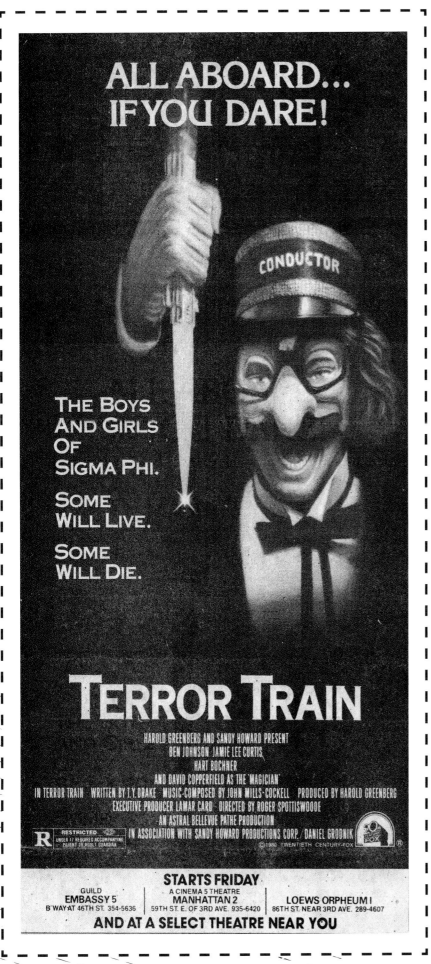

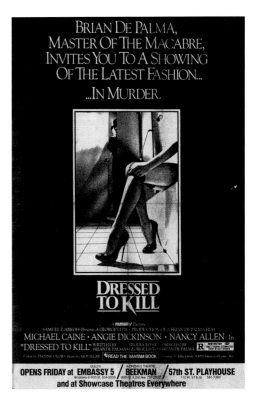

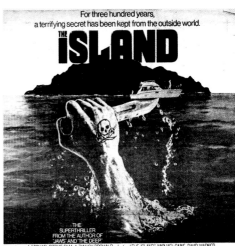

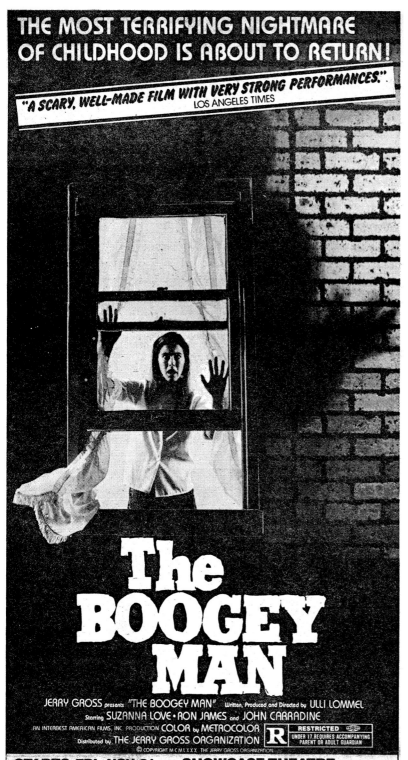

THE MOST TERRIFYING NIGHTMARE OF CHILDHOOD IS ABOUT TO RETURN!

"A SCARY, WELL-MADE FILM WITH VERY STRONG PERFORMANCES."
LOS ANGELES TIMES

The BOOGEY MAN

JERRY GROSS presents "THE BOOGEY MAN" Written, Produced and Directed by ULLI LOMMEL
Starring SUZANNA LOVE • RON JAMES and JOHN CARRADINE
AN INTERBEST AMERICAN FILMS, INC. PRODUCTION COLOR by METROCOLOR
Distributed by THE JERRY GROSS ORGANIZATION
RESTRICTED
UNDER 17 REQUIRES ACCOMPANYING PARENT OR ADULT GUARDIAN
© COPYRIGHT MCMLXXX THE JERRY GROSS ORGANIZATION

STARTS FRI., NOV. 21 AT A SHOWCASE THEATRE NEAR YOU

MANHATTAN
RIVOLI
B'WAY & 49 ST
UA EAST
85 ST & 1ST AVE
COLISEUM 2
B'WAY & 181 ST
COSMO
116 ST BET
LEXINGTON & 3 AVES
ESSEX
OFF COR
GRAND & ESSEX
NEW AMSTERDAM
42 STREET
BET 7 & 8 AVES
NOVA
B'WAY AT 147 ST

STATEN ISLAND
ELTINGVILLE
AMBOY

BRONX
INTERBORO 4
KENT
MELBA
PARADISE
PROSPECT
BROOKLYN
COMMODORE
DUFFIELD
FORTWAY
HIGHWAY
KENMORE
OCEANA
REGENT
RIDGEWOOD
RUGBY

ROCKLAND
NANUET
MOVIES 4

QUEENS
ASTORIA
ASTORIA 2
FLUSHING
PARSONS
QUARTET 1
FOREST HILLS
MIDWAY 4
JAMAICA
ALDEN
ROCHDALE
QUEENS VILLAGE
COMMUNITY 2
RICHMOND HILL
LEFFERTS
WESTCHESTER
BRONXVILLE
BRONXVILLE 2
MAMARONECK
MAMARONECK 2
NEW ROCHELLE
PROCTOR

NASSAU
CEDARHURST
CENTRAL
EAST MEADOW
MEADOWBROOK 4
HICKSVILLE
HICKSVILLE 2
LYNBROOK
LYNBROOK 3
MANHASSET
MANHASSET 1
MASSAPEQUA
SUNRISE MALL
WESTBURY
WESTBURY DI

PEEKSKILL
BEACH
WHITE PLAINS
COLONY
YONKERS
PARK HILL

SUFFOLK
BROOKHAVEN
STONY BROOK 1
COMMACK
COMMACK DI
FARMINGVILLE
COLLEGE PLAZA 2
HUNTINGTON
YORK
PATCHOGUE
PATCHOGUE ALL
WEATHER DI
SHIRLEY
SHIRLEY
WEST BABYLON
SOUTH BAY
PUTNAM
CARMEL CARMEL

UPSTATE
CHESTER KINGSTON LIBERTY POUGHKEEPSIE VAILS GATE
QUICKWAY CINEMA LIBERTY HUDSON PLAZA WINDSOR

NEW JERSEY
CARTERET
JERRY LEWIS
E. BRUNSWICK
TURNPIKE DI
EDGEWATER
SHOWBOAT
EDISON
PLAINFIELD IND'L
ELIZABETH
LIBERTY
FAIRLAWNHighway
HACKENSACKFOX
HARRISON
WARNER
HOBOKEN
HOBOKEN 1
IRVINGTON
SANFORD

JERSEY CITY
STATE 1
NEWARK
PARAMOUNT
ORANGE
PALACE
PATERSON
FABIAN
RAHWAY
OLD RAHWAY
RARITAN
SOMERVILLE CIRCLE
ROCKAWAY
TOWNSHIP
ROCKAWAY 1
WAYNE
WILLOWBROOK
WESTFIELD
RIALTO

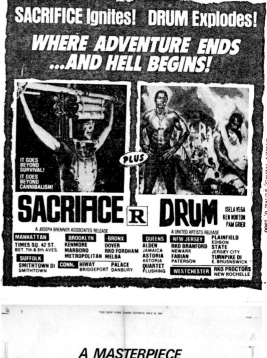

SACRIFICE Ignites! DRUM Explodes!
WHERE ADVENTURE ENDS ...AND HELL BEGINS!

IT GOES BEYOND SURVIVAL!
IT GOES BEYOND CANNIBALISM!

SACRIFICE R PLUS DRUM R
ISELA VEGA
KEN NORTON
PAM GRIER

A JOSEPH BRENNER ASSOCIATES RELEASE A UNITED ARTISTS RELEASE

MANHATTAN
TIMES SQ. 42 ST.
BET. 7th & 8th AVES.
SUFFOLK
SMITHTOWN DI
SMITHTOWN

BROOKLYN
KENMORE
MARBORO
METROPOLITAN
CONN. HIWAY
BRIDGEPORT

BRONX
DOVER
RKO FORDHAM
MELBA
PALACE
DANBURY

QUEENS
ALDEN
JAMAICA
ASTORIA
ASTORIA
QUARTET
FLUSHING

NEW JERSEY
RKO BRANFORD
NEWARK
FABIAN
PATERSON
WESTCHESTER

PLAINFIELD
EDISON
STATE
JERSEY CITY
TURNPIKE DI
E. BRUNSWICK
RKO PROCTORS
NEW ROCHELLE

DAILY NEWS, JUNE 6, 1980

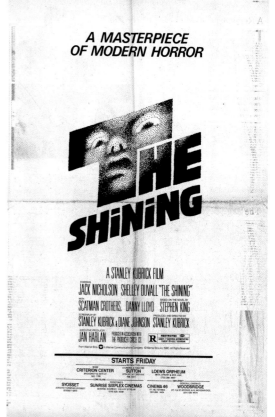

A MASTERPIECE OF MODERN HORROR

THE SHINING

A STANLEY KUBRICK FILM
JACK NICHOLSON SHELLEY DUVALL "THE SHINING"
WITH SCATMAN CROTHERS, DANNY LLOYD BASED ON THE NOVEL BY STEPHEN KING
SCREENPLAY BY STANLEY KUBRICK & DIANE JOHNSON PRODUCED AND DIRECTED BY STANLEY KUBRICK
EXECUTIVE PRODUCER JAN HARLAN PRODUCED IN ASSOCIATION WITH THE PRODUCER CIRCLE CO.
From Warner Bros. A Warner Communications Company © Warner Bros. Inc. 1980. All Rights Reserved.
RESTRICTED
UNDER 17 REQUIRES ACCOMPANYING PARENT OR ADULT GUARDIAN

STARTS FRIDAY
CRITERION CENTER SUTTON LOEWS ORPHEUM
SYOSSET SUNRISE SIXPLEX CINEMAS CINEMA 46 WOODBRIDGE

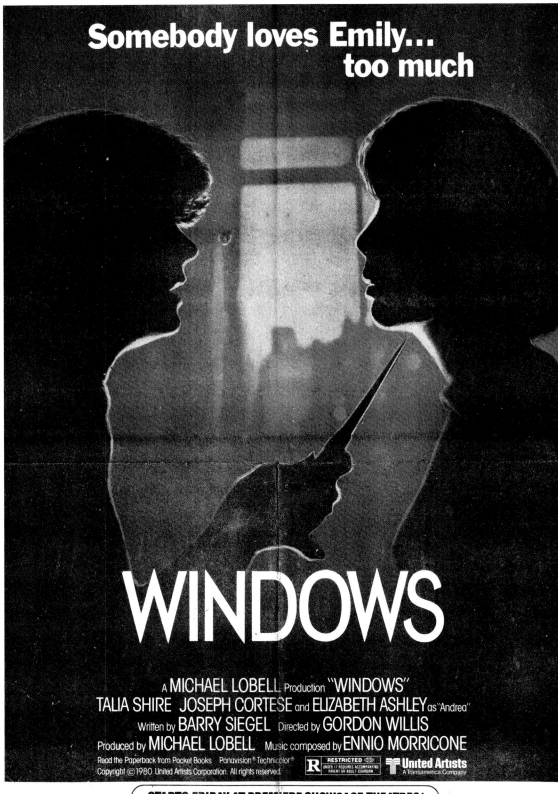

Somebody loves Emily...
too much

WINDOWS

A MICHAEL LOBELL Production "WINDOWS"
TALIA SHIRE JOSEPH CORTESE and ELIZABETH ASHLEY as "Andrea"
Written by BARRY SIEGEL Directed by GORDON WILLIS
Produced by MICHAEL LOBELL Music composed by ENNIO MORRICONE

Read the Paperback from Pocket Books Panavision® Technicolor®
Copyright ©1980 United Artists Corporation. All rights reserved.

R RESTRICTED
UNDER 17 REQUIRES ACCOMPANYING
PARENT OR ADULT GUARDIAN

United Artists
A Transamerica Company

STARTS FRIDAY AT PREMIERE SHOWCASE THEATRES!

MANHATTAN	BRONX	BROOKLYN		STATEN ISLAND	QUEENS		NASSAU	
RKO CINERAMA BROADWAY AT 47TH ST. 975-8366	**VALENTINE** 237 E. FORDHAM RD. 584-9583	CENTURY'S **KINGSWAY 1** KINGS HIGHWAY 645-8588	**MARBORO 1** 6817 BAY PARKWAY 232-4000	CENTURY'S **RICHMOND** RICHMOND AVE. NEW SPRINGVILLE 761-3103	CENTURY'S **MEADOWS 2** 190TH STREET FRESH MEADOWS 454-6800	**MIDWAY 3** QUEENS BLVD. FOREST HILLS 261-8572	CENTURY'S **PLAINVIEW** SO. OYSTER BAY RD. PLAINVIEW (516) 935-6100	**LYNBROOK 2** MERRICK ROAD LYNBROOK (516) 593-1033
WALTER READE'S **BARONET** 59TH ST. AT 3RD AVE. 355-1663								

SUFFOLK	WESTCHESTER		ROCKLAND		NEW JERSEY	
CENTURY'S **MALL** SMITHHAVEN SHOPPING CENTER LAKE GROVE (516) 724-9550	BRANDT'S **TOWN** 600 MAIN STREET NEW ROCHELLE (914) 632-4000	GENERAL CINEMA'S **CENTRAL PLAZA 2** YONKERS (914) 793-3232	VENTURINI'S **LAFAYETTE** 97-99 LAFAYETTE AVE. SUFFERN	GENERAL CINEMA'S **BLUE STAR CINEMA** WATCHUNG (201) 322-7007	**CINEMA 46** ROUTE 46 TOTOWA	**HYWAY TWIN** BROADWAY FAIRLAWN

159

1981

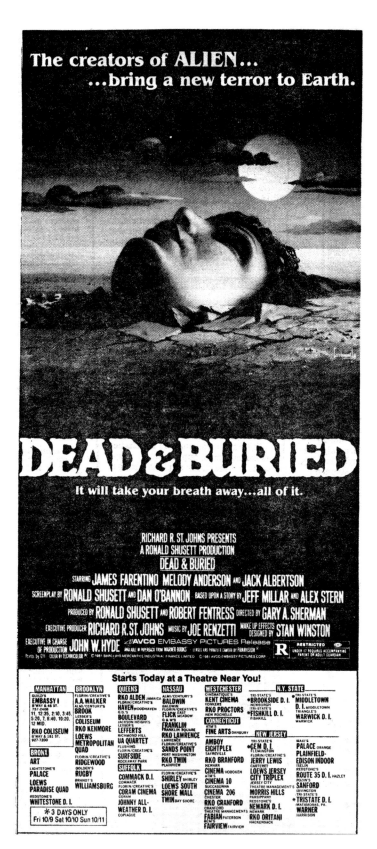

The creators of ALIEN...
...bring a new terror to Earth.

DEAD & BURIED

It will take your breath away...all of it.

RICHARD R. ST. JOHNS PRESENTS
A RONALD SHUSETT PRODUCTION
DEAD & BURIED
STARRING JAMES FARENTINO MELODY ANDERSON AND JACK ALBERTSON
SCREENPLAY BY RONALD SHUSETT AND DAN O'BANNON BASED UPON A STORY BY JEFF MILLAR AND ALEX STERN
PRODUCED BY RONALD SHUSETT AND ROBERT FENTRESS DIRECTED BY GARY A. SHERMAN
EXECUTIVE PRODUCER RICHARD R. ST. JOHNS MUSIC BY JOE RENZETTI MAKE UP EFFECTS DESIGNED BY STAN WINSTON
EXECUTIVE IN CHARGE OF PRODUCTION JOHN W. HYDE AVCO EMBASSY PICTURES Release R RESTRICTED

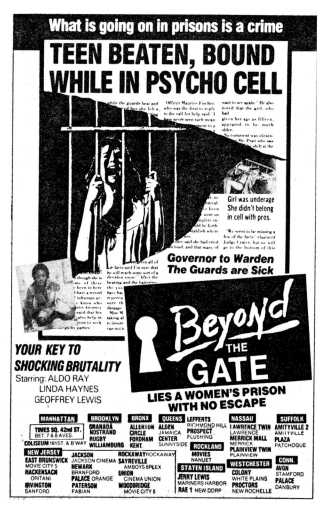

What is going on in prisons is a crime

TEEN BEATEN, BOUND WHILE IN PSYCHO CELL

Girl was underage She didn't belong in cell with pros.

Governor to Warden
The Guards are Sick

YOUR KEY TO
SHOCKING BRUTALITY
Starring: ALDO RAY
LINDA HAYNES
GEOFFREY LEWIS

Beyond THE GATE

LIES A WOMEN'S PRISON
WITH NO ESCAPE

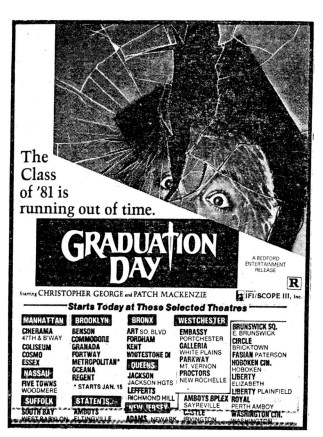

The Class of '81 is running out of time.

GRADUATION DAY

Starring CHRISTOPHER GEORGE and PATCH MACKENZIE

A BEDFORD ENTERTAINMENT RELEASE

IFI/SCOPE III, Inc. R

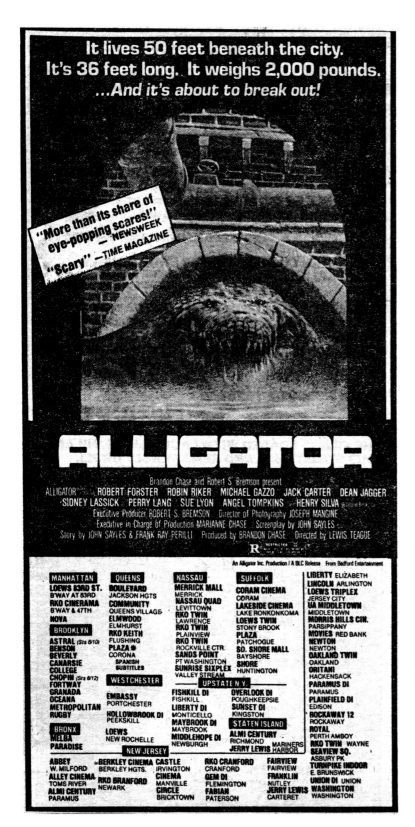

It lives 50 feet beneath the city. It's 36 feet long. It weighs 2,000 pounds. ...And it's about to break out!

"More than its share of eye-popping scares!" — NEWSWEEK
"Scary" — TIME MAGAZINE

ALLIGATOR

Brandon Chase and Robert S. Bremson present
ALLIGATOR · ROBERT FORSTER · ROBIN RIKER · MICHAEL GAZZO · JACK CARTER · DEAN JAGGER
SIDNEY LASSICK · PERRY LANG · SUE LYON · ANGEL TOMPKINS · HENRY SILVA
Executive Producer ROBERT S. BREMSON · Director of Photography JOSEPH MANGINE
Executive in Charge of Production MARIANNE CHASE · Screenplay by JOHN SAYLES
Story by JOHN SAYLES & FRANK RAY PERILLI · Produced by BRANDON CHASE · Directed by LEWIS TEAGUE

R RESTRICTED

An Alligator Inc. Production / A BLC Release From Bedford Entertainment

ALLIGATOR

Lewis Teague's reptile rampage epic began its regional release in late 1980. One of its stops was Connecticut, from which that more exploitative ad hailed. By the time the movie arrived in New York, early in the '81 summer movie season, it had earned positive reviews in both *Time* and *Newsweek* magazines. And they weren't the only ones who appreciated *Alligator*.

"...a formula film that simultaneously demonstrates the specific requirements of the formula while sending them up in good humor. Lewis Teague, the director, and John Sayles, who wrote the screenplay, know exactly what they're doing... [T]he film's suspense is frequently as genuine as its wit and its fond awareness of the clichés it's using."

— Vincent Canby, *The New York Times*

"Director Lewis Teague and writer John Sayles have taken the conventions of those awful 'nature's revenge' movies of the past 25 years and exaggerated them to the point of ludicrousness. The results are quite entertaining. This is not to say, however, that *Alligator* is strictly a comedy; it aims to scare us, and it does."

— Tom Jacobs, *Albuquerque Journal*

"You're not going to believe this one, but stick with me, it's important. This is an excellent movie. *Alligator* is one of the happiest surprises to show up in a long time. It's well acted, powerfully directed, and intelligently written."

— MIKE HUGHES,
LANSING STATE JOURNAL

"Ah, my friends, what is comedy? In *Alligator*... we have such laughable episodes as a man's leg being ripped off, a child at a birthday party being torn apart in his swimming pool while the water turns bright red, people being decapitated... Well, what can I tell you. Something went wrong in my upbringing and I lost my sense of humor. I guess as a kid nobody told me decapitation jokes."

— Murry Frymer, *San Jose Mercury News*

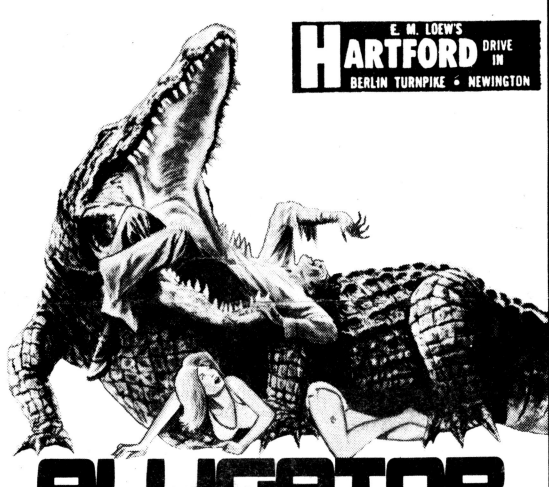

163

BEYOND THE FOG & THE DAY AFTER HALLOWEEN

Two of the more blatant cases of false advertising — or at least false titling — both opened in New York in February 1981. *Beyond the Fog* was a re-release of a 1972 British hack-'em-up previously known by the names *Tower of Evil* and *Horror on Snape Island*, and *The Day After Halloween* was an Australian psychothriller initially called *Snapshot* when it opened on home turf in 1979. It was also issued Stateside as *One More Minute*, and later hit VHS with the title *The Night After Halloween* on the box! John Carpenter, as far as I'm aware, has yet to comment.

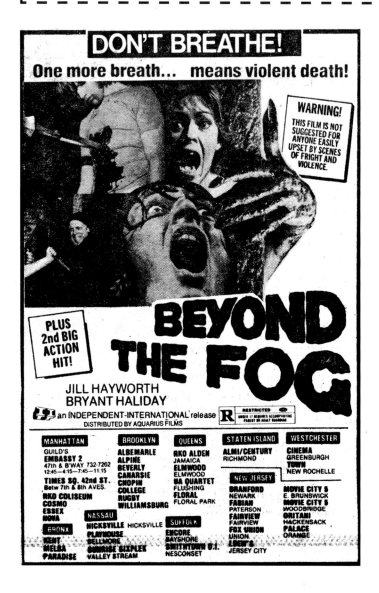

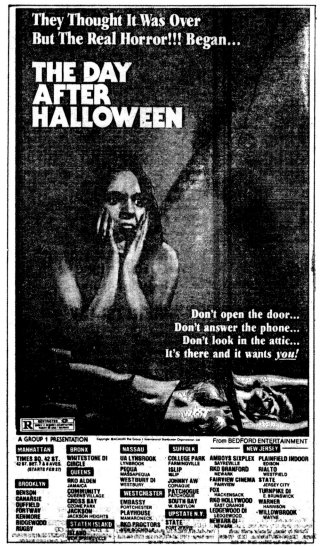

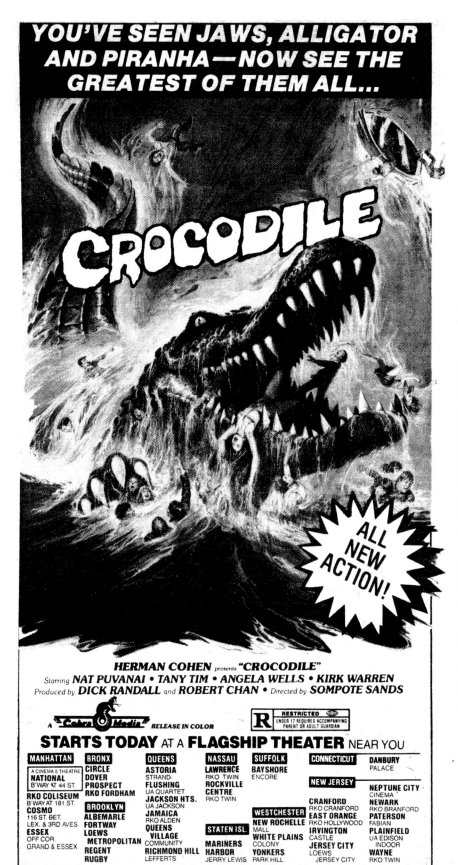
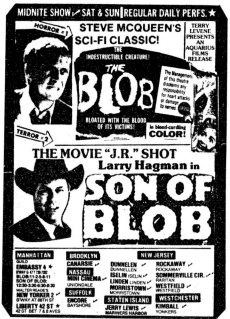
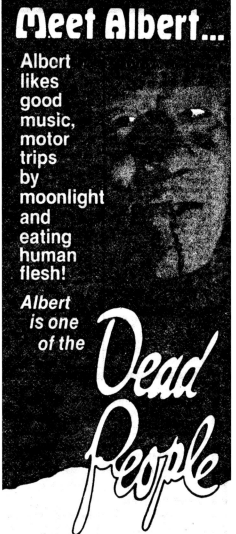
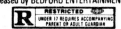

THE FUNHOUSE

Tobe Hooper's first major studio movie was one of a handful in the '80s (along with *Dead & Buried* and *Nomads*) that had a novelization come out in bookstores many months before it hit theaters. In this case, Dean Koontz (under the pseudonym Owen West) greatly expanded upon Larry Block's screenplay — which didn't find favor with all critics.

"*Funhouse* is a horror movie, not a really good one, but considering that its central horror is a standard monster...who pursues four standard teenagers...it is not a really bad movie, either. Tobe Hooper, the director, was in there trying."

— John Corry, *The New York Times*

"Though the movie is exceptionally ugly and unimaginative in its atrocities, it might be partially redeemed by interesting heroes...or by a complex villain. But the misshapen, twisted thing that does the killing is straight out of *Dick Tracy*: he is grotesque, therefore he's a criminal. It's an offensive and stupid notion, appropriate to the movie as a whole."

— David Brudnoy, *Boston Herald American*

"Themes of retribution and destiny are woven through the narrative, and Hooper maintains the fever pitch of tension and growing terror with rare skill. It's as if *Texas Chainsaw* were a practice run for this one."

— TED MAHAR,
THE OREGONIAN

"It's hard to believe that Tobe Hooper, who tightened the screws on audiences' psyches so mercilessly in his direction of *The Texas Chainsaw Massacre*, was anywhere near *The Funhouse*. This is meandering claptrap, weak in the script, illogical in production, whose central element of fear is a monster who terrorizes more with mucus than with menace."

— Sheila Benson, *Los Angeles Times*

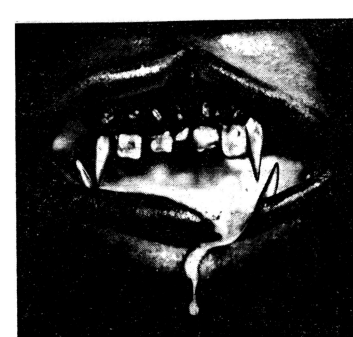

Something is alive in the Funhouse!

THE FUN HOUSE

From the director who brought you
"The Texas Chainsaw Massacre"

COOPER HUCKABEE MILES CHAPIN SYLVIA MILES WILLIAM FINLEY
KEVIN CONWAY as the Barker introducing ELIZABETH BERRIDGE in THE FUNHOUSE
Written by LARRY BLOCK Directed by TOBE HOOPER Produced by DEREK POWER
and STEVEN BERNHARDT Executive Producers MACE NEUFELD and MARK LESTER

A UNIVERSAL RELEASE READ THE JOVE BOOK Copyright ©1981 by Universal City Studios Inc

R RESTRICTED UNDER 17 REQUIRES ACCOMPANYING PARENT OR ADULT GUARDIAN

Starts TODAY at a Universal Blue Ribbon Theatre Near You

MANHATTAN

★ RKO 86TH ST. 2
86TH ST. AT LEX. AVE.
289-8900
1:20, 3:15, 5:10, 7:05,
9:00, 11:00

★ UA RIVOLI
B'WAY & 49TH ST.
247-1633
12:00, 1:55, 3:45, 5:40,
7:30, 9:25, 11:20

★ UA GEMINI 1
2ND AVE. AT 64TH ST
832-1670
12:10, 2:00, 3:50, 5:40,
7:30, 9:20 11:10

BRONX
ALLERTON 1
547-2444
CAPRI 367-0558
INTERBORO 1
792-2100
PALACE 2
829-3900

BROOKLYN
FLORIN/CREATIVE'S
● CANARSIE 2
251-0700
DUFFIELD 855-3967
GOLDEN'S
★ OCEANA 1 743-4333

RKO
KENMORE 3
284-5700
GOLDEN'S
★ FORTWAY 1
238-3967

MARBORO 1
232-4000
CENTURY'S
NOSTRAND
252-6112

QUEENS
RKO ALDEN 1
JAMAICA
739-8678
JACKSON 2
JACKSON HEIGHTS
335-0242

LESSER'S
LEFFERTS 843-8240
RICHMOND HILL
MIDWAY 1
FOREST HILLS
261-8572

QUARTET 1
FLUSHING 359-6777

STATEN ISLAND
ACKERMAN'S
LANE NEW DORP
351-2110

WESTCHESTER
LESSER'S
BEACH CINEMA 2
PEEKSKILL
737-6262
★ BRONXVILLE 2
BRONXVILLE
961-4030
ACKERMAN'S
CINEMA 100
GREENBURGH
946-4680
★ MAMARONECK 1
MAMARONECK
698-2200
LESSER'S
MOUNT KISCO 2
MT. KISCO
666-6900
RKO PROCTORS 3
NEW ROCHELLE
632-1100

NASSAU
B.S. MOSS'
CENTRAL 1
CEDARHURST
569-0105
SUNRISE MALL 4
MASSAPEQUA
795-2244

HICKSVILLE 1
HICKSVILLE
931-0749
LYNBROOK 2
LYNBROOK
593-1033

MANHASSET 2
MANHASSET
627-7887
WESTBURY D/I #3
WESTBURY
334-3400

SUFFOLK
BAYSHORE
CINEMA
BAYSHORE
665-1722
ALMI'S
● PLAZA 475-5225
PATCHOGUE

CENTURY'S
SHORE 3 421-5200.
HUNTINGTON
LESSER'S
SOUTHAMPTON
SOUTHAMPTON
283-1300

JOHNNY ALL-WEATHER D/I
COPAIGUE
842-4258
SMITHTOWN INDOOR
NESCONSET
264-8118

UPSTATE
A.T.M.'S
FINE ARTS 2
DANBURY, CONN. 775-0070

ROUTE 59
NANUET
623-3355

SOUTHERN CONN.
A.T.M.'S
GREENWICH CINEMA
GREENWICH 869-4030

A.T.M.'S
NORWALK
NORWALK 866-3010

PLAYHOUSE
DARIEN
655-0100

NEW JERSEY

T.M.'S
ALLWOOD 1
CLIFTON
778-9747
NATHAN'S
BERKELEY
BERKELEY HEIGHTS
464-8888
CINEMA SERVICE'S
CENTER
BLOOMFIELD
748-7900
CINEMA 35
PARAMUS
845-5070

MUSIC MAKER'S
CIRCLE 1
BRICKTOWN
458-5077
MUSIC MAKER'S
COMMUNITY 2
EATON TOWN
542-4200
MUSIC MAKER'S
DOVER 2
TOMS RIVER
244-5454
T.M.'S
FABIAN 1
PATERSON
742-4800

FOX
HACKENSACK
488-8000

GENERAL CINEMA'S
★ HUDSON PLAZA 2
JERSEY CITY
433-1100
NATHAN'S
HUNTERDON
FLEMINGTON
782-4815
HYWAY 1
FAIRLAWN
796-1717

MOVIES AT
MIDDLETOWN 3
MIDDLETOWN 671-1020
GENERAL CINEMA'S
● MORRIS COUNTY MALL 2
HANOVER TOWNSHIP
539-7966
WOOD'S
● OLD RAHWAY
RAHWAY
388-1511
FLORIN-CREATIVE'S
PARAMOUNT
NEWARK
623-5030

PLAINFIELD INDOOR 2
PLAINFIELD
548-3100

RIALTO 2
WESTFIELD
232-1288

A.M.C.'S
★ ROCKAWAY TWELVE 2
ROCKAWAY TOWNSHIP
328-0666

SHOWBOAT 3
EDGEWATER
941-3660

GENERAL CINEMA'S
● SOMMERVILLE
CIRCLE 3
RARITAN
526-0101
TURNPIKE 1
EAST BRUNSWICK
257-5050
WAYNE
WAYNE
694-4136

★ DOLBY STEREO

● "Special Friday the 13th Midnight Show." Come if you dare!

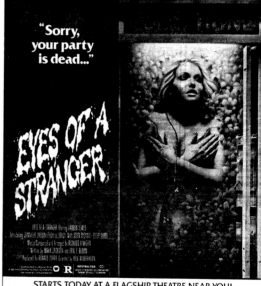

1981

DEMONOID

I've loved promotional giveaway gimmicks ever since I was a kid, so of course I hustled over to a local theater with a friend to see *Demonoid* and pick up our "*Demonoid* Diplomas." Sadly, this particular offering didn't extend to that venue, so we went unrewarded — by the movie as well, in which, as the ads fail to tell you, the would-be terror is generated by a series of possessed hands.

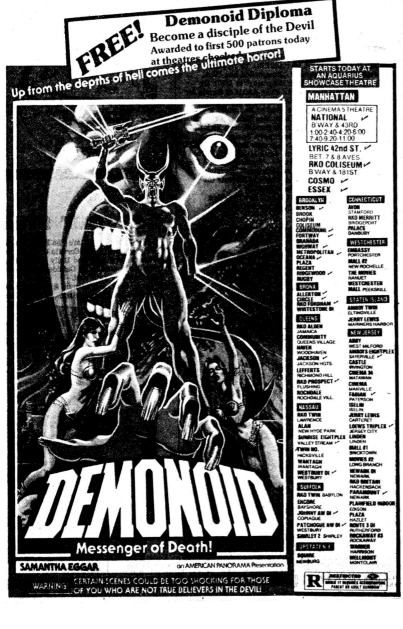

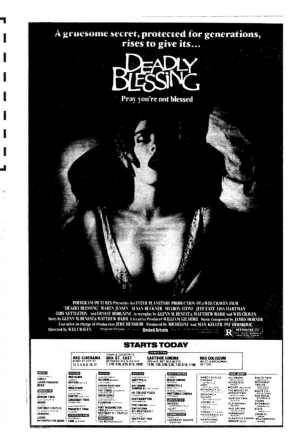

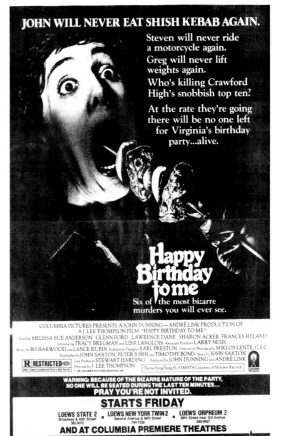

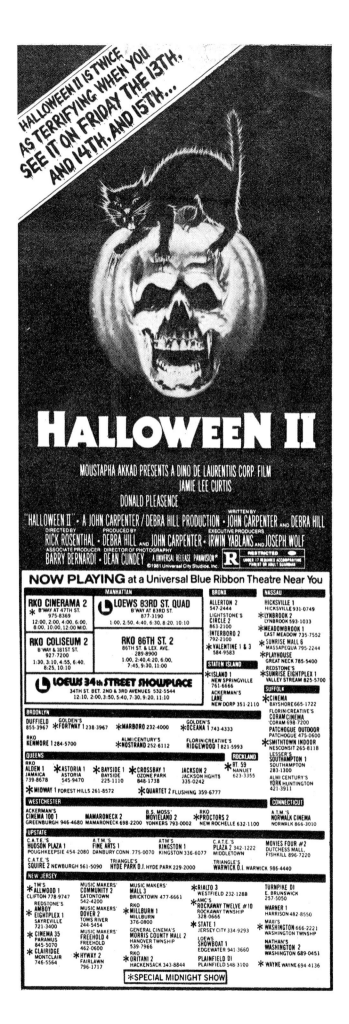

HALLOWEEN II

The sequel to John Carpenter's 1978 landmark set a box-office record for movies opening on Halloween weekend when it debuted three years after the original. Many reviewers, however, weren't as enthusiastic about the film as audiences were.

"By almost any standard, *Halloween II* is a fearsomely effective thriller. By almost any standard, that is, except the one established by its illustrious predecessor... Put simply, *Halloween* is a hard act to follow. Even so, Carpenter has tried."

— Joe Leydon, *The Dallas Morning News*

"Schlock and gore and disembowelment are the nasty ingredients in today's horror movies... The latest in this genre is...*Halloween II*, which opens today all over the country just in time to make you swear off pumpkin pie forever...If there's a *Halloween III* I'm burning my press card. [Sadly, he didn't.—M.G.]"

— REX REED,
NEW YORK DAILY NEWS

"By the standards of most recent horror films, this – like its predecessor – is a class act. There's some variety to the crimes, as there is to the characters, and an audience is likely to do more screaming at suspenseful moments than at scary ones. ... And *Halloween II*, in addition to all this, has a quick pace and something like a sense of style."

— Janet Maslin, *The New York Times*

"It is, after its fashion and in its narrow way, a brilliant film. It develops an ugly power and is choreographed at blinding pace. ... Rosenthal has a great sense of timing; he knows just when to squeeze, just when to let go. ... But it's all so cold."

— Stephen Hunter, *The Baltimore Sun*

HALLOWEEN II

ALL NEW

From The People Who Brought You "HALLOWEEN"...
More Of The Night *He* Came Home.

MOUSTAPHA AKKAD PRESENTS A DINO DE LAURENTIIS CORP. FILM
JAMIE LEE CURTIS
DONALD PLEASENCE

"HALLOWEEN II" · A JOHN CARPENTER / DEBRA HILL PRODUCTION · WRITTEN BY JOHN CARPENTER AND DEBRA HILL

DIRECTED BY RICK ROSENTHAL · PRODUCED BY DEBRA HILL AND JOHN CARPENTER · EXECUTIVE PRODUCERS IRWIN YABLANS AND JOSEPH WOLF

ASSOCIATE PRODUCER BARRY BERNARDI · DIRECTOR OF PHOTOGRAPHY DEAN CUNDEY · A UNIVERSAL RELEASE PANAVISION®
©1981 Universal City Studios, Inc.

R RESTRICTED
UNDER 17 REQUIRES ACCOMPANYING PARENT OR ADULT GUARDIAN

On The Eve Of Halloween...
Trick Or Treat Yourself To HALLOWEEN II

Starts Friday, October 30th At Universal Blue Ribbon Theatres Everywhere

NIGHTMARE

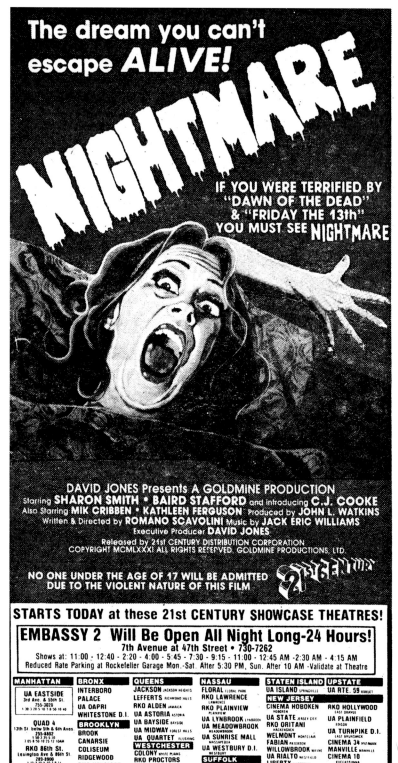

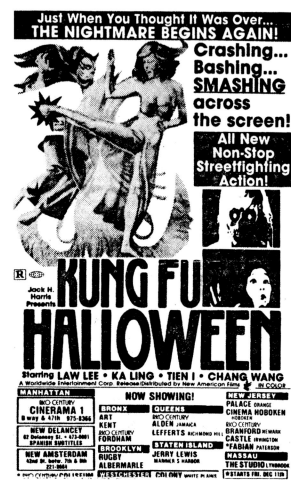

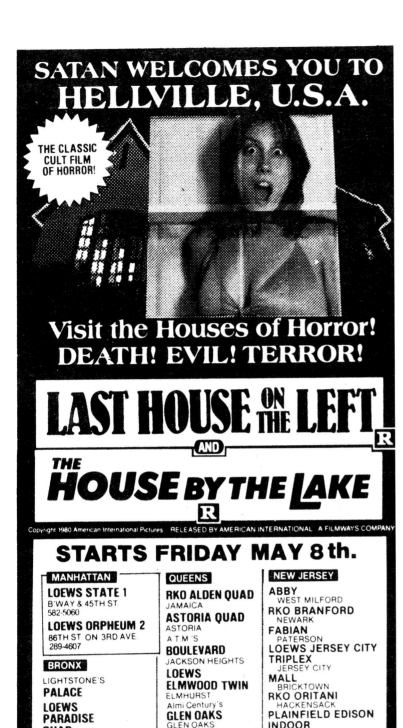

THE MOST ENDANGERED SPECIES IS NOW MAN

SAVAGE HARVEST
BASED ON A TRUE INCIDENT

SANDY HOWARD Presents a ROBERT COLLINS Film SAVAGE HARVEST

TOM SKERRITT · MICHELLE PHILLIPS · SHAWN STEVENS · ANNE-MARIE MARTIN

Screenplay by ROBERT BLEES and ROBERT COLLINS based on a Story by RALPH HELFER and KEN NOYLE

Produced by RALPH HELFER and SANDY HOWARD Executive Producer DEREK GIBSON Directed by ROBERT COLLINS

A Buckslass Production Released through Twentieth Century Fox Film Corporation **PG** PARENTAL GUIDANCE SUGGESTED
SOME MATERIAL MAY NOT BE SUITABLE FOR CHILDREN
© 1981 TWENTIETH CENTURY-FOX

STARTS TODAY AT THESE SELECTED THEATRES

MANHATTAN

B. S. MOSS
CRITERION CENTER
B'WAY BET. 44TH & 45TH STS.
582-1795
12:25, 2:05, 3:40, 5:15, 6:55,
8:40, 10:20, 11:45

RKO
COLISEUM
B'WAY AND 181ST ST. 927-7200
2, 5:20, 8:40

WESTCHESTER

LOEWS
NEW ROCHELLE TWIN
NEW ROCHELLE (914) 632-1700

BRONX

LOEWS
**PARADISE
QUAD**
367-1288

BROOKLYN

LOEWS
ALPINE TWIN
748-4200

QUEENS

RKO
ALDEN
JAMAICA 739-8678

NASSAU

RKO
PLAINVIEW
PLAINVIEW 931-1333

NEW JERSEY

RKO
BRANFORD
NEWARK 623-5236

RKO
ORITANI
HACKENSACK
343-8844

HOLY TERROR

Alfred Sole's religious-themed horror/mystery, first saw U.S. release in 1977-78 as *Communion* and *Alice, Sweet Alice*, but did not make it to the New York area before distributor Allied Artists went out of business. A few years later, Dynamite Entertainment picked up the film, retitled it again, and took advantage of ascendant star Brooke Shields, who had played the movie's first victim at age ten.

Critics took note that she only played a small role, and in March '81, Rita Rose of *The Indianapolis Star* talked with a spokesman from Dynamite Entertainment, who told her, "The advertising is supposed to say, '*Introducing* Brooke Shields.' After the promotional material (which includes newspaper ads) was sent to the regional distributor, we decided to make the change and insert the word 'introducing' in the copy. The change was to be inserted at the local level."

That didn't happen in Indianapolis, though it did in New York, and that June, the *New York Post* reported that Shields had publicly complained about the campaign, and an agreement had been reached to change it. Said Shields' attorney, Peter M. Thall, "Brooke was concerned that filmgoers could only be disappointed if led into the theater with the promise that the film was of recent vintage or that she had a central part in it." On the positive side, the *Holy Terror* release gave New York audiences the chance to enjoy Sole's accomplished chiller, and some local critics the chance to laud it.

"The movie has qualities that take it out of the usual run of sanguinary homicidal horror movies, an attention given to dialogue, to authenticity of setting and to revelatory and atmospheric touches."
— **Ernest Leogrande**, *New York Daily News*

"Mr. Sole... has a good feeling for the lower middle-class locale and the realities of the lives of the people who live in it."
— **VINCENT CANBY,**
THE NEW YORK TIMES

"...*Holy Terror/Alice/Communion* holds its own in the genre of suspense-horror films. There are plenty of stabbings to fill your Gore Quotient, and oddball characters add the proper touch of insanity. Especially good is Paula Sheppard as Alice."
— **Rita Rose**, *The Indianapolis Star*

Introducing
BROOKE SHIELDS

A story of unnatural love...

and unnatural death

Holy Terror

It's too late for prayers.

A RICHARD K. ROSENBERG—ALFRED SOLE PRODUCTION • HOLY TERROR
Original Screenplay by ROSEMARY RITVO and ALFRED SOLE
Produced by RICHARD K. ROSENBERG • Directed by ALFRED SOLE TECHNICOLOR® A DYNAMITE ENTERTAINMENT RELEASE

R RESTRICTED
UNDER 17 REQUIRES ACCOMPANYING PARENT OR ADULT GUARDIAN

STARTS TODAY AT A DELUXE THEATRE NEAR YOU

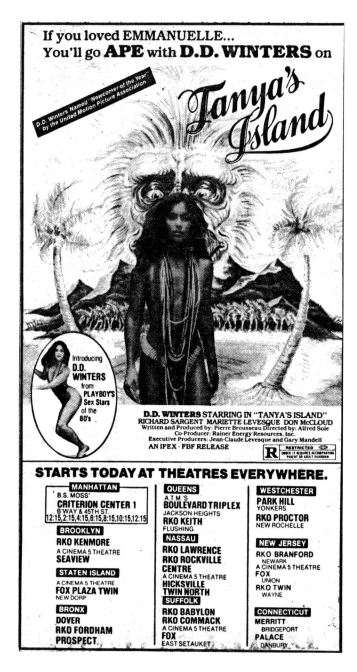

I SPIT ON YOUR GRAVE

Filmmaker Meir Zarchi initially released his rape-revenge shocker himself in 1978 under his Cinemagic Pictures banner, with the title *Day of the Woman*. Then it was picked up by the Jerry Gross Organization, which gave it a new title, borrowed from a racially themed 1959 French crime drama, and created an attention-grabbing poster and newspaper ad campaign. But the film truly gained notoriety when it opened in Chicago in July 1980 and was famously excoriated by local critics Roger Ebert and Gene Siskel, both in print and on their PBS show *Sneak Previews*.

Nonetheless, *Grave* didn't receive quite the same condemnation from reviewers in other cities — when it was reviewed at all. When it finally slinked into New York City in June 1981 — as part of a double bill, no less — it didn't get any notice from the local papers.

"*I Spit on Your Grave* is easily the most offensive film I have seen in my eleven years on the movie beat. The story...debases strong women in the guise of heralding them. ... *I Spit on Your Grave* is a very cruel film that expands upon the notion that women are nothing but sexual playthings."
— Gene Siskel, *Chicago Tribune*

"It is a movie so sick, reprehensible and contemptible that I can hardly believe it's playing in respectable theaters. ... There is no reason to see this movie except to be entertained by the sight of sadism and suffering."
— ROGER EBERT, *CHICAGO SUN-TIMES*

"*I Spit on Your Grave* is many bad things – bad title, bad idea, bad taste. But I can't go the full distance with the Chicago people. The film just isn't worth a torch campaign. ... *I Spit on Your Grave* is by no means the worst, even the most offensive, film to play South Florida in recent years."
— *The Miami Herald*, author unknown

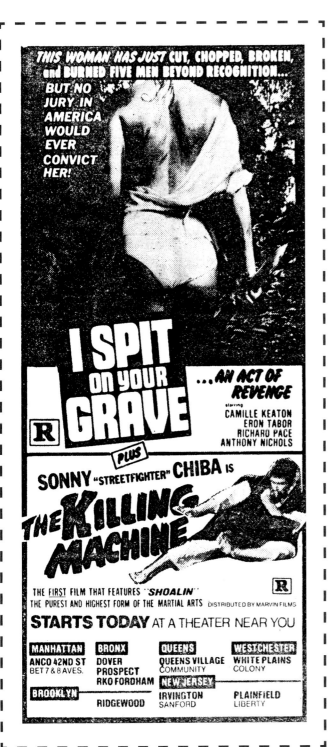

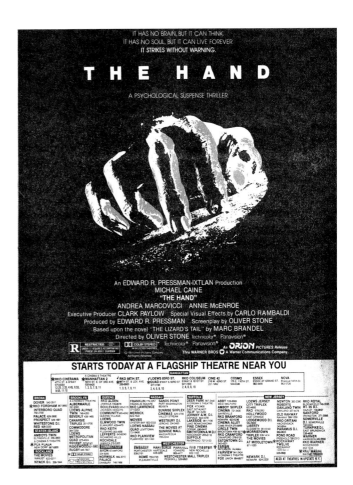

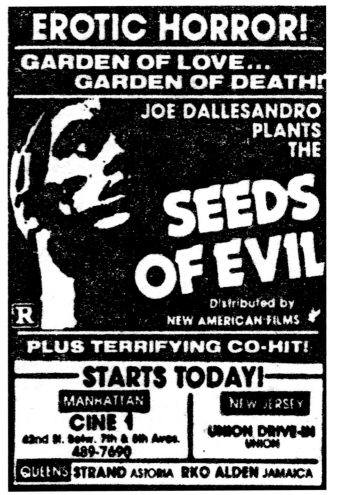

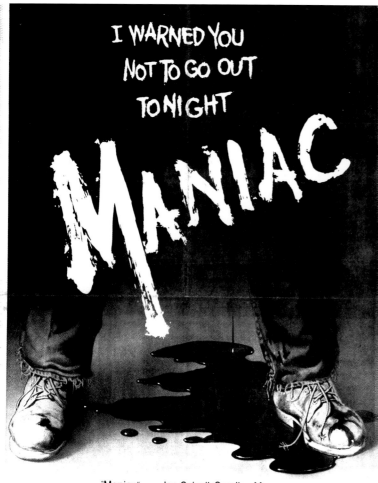

MANIAC

When Analysis Film Corporation opened William Lustig's extreme gorefest and sweaty character study in New York in January 1981, two versions of the newspaper ad were prepared. One, seen in the *Daily News* and the *Post*, replicated the explicitly suggestive poster, while a more genteel one that obscured the nasty details appeared in *The Times*. The responses from critics around the country, however, were pretty much the same.

"Good sense, if not heaven, should protect anyone who thinks he likes horror films from wasting a price of admission on *Maniac*... Watching [Spinell] act like a psychopathic killer with a mommy-complex is like watching someone else throw up."

— Vincent Canby, *The New York Times*

"[Spinell] actually manages to make Frank a creature of some pity. It's a dubious achievement if there ever was one, and a measure of just how far *Maniac* is willing to go to justify its 'meat.'"

— *The Washington Star*, author unknown

"What is one to make of such nonsense? The nearest garbage can might do, but tribute should be paid for good photography, NYC locations, and the lurid imaginations of star-writer Joe Spinell and his faithful director, William Lustig."

— Archer Winsten, *New York Post*

"Probably the most glowing testimonial for *Maniac* occurred yesterday when a woman in the audience was seen to retch and hastily flee her seat."

— BILL KAUFMAN,
NEW YORK NEWSDAY

"[A] thoroughly repulsive, semi-pornographic little thriller."

— Richard Freedman, *Newark Star-Ledger*

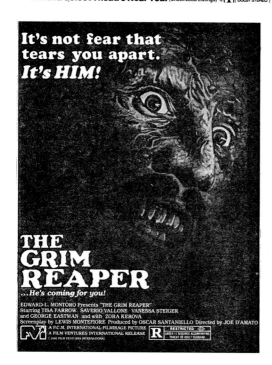

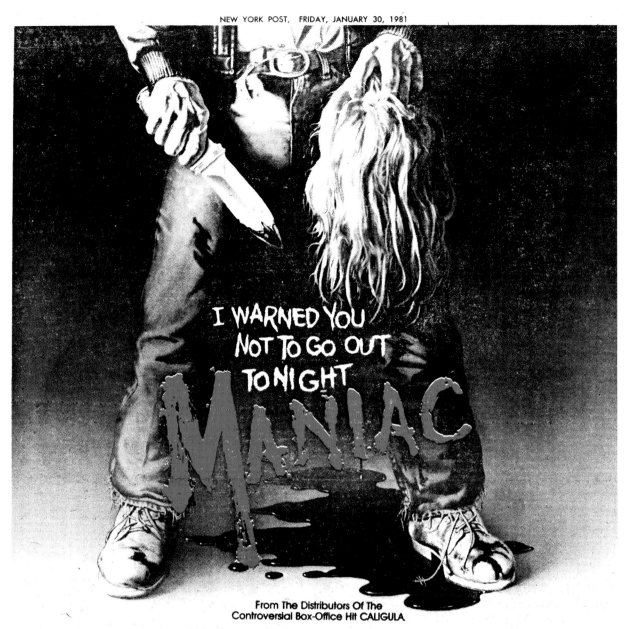

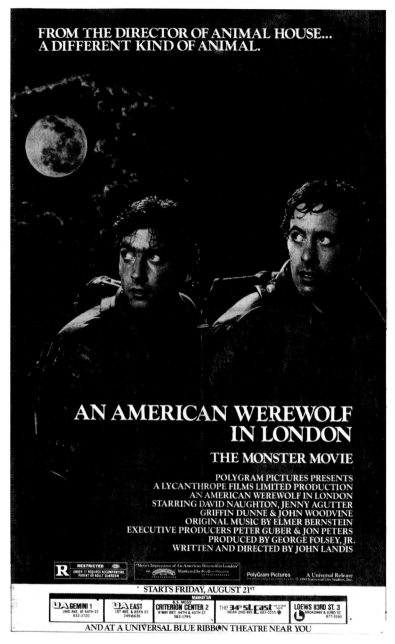

FROM THE DIRECTOR OF ANIMAL HOUSE...
A DIFFERENT KIND OF ANIMAL.

AN AMERICAN WEREWOLF IN LONDON

THE MONSTER MOVIE

POLYGRAM PICTURES PRESENTS
A LYCANTHROPE FILMS LIMITED PRODUCTION
AN AMERICAN WEREWOLF IN LONDON
STARRING DAVID NAUGHTON, JENNY AGUTTER,
GRIFFIN DUNNE & JOHN WOODVINE
ORIGINAL MUSIC BY ELMER BERNSTEIN
EXECUTIVE PRODUCERS PETER GUBER & JON PETERS
PRODUCED BY GEORGE FOLSEY, JR.
WRITTEN AND DIRECTED BY JOHN LANDIS

STARTS FRIDAY, AUGUST 21ST

AND AT A UNIVERSAL BLUE RIBBON THEATRE NEAR YOU

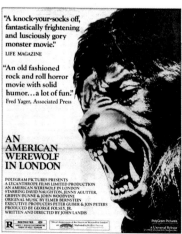

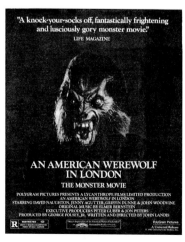

HELL NIGHT

With *Halloween* moving to the big studio environs of Universal Pictures, the first picture's distributor, Compass International, took another shot at youth stalking with *Hell Night*, casting *The Exorcist*'s Linda Blair for extra marquee value. But the critical notices weren't as plentiful or as positive as they were for either *Halloween* or *The Exorcist*.

"It is a thankless task to apply serious criticism to this kind of pointed nonsense. The kids who jump and squeal at its bloody displays have run up box-office successes at equally idiotic films. Who's going to eschew a film just because it stinks?"
— Archer Winsten, *New York Post*

"As the popular culture declines, the horror film declines with it, and whereas the horror film was once spooky, now it is nauseating, measured by the barf, rather than the shiver. *Hell Night*, however, is only about half a barf, an improvement, therefore, over its kind."
— JOHN CORRY,
THE NEW YORK TIMES

"At a time when horror pictures are jolting us with bravura special effects, along come two talented young film makers, director Tom DeSimone and writer Randolph Feldman (in his debut), to show us there are still plenty of scares to be found in the old haunted house with its creaks, squeaks, groans, and things that go bump in the night."
— Kevin Thomas, *Los Angeles Times*

"For those unfamiliar with [this] subgenre of films...this may be mildly diverting. But the film borrows so liberally from earlier efforts that the proceedings will be intolerably boring for others."
— Robert C. Trussell, *The Kansas City Star*

1981

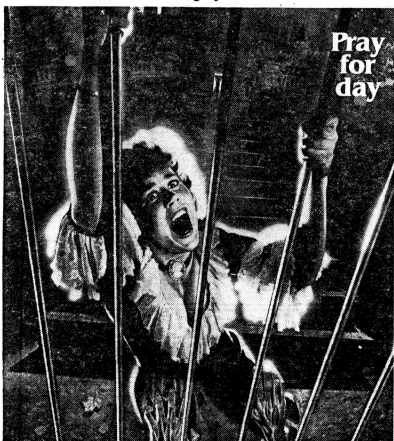

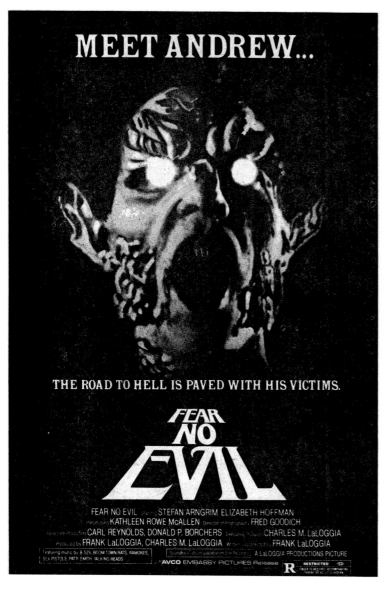

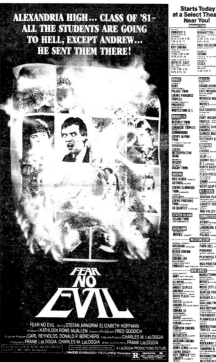

THE HOWLING

Avco Embassy had originally planned to release Joe Dante's satirical lycanthropicture — featuring a screenplay by John Sayles and Rob Bottin's groundbreaking makeup effects — in time for Halloween 1980. When it ultimately emerged the following spring, it proved to be well worth the wait, and most critics were particularly taken with Rob Bottin's special effects.

"Whatever you want from a horror movie, *The Howling* has it: Werewolves that are quite different and much scarier than any previously seen on the screen; special effects that leave the viewer wondering how in the world they were created."

— Larry Kart, *Chicago Tribune*

"It's high time Hollywood unleashed a scare picture we can really sink our teeth into. *The Howling*, a satiric blend of werewolf lore and the best makeup effects since *Alien*, is just such a repast – stylish, sexy, scary, and spiked with enough arcane Creature Feature trivia for the real addict."

— GLENN LOVELL, *SAN JOSE MERCURY NEWS*

"It's got a smidgen of pseudointellectual 'camp' touches that will mean nothing to horror movie freaks. ... These little in-jokes just serve to satisfy the souls of filmmakers who'd probably rather be tackling a subject meatier than werewolves."

— Judy Stone, *San Francisco Chronicle*

"Dante and Sayles accomplish what the modern filmmakers responsible for remakes of *King Kong* and *Superman* and dozens of lesser fantasy projects grabbed at but missed: They get the ironies of the update without the cuteness of camp."

— Bill Cosford, *The Miami Herald*

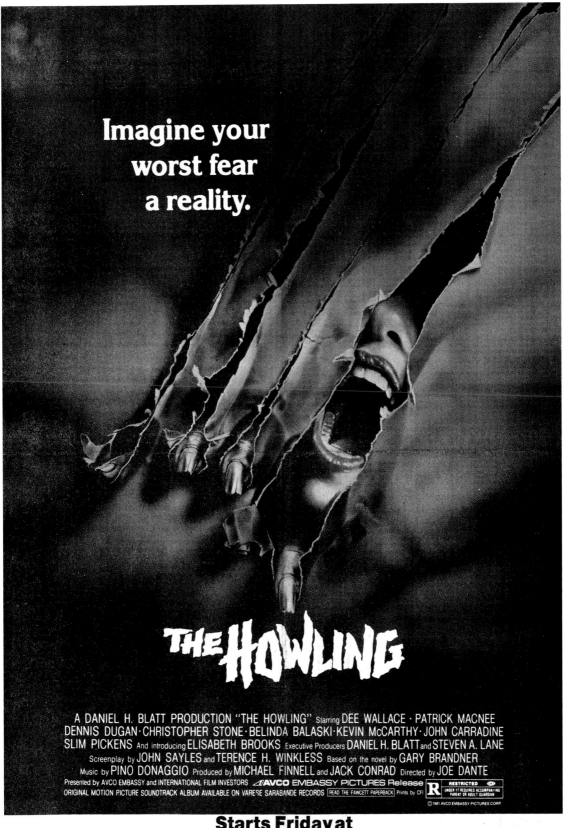

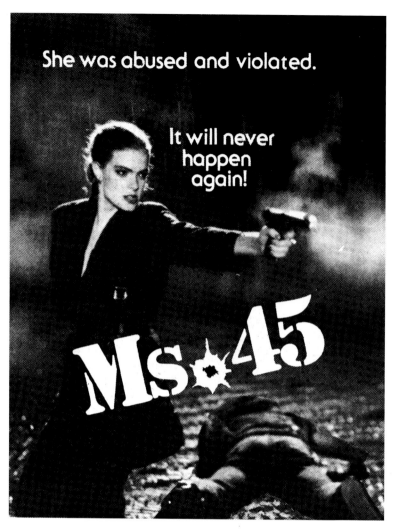

She was abused and violated.

It will never happen again!

MS•45

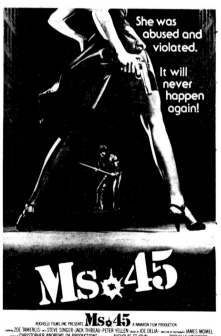

She was abused and violated.

It will never happen again!

MS•45

MY BLOODY VALENTINE

Flush with the success of *Friday the 13th*, Paramount Pictures picked up another date-centric slasher flick for release tied to its namesake holiday. By a happy accident of timing, Valentine's Day 1981 fell on a Saturday, which meant the day before, when Paramount opened the movie, was Friday the 13th. (The film actually debuted in New York two days earlier, on February 11, to take advantage of pre-holiday promotional opportunities.) Today, *My Bloody Valentine* is considered by many fans to be among the most stylish and scary post-*Halloween* stalker sagas, but unfortunately, the majority of the critics didn't agree at the time.

❝'It can't be happening again,' somebody wails early in *My Bloody Valentine*. Oh, but it is, and not with any originality either. … It has little to distinguish it besides the colorful working-class setting.❞

— Pat Dowell, *The Washington Star*

❝*My Bloody Valentine* has an appealing cast of young merrymakers and an effective climax down in the mine. … Movies like this are designed to make you jump, scream, hide your eyes, hug your date, and talk with glee about what bad taste the movie makers are capable of. *My Bloody Valentine* does all that.❞

— Ernest Leogrande, *New York Daily News*

❝What intrigued me about a special credit for 'story concept' is that *My Bloody Valentine* is such a blatant ripoff that I can't imagine Miller coming up with any concept more original than, 'Hey, gang! Let's rent the old mine shaft and remake *Halloween*!' ❞

— *Chicago Sun-Times*, author unknown

❝[T]he MPAA should have its collective head examined for not establishing a whole new category – P for POISON, no one in their right mind admitted. What else can you call these hemoglobin epics?❞

— PETER STACK, *SAN FRANCISCO CHRONICLE*

1981

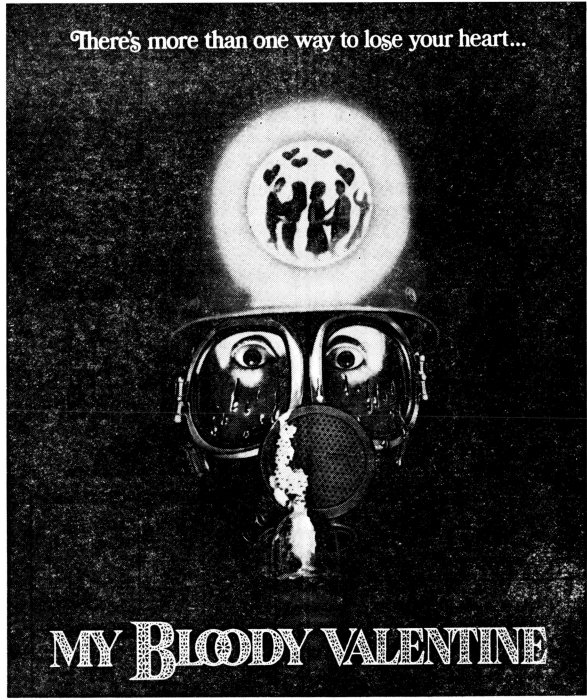

There's more than one way to lose your heart...

MY BLOODY VALENTINE

PARAMOUNT PICTURES CORPORATION PRESENTS MY BLOODY VALENTINE STARRING PAUL KELMAN LORI HALLIER NEIL AFFLECK MUSIC BY PAUL ZAZA PRODUCTION SUPERVISOR BOB PRESNER ASSOCIATE PRODUCER LAWRENCE NESIS STORY CONCEPT STEPHEN MILLER
WRITTEN BY JOHN BEAIRD PRODUCED BY JOHN DUNNING ANDRE LINK STEPHEN MILLER DIRECTED BY GEORGE MIHALKA
A PARAMOUNT RELEASE

STARTS TODAY

185

It's dead of night and everybody's asleep. ...ALMOST EVERYBODY!

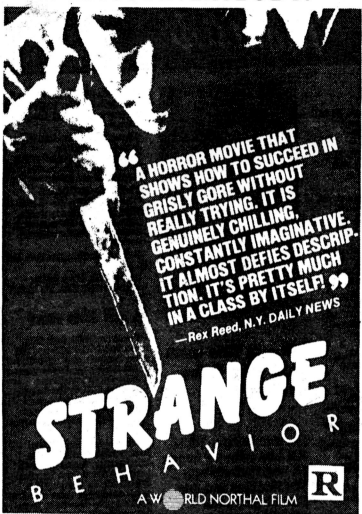

"A HORROR MOVIE THAT SHOWS HOW TO SUCCEED IN GRISLY GORE WITHOUT REALLY TRYING. IT IS GENUINELY CHILLING, CONSTANTLY IMAGINATIVE. IT ALMOST DEFIES DESCRIPTION. IT'S PRETTY MUCH IN A CLASS BY ITSELF!"
— Rex Reed, N.Y. DAILY NEWS

STRANGE BEHAVIOR

A W🌐RLD NORTHAL FILM R

HELD OVER FOR A 2ND TERRIFYING WEEK

STRANGE BEHAVIOR

World Northal, a distributor whose bread and butter was martial arts pictures, occasionally ventured into horror territory with films like *The Children* (1980) and *The Unseen* (1981). Its releases typically went unscreened and unreviewed in New York, with modest ad campaigns, but the company made an exception with this Australian import, originally titled *Dead Kids*. The feature debut of Michael Laughlin and William Condon (the latter would go on to write and direct *Gods and Monsters*, which won him a Best Adapted Screenplay Oscar), *Strange Behavior* got a full-page *Times* ad replicating the one-sheet while being sold more overtly as a slasher in the *Daily News*.

Newsweek's David Ansen was one of a few critics who noted that both *Strange Behavior* and *Halloween II*, released around the same time, contained scenes involving hypodermic needles in eyeballs. Ansen preferred *Behavior* over *Halloween*, and a few others found things to like about the former.

"It's a 1950's mad-scientist movie, or at least a very fond and painstaking reincarnation of same. And it's a small, original, offbeat film of the sort that is out of fashion. ... [it] has just enough of the unexpected to hold the audience's interest."
— Janet Maslin, *The New York Times*

"*Strange Behavior* is a horror movie that shows how to succeed in grisly gore without really trying, and, moreover, how to do it while being intentionally funny at the same time. It is genuinely chilling, constantly imaginative, and full of exquisite throwaway comedy."
— Rex Reed, *New York Daily News*

"Grisly but sly, *Strange Behavior* is the genre film at its most knowing and controlled... It is able to take its people and their relationships seriously, yet affectionately spoof the conventions of its genre, embracing even its own campy title."
— KEVIN THOMAS, *LOS ANGELES TIMES*

In a college somewhere in the Midwest, Dr. Claude LeSange is conducting a few experiments...

MICHAEL MURPHY LOUISE FLETCHER DAN SHOR FIONA LEWIS ARTHUR DIGNAM
"STRANGE BEHAVIOR"
Associate Producer WILLIAM CONDON Executive Producers JOHN DALY / DAVID HEMMINGS / WILLIAM FAYMAN Produced by ANTHONY I. GINNANE and JOHN BARNETT Original Music by TANGERINE DREAM A Hemdale and Fay Richwhite Presentation of a South Street Films Production of a Michael Laughlin Film
Screenplay by WILLIAM CONDON and MICHAEL LAUGHLIN
Directed by MICHAEL LAUGHLIN

A W RLD NORTHAL FILM

R RESTRICTED
Under 17 requires accompanying Parent or Adult Guardian

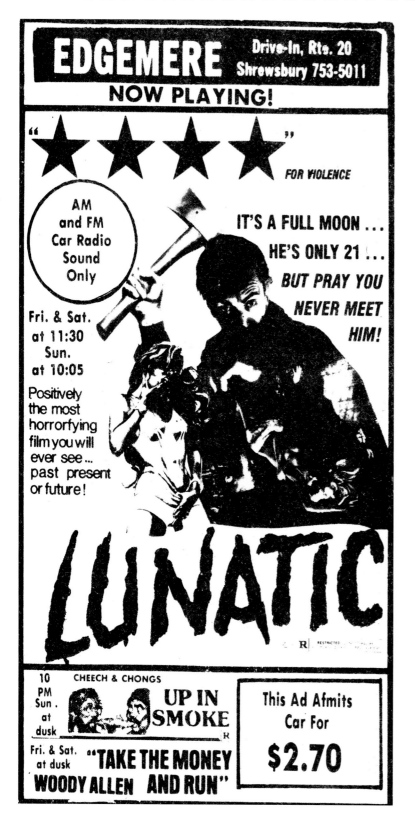

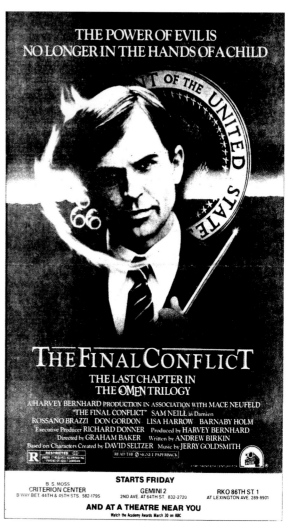

STUDENT BODIES / NIGHT SCHOOL

Paramount apparently thought enough of its slasher spoof to give it an advertised sneak preview in the NYC borough of Queens (and presumably other cities). It didn't go so well, though, because when the studio gave *Student Bodies* a nationwide break in August 1981, the New York area was bypassed. The film opened there two months later, paired with the studio's straight-faced murderama *Night School*.

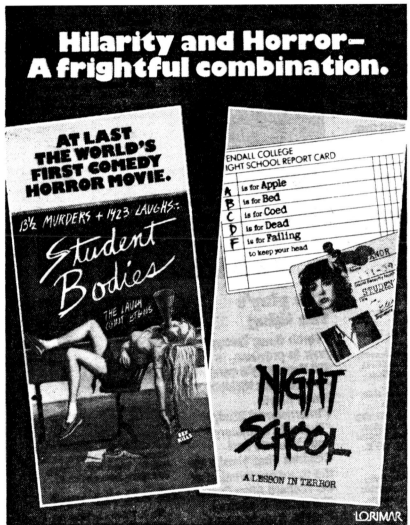

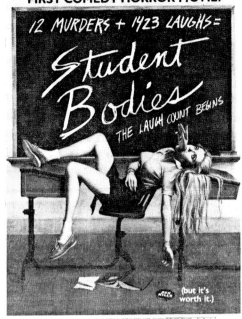
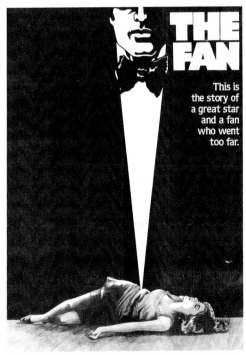
189

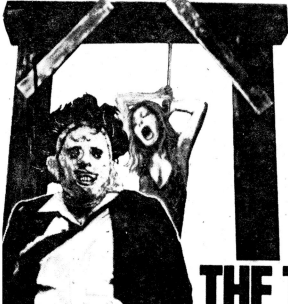

"UNPARALLELED TERROR
...THE MOST HORRIFYING MOTION PICTURE YOU'LL EVER SEE!"
—Rex Reed

What happened is true. Now the motion picture that's just as real!

THE TEXAS CHAINSAW MASSACRE

THE TEXAS CHAINSAW MASSACRE • A film by TOBE HOOPER
Starring MARILYN BURNS and GUNNAR HANSEN as "Leatherface"
Screenplay by KIM HENKEL and TOBE HOOPER • Produced and Directed by TOBE HOOPER
In Color • From ∧V NEW LINE CINEMA
© MCMLXXX New Line Cinema Corp

R RESTRICTED
UNDER 17 REQUIRES ACCOMPANYING PARENT OR ADULT GUARDIAN

STARTS TODAY AT A SHOWCASE THEATRE NEAR YOU

MANHATTAN	BRONX	QUEENS	GLEN OAKS	SUFFOLK	ROCKLAND	NEW JERSEY	MIDDLETOWN
CINERAMA B'WAY AT 47 ST	FORDHAM INTERBORO KENT	ASTORIA ASTORIA FLUSHING KEITHS	GLEN OAKS JAMAICA ALDEN OZONE PARK CROSS BAY	BABYLON RKO BABYLON BAYSHORE CINEMA	BLAUVELT NYACK DI NANUET MALL ORANGEBURG	BLOOMFIELD ROYAL BRICKTOWN MALL	MIDDLETOWN MORRISTOWN MORRISTOWN TRIPLEX
RKO 86TH ST. AT LEX AVE.	MELBA PALACE PROSPECT	FOREST HILLS MIDWAY	QUEENS VILLAGE COMMUNITY	COMMACK COMMACK DI	ORANGEBURG	CRANFORD CRANFORD	NEWARK BRANFORD
EASTSIDE CIN. 3RD AVE AT 55 ST		NASSAU	MASSAPEQUA	FARMINGVILLE COLLEGE PLAZA	UPSTATE	EAST BRUNSWICK TURNPIKE INDOOR	PARAMUS PARAMUS DI
GRAMERCY LEX AVE AT 23 ST		BALDWIN BALDWIN	SUNRISE MALL PLAINVIEW	HUNTINGTON WHITMAN	CARMEL CARMEL FISHKILL MOVIES	EATONTOWN EATONTOWN DI	PATERSON FABIAN
CINE 42ND ST BET 7 & 8 AVES	BROOKLYN	EAST MEADOW MEADOWBROOK	RKO PLAINVIEW PORT	PATCHOGUE PATCHOGUE DI	MAYBROOK MAYBROOK DI	EDISON PLAINFIELD	PLAINFIELD LIBERTY
COLISEUM B'WAY AT 181 ST	BEVERLY CANARSIE	LAWRENCE RKO LAWRENCE	WASHINGTON PORT WASHING-	ROCKY POINT ROCKY POINT DI	MIDDLE HOPE MIDDLE HOPE DI	INDOOR FAIRVIEW	RAHWAY OLD RAHWAY
NOVA B'WAY AT 147 ST	COLLEGE FORTWAY	LYNBROOK LYNBROOK	TON TRIPLEX	SMITHTOWN SMITHTOWN DI	MIDDLETOWN CINEMA	FAIRVIEW HACKENSACK	ROCKAWAY TWP ROCKAWAY
STATEN ISL.	GRANADA MARBORO	WESTCHESTER			NEWBURGH MID VALLEY	ORITANI HARRISON	SOMERVILLE SOMERVILLE DI
ELTINGVILLE AMBOY	METROPOLITAN OCEANA	MAMARONECK MAMARONECK	PEEKSKILL HOLLOWBROOK DI	WHITE PLAINS COLONY	POUGHKEEPSIE HUDSON PLAZA	WARNER IRVINGTON	TOMS RIVER DOVER
NEW DORP FOX PLAZA	RUGBY WILLIAMSBURG	NEW ROCHELLE PROCTORS	PORT CHESTER EMBASSY	YONKERS PARK HILL	OVERLOOK DI WARWICK WARWICK DI	SANFORD JERSEY CITY STATE	UNION UNION DI WAYNE RKO WAYNE

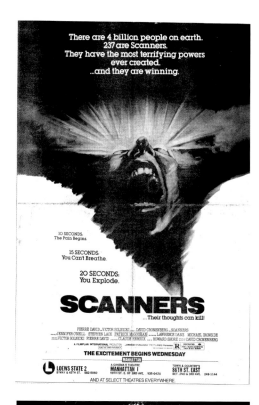

There are 4 billion people on earth.
237 are Scanners.
They have the most terrifying powers ever created.
...and they are winning.

10 SECONDS.
The Pain Begins.

15 SECONDS.
You Can't Breathe.

20 SECONDS.
You Explode.

SCANNERS
...Their thoughts can kill!

PIERRE DAVID and VICTOR SOLNICKI present DAVID CRONENBERG film SCANNERS
starring JENNIFER O'NEILL · STEPHEN LACK · PATRICK McGOOHAN · LAWRENCE DANE · MICHAEL IRONSIDE
produced by VICTOR SOLNICKI · PIERRE DAVID · executive producer CLAUDE HEROUX · music by HOWARD SHORE · written and directed by DAVID CRONENBERG
A FILMPLAN INTERNATIONAL PRODUCTION · AN AVCO EMBASSY PICTURES Release **R**

THE EXCITEMENT BEGINS WEDNESDAY

MANHATTAN

LOEWS STATE 2 B'WAY & 45TH ST. 582-5060 | A CINEMA 5 THEATRE MANHATTAN 1 59TH ST. E. OF 3RD AVE. 935-0420 | TOWN & COUNTRY'S 86TH ST. EAST BET. 2ND & 3RD AVE. 249-1144

AND AT SELECT THEATRES EVERYWHERE.

"MIND-BOGGLING!
The special effects are truly shocking and gory and surely pleasing to the most ghoulish fancies... Provides you with gigantic goose pimples of horror! Kids in search of a movie thrill will be delighted."
—Archer Winsten, N.Y. POST

"A POP MIND-BLOWER.
A tense and unusually brainy chiller."
—Gary Arnold, WASHINGTON POST

10 SECONDS.
The Pain Begins.

15 SECONDS.
You Can't Breathe.

20 SECONDS.
You Explode.

SCANNERS
...Their thoughts can kill!

PIERRE DAVID and VICTOR SOLNICKI present DAVID CRONENBERG film SCANNERS
starring JENNIFER O'NEILL · STEPHEN LACK · PATRICK McGOOHAN
also starring LAWRENCE DANE · MICHAEL IRONSIDE produced by VICTOR SOLNICKI · PIERRE DAVID
executive producer CLAUDE HEROUX · music by HOWARD SHORE · written and directed by DAVID CRONENBERG
A FILMPLAN INTERNATIONAL PRODUCTION · AN AVCO EMBASSY PICTURES Release **R**

Now Playing at a Select Theatre Near You

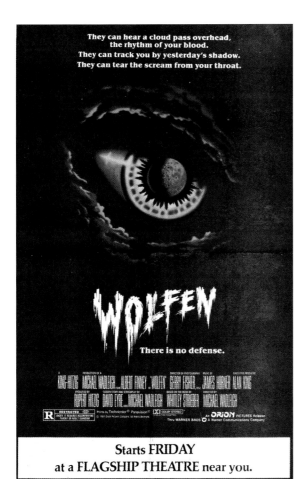

They can hear a cloud pass overhead,
the rhythm of your blood.
They can track you by yesterday's shadow.
They can tear the scream from your throat.

WOLFEN

There is no defense.

**Starts FRIDAY
at a FLAGSHIP THEATRE near you.**

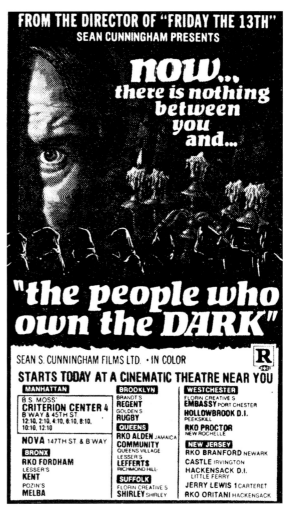

FROM THE DIRECTOR OF "FRIDAY THE 13TH"
SEAN CUNNINGHAM PRESENTS

now...
there is nothing
between
you
and...

"the people who
own the DARK"

SEAN S. CUNNINGHAM FILMS LTD. · IN COLOR
STARTS TODAY AT A CINEMATIC THEATRE NEAR YOU

"A chilling blend of psychological and supernatural terror...
The film succeeds in fusing the scariest elements from Nicholas
Roeg's 'Don't Look Now' and Roman Polanski's 'Repulsion.'"
—Gary Arnold, The Washington Post

"A nearly flawless gem of supernatural mystery."
—Pat Dowell, The Washington Star

The Haunting of Julia

From the author
of "GHOST STORY," Peter Straub.

MIA FARROW · TOM CONTI
in THE HAUNTING OF JULIA Starring KEIR DULLEA
ROBIN GAMMELL • JILL BENNETT • CATHLEEN NESBITT
Produced by PETER FETTERMAN and ALFRED PARISER
Executive Producer JULIAN MELZACK Directed by RICHARD LONCRAINE
Music by COLIN TOWNS Screenplay by DAVE HUMPHRIES
Read the Pocket Book A DISCOVERY FILM RELEASE

STARTS TODAY
THE Coronet

1982

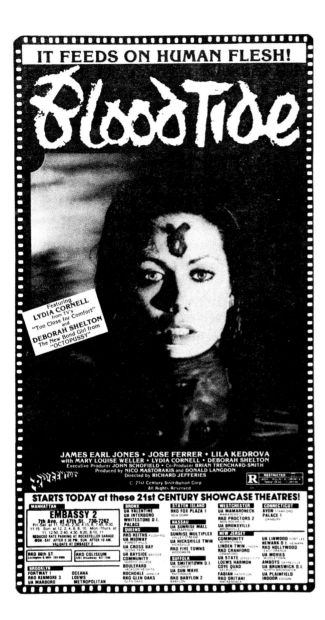
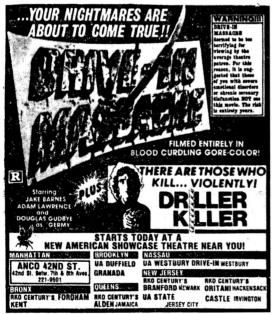

193

ANDY WARHOL'S FRANKENSTEIN & HOUSE OF WAX

The surprise success of the low-budget 3-D Western *Comin' at Ya!* in 1981 led to a sudden resurgence of dimensional film fare. While various studios and producers rushed to get new 3-D films ready for the marketplace, a few enterprising distributors got existing features back on screens. Among them were two films with diametrically opposed approaches to horror: 1973's guts-in-your-face opus *Andy Warhol's Frankenstein* (a.k.a. *Flesh for Frankenstein*), and the far less explicit, more atmospheric *House of Wax* from 20 years earlier. The latter had already been reissued in 1971 – the first time the actor credited in the movie as "Charles Buchinsky" was added to the billing block under his better-known *nom de film*: Charles Bronson.

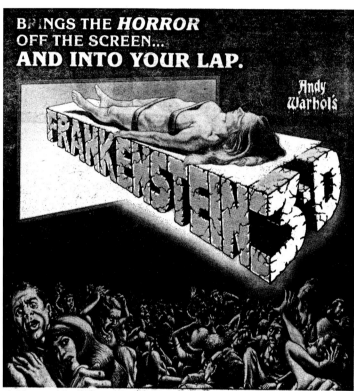

BRINGS THE *HORROR* OFF THE SCREEN... **AND INTO YOUR LAP.**

Andy Warhol's

R RESTRICTED
UNDER 17 REQUIRES ACCOMPANYING PARENT OR ADULT GUARDIAN

ANDY WARHOL'S "FRANKENSTEIN" • A Film By PAUL MORRISSEY
A CARLO PONTI-BRAUNSBERG-RASSAM PRODUCTION
DISTRIBUTED BY ALMI CINEMA 5 FILMS
A LANDMARK FILMS RELEASE

THESE THEATRES HAVE BEEN SPECIALLY EQUIPPED TO
VIEW "FRANKENSTEIN" IN REMARKABLE EXTRA-DEPTH 3-D

STARTS TODAY AT A "3-D HORROR" THEATRE NEAR YOU

 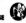

MANHATTAN	BROOKLYN	NASSAU		NEW JERSEY	
RKO CENTURY **RKO CINERAMA TWIN** 47TH ST. & B'WAY. 975-8366 12, 1:50, 3:40, 5:35, 7:35, 9:25	GOLDEN **FORTWAY FIVEPLEX**	RKO CENTURY **RKO 5 TOWNS** WOODMERE	**AMBOY MULTIPLEX CINEMAS** SAYREVILLE	**MORRIS HILLS TWIN** PARSIPPANY	
RKO CENTURY **RKO 86th STREET TWIN** 86TH ST. & LEX.AVE. 289-8900 1, 3, 5, 7, 9	RKO CENTURY **RKO KENMORE FOURPLEX**	RKO CENTURY **RKO FLORAL** FLORAL PARK	RKO CENTURY **RKO BRANFORD FOURPLEX** NEWARK	**NEWARK D.I.** NEWARK	
RKO CENTURY **RKO COLISEUM TWIN** B'WAY & 181ST ST. 927-7200 1, 2:50, 4:40, 6:30, 8:20, 10:10	RKO CENTURY **RKO KINGSWAY TRIPLEX**	**THE MOVIES AT SUNRISE MALL** MASSAPEQUA	**CINEMA** HOBOKEN	RKO CENTURY ✓**RKO ROUTE 4 SEVENPLEX** PARAMUS	
✓**LOEWS 83RD ST. QUAD** B'WAY & 83RD ST. 877-3190 1, 2:50, 4:40, 6:30, 8:20, 10:10	GOLDEN ✓**OCEANA QUAD**	RKO CENTURY **LOEWS NASSAU QUAD** LEVITTOWN	**CIRCLE CINEMAS** BRICKTOWN	RKO CENTURY **RKO ROYAL TWIN** BLOOMFIELD	
A CINEMA 5 THEATRE **GRAMERCY** 23RD ST. AT LEX.AVE. 475-1660 1:30, 3:25, 5:20, 7:15, 9:10, 11	GOLDEN **RIDGEWOOD TRIPLEX**	RKO CENTURY **RKO PLAINVIEW TWIN** PLAINVIEW	RKO CENTURY **RKO CRANFORD TWIN** CRANFORD	**ROCKAWAY TWELVE** ROCKAWAY TOWNSHIP	
BRONX	GOLDEN **RUGBY TWIN**	GG **PORT WASHINGTON TRIPLEX**	**DUNELLEN** DUNELLEN	**LOEWS SHOWBOAT QUAD** EDGEWATER	
RKO CENTURY **RKO FORDHAM FOURPLEX**	**QUEENS**	REDSTONE **SUNRISE MULTIPLEX CINEMAS** VALLEY STREAM	**FABIAN** PATERSON	RKO CENTURY **RKO WAYNE** Starts Wed. 5/19	
LIGHTSTONE **PALACE TWIN**	**ASTORIA QUAD** ASTORIA	**SUFFOLK**	**HILLSBORO** BELLE MEAD		
REDSTONE **WHITESTONE D.I.**	RKO CENTURY **RKO KEITH TRIPLEX** FLUSHING	RKO CENTURY **RKO AMITYVILLE**	RKO CENTURY **RKO HOLLYWOOD** EAST ORANGE	**WESTCHESTER**	
	GOLDEN **MIDWAY QUAD** FOREST HILLS	RKO CENTURY **RKO PLAZA TWIN** PATCHOGUE	**CONNECTICUT**	**UA CINEMA** WHITE PLAINS	
		LOEWS SOUTH SHORE MALL TWIN BAY SHORE	**CINEMA** NORWALK	RKO CENTURY **RKO PROCTOR FIVEPLEX** NEW ROCHELLE	
		STATEN ISLAND	**HIWAY CINEMA** BRIDGEPORT	**UPSTATE N Y**	
		RKO CENTURY **RKO RICHMOND** NEW SPRINGVILLE	RKO CENTURY **RKO MERRITT TWIN** BRIDGEPORT	**NEW PALTZ CINEMA** NEW PALTZ	
			PALACE DANBURY	**PLAZA** MIDDLETOWN	
				SQUIRE NEWBURGH	

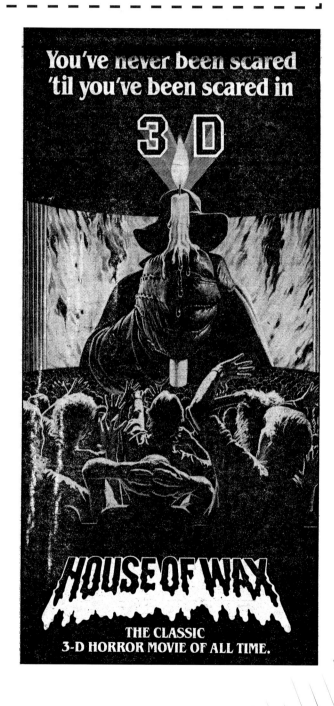

You've never been scared 'til you've been scared in

3·D

HOUSE OF WAX

THE CLASSIC
3-D HORROR MOVIE OF ALL TIME.

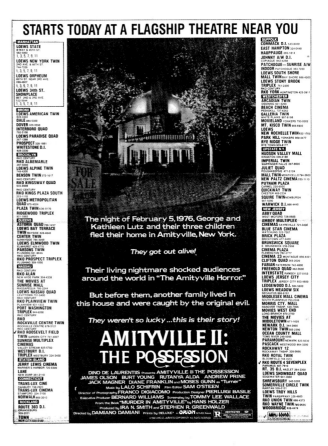

The night of February 5, 1976, George and Kathleen Lutz and their three children fled their home in Amityville, New York.

They got out alive!

Their living nightmare shocked audiences around the world in "The Amityville Horror."

But before them, another family lived in this house and were caught by the original evil.

They weren't so lucky...this is their story!

AMITYVILLE II: THE POSSESSION

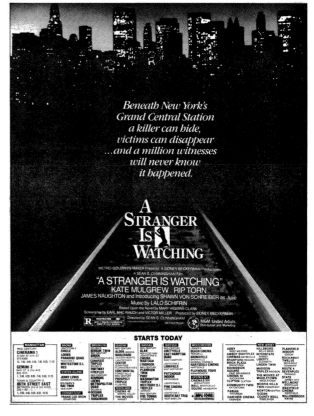

Beneath New York's Grand Central Station a killer can hide, victims can disappear ...and a million witnesses will never know it happened.

A STRANGER IS WATCHING

METRO-GOLDWYN-MAYER Presents A Sidney Beckerman Production A SEAN S. CUNNINGHAM Film "A STRANGER IS WATCHING" KATE MULGREW RIP TORN JAMES NAUGHTON and Introducing SHAWN VON SCHREIBER as Julie Music by LALO SCHIFRIN Based Upon the Novel by MARY HIGGINS CLARK Screenplay by EARL MAC RAUCH and VICTOR MILLER Produced by SIDNEY BECKERMAN Directed by SEAN S. CUNNINGHAM MGM United Artists Distribution and Marketing

STARTS TODAY

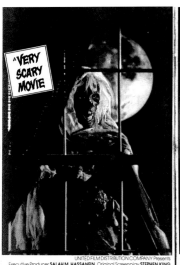

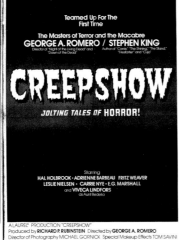

HALLOWEEN III: SEASON OF THE WITCH

Today, many genre buffs appreciate *Halloween III*'s divergence from the Michael Myers formula to offer a different flavor of All Hallow's horror. Back at the time of its release, it was largely rejected by fans wondering why their favorite masked slasher hadn't been resurrected for this go-round. And while a handful of reviewers enjoyed the venture into fresh territory, others felt the trip just wasn't necessary.

"[P]robably as good as any cheerful ghoul could ask for...*Halloween III* means to be funny and frequently is...Mr. Wallace clearly has a fondness for the clichés he is parodying and he does it with style."
— Vincent Canby, *The New York Times*

"The third installment of the series is a relentless, offensive exploitation of the most vulnerable of children's fears. There is no happy ending, no return to safety for the frightened viewer – *Halloween III* offers only revulsion, perversion, and the relentless assault of the stuff of nightmares."
— BILL NICHOLS, *JACKSON (MS) CLARION-LEDGER*

"It finds a new angle on the holiday and manages to turn into an entertaining thriller. It throws out the worn out characters from the earlier movies in favor of a far-fetched but intriguing story."
— Roger Catlin, *Omaha World-Herald*

"Though the story itself is far fetched even by fantasy/horror standards, it is also loads more ambitious than its single-minded precursors. Add to this the usual quota of gross-out moment, and loads of *Psycho* in-jokes (I spotted seven or eight), and you've got an outrageous, genuinely spooky genre outing."
— Glenn Lovell, *San Jose Mercury News*

"*Halloween III: Season of the Witch* has the dubious distinction of being the first movie about Halloween that not only will not scare you, but is guaranteed to put you to sleep... I've had worse scares from my goldfish bowl."
— Rex Reed, *New York Post*

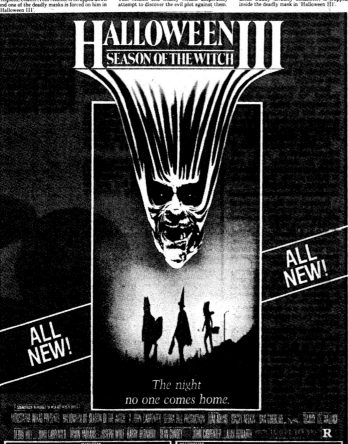

197

DEATH VALLEY

While on vacation in Arizona with my family in summer 1981, I came across an intriguing ad for a horror movie sneak preview. Since I hadn't read anything about *Death Valley* in any genre and trade magazines, my curiosity was piqued. It wasn't until nearly a year later that I would finally get to see the film, now advertised with two different degrees of emphasis on terrorizing the little protagonist, *A Christmas Story*'s Peter Billingsley.

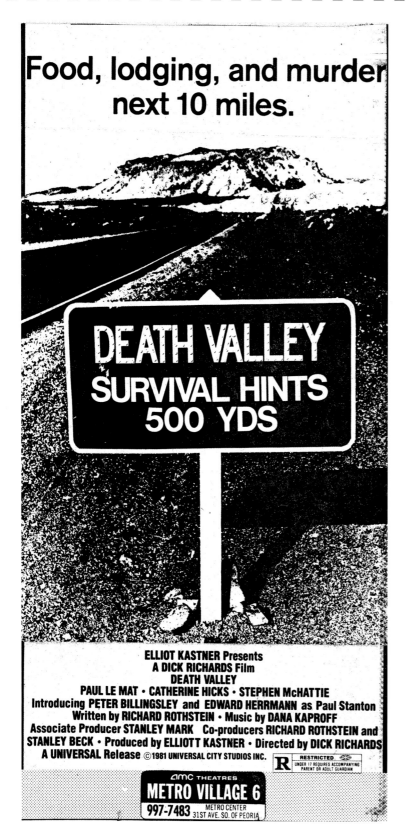

Food, lodging, and murder next 10 miles.

DEATH VALLEY
SURVIVAL HINTS
500 YDS

ELLIOT KASTNER Presents
A DICK RICHARDS Film
DEATH VALLEY
PAUL LE MAT · CATHERINE HICKS · STEPHEN McHATTIE
Introducing PETER BILLINGSLEY and EDWARD HERRMANN as Paul Stanton
Written by RICHARD ROTHSTEIN · Music by DANA KAPROFF
Associate Producer STANLEY MARK Co-producers RICHARD ROTHSTEIN and
STANLEY BECK · Produced by ELLIOTT KASTNER · Directed by DICK RICHARDS
A UNIVERSAL Release ©1981 UNIVERSAL CITY STUDIOS INC.

RESTRICTED
UNDER 17 REQUIRES ACCOMPANYING
PARENT OR ADULT GUARDIAN

AMC THEATRES
METRO VILLAGE 6
997-7483 METRO CENTER
31ST AVE. SO. OF PEORIA

NOT EVEN A SCREAM ESCAPES...

DEATH VALLEY

ELLIOTT KASTNER · A DICK RICHARDS FILM · DEATH VALLEY
PAUL LE MAT · CATHERINE HICKS · STEPHEN McHATTIE
PETER BILLINGSLEY · EDWARD HERRMANN · PAUL STANTON
RICHARD ROTHSTEIN · DANA KAPROFF · STANLEY MARK
RICHARD ROTHSTEIN · STANLEY BECK · ELLIOTT KASTNER
DICK RICHARDS · A UNIVERSAL RELEASE R RESTRICTED

Not Even A Scream Escapes.

DEATH VALLEY

ELLIOTT KASTNER Presents A DICK RICHARDS FILM "DEATH VALLEY"
PAUL LE MAT · CATHERINE HICKS · STEPHEN McHATTIE
Introducing PETER BILLINGSLEY and EDWARD HERRMANN as PAUL STANTON
Written by RICHARD ROTHSTEIN Music by DANA KAPROFF Associate Producer STANLEY MARK
Co-producers RICHARD ROTHSTEIN and STANLEY BECK Produced by ELLIOTT KASTNER
Directed by DICK RICHARDS · A UNIVERSAL RELEASE R

SEASON OF THE WITCH

In 1972, George A. Romero shot his witchcraft drama under the title *Jack's Wife*. The following year, distributor Jack H. Harris cut just over 40 minutes from Romero's 130-minute version and released it as *Hungry Wives*, with posters and ads selling it as a soft-core porn flick. It was then reissued in '82 with another misleading campaign that promised a movie more frightening than it actually was — and attempted to cash in on this year's release of *Halloween III: Season of the Witch*.

SCREAMERS

One of the more notorious false claims in horror promotion history was affixed to the posters and ads for New World's *Screamers*. There are not, in fact, any "men turned inside out" in the film, a combination of Sergio Martino's Italian monster adventure *Island of the Fish Men* and a new prologue shot Stateside by Miller Drake, and audiences expecting this shocking sight were not pleased.

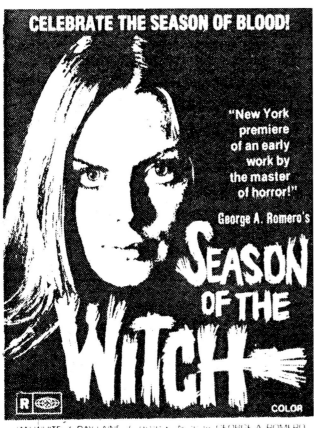

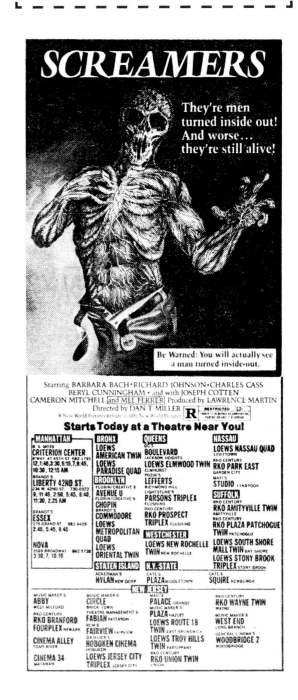

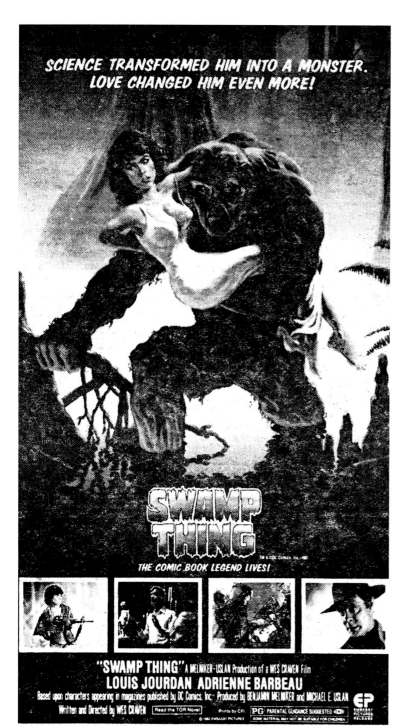

**SCIENCE TRANSFORMED HIM INTO A MONSTER.
LOVE CHANGED HIM EVEN MORE!**

SWAMP THING

THE COMIC BOOK LEGEND LIVES!

TM & © DC Comics, Inc.-1981

"SWAMP THING" A MELNIKER-USLAN Production of a WES CRAVEN Film
LOUIS JOURDAN ADRIENNE BARBEAU
Based upon characters appearing in magazines published by DC Comics, Inc. Produced by BENJAMIN MELNIKER and MICHAEL E. USLAN
Written and Directed by WES CRAVEN [Read the TOR Novel] [PG PARENTAL GUIDANCE SUGGESTED] Prints by CFI © 1982 EMBASSY PICTURES
SOME MATERIAL MAY NOT BE SUITABLE FOR CHILDREN

Starts Today at a Theatre Near You!

Q

Larry Cohen employed some of his usual guerrilla tactics when shooting his monster movie (originally titled *The Winged Serpent*) on and above the streets of New York, and United Film Distribution followed suit with the promotional campaign, scattering "Q is Coming" signs around Manhattan in advance of its release. Once it flew into theaters there and elsewhere, reviews were wildly mixed, the responses encapsulated by a comment Rex Reed reportedly made to producer Samuel Z. Arkoff following a Cannes screening: "What a surprise! All the dreck — and right in the middle of it, a great Method performance by Michael Moriarty!" (Arkoff's answer: "The dreck was my idea.")

"This is either one of the worst monster movies ever made or else one of the subtlest comedies. If there is a reason to see it, it's to watch Michael Moriarty giving one of the flakiest performances of his career, whining and twitching and enjoying every minute of it."
— Ernest Leogrande, *New York Daily News*

"One of the clever things about *Q* is that for most of its 90-odd minutes you never see more than a fleeting glimpse of the title character, Quetzalcoatl. ... Even more brilliant is Michael Moriarty...whose tendency toward bizarre, mannered performances suits the horror of *Q* to a T."
— ALEX KENEAS,
NEW YORK NEWSDAY

"*Q* is a delightfully irreverent monster movie that retains a solid sense of the necessary ingredients of classic schlock horror. ... Moriarty's high-voltage mugging as Quinn is alone worth the price of admission."
— Bill Nichols, *Jackson (MS) Clarion-Ledger*

"Just because of what Moriarty does with his sloppily spoken, wild-eyed, arm-flailing low life, *Q* has a certain bizarre value. ... [It] also boasts decent special effects, and a grisly sense of fun. ... But without Moriarty, it would all be merely ho-hum."
— Malcolm L. Johnson, *Hartford Courant*

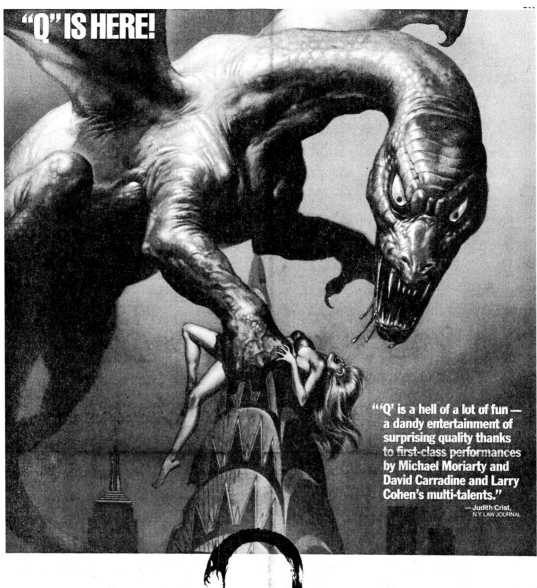

"Q" IS HERE!

"'Q' is a hell of a lot of fun — a dandy entertainment of surprising quality thanks to first-class performances by Michael Moriarty and David Carradine and Larry Cohen's multi-talents."
— Judith Crist, N.Y. LAW JOURNAL

It's name is Quetzalcoatl... 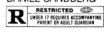 *just call it "Q"...* *that's all you'll have time to say before it tears you apart!*

MICHAEL MORIARTY · **CANDY CLARK** · **DAVID CARRADINE** AS SHEPARD · **RICHARD ROUNDTREE**

IN A LARRY COHEN FILM "Q"

SAMUEL Z. ARKOFF PRESENTS A LARCO PRODUCTION

MUSIC by	PRODUCTION EXECUTIVE	WRITTEN, PRODUCED and DIRECTED by	EXECUTIVE PRODUCER
ROBERT O. RAGLAND	PETER SABISTON	LARRY COHEN	DANIEL SANDBERG

A SALAH M. HASSANEIN Presentation Released by UNITED FILM DISTRIBUTION COMPANY

R RESTRICTED
UNDER 17 REQUIRES ACCOMPANYING PARENT OR ADULT GUARDIAN

© 1982 LARCO PRODUCTIONS, INC.

STARTS TODAY AT A THEATRE NEAR YOU

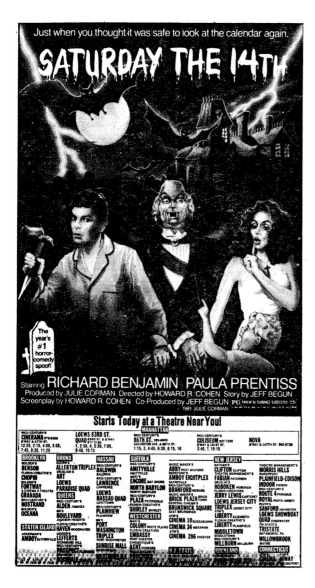

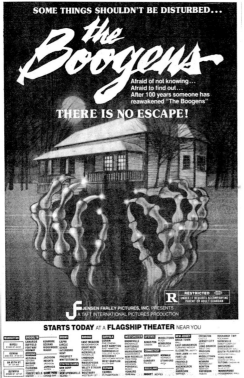

THE SLUMBER PARTY MASSACRE

Misogyny was a charge often leveled by critics against the slasher movies of the early 1980s. So when a female writer and director took on the form, the result would naturally eschew the more offensive elements in favor of a more sympathetic presentation, right? Not according to the reviews at the time.

"It is disheartening to look at the credits of *The Slumber Party Massacre* and see that its screenplay is written by feminist-lesbian polemicist-writer Rita Mae Brown. In spite of some credibly and sympathetically written relationships between characters and some good performances by its young actors, *The Slumber Party Massacre* is yet another reprehensible and gory exploitation movie."

— Linda Gross, *Los Angeles Times*

"*Slumber Party Massacre*, says author Rita Mae Brown, is a satire on slaughter movies. Good thing she told us, because we normally associate satire with at least a hint of subtlety, and *Slumber Party Massacre* is about as subtle as a kick in the groin."

— David Hinckley, *New York Daily News*

"*Slumber Party Massacre* was written and directed by women, so it could be viewed as a giant step backward for feminism. But because the film is as bad as the worst movies produced by men, you could say that women have made a mighty stride toward true equality."

— ROBERT C. TRUSSELL,
THE KANSAS CITY STAR

"What do you get when today's cheap, bloody horror movie format is turned over to a woman screenwriter and a woman director? Not much, and nothing good. ... And the fact that Miss Brown and Miss Jones have obviously tried to inject a little satire and innovation into the genre just makes the ultimate vulgarity of their film all the more disappointing."

— Janet Maslin, *The New York Times*

1982

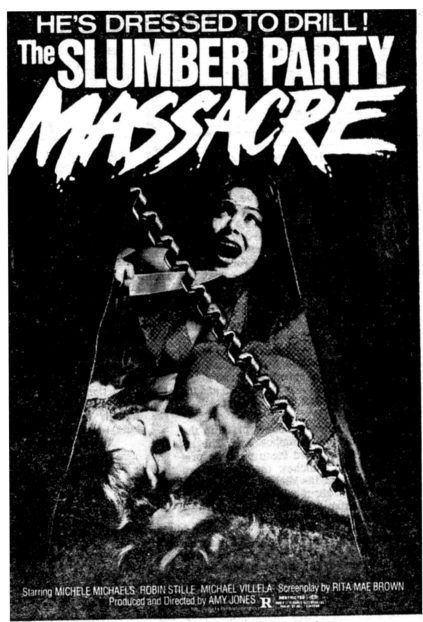

HUMONGOUS

The poster tagline for Paul Lynch's follow-up to *Prom Night* (released in New York the same day as *E.T.*!) read, "Here are the monster's little toys. Once they were little girls and boys." Although the movie's victims are not so little anymore, it was probably questions of taste rather than accuracy that resulted in different copy being used for the newspaper ads.

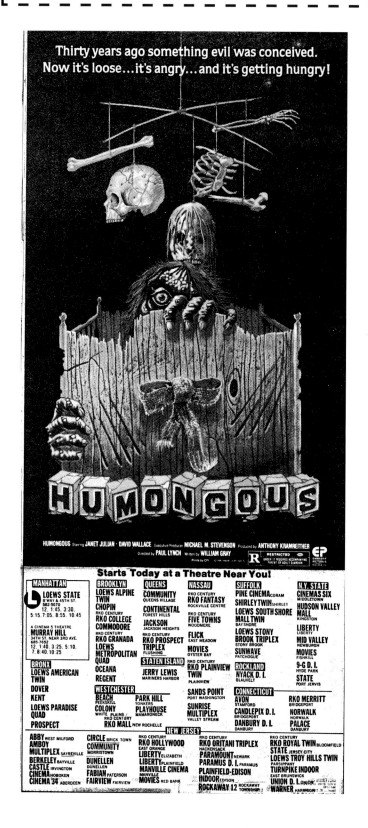

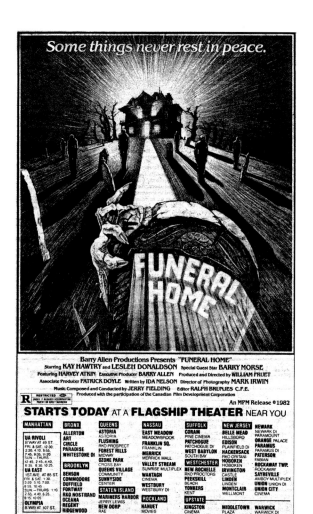

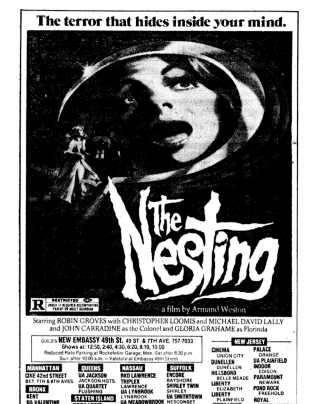

THE PHANTOM OF TERROR

More than a decade after its U.S. theatrical run from Universal Marion Corporation, Dario Argento's *giallo* debut *The Bird with the Crystal Plumage* was picked up by 21st Century Distribution Corp., which slapped a new title on it and sent it back out to theaters. (Give 'em credit for actually acknowledging the original name in the ads, albeit in tiny type.) Around this time, 21st Century did the same with a couple of other UMC films, including *The Night Visitor*, which became *Lunatic* (as seen in the 1981 section).

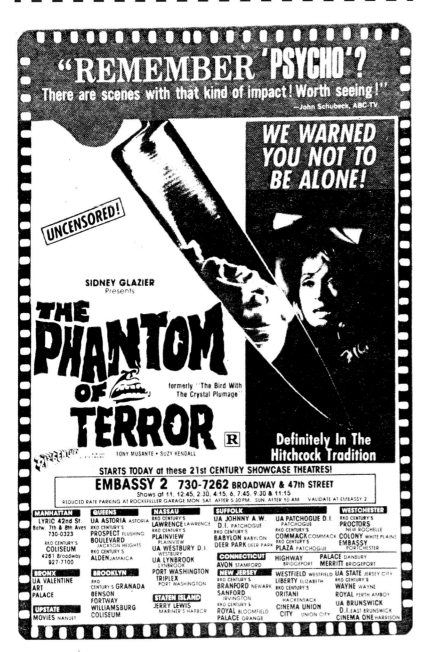

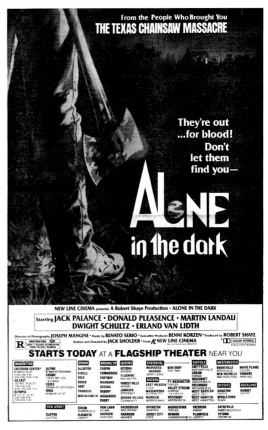

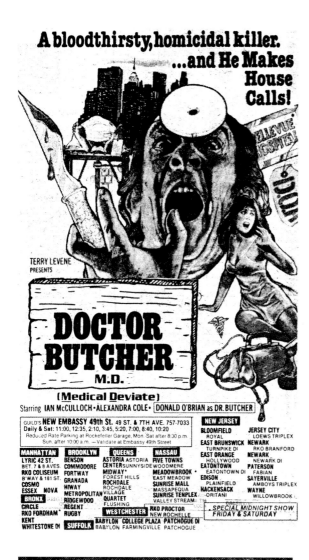

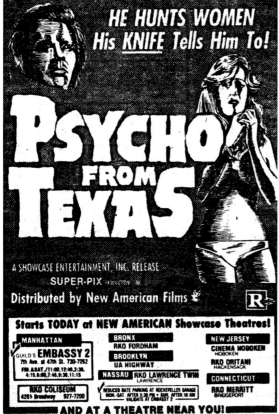

FRIDAY THE 13TH PART III

Although *Friday the 13th Part II* had been highly profitable in 1981, its box-office take was a significant step down from its predecessor. To give the second sequel additional appeal, the producers introduced the third dimension, and *Part III* became the widest 3-D release in history at that point. It was also the highest-grossing of all the Paramount *Friday* sequels. And while the critics had almost unanimously slammed *Part II*, a few of them begrudgingly found nice things to say about *Part III*.

"*Friday the 13th Part III* would be a little better than *Part I* or *Part II* even without 3-D. ... [It] isn't any more vicious or clever than its predecessors, which were a lot more vicious than clever, to be sure. But it's a little more adept at teasing the audience. Mr. Miner generates a few amusing and hair-raising false alarms, and he coaxes a better level of acting out of [the] cast."

— Janet Maslin, *The New York Times*

"Rest assured, *Part III* is as bloody, banal, and stupid as the others— perhaps even more stupid. But, shock of shock, it is also occasionally funny. ... [W]hat makes *Friday the 13th Part III* work better than expected is that the 3-D...actually turns out to be a kick."

— PETER TRAVERS, *GANNETT NEWS SERVICE*

"The heavy-duty slaughter doesn't come until one hour into the film; before that, *Part III* is almost cheerful and innocent in its approach to the 3-D effects. ... It's too bad that the rest of the film couldn't have been more upbeat; instead, *Friday the 13th Part III* wallows in blood and knives being stuck through people's chests."

— Gene Siskel, *Chicago Tribune*

"This so-called 'horror' film is really nothing more than a 'snuff' movie with phony blood and gruesome special effects invented by minds almost as sick as those who produce the real thing."

— Gene Triplett, *The Daily Oklahoman*

1982

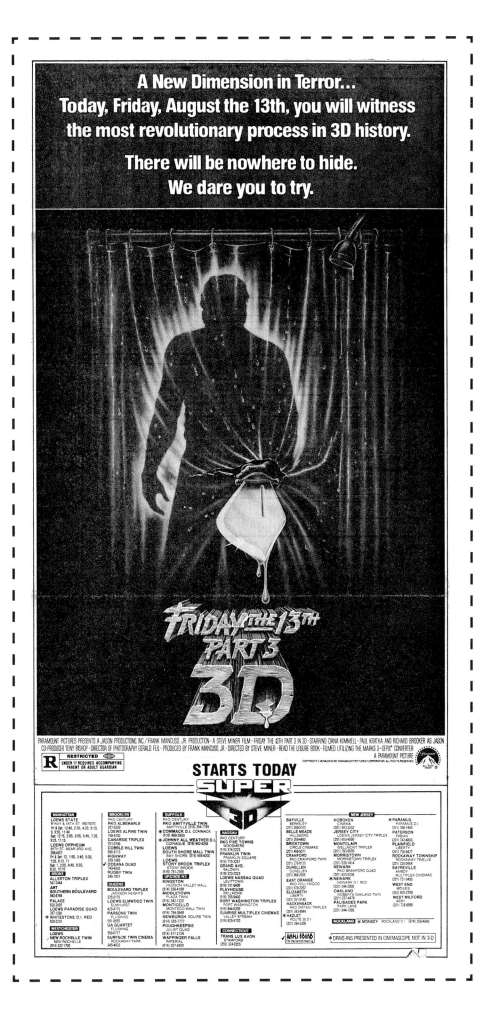

THE BURNING

When this summer-camp showcase for Tom Savini's gore effects first went into release via Filmways in summer 1981, the advertising art featured the murderous Cropsy raising his giant shears over a couple clinching in a lake. The following year, Filmways was bought by Orion Pictures, which finally brought *The Burning* to New York in November 1982 and promoted it with this more expressionistic ad.

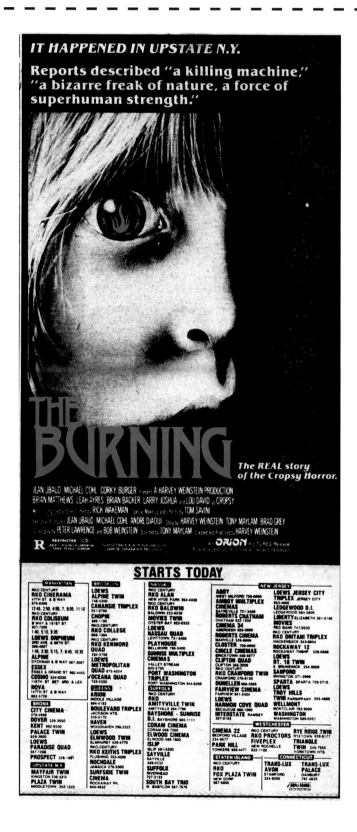

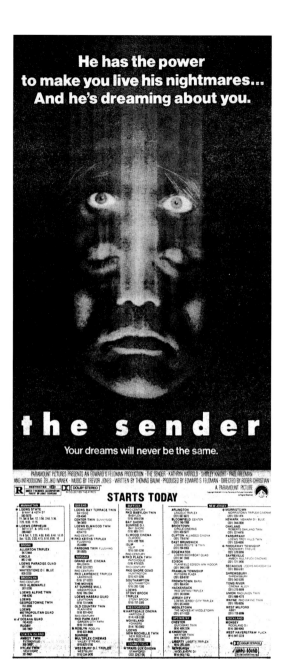

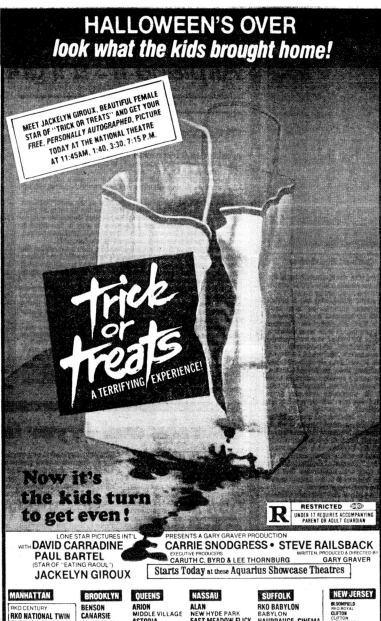

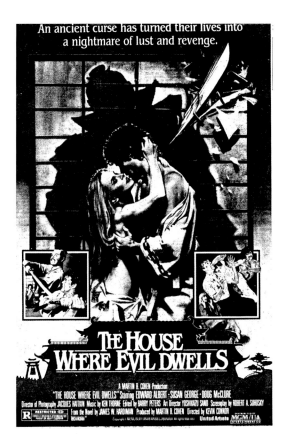

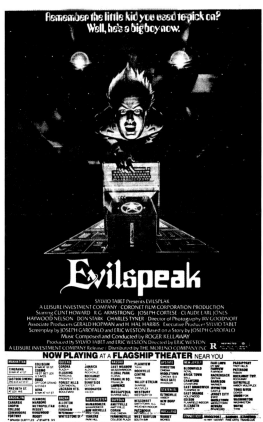

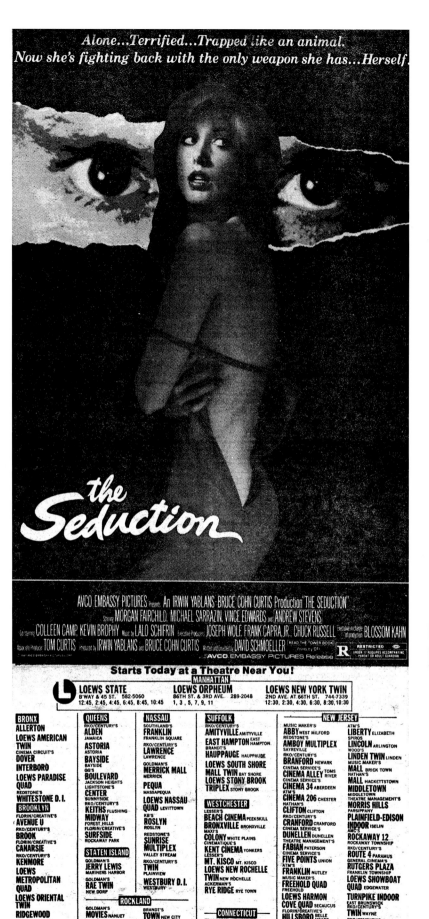

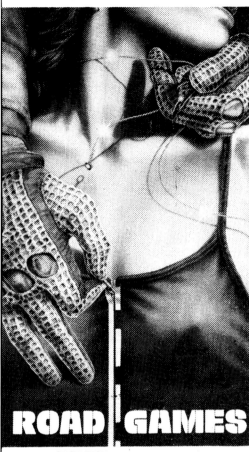

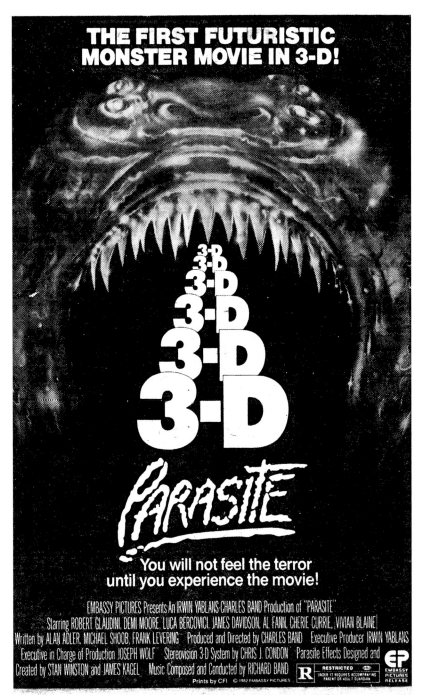

THE FIRST FUTURISTIC MONSTER MOVIE IN 3-D!

3-D
3-D
3-D
3-D
3-D
3-D
3-D

PARASITE

You will not feel the terror until you experience the movie!

EMBASSY PICTURES Presents An IRWIN YABLANS-CHARLES BAND Production of "PARASITE" Starring ROBERT GLAUDINI, DEMI MOORE, LUCA BERCOVICI, JAMES DAVIDSON, AL FANN, CHERIE CURRIE, VIVIAN BLAINE Written by ALAN ADLER, MICHAEL SHOOB, FRANK LEVERING Produced and Directed by CHARLES BAND Executive Producer IRWIN YABLANS Executive in Charge of Production JOSEPH WOLF Stereovision 3-D System by CHRIS J. CONDON Parasite Effects Designed and Created by STAN WINSTON and JAMES KAGEL Music Composed and Conducted by RICHARD BAND

RESTRICTED — UNDER 17 REQUIRES ACCOMPANYING PARENT OR ADULT GUARDIAN

EMBASSY PICTURES RELEASE

Prints by CFI © 1982 EMBASSY PICTURES

Starts Today at a Theatre Near You!

MANHATTAN

LOEWS STATE 582-5070 B'WAY & 45 ST.
12, 1:35, 3:10, 4:50, 6:30, 8:10, 9:50, 11:30

UA gemini 1 832-1670 2ND AVE. & 64TH ST.
1, 2:45, 4:30, 6:15, 8, 9:45, 11:30

BRONX
ALLERTON
ART
LIGHTSTONE'S
PALACE
LOEWS PARADISE
QUAD

BROOKLYN
LOEWS ALPINE TWIN
RKO/CENTURY'S
KENMORE
GOLDEN'S
OCEANA
RIDGEWOOD
GOLDEN'S
RUGBY

WESTCHESTER
UA CINEMA WHITE PLAINS

QUEENS
RKO/CENTURY'S
ALDEN JAMAICA
ASTORIA ASTORIA
GG'S
BOULEVARD JACKSON HEIGHTS
CROSS BAY OZONE PARK
RKO/CENTURY'S
KEITHS FLUSHING
MIDWAY FOREST HILLS

STATEN ISLAND
GOLDEN'S
JERRY LEWIS MARINERS HARBOR
GOLDMAN'S
RAE TWIN NEW DORP
RKO/CENTURY'S
PROCTORS NEW ROCHELLE

NASSAU
SOUTHLAND'S
FRANKLIN FRANKLIN SQUARE
RKO/CENTURY'S
LAWRENCE LAWRENCE
GOLDMAN'S
MERRICK MALL MERRICK
MOVIES AT SUNRISE MALL MASSAPEQUA
LOEWS NASSAU
QUAD LEVITTOWN
REDSTONE'S
SUNRISE MULTIPLEX VALLEY STREAM
GG'S
TRIPLEX PORT WASHINGTON
RKO/CENTURY'S
TWIN PLAINVIEW

SUFFOLK
RKO/CENTURY'S
AMITYVILLE AMITYVILLE
ATM'S
ELWOOD ELWOOD
LOEWS SOUTH SHORE MALL TWIN BAY SHORE
LOEWS STONY BROOK TRIPLEX STONY BROOK
SUNWAVE PATCHOGUE

ROCKLAND
GOLDMAN'S
MOVIES NANUET

N.Y. STATE
FLORIN/CREATIVE'S
NEW PALTZ NEW PALTZ
CATE'S
PLAZA MIDDLETOWN
CATE'S
SQUIRE NEWBURGH

REDSTONE'S
AMBOY MULTIPLEX SAYREVILLE
RKO/CENTURY'S
BRANFORD NEWARK
ATM'S
CINEMA HOBOKEN
ATM'S
CINEMA 206 CHESTER
MUSIC MAKER'S
CIRCLE BRICK TOWN
RKO/CENTURY'S
CRANFORD CRANFORD
CINEMA SERVICE'S
DUNELLEN DUNELLEN
THEATRE MANAGEMENT'S
FABIAN PATERSON
FLORIN/CREATIVE'S
HILLSBORO BELLE MEADE
RKO/CENTURY'S
HOLLYWOOD EAST ORANGE
LOEWS JERSEY CITY TRIPLEX JERSEY CITY
ATM'S
LIBERTY ELIZABETH
WOOD'S
LINDEN TWIN LINDEN

NEW JERSEY
WOOD'S
LOST PICTURE SHOW UNION
MIDDLETOWN MIDDLETOWN
THEATRE MANAGEMENT'S
MORRIS HILLS PARSIPPANY
WOOD'S
MORRISTOWN TRIPLEX MORRISTOWN
RKO/CENTURY'S
ORITANI HACKENSACK
PLAINFIELD EDISON INDOOR ISELIN
AMC'S
ROCKAWAY 12 ROCKAWAY TOWNSHIP
RKO/CENTURY'S
ROYAL BLOOMFIELD
GENERAL CINEMA'S
RUTGERS PLAZA FRANKLIN TOWNSHIP
LOEWS SHOWBOAT QUAD EDGEWATER
RKO/CENTURY'S
TWIN WAYNE

CONNECTICUT
TRANS-LUX
AVON STAMFORD
ATM'S
CINEMA NORWALK
ATM'S
HIWAY BRIDGEPORT
TRANS-LUX
PALACE DANBURY

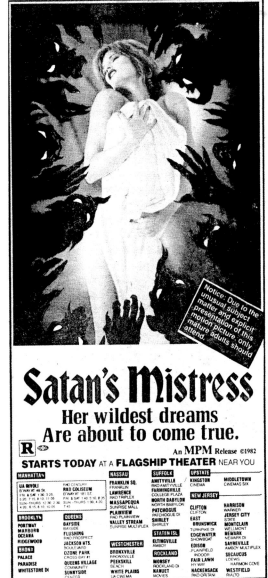

Notice: Due to the unusual subject matter and explicit presentation of this motion picture only mature adults should attend.

Satan's Mistress

Her wildest dreams Are about to come true.

R

An MPM Release ©1982

STARTS TODAY AT A **FLAGSHIP THEATER** NEAR YOU

MANHATTAN
UA RIVOLI B'WAY AT 49 St.
FRI & SAT 1:00 3:25 5:20 7:15 9:10 11:05 SUN-THURS 12:30 2:30

RKO CENTURY
RKO COLISEUM B'WAY AT 181 ST.
FRI & SAT 1:40 5:10 8:35 SUN-THURS 1:00 4:20 7:45

BROOKLYN
PORTWAY MARBORO OCEANA RIDGEWOOD

BRONX
PALACE PARADISE WHITESTONE DI

QUEENS
BAYSIDE BAYSIDE
FLUSHING RKO PROSPECT
JACKSON HTS. BOULEVARD
OZONE PARK CROSS BAY #1
QUEENS VILLAGE COMMUNITY
SUNNYSIDE CENTER

NASSAU
FRANKLIN SQ. FRANKLIN
LAWRENCE RKO TRIPLEX
MASSAPEQUA SUNRISE MALL
PLAINVIEW RKO PLAINVIEW
VALLEY STREAM SUNRISE MULTIPLEX

WESTCHESTER
BRONXVILLE BRONXVILLE
PEEKSKILL BEACH
WHITE PLAINS UA CINEMA

SUFFOLK
AMITYVILLE RKO AMITYVILLE
FARMINGVILLE COLLEGE PLAZA
NORTH BABYLON NORTH BABYLON
PATCHOGUE PATCHOGUE DI
SHIRLEY SHIRLEY

STATEN ISL
ELTINGVILLE AMBOY

ROCKLAND
MONSEY ROCKLAND DI
NANUET MOVIES

UPSTATE
KINGSTON CINEMA
MIDDLETOWN CINEMAS SIX

NEW JERSEY
CLIFTON CLIFTON
EAST BRUNSWICK TURNPIKE DI
EDGEWATER SHOWBOAT
EDISON PLAINFIELD INDOOR
FAIR LAWN HY WAY
HACKENSACK RKO ORITANI

HARRISON WARNER
JERSEY CITY STATE
MONTCLAIR WELLMONT
NEWARK NEWARK DI
SAYREVILLE AMBOY MULTIPLEX
SECAUCUS LOEWS HARMON COVE
WESTFIELD RIALTO

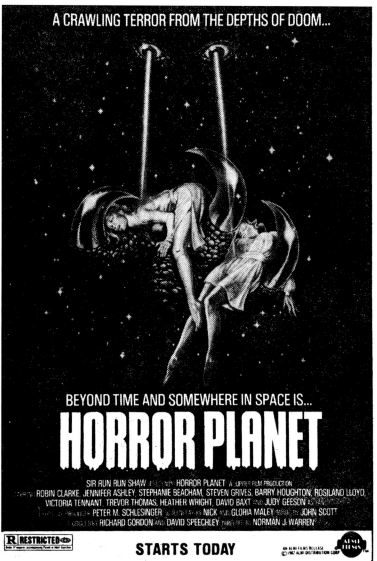

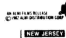

THE THING

As John Carpenter fans know, the director's first major studio picture was excoriated by critics upon its theatrical release, only to be recognized for its superior quality years later. Rob Bottin's astonishing effects, initially dismissed as a bloody liability, are now properly seen as landmark, unparalleled creations. There were supporters here and there, whose praise is excerpted below, along with just enough comments from detractors.

"As suspense entertainment the picture ranks high, and as horror it's even better. A cast of comparative unknowns permit easy belief to the observer while Carpenter...works effectively when given material as gruesome as this."

—Archer Winsten, *New York Post*

"This version is visually more elaborate and faster-paced than the earlier one, but its only plot progression is knocking off the cast one by one. ... [Bottin's effects] are truly astonishing, stomach-turning creations that have the look of reality – or unreality – to them."

— Ernest Leogrande, *New York Daily News*

"[A] foolish, depressing, overproduced movie that mixes horror with science fiction to make something that is fun as neither one thing or the other. Sometimes it looks as if it aspired to be the quintessential moron movie of the '80s. ... It qualifies only as instant junk."

— VINCENT CANBY, *THE NEW YORK TIMES*

"...*The Thing* is bereft, despairing, and nihilistic. It is also overpowered by Rob Bottin's visceral and vicious makeup effects. The most disturbing aspect of *The Thing* is its terrible absence of love. The film is so frigid and devoid of feeling that death no longer has any meaning."

— Linda Gross, *Los Angeles Times*

"There is no suspense in Carpenter's version of *The Thing*. ... In any case *Alien* was the last word in people-turning-into-monster movies. All these others have become tiresome, silly and redundant."

— Bernard Drew, *Gannett News Service*

The ultimate in alien terror.

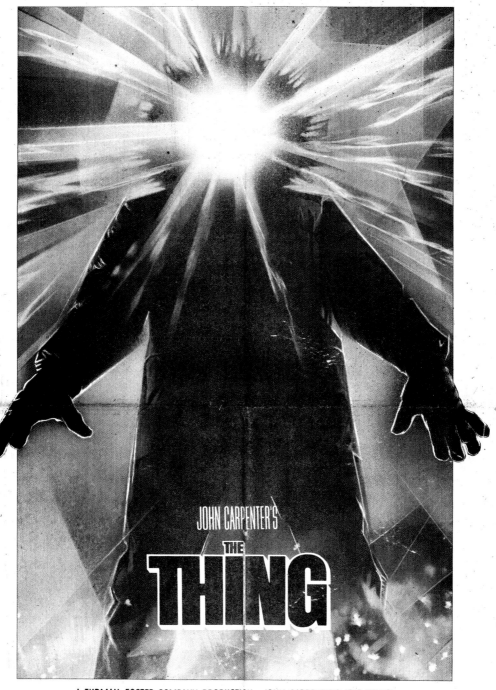

JOHN CARPENTER'S

THE THING

A TURMAN-FOSTER COMPANY PRODUCTION JOHN CARPENTER'S "THE THING"

STARRING
KURT RUSSELL
SCREENPLAY BY
BILL LANCASTER
SPECIAL VISUAL EFFECTS BY
ALBERT WHITLOCK
SPECIAL MAKE-UP EFFECTS BY
ROB BOTTIN
MUSIC BY
ENNIO MORRICONE
DIRECTOR OF PHOTOGRAPHY
DEAN CUNDEY

ASSOCIATE PRODUCER
LARRY FRANCO
EXECUTIVE PRODUCER
WILBUR STARK
CO-PRODUCER
STUART COHEN
PRODUCED BY
DAVID FOSTER & LAWRENCE TURMAN
DIRECTED BY
JOHN CARPENTER

STARTS FRIDAY JUNE 25
AT A UNIVERSAL BLUE RIBBON THEATRE NEAR YOU

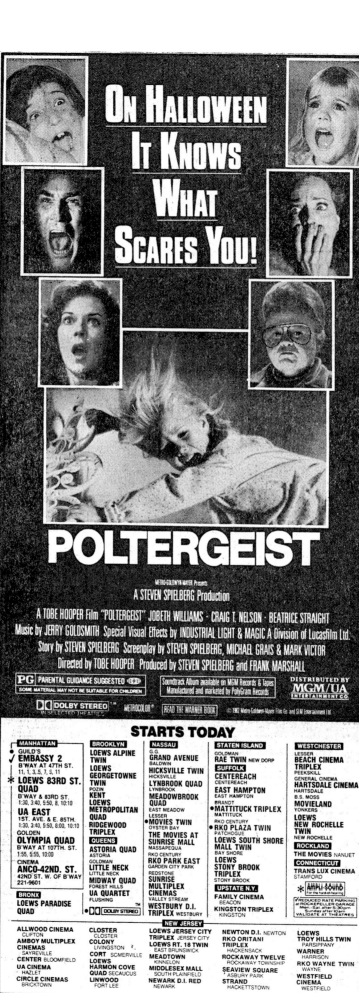

ON HALLOWEEN
IT KNOWS
WHAT
SCARES YOU!

POLTERGEIST

METRO-GOLDWYN-MAYER Presents

A STEVEN SPIELBERG Production

A TOBE HOOPER Film "POLTERGEIST" JOBETH WILLIAMS · CRAIG T. NELSON · BEATRICE STRAIGHT
Music by JERRY GOLDSMITH Special Visual Effects by INDUSTRIAL LIGHT & MAGIC A Division of Lucasfilm Ltd.
Story by STEVEN SPIELBERG Screenplay by STEVEN SPIELBERG, MICHAEL GRAIS & MARK VICTOR
Directed by TOBE HOOPER Produced by STEVEN SPIELBERG and FRANK MARSHALL

PG PARENTAL GUIDANCE SUGGESTED
SOME MATERIAL MAY NOT BE SUITABLE FOR CHILDREN

Soundtrack Album available on MGM Records & Tapes
Manufactured and marketed by PolyGram Records

DISTRIBUTED BY
MGM/UA
ENTERTAINMENT CO.

DOLBY STEREO ™ · METROCOLOR® · READ THE WARNER BOOK · © 1982 Metro-Goldwyn-Mayer Film Co. and SLM Entertainment Ltd.

STARTS TODAY

MANHATTAN
● GUILD'S
✓ **EMBASSY 2**
B'WAY AT 47TH ST.
11, 1, 3, 5, 7, 9, 11
✱ **LOEWS 83RD ST.
QUAD**
B'WAY & 83RD ST.
1:30, 3:40, 5:50, 8, 10:10
UA EAST
1ST. AVE. & E. 85TH.
1:30, 3:40, 5:50, 8:00, 10:10
GOLDEN
OLYMPIA QUAD
B'WAY AT 107TH. ST.
1:55, 5:55, 10:00
CINEMA
ANCO-42ND. ST.
42ND ST. W. OF B'WAY
221-9601

BRONX
**LOEWS PARADISE
QUAD**

BROOKLYN
**LOEWS ALPINE
TWIN**
**LOEWS
GEORGETOWNE
TWIN**
POZIN
KENT
**LOEWS
METROPOLITAN
QUAD**
**RIDGEWOOD
TRIPLEX**

QUEENS
ASTORIA QUAD
ASTORIA
GOLDMAN
LITTLE NECK
LITTLE NECK
MIDWAY QUAD
FOREST HILLS
UA QUARTET
FLUSHING

● DOLBY STEREO

NASSAU
G.G.
GRAND AVENUE
BALDWIN
HICKSVILLE TWIN
HICKSVILLE
LYNBROOK QUAD
LYNBROOK
**MEADOWBROOK
QUAD**
EAST MEADOW
LESSER
● **MOVIES TWIN**
OYSTER BAY
**THE MOVIES AT
SUNRISE MALL**
MASSAPEQUA
RKO CENTURY
RKO PARK EAST
GARDEN CITY PARK
REDSTONE
**SUNRISE
MULTIPLEX
CINEMAS**
VALLEY STREAM
**WESTBURY D.I.
TRIPLEX** WESTBURY

STATEN ISLAND
GOLDMAN
RAE TWIN NEW DORP
SUFFOLK
CENTEREACH
CENTEREACH
EAST HAMPTON
EAST HAMPTON
BRANDT
● **MATTITUCK TRIPLEX**
MATTITUCK
RKO CENTURY
● **RKO PLAZA TWIN**
PATCHOGUE
**LOEWS SOUTH SHORE
MALL TWIN**
BAY SHORE
**LOEWS
STONY BROOK
TRIPLEX**
STONY BROOK

UPSTATE N.Y.
FAMILY CINEMA
BEACON
KINGSTON TRIPLEX
KINGSTON

WESTCHESTER
LESSER
**BEACH CINEMA
TRIPLEX**
PEEKSKILL
GENERAL CINEMA
HARTSDALE CINEMA
HARTSDALE
B.S. MOSS
MOVIELAND
YONKERS
**LOEWS
NEW ROCHELLE
TWIN**
NEW ROCHELLE
ROCKLAND
THE MOVIES NANUET
CONNECTICUT
TRANS LUX CINEMA
STAMFORD

✱ AMPLI-SOUND
for the hard-of-hearing

✓ REDUCED RATE PARKING
at ROCKEFELLER GARAGE
Mon.-Sat. after 5:30pm
Sunday after 10am
VALIDATE AT THEATRES

NEW JERSEY

ALLWOOD CINEMA
CLIFTON
**AMBOY MULTIPLEX
CINEMAS**
SAYREVILLE
CENTER BLOOMFIELD
UA CINEMA
HAZLET
CIRCLE CINEMAS
BRICKTOWN

CLOSTER
CLOSTER
COLONY
LIVINGSTON
CORT SOMERVILLE
LOEWS
**HARMON COVE
QUAD** SECAUCUS
LINWOOD
FORT LEE

**LOEWS JERSEY CITY
TRIPLEX** JERSEY CITY
LOEWS RT. 18 TWIN
EAST BRUNSWICK
MEADTOWN
KINNELON
MIDDLESEX MALL
SOUTH PLAINFIELD
NEWARK D.I. RED
NEWARK

NEWTON D.I. NEWTON
**RKO ORITANI
TRIPLEX**
HACKENSACK
ROCKAWAY TWELVE
ROCKAWAY TOWNSHIP
SEAVIEW SQUARE
ASBURY PARK
STRAND
HACKETTSTOWN

**LOEWS
TROY HILLS TWIN**
PARSIPPANY
WARNER
HARRISON
RKO WAYNE TWIN
WAYNE
**WESTFIELD
CINEMA**
WESTFIELD

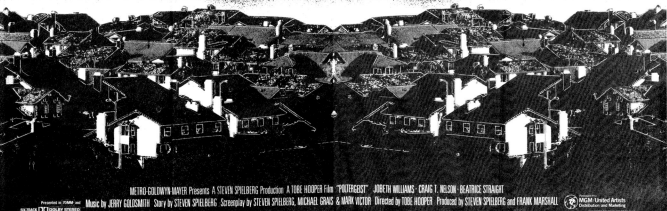

Steven Spielberg has been called the American screen's master story-teller. From the thrashing terror of "Jaws" to the awesome spectacle of "Close Encounters of the Third Kind" to the globe-trotting adventure of "Raiders of the Lost Ark," he has delighted, mystified and scared more audiences... more imaginatively... than any filmmaker of our time.

As producer and co-author of "Poltergeist," Spielberg is joined by co-producer Frank Marshall, with whom he made "Raiders of the Lost Ark," co-authors Michael Grais and Mark Victor, director Tobe Hooper, and the special effects wizardry of Oscar winner Richard Edlund ("Star Wars") and Industrial Light and Magic.

In "Poltergeist," they cross a frightening new threshold, encountering forces which baffle science, defy reason...and turn the once peaceful lives of a normal American family into an existence that must be experienced to be believed.

Opens June 4, 1982.

POLTERGEIST

The first real ghost story.

METRO-GOLDWYN-MAYER Presents A STEVEN SPIELBERG Production A TOBE HOOPER Film "POLTERGEIST" JOBETH WILLIAMS · CRAIG T. NELSON · BEATRICE STRAIGHT
Presented in 70MM and Music by JERRY GOLDSMITH Story by STEVEN SPIELBERG Screenplay by STEVEN SPIELBERG, MICHAEL GRAIS & MARK VICTOR Directed by TOBE HOOPER Produced by STEVEN SPIELBERG and FRANK MARSHALL
SIX-TRACK [DD] DOLBY STEREO

VENOM

Prior to the release of *Venom*, about a deadly black mamba loose in a London townhouse while a kidnapping/hostage scenario goes down, Paramount's marketing team tried to figure out if they should emphasize the snaky menace or be more oblique about the threat. "The bottom line," an executive told *The New York Times*, "is whether snakes hold a fatal fascination for Americans. Are they a turn-on or a turn-off?" The studio eventually decided to have it both ways: the reptile appeared in the pre-release ads, but a more suggestive design was used for opening day and after.

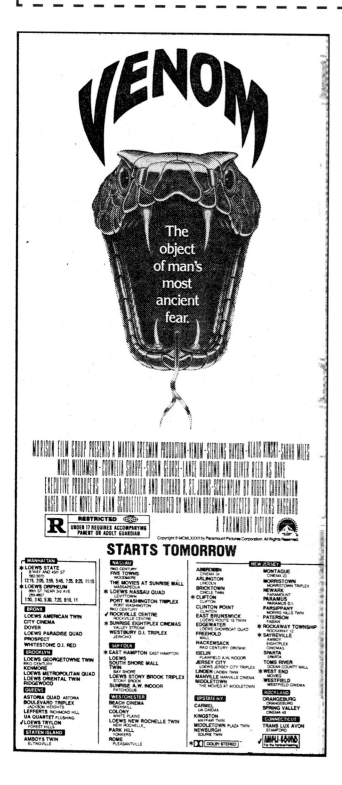

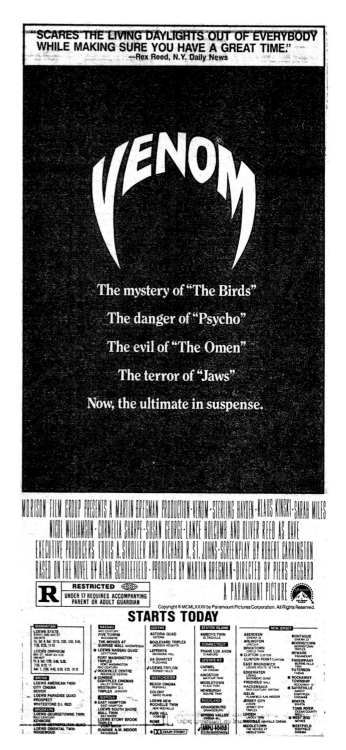

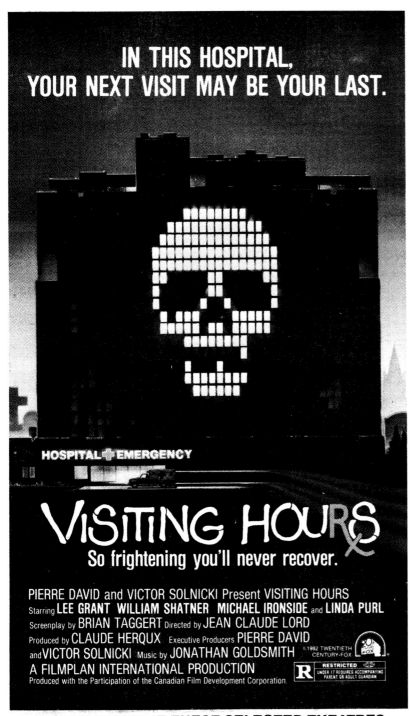
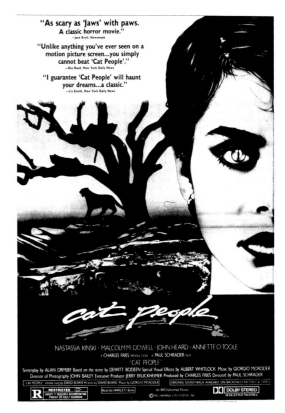
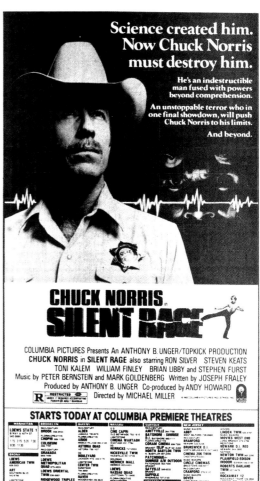

1983

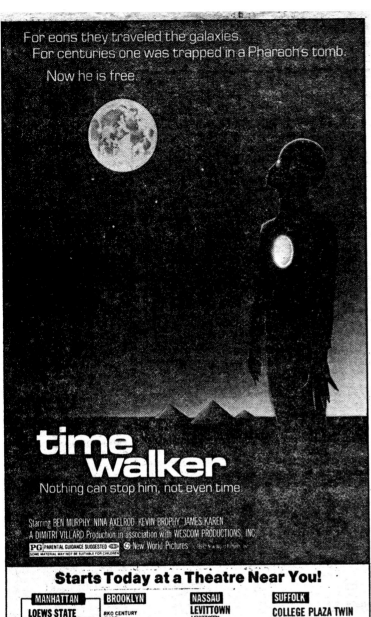

For eons they traveled the galaxies.
For centuries one was trapped in a Pharaoh's tomb.

Now he is free.

time walker

Nothing can stop him, not even time.

Starring BEN MURPHY · NINA AXELROD · KEVIN BROPHY · JAMES KAREN
A DIMITRI VILLARD Production in association with WESCOM PRODUCTIONS, INC.

PG PARENTAL GUIDANCE SUGGESTED · New World Pictures
SOME MATERIAL MAY NOT BE SUITABLE FOR CHILDREN

Starts Today at a Theatre Near You!

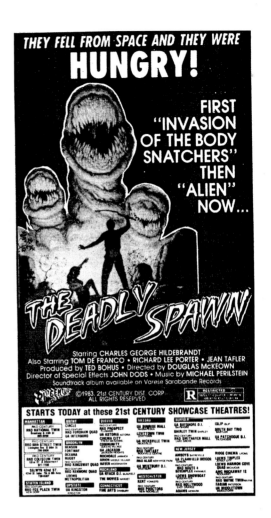

THEY FELL FROM SPACE AND THEY WERE
HUNGRY!

FIRST
"INVASION
OF THE BODY
SNATCHERS"
THEN
"ALIEN"
NOW...

THE DEADLY SPAWN

Starring CHARLES GEORGE HILDEBRANDT
Also Starring TOM DE FRANCO · RICHARD LEE PORTER · JEAN TAFLER
Produced by TED BOHUS · Directed by DOUGLAS McKEOWN
Director of Special Effects JOHN DODS · Music by MICHAEL PERILSTEIN
Soundtrack album available on Varese Sarabande Records
©1983, 21st CENTURY DIST. CORP.
ALL RIGHTS RESERVED · R RESTRICTED

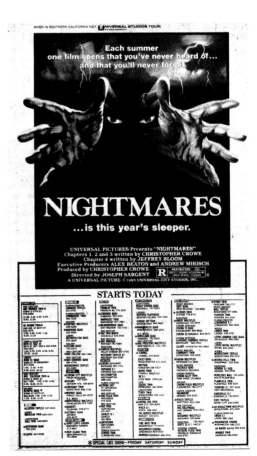

WHEN IN SOUTHERN CALIFORNIA VISIT UNIVERSAL STUDIOS TOUR

Each summer
one film opens that you've never heard of...
and that you'll never forget.

NIGHTMARES

...is this year's sleeper.

UNIVERSAL PICTURES Presents "NIGHTMARES"
Chapters 1, 2 and 3 written by CHRISTOPHER CROWE
Chapter 4 written by JEFFREY BLOOM
Executive Producers ALEX BEATON and ANDREW MIRISCH
Produced by CHRISTOPHER CROWE
Directed by JOSEPH SARGENT · R RESTRICTED
A UNIVERSAL PICTURE ©1983 UNIVERSAL CITY STUDIOS, INC.

STARTS TODAY

CREEPSHOW / DAWN OF THE DEAD

After its big-grossing original release in 1979 and a couple of reissues (paired at one point with the similarly unrated *Mother's Day*), George A. Romero's *Dawn of the Dead* was trimmed significantly, losing much of its startling gore, and thus qualifed for an R rating in 1983. This allowed it to be brought back to theaters on a bill with Romero's *Creepshow*, but audiences weren't happy, and the R was surrendered a few months later.

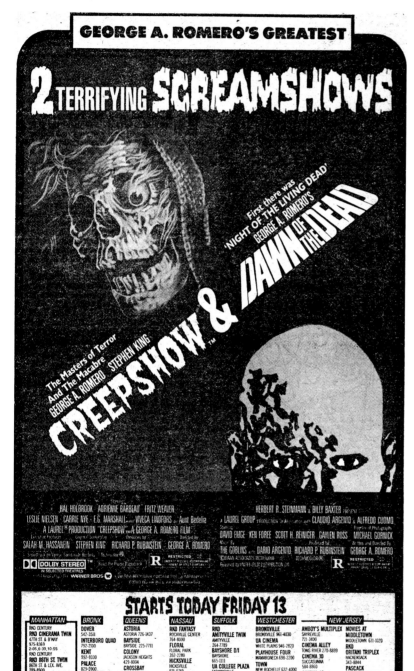

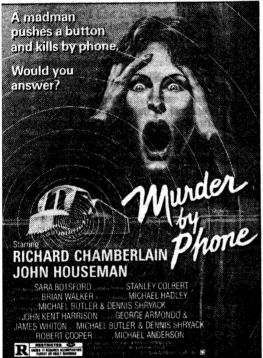

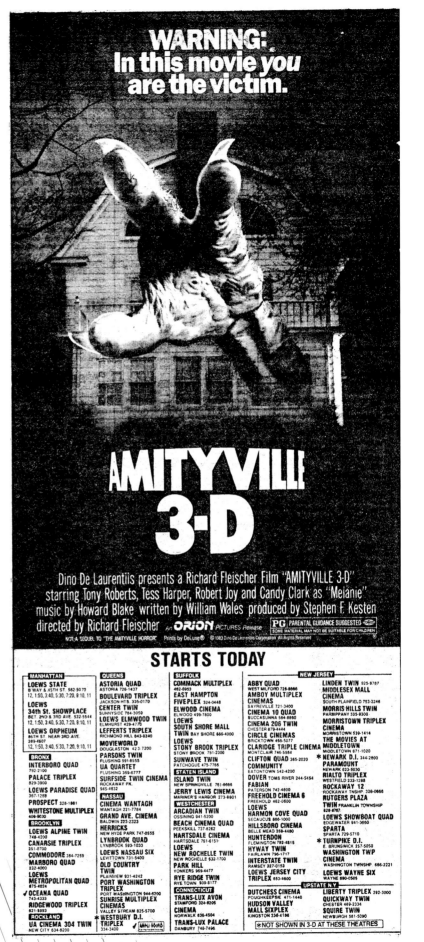

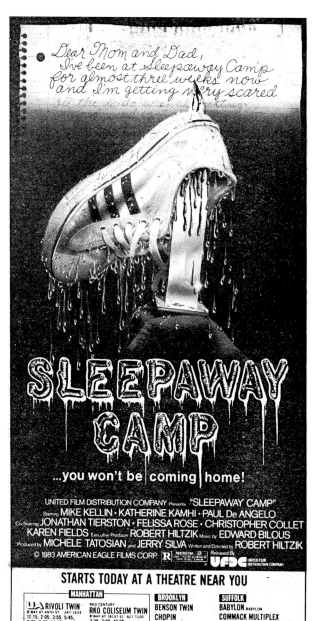

CUJO

Despite its being based on a Stephen King best seller, Warner Bros. didn't have much faith in *Cujo*. The print ads and posters hid the fact that its menace was a rabid St. Bernard, and it was released in the, ahem, dog days of August 1983 with no screenings for critics. Nonetheless, this first of three King pics in five months (*The Dead Zone* and *Christine* followed it) became a modest hit and won praise from a number of reviewers.

"The trained animal that plays Cujo, the dog, should get a doggy Oscar. ... [It] is as frightening a central figure as any horror movie ghost or demon."

— Ernest Leogrande, *New York Daily News*

"*Cujo* is nearly as frightening as *Jaws*. ... Although there are only a couple of moments that make us leap from our seats the way we did whenever Bruce would break out of the water, *Cujo* gets to us in an entirely different way, building on the terror of a domesticated pet turned wild again."

— **MALCOLM L. JOHNSON,**
HARTFORD COURANT

"[*Cujo*] ought to be wrapped up in newspaper and thrown in the trash. This is one of the dumbest, flimsiest excuses for a movie I have ever seen."

— Gene Siskel, *Chicago Tribune*

"You can add the name *Cujo* to the list of the scariest movies of all time. It's the scariest film I've seen since the original *Psycho* and, because it's so grimly realistic, the terror lingers in your mind long after you're safe at home."

— Ron Miller, *San Jose Mercury News*

"The movie, like the book, is a single-minded scare machine. It's fun to watch the little gears and wheels clicking into place, but once the story's basic, no-escape situation has been set up, it's intense in a rather flat, monotonous way."

— David Chute, *Los Angeles Herald Examiner*

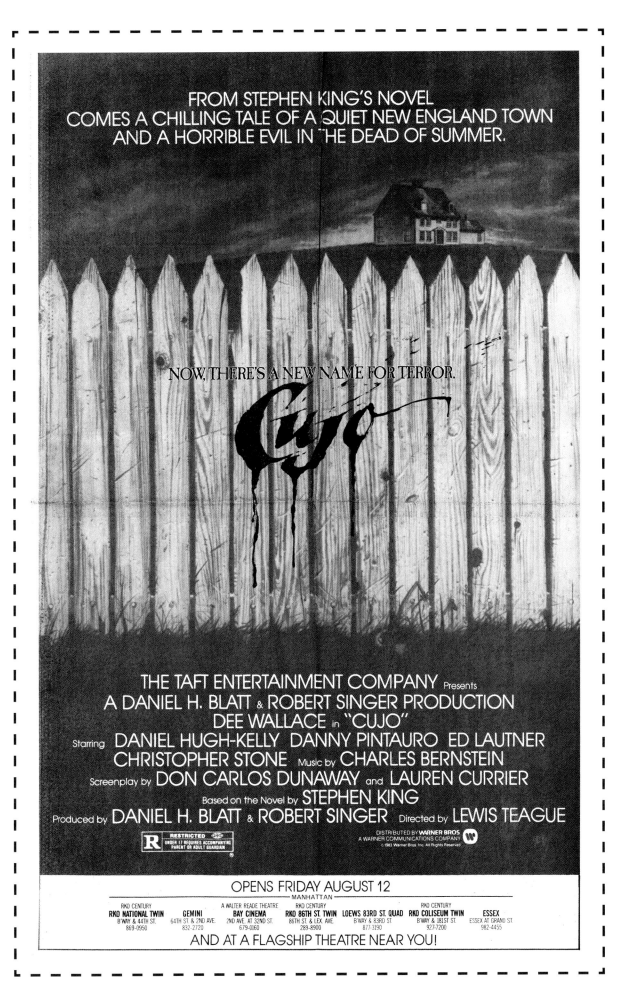

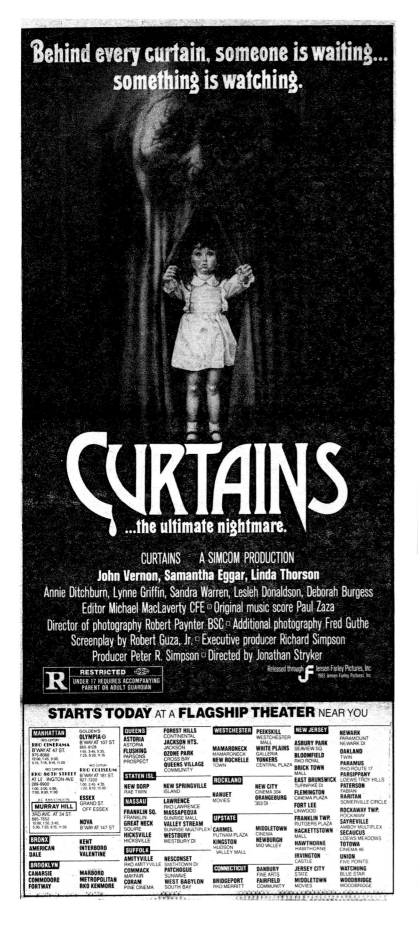

Behind every curtain, someone is waiting...
something is watching.

CURTAINS
...the ultimate nightmare.

CURTAINS A SIMCOM PRODUCTION
John Vernon, Samantha Eggar, Linda Thorson
Annie Ditchburn, Lynne Griffin, Sandra Warren, Lesleh Donaldson, Deborah Burgess
Editor Michael MacLaverty CFE ▫ Original music score Paul Zaza
Director of photography Robert Paynter BSC ▫ Additional photography Fred Guthe
Screenplay by Robert Guza, Jr. ▫ Executive producer Richard Simpson
Producer Peter R. Simpson ▫ Directed by Jonathan Stryker

Released through JF Jensen-Farley Pictures, Inc.
1983 Jensen Farley Pictures, Inc.

R RESTRICTED
UNDER 17 REQUIRES ACCOMPANYING
PARENT OR ADULT GUARDIAN

STARTS TODAY AT A FLAGSHIP THEATER NEAR YOU

MANHATTAN	GOLDEN'S	**QUEENS**	**FOREST HILLS**	**WESTCHESTER**	**PEEKSKILL**	**NEW JERSEY**	**NEWARK**
RKO CENTURY	OLYMPIA ⊚	**ASTORIA**	CONTINENTAL		MALL		PARAMOUNT
RKO CINERAMA	B'WAY AT 107 ST.	ASTORIA	JACKSON HTS.	**MAMARONECK**	WESTCHESTER	**ASBURY PARK**	NEWARK DI
B'WAY AT 47 ST.	865-8128	**FLUSHING**	JACKSON	MAMARONECK	**WHITE PLAINS**	SEAVIEW SQ.	**OAKLAND**
975-8366	1:55, 3:45, 5:35,	PARSONS	**OZONE PARK**	**NEW ROCHELLE**	GALLERIA	**BLOOMFIELD**	TWIN
12:00, 1:45, 3:30,	7:25, 9:20, 11:15	PROSPECT	CROSS BAY	TOWN	**YONKERS**	RKO ROYAL	**PARAMUS**
5:15, 7:15, 9:15, 11:20			QUEENS VILLAGE		CENTRAL PLAZA	**BRICK TOWN**	RKO ROUTE 17
RKO CENTURY	RKO COLISEUM		COMMUNITY			MALL	**PARSIPPANY**
RKO 86TH STREET	B'WAY AT 181 ST.	**STATEN ISL**		**ROCKLAND**		**EAST BRUNSWICK**	LOEWS TROY HILLS
AT LEXINGTON AVE	927-7200	**NEW DORP**	**NEW SPRINGVILLE**		**NEW CITY**	TURNPIKE DI	**PATERSON**
289-8900	1:00, 2:45, 4:35,	RAE TWIN	ISLAND	**NANUET**	CINEMA 304	**FLEMINGTON**	FABIAN
1:00, 3:00, 5:00,	1:20, 8:10, 10:00			MOVIES	**ORANGEBURG**	CINEMA PLAZA	**RARITAN**
7:00, 9:00, 11:00		**NASSAU**	**LAWRENCE**		'303 DI	**FORT LEE**	SOMERVILLE CIRCLE
A.C. CINEMA'S THEATRE	**ESSEX**	**FRANKLIN SQ.**	RKO LAWRENCE			LINWOOD	**ROCKAWAY TWP.**
MURRAY HILL	GRAND ST.	FRANKLIN	**MASSAPEQUA**	**UPSTATE**		**FRANKLIN TWP.**	ROCKAWAY
3RD AVE. AT 34 ST.	OFF ESSEX	**GREAT NECK**	SUNRISE MALL			RUTGERS PLAZA	**SAYREVILLE**
685-7652		SQUIRE	**VALLEY STREAM**	**CARMEL**	**MIDDLETOWN**	**HACKETTSTOWN**	AMBOY MULTIPLEX
12:00, 1:50, 3:40,	**NOVA**	**HICKSVILLE**	SUNRISE MULTIPLEX	PUTNAM PLAZA	CINEMA	MALL	**SECAUCUS**
5:30, 7:20, 9:15, 11:00	B'WAY AT 147 ST.	HICKSVILLE	**WESTBURY**	**KINGSTON**	**NEWBURGH**	**HAWTHORNE**	LOEWS MEADOWS
			WESTBURY DI	HUDSON	MID VALLEY	HAWTHORNE	**TOTOWA**
BRONX	**KENT**	**SUFFOLK**		VALLEY MALL		**IRVINGTON**	CINEMA 46
AMERICAN	INTERBORO	**AMITYVILLE**	**NESCONSET**			CASTLE	**UNION**
DALE	VALENTINE	RKO AMITYVILLE	SMITHTOWN DI	**CONNECTICUT**	**DANBURY**	**JERSEY CITY**	FIVE POINTS
BROOKLYN		**COMMACK**	**PATCHOGUE**		FINE ARTS	STATE	**WATCHUNG**
CANARSIE	**MARBORO**	MAYFAIR	SUNWAVE	**BRIDGEPORT**	**FAIRFIELD**	**MIDDLETOWN**	BLUE STAR
COMMODORE	METROPOLITAN	**CORAM**	**WEST BABYLON**	RKO MERRITT	COMMUNITY	MOVIES	**WOODBRIDGE**
FORTWAY	RKO KENMORE	PINE CINEMA	SOUTH BAY				WOODBRIDGE

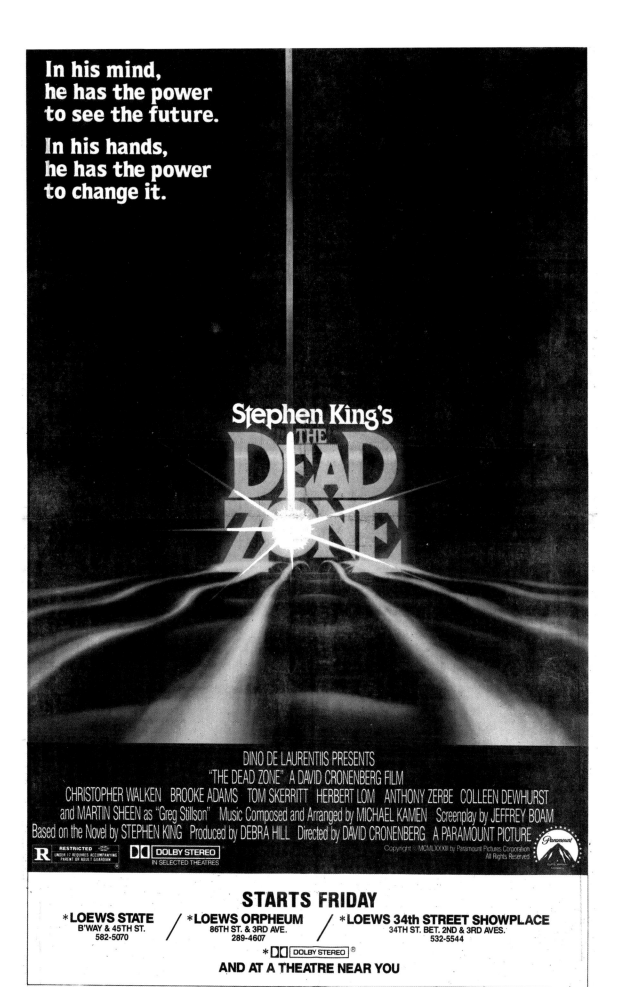

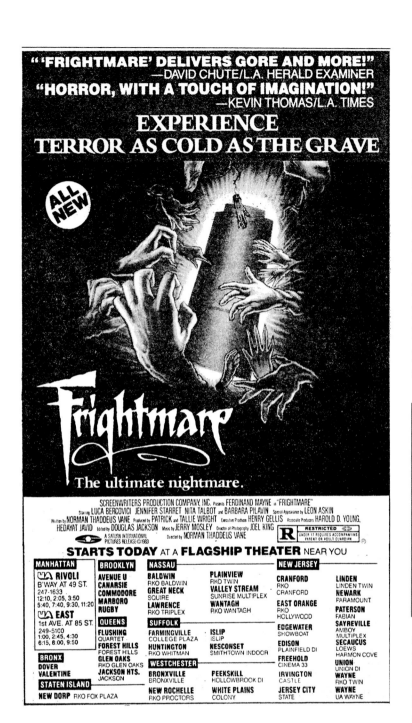

THE EVIL DEAD

The first "critic" to review *The Evil Dead* in print was Stephen King, writing in the November 1982 issue of *Twilight Zone* magazine about the movie that had so impressed him at the previous spring's Cannes Film Festival, yet had no takers when it came to U.S. distribution. That didn't last long once the issue came out; New Line Cinema snapped up Sam Raimi's precocious debut feature, and a quote from King's article became the centerpiece of the ad campaign. Once the newspaper critics laid eyes on it, their opinions ran perhaps the widest gamut of any film in this book.

"Horror addicts who gobble up this dish of gore and disgust are hereby notified that this is their *piece de resistance*. All others, beware!"

— Archer Winsten, *New York Post*

"Unquestionably it's an instant classic, probably the grisliest well-made movie ever. ... Raimi is one of those film creatures who unerringly knows where to put the camera and at what angle and how to assemble images for absolute maximum effect."

— KEVIN THOMAS,
LOS ANGELES TIMES

"*The Evil Dead* has plenty of gore, it assaults your sensibilities like the D-Day invasion force and it buries you in corpses up to your eyeballs, but it has no central idea. It has no idea at all. ... [It] is so primitive it's essentially a home movie – but from a very sick house."

— *The Baltimore Sun*, author unknown

"...[T]he greatest unintentionally funny motion picture to be brought to the screen in decades. This turkey gobbles so loudly that every Honeysuckle White and Butterball in this part of the United States must be startled into activity every time the projectionist cranks up another go-'round for *Evil Dead*."

— *Arkansas Gazette*, author unknown

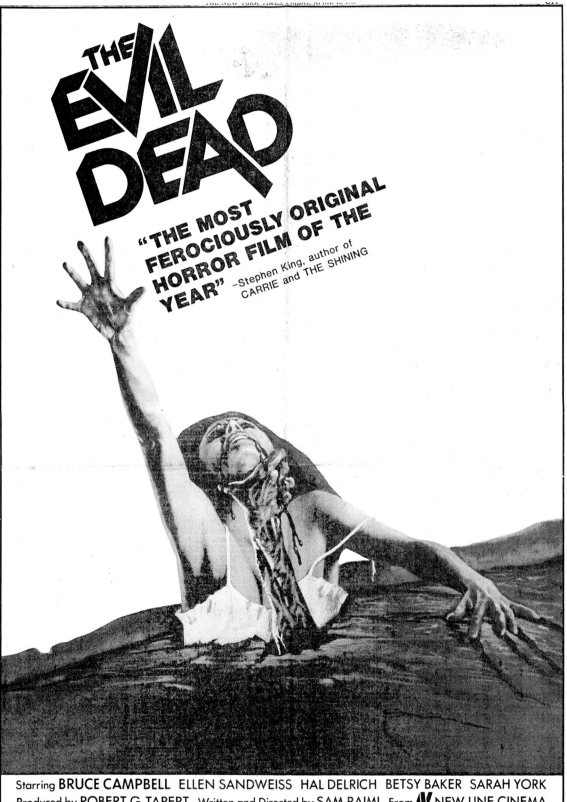

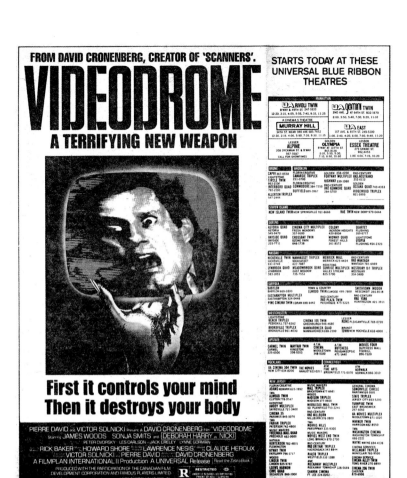

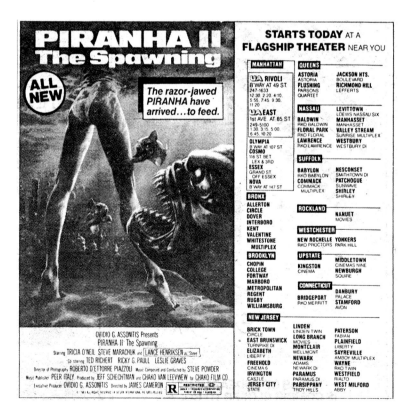

VIDEODROME

David Cronenberg's visceral shocker, tinged with vicious satire of television obsession, was originally targeted by Universal Pictures for October 1982 release, as part of what was supposed to be a big genre year that also included *Cat People*, *Conan the Barbarian*, and *The Thing*. Only *Conan* scored at the box office, and the disappointment was compounded when *Videodrome* was moved from its Halloween time slot to January 1983. Perhaps the studio predicted that some critics wouldn't be in tune with Cronenberg's vision.

"After watching Cronenberg's previous movies...we are prepared for shock effects and unprecedented horror. But, in *Videodrome*, he pioneers new territory with macabre metaphor and imaginative ideas."
— George Williams, *The Sacramento Bee*

"Wonderfully eerie, occasionally sickening, and at times disgusting, *Videodrome* is nonetheless a classy nightmare of paranoid horror. Its macabre wit is directed at folk who think they can't live without non-stop television."
— Richard Freedman, *Cleveland Plain Dealer*

"The medium is not only the message in this chillingly cheerless view of things to come, it's the whole ball of wax. ... The groundwork that gives this film its reality base is ultimately undermined by Cronenberg's relentless flinch-and-wince mayhem."
— HARRY HAUN,
NEW YORK DAILY NEWS

"Cronenberg wants nothing better than to combine these grotesque effects with a script and story that are more intelligent than most horror films. He tried it in *Scanners* and failed. He has come closer in *Videodrome*."
— John A. Douglas, *The Grand Rapids Press*

VIDEODROME is a terrifying new weapon, a broadcast signal which can control and change human reality.

You will watch it, it will program you.

VIDEODROME is an electrifying new film from David Cronenberg, the creator of "Scanners."

VIDEODROME is real...it is the next step.

VIDEODROME

First it controls your mind

Then it destroys your body

PIERRE DAVID and VICTOR SOLNICKI Present A DAVID CRONENBERG Film "VIDEODROME"
Starring JAMES WOODS SONJA SMITS and DEBORAH HARRY as NICKI
Also starring PETER DVORSKY LES CARLSON JACK CRELEY LYNNE GORMAN
Special Makeup RICK BAKER Music by HOWARD SHORE Associate Producer LAWRENCE NESIS Produced by CLAUDE HEROUX
Executive Producers VICTOR SOLNICKI and PIERRE DAVID Written and Directed by DAVID CRONENBERG
A FILMPLAN INTERNATIONAL II Production A UNIVERSAL Release [Read the Zebra Book.]
PRODUCED WITH THE PARTICIPATION OF THE CANADIAN FILM DEVELOPMENT CORPORATION AND FAMOUS PLAYERS LIMITED

R RESTRICTED — UNDER 17 REQUIRES ACCOMPANYING PARENT OR ADULT GUARDIAN

STARTS FEBRUARY 4th at Universal Blue Ribbon Theatres near you

229

THEY WERE ALL DRAWN TO THE KEEP.

The soldiers who brought death.
The father and daughter fighting for life.
The people who have always feared it.
And the one man who knows its secret...

Tonight, they will all face the evil.

A shocking tale of horror that takes you beyond fear.

ONE DARK NIGHT

It's a night you will remember until the day you die!

PG PARENTAL GUIDANCE SUGGESTED
SOME MATERIAL MAY NOT BE SUITABLE FOR CHILDREN

"ONE DARK NIGHT"
Starring MEG TILLY, MELISSA NEWMAN Introducing ROBIN EVANS as CAROL
DONALD HOTTON and ADAM WEST as ALLAN
Written by TOM McLOUGHLIN and MICHAEL HAWES Produced by MICHAEL SCHROEDER
Directed by TOM McLOUGHLIN Special Effects Design TOM BURMAN, ELLIS BURMAN and BOB WILLIAMS
© 1982 Comworld Pictures, Inc.

POSSESSION

When Andrzej Zulawski's mélange of horror and dysfunctional relationship drama premiered at 1981's Cannes Film Festival, it ran 124 minutes and was booed by many in attendance (though star Isabelle Adjani won the fest's Best Actress Award for this movie and James Ivory's *Quartet*). In the U.S., where it hit theaters two years later, it was trimmed by a third, and the reaction from reviewers was not much better. *The Kansas City Star*'s Robert C. Trussell didn't get to see it until two years after that, when the movie was reissued as *The Night the Screaming Stopped* — with vomit bags given out to patrons!

"This appears to be a mangled version of the original and the result is an incoherent movie with an unrelentingly hysterical tone. ... This version offers enough interesting elements to stoke one's curiosity about the original director's cut."

— Robert C. Trussell, *The Kansas City Star*

"From the 1981 Cannes Film Festival, where this lunacy was greeted with boos and flying bottles, I wrote that it was 'the kind of senseless gibberish you never see anywhere in the world but Cannes.' How it missed the New York Film Festival is still a mystery, but here it is on local marquees, landing in town like an outbreak of swine flu."

— Rex Reed, *New York Post*

"*Repulsion* would make a better title – on several counts – for this extravagantly sick-making portrayal of a woman's dizzying descent into madness and murder bears, in the broadest of outlines, a resemblance to Roman Polanski's classic chiller of that name. The given is the same, but the results are Poles apart."

— **HARRY HAUN,**
NEW YORK DAILY NEWS

"[*Possession*] has been described as 'an intellectual horror film.' That means it's a movie that contains a certain amount of unseemly gore and makes no sense whatsoever."

— Vincent Canby, *The New York Times*

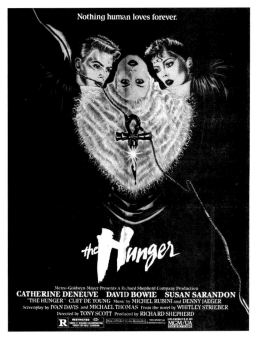

MAUSOLEUM

After reissuing assorted horror and exploitation flicks under new titles (see *Vampire Playgirls*/*Eager Beavers* in 1980), Motion Picture Marketing got a cash infusion when Michael Franzese — a member of the Colombo crime family — bought in and became co-owner with original co-founder John L. Chambliss. The studio went big with *Mausoleum*, buying a full page in *The New York Times* and giving it a wider theatrical break. It turned out to be one of the company's last films; in 1985, Franzese was indicted on racketeering charges tied to a gasoline bootlegging scheme, and was sentenced to ten years in prison (he wound up being paroled after less than four, having renounced organized crime). Chambliss went on to develop Film Concept Group, releasing Euroshockers *Burial Ground*, *The Craving*, and *Guardian of Hell*.

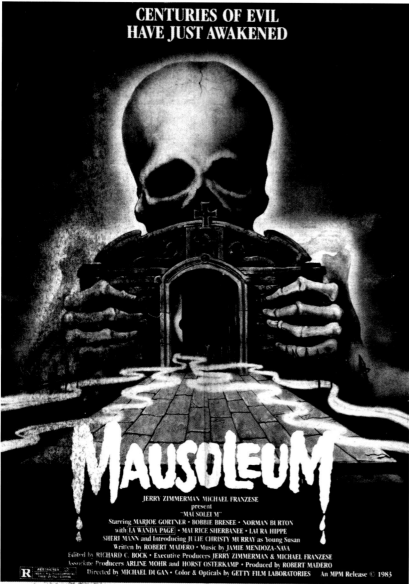

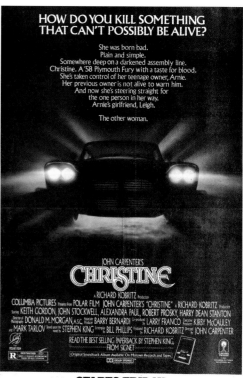

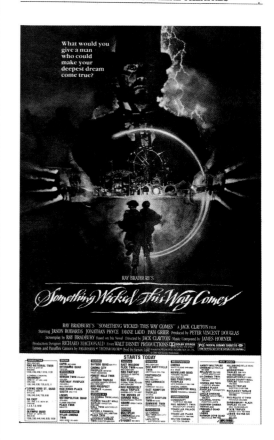

7 DOORS OF DEATH

Aquarius Releasing, like MPM, got more ambitious in promoting one of its titles in '83, in this case a renaming of Lucio Fulci's *The Beyond*. The company took out a much larger than usual ad in *The New York Times*, opened in more theaters... and, by most accounts, invented those quotes from *Texas Chainsaw Massacre* creators Tobe Hooper and Kim Henkel. Also atypical for Aquarius: the movie was trimmed for an R instead of being released unrated, losing a number of its ickiest moments and a few other scenes. The Anglicization of Italian names in the billing block — including "directed by Louis Fuller" — helped obscure the film's true identity.

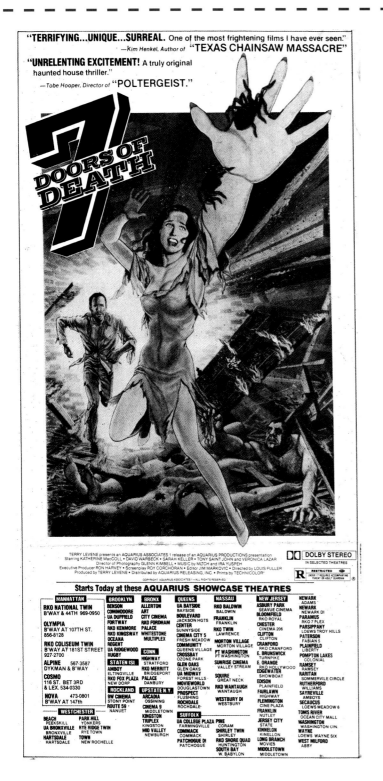

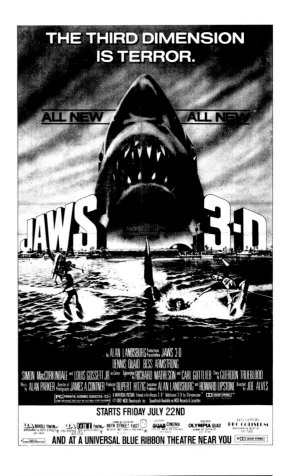

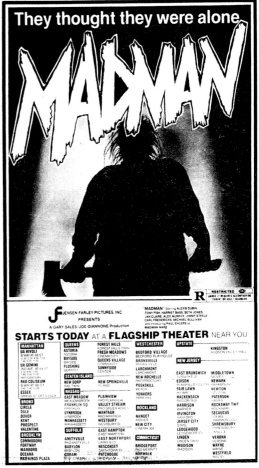

STARTS TODAY
AT A FLAGSHIP
THEATER NEAR YOU

1983

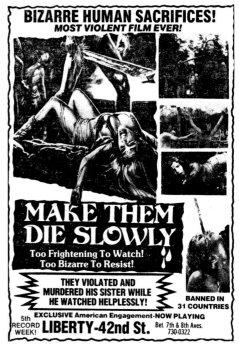

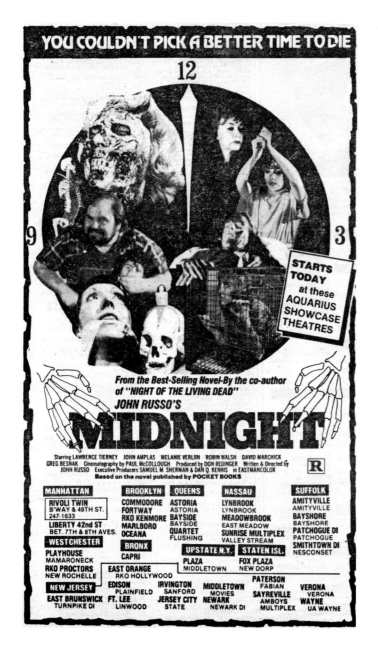

PIECES

Film Ventures International came up with one of the bluntest ad campaigns in horror history for *Pieces* — appropriate for a movie that is itself relentlessly unsubtle. While it became a favorite of gore fans, it was avoided like the plague by many critics, and the reactions of those who did see it were exactly what you'd think they'd be.

❝*Pieces*, a gore extravaganza, takes place on the emptiest campus in the history of education. … The ending is lurid even by slasher epic standards.❞

— Scott Cain, *The Atlanta Journal*

❝Any moron will know as soon as the killer makes his first appearance who he is, but 10-minute movies don't get many bookings, so we have to sit through filler to get to the obvious. … *Pieces* is as dumb as they come and dreadfully acted.❞

— ED BLANK,
THE PITTSBURGH PRESS

❝*Pieces* is a wretched, stupid little picture whose sole purpose is the exploitation of extreme violence against women... [It] was actually filmed largely in Madrid and is poorly dubbed, generates no suspense whatsoever, just disgust.❞

— Kevin Thomas, *Los Angeles Times*

❝[*Pieces*] is just about the tackiest murder mystery ever filmed. … The English was dubbed in later; in fact, it appears as if the voices were dubbed by volunteers out in the lobby.❞

— George Williams, *The Sacramento Bee*

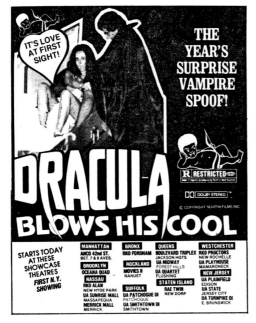

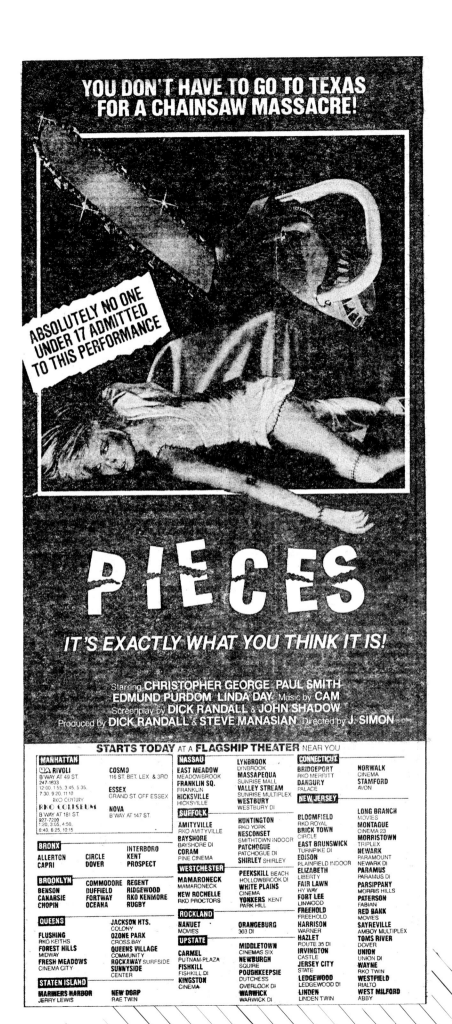

237

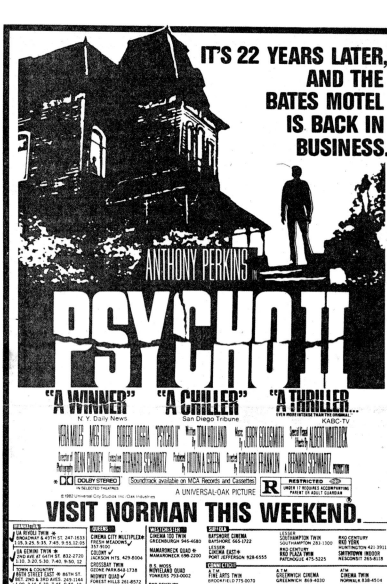

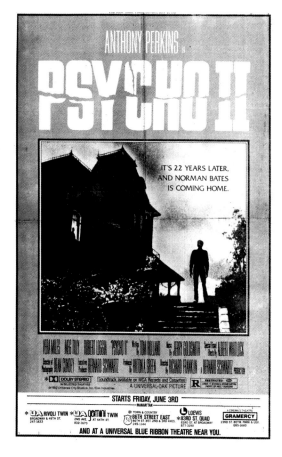

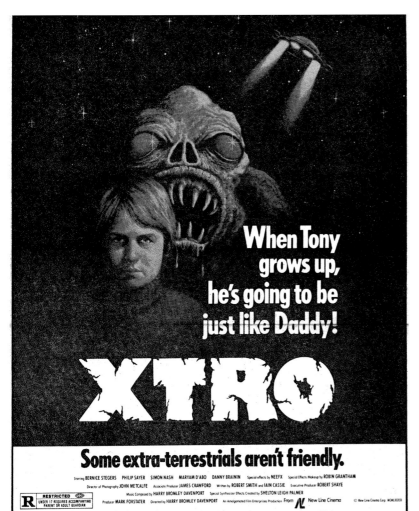

When Tony grows up, he's going to be just like Daddy!

XTRO

Some extra-terrestrials aren't friendly.

Starring BERNICE STEGERS PHILIP SAYER SIMON NASH MARYAM D'ABO DANNY BRAININ Special effects by NEEFX Special Effects Makeup by ROBIN GRANTHAM
Director of Photography JOHN METCALFE Associate Producer JAMES CRAWFORD Written by ROBERT SMITH and IAIN CASSIE Executive Producer ROBERT SHAYE
Music Composed by HARRY BROMLEY DAVENPORT Special Synthesizer Effects Created by SHELTON LEIGH PALMER

Producer MARK FORSTATER Directed by HARRY BROMLEY DAVENPORT An Amalgamated Film Enterprises Production From N✦ New Line Cinema © New Line Cinema Corp. MCMLXXXIII

STARTS TODAY AT A FLAGSHIP THEATER NEAR YOU

MANHATTAN	BRONX	QUEENS	NASSAU	SUFFOLK	WESTCHESTER	NEW JERSEY	MONTCLAIR
RKO CENTURY **RKO NATIONAL** B'WAY AT 44 ST 12:15, 2:05, 3:55, 5:45, 7:35, 9:25, 11:15	ALLERTON CIRCLE DOVER KENT PARADISE PROSPECT	ASTORIA ASTORIA FLUSHING QUARTET FOREST HILLS MIDWAY JACKSON HTS. BOULEVARD	BALDWIN RKO BALDWIN EAST MEADOW MEADOWBROOK FRANKLIN SQ. FRANKLIN PLAINVIEW	FARMINGVILLE COLLEGE PLAZA HAUPPAUGE HAUPPAUGE ISLIP ISLIP NESCONSET SMITHTOWN DI	MAMARONECK PLAYHOUSE NEW ROCHELLE TOWN PEEKSKILL BEACH YONKERS PARK HILL	EAST BRUNSWICK TURNPIKE DI EDGEWATER SHOWBOAT EDISON PLAINFIELD INDOOR FAIR LAWN HY WAY	WELLMONT MORRISTOWN COMMUNITY NEWARK PARAMOUNT ORANGE PALACE PARSIPPANY TROY HILLS
☾ **LOEWS ORPHEUM** 3RD AVE AT 86 ST 1:00, 2:40, 4:20, 6:00, 7:40, 9:20, 11:00	**BROOKLYN** CHOPIN COMMODORE DUFFIELD FORTWAY HIGHWAY OCEANA RIDGEWOOD RKO KENMORE	JAMAICA ROCHDALE OZONE PARK CROSS BAY QUEENS VILLAGE COMMUNITY	RKO PLAINVIEW PT. WASHINGTON TRIPLEX VALLEY STREAM SUNRISE MULTIPLEX WANTAGH RKO WANTAGH WESTBURY WESTBURY DI	WEST BABYLON SOUTH BAY TRIO	**UPSTATE** KINGSTON MAYFAIR MIDDLETOWN PLAZA	FREEHOLD ROUTE 9 HACKENSACK RKO ORITANI HARRISON WARNER IRVINGTON CASTLE JERSEY CITY STATE	PATERSON FABIAN ROCKAWAY TWP. ROCKAWAY SAYREVILLE SECAUCUS LOEWS HARMON COVE WAYNE RKO WAYNE
COSMO 116 ST BET LEX & 3RD	**STATEN ISL** NEW SPRINGVILLE ISLAND			**ROCKLAND** NANUET MOVIES	**CONNECTICUT** BRIDGEPORT RKO MERRITT	MIDDLETOWN MOVIES	
ESSEX GRAND ST. OFF ESSEX							

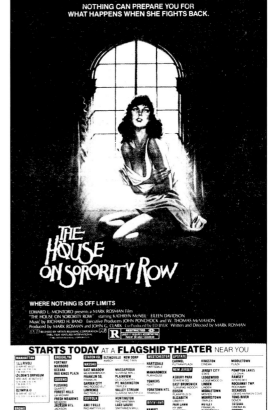

THE HOUSE ON SORORITY ROW

WHERE NOTHING IS OFF LIMITS

EDWARD L. MONTORO presents a MARK ROSMAN Film
"THE HOUSE ON SORORITY ROW" starring KATHRYN McNEIL · EILEEN DAVIDSON
Music by RICHARD H. BAND Executive Producers JOHN PONCHOCK and W. THOMAS McMAHON
Produced by MARK ROSMAN and JOHN G. CLARK Co-Producer ED BYER Written and Directed by MARK ROSMAN

STARTS TODAY AT A FLAGSHIP THEATER NEAR YOU

MANHATTAN	BROOKLYN	STATEN ISL ELTINGVILLE NEW DORP	WESTCHESTER	UPSTATE	KINGSTON	MIDDLETOWN	
U.A. RIVOLI B'WAY AT 49 ST	FORTWAY MARBORO OCEANA RKO KINGS PLAZA	AMBOY RAE TWIN **NASSAU** EAST MEADOW MEADOWBROOK FRANKLIN SQ.	HARTSDALE HARTSDALE MAMARONECK PLAYHOUSE	CARMEL PUTNAM PLAZA **NEW JERSEY** ASBURY PARK	CINEMA KINGSTON CINEMA	PLAZA **POMPTON LAKES** COLONIAL RAMSEY	
U LOEW'S ORPHEUM 3RD AVE AT 86TH ST	**QUEENS** FLUSHING QUARTET FOREST HILLS UA MIDWAY FRESH MEADOWS MEADOW	FRANKLIN GARDEN CITY RKO ROOSEVELT LAWRENCE RKO TRIPLEX	YONKERS KENT YORKTOWN HTS. TRIANGLE	SEAVIEW SQ EAST BRUNSWICK TURNPIKE INDOOR EDISON PLAINFIELD DI	LEDGEWOOD LEDGEWOOD DI LINDEN LINDEN MIDDLETOWN	INTERSTATE ROCKAWAY TWP. ROCKAWAY SECAUCUS LOEWS HARMON COVE	
OLYMPIA ☾	JACKSON HTS. JACKSON	**SUFFOLK** MASSAPEQUA SUNRISE MALL	**ROCKLAND** NANUET	ELIZABETH LIBERTY	MOVIES MORRISTOWN TRIPLEX	TOMS RIVER DOVER	
	BRONX ALLERTON AMERICAN PARADISE	ROCKAWAY SURFSIDE SUNNYSIDE CENTER	PLAINVIEW OLD COUNTRY PT. WASHINGTON TRIPLEX VALLEY STREAM SUNRISE MULTIPLEX HUNTINGTON TWO WHITMAN LAKE GROVE SMITHAVEN MALL PATCHOGUE PATCHOGUE DI WEST BABYLON SOUTH BAY TRIO	MOVIES BRICKTOWN RKO CINE MA.	FAIR LAWN HY WAY FAIRVIEW FAIRVIEW HACKENSACK RKO ORITANI	PLAIN LAWN FRANKLIN PARSIPPANY LOEWS TROY HILLS PATERSON FABIAN	VERONA CINEMA 46 WEST MILFORD ABBY

1984

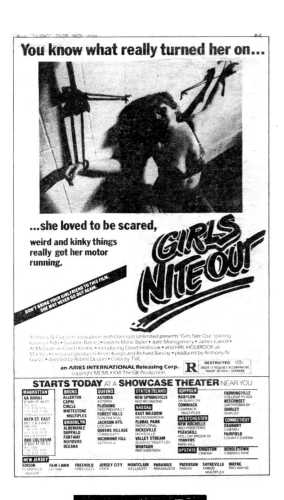

241

C.H.U.D.

New Yorkers had long suspected that something horrible was dwelling beneath their city's streets, and this film fueled their fear with a plotline combining illegal toxic waste dumping and people-eating monsters. When the movie went to other territories, New World provided ads with a blank space in the opening line to replace the city name. Expectedly, the more positive reviews at the time came from Manhattan critics.

"[L]ight entertainment that makes us shudder and laugh at all the right times. Granted, there's no art here, but it's not all that bad either. ... Daniel Stern is most convincing as the concerned hippie Reverend A.J. and John Heard's photographer is believably 'up to here' with the *haute couture*."

— Hank Gallo, *New York Daily News*

"Helping matters are a knowing feel for the atmosphere of New York City, occasional flashes of wit in the script by Parnell Hall, and commendable restraint (presumably by the director Douglas Cheek) in the administration of the requisite doses of monsters."

— LAWRENCE VAN GELDER, THE NEW YORK TIMES

"*C.H.U.D.* is a B-movie that wants to be a B-movie. ... It has the same feel as some of the old ones—like *Creature from the Black Lagoon* or *Them*."

— Bill O'Connor, *Akron Beacon Journal*

"Kind of a cross between *Alien* and *Alligator*, *C.H.U.D.* is filmed in that cheapo netherworld where some of the people know how to act, some of them don't, and nobody can quite figure out how to make the camera work right."

— Rick Lyman, *The Philadelphia Inquirer*

"This could have been a rich mix of horror glop and anti-nuke anxiety. But director Douglas Cheek...lets it down. There are long, trite stretches of talk, the shockers are laughable, and when Cheek gets some action going, he kills it by cutting to other scenes."

— David Elliott, *The San Diego Union*

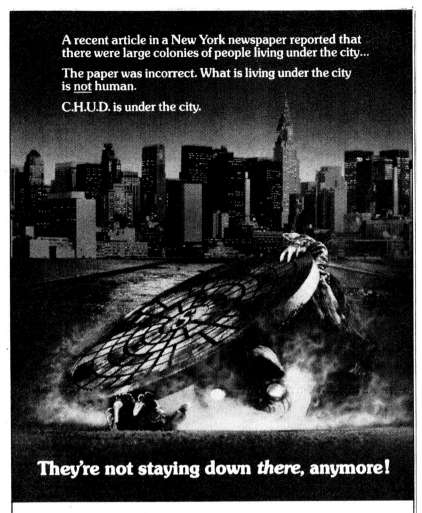

A recent article in a New York newspaper reported that there were large colonies of people living under the city...

The paper was incorrect. What is living under the city is <u>not</u> human.

C.H.U.D. is under the city.

They're not staying down *there*, anymore!

C.H.U.D.

(Cannibalistic. Humanoid. Underground. Dwellers.)

ANDREW BONIME presents JOHN HEARD DANIEL STERN CHRISTOPHER CURRY C.H.U.D.
Director of Photography PETER STEIN Screenplay by PARNELL HALL Story by SHEPARD ABBOTT
Produced by ANDREW BONIME Directed by DOUGLAS CHEEK

STARTS TODAY AT A THEATRE NEAR YOU

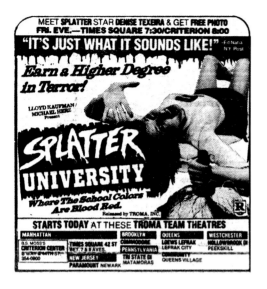

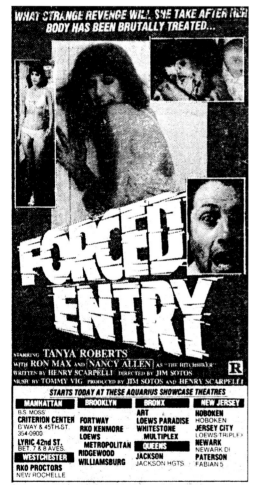

SILENT NIGHT, DEADLY NIGHT

This ad was part of the promotional campaign — notoriously including a TV commercial aired at times when children could see it — that led *Silent Night, Deadly Night* and its Santa-clad killer to go down in infamy. Given the outrage that greeted the marketing, it wasn't surprising that the film received some of the most hyperbolically vitriolic reviews in horror history.

"Not since *Friday the 13th: The Final Chapter* has there been such a repulsive piece of garbage."

— John A. Douglas, *Grand Rapids Press*

"*Silent Night, Deadly Night*...could kill the spirit of the season for good."

— Hank Gallo, *New York Daily News*

"The hateful and sick *Silent Night, Deadly Night* lacks the slightest bit of psychological tension or fright-filled suspense."

— Lou Gaul, *Calkins Newspapers*

"If Charles Dickens were alive today, if he lived in Utah, and was raised by a castrating nun, if he learned to hate women almost as much as he hated life, if he admired grade-B horror movies, and – most importantly – if he suffered from massive brain damage, he might have written the screenplay for *Silent Night, Deadly Night*."

— ROBERT S. CAUTHORN, *ARIZONA DAILY STAR*

"I think I figured out how pictures like this get made. A screenwriter who can't get laid gets together with a director who can't get laid with the story of a guy who can't get laid, so he kills people."

— Mick LaSalle, *San Francisco Chronicle*

"It's an absolute travesty, a movie so grotesquely perverted in its shabby pandering to the sicky crowd that you wonder whether the no-talent no-namers who made it are maybe outpatients somewhere."

— Fred Lutz, *The Toledo Blade*

"*Silent Night, Deadly Night* is a sleazy, miserable, insulting, disgusting, worthless, exploitive piece of garbage."

— Roxanne T. Mueller, *Cleveland Plain Dealer*

"Director Charles Sellier isn't content with nudity and violence delivered directly and cleanly. He insists upon breasts being pinched and kneaded and repetition of the killings. ... Can any director sink lower?"

— Joan E. Vadeboncoeur, *Syracuse Herald-Journal*

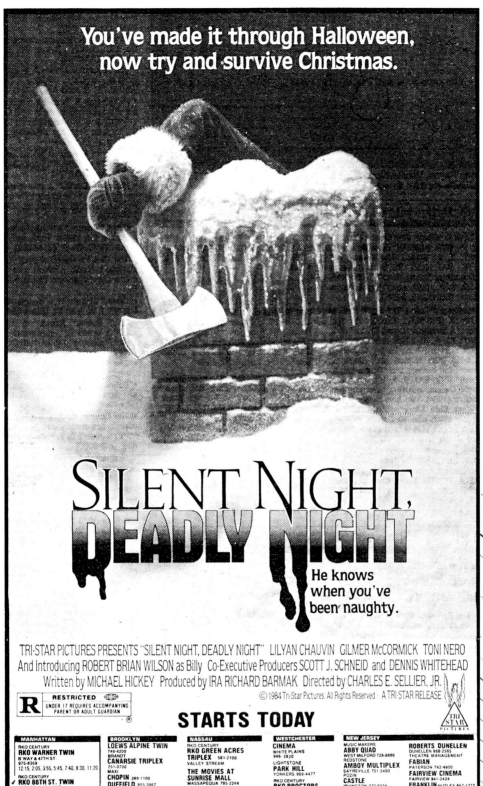

You've made it through Halloween, now try and survive Christmas.

SILENT NIGHT, DEADLY NIGHT

He knows when you've been naughty.

TRI-STAR PICTURES PRESENTS "SILENT NIGHT, DEADLY NIGHT" LILYAN CHAUVIN GILMER McCORMICK TONI NERO
And Introducing ROBERT BRIAN WILSON as Billy Co-Executive Producers SCOTT J. SCHNEID and DENNIS WHITEHEAD
Written by MICHAEL HICKEY Produced by IRA RICHARD BARMAK Directed by CHARLES E. SELLIER, JR.

© 1984 Tri-Star Pictures. All Rights Reserved · A TRI-STAR RELEASE

R RESTRICTED
UNDER 17 REQUIRES ACCOMPANYING
PARENT OR ADULT GUARDIAN

STARTS TODAY

FRIDAY THE 13TH: THE FINAL CHAPTER

Although this was hardly Jason's last hurrah, the promise of witnessing his demise helped make *The Final Chapter* another hit for the *Friday* franchise. The first round of ads appealed to the desire to see Mr. Voorhees get it in the eye, so to speak, but their violent implications stirred up some consternation, and the offending knife and pool of blood were removed after the first week.

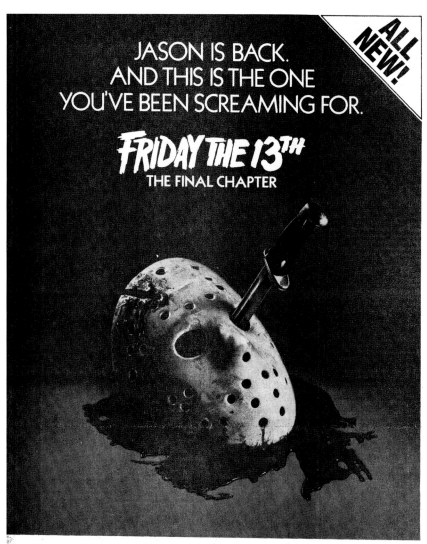

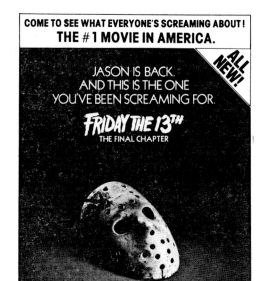

LEGEND OF THE BAYOU

This was just one of several alternate titles given to *Eaten Alive*, Tobe Hooper's saga of a rural maniac and his pet alligator, since its initial release in 1977. It was also issued under production title *Death Trap*, as well as *Horror Hotel*, and *Starlight Slaughter*.

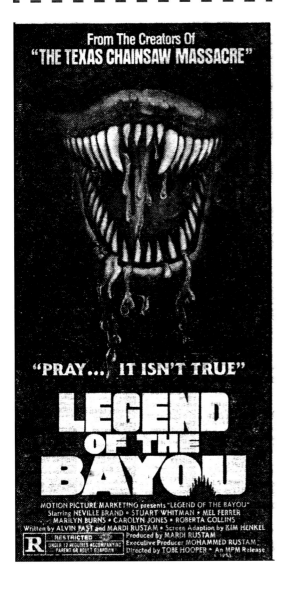

From The Creators Of "THE TEXAS CHAINSAW MASSACRE"

"PRAY.... IT ISN'T TRUE"

LEGEND OF THE BAYOU

MOTION PICTURE MARKETING presents "LEGEND OF THE BAYOU" Starring NEVILLE BRAND • STUART WHITMAN • MEL FERRER • MARILYN BURNS • CAROLYN JONES • ROBERTA COLLINS Written by ALVIN FAST and MARDI RUSTAM • Screen Adaption by KIM HENKEL Produced by MARDI RUSTAM Executive Producer MOHAMMED RUSTAM Directed by TOBE HOOPER • An MPM Release

R RESTRICTED UNDER 17 REQUIRES ACCOMPANYING PARENT OR ADULT GUARDIAN

READ THE FINE PRINT. YOU MAY HAVE JUST MORTGAGED YOUR LIFE.

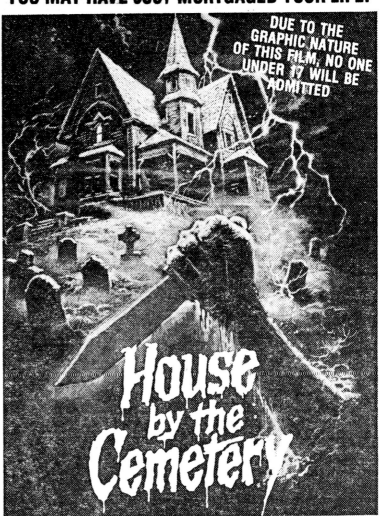

DUE TO THE GRAPHIC NATURE OF THIS FILM, NO ONE UNDER 17 WILL BE ADMITTED

House by the Cemetery

AN ALMI PICTURES PRESENTATION
Starring KATHERINE MACCOLL • PAOLO MALCO • ANNA PIERONI • SILVIA COLLATINA
AND WITH DAGMAR LASSANDER DIRECTED BY LUCIO FULCI
©1984 ALMI PICTURES, INC. ALL RIGHTS RESERVED

STARTS TODAY

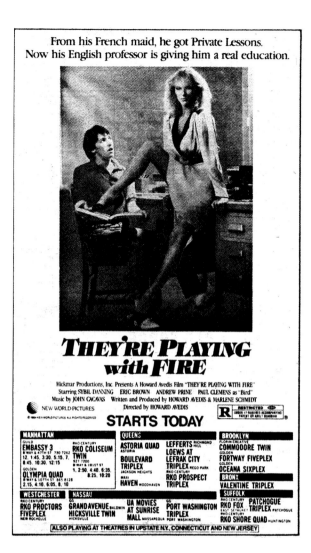

From his French maid, he got Private Lessons. Now his English professor is giving him a real education.

THEY'RE PLAYING with FIRE

Hickmar Productions, Inc. Presents A Howard Avedis Film "THEY'RE PLAYING WITH FIRE" Starring SYBIL DANNING · ERIC BROWN · ANDREW PRINE · PAUL CLEMENS as "Bird"
Music by JOHN CACAVAS Written and Produced by HOWARD AVEDIS & MARLENE SCHMIDT
NEW WORLD PICTURES Directed by HOWARD AVEDIS
© NEW WORLD PICTURES. ALL RIGHTS RESERVED.

STARTS TODAY

MANHATTAN
GUILD
EMBASSY 3 B'WAY & 47TH ST 730 7262
12, 1.45, 3.30, 5.19, 7, 8.45, 10.30, 12.15
GOLDEN
OLYMPIA QUAD B'WAY & 107TH ST 865 8128
2.15, 4.10, 6.05, 8, 10

RKO CENTURY
RKO COLISEUM TWIN 927 7200
B'WAY & 181ST ST
1, 2.50, 4.40, 6.35, 8.25, 10.20

QUEENS
ASTORIA QUAD ASTORIA
BOULEVARD TRIPLEX JACKSON HEIGHTS
MAXI **HAVEN** WOODHAVEN

LEFFERTS RICHMOND HILL
LOEWS AT LEFRAK CITY REGO PARK
RKO CENTURY
RKO PROSPECT TRIPLEX

BROOKLYN
COMMODORE TWIN
GOLDEN
FORTWAY FIVEPLEX
GOLDEN
OCEANA SIXPLEX
BRONX
VALENTINE TRIPLEX
SUFFOLK

WESTCHESTER
RKO CENTURY
RKO PROCTORS FIVEPLEX NEW ROCHELLE

NASSAU
GG
GRAND AVENUE BALDWIN
HICKSVILLE TWIN HICKSVILLE

GG
UA MOVIES AT SUNRISE MALL MASSAPEQUA

GG
PORT WASHINGTON TRIPLEX PORT WASHINGTON

RKO CENTURY
RKO FOX EAST SETAUKET **PATCHOGUE TRIPLEX** PATCHOGUE
RKO CENTURY
RKO SHORE QUAD HUNTINGTON

ALSO PLAYING AT THEATRES IN UPSTATE N.Y., CONNECTICUT AND NEW JERSEY

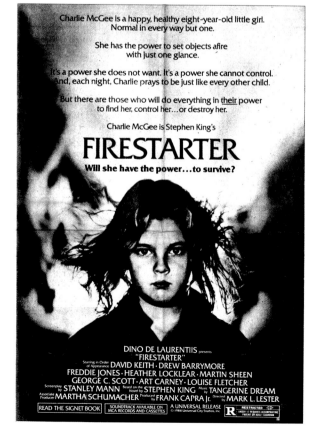

Charlie McGee is a happy, healthy eight-year-old little girl. Normal in every way but one.

She has the power to set objects afire with just one glance.

It's a power she does not want. It's a power she cannot control. And, each night, Charlie prays to be just like every other child.

But there are those who will do everything in their power to find her, control her...or destroy her.

Charlie McGee is Stephen King's

FIRESTARTER

Will she have the power...to survive?

DINO DE LAURENTIIS presents
"FIRESTARTER"
Starring in Order of Appearance DAVID KEITH · DREW BARRYMORE
FREDDIE JONES · HEATHER LOCKLEAR · MARTIN SHEEN
GEORGE C. SCOTT · ART CARNEY · LOUISE FLETCHER
Screenplay by STANLEY MANN Based on the Novel by STEPHEN KING Music by TANGERINE DREAM
Associate Producer MARTHA SCHUMACHER Produced by FRANK CAPRA Jr. Directed by MARK L. LESTER
A UNIVERSAL RELEASE
READ THE SIGNET BOOK SOUNDTRACK AVAILABLE ON MCA RECORDS AND CASSETTES © 1984 Universal City Studios, Inc.

CHILDREN OF THE CORN

After a string of movies based on Stephen King novels, *Children of the Corn* was the first adaptation of one of the author's short stories into a full-length feature film. Though successful enough to spawn a succession of nine (mostly direct-to-video) sequels, it wasn't received as well by many of the critics.

"As such movies go, *Children of the Corn* is fairly entertaining, if you can stomach the gore and the sound of child actors trying to talk in something that might be called farmbelt biblical. ... [T]he film is full of beautifully evocative, broad, flat, sun-baked landscapes, in which even cornfields are made to seem menacing."
— Vincent Canby, *The New York Times*

"If the whole thing fails to horrify as well as it should, it's because the producers forgot Horror Show Rule One: Don't show your monster if your monster is an idea... It's still an excellent piece of storytelling. Production values are high; nobody skimped on sets or on time to flesh out the characters, weird as some of the kids are."
— DAVE MATHENY,
MINNEAPOLIS STAR TRIBUNE

"This is mean, angry stuff without a drop of poetry in it. And the awfulness is gratuitously amplified by the acting. The MD (Peter Horton) and the Mrs. (Linda Hamilton) are adequate, but the kids are so bad it's almost supernatural."
— Leo Seligsohn, *New York Newsday*

"If the thought even fleetingly crosses your mind that somebody should have reported all the missing adults, you're in the wrong movie. This was apparently a town where none of the adults made or received long-distance calls, used charge cards, had out-of-town relatives, or knew anybody who would miss them. Maybe they deserved to die."
— Roger Ebert, *Chicago Sun-Times*

"Fritz Kiersch's judge-sober direction makes molasses in January look like the Johnstown Flood. Consequently the audience has ample opportunity to wander through the gaping holes in George Goldsmith's script."
— David Ehrenstein, *Los Angeles Herald Examiner*

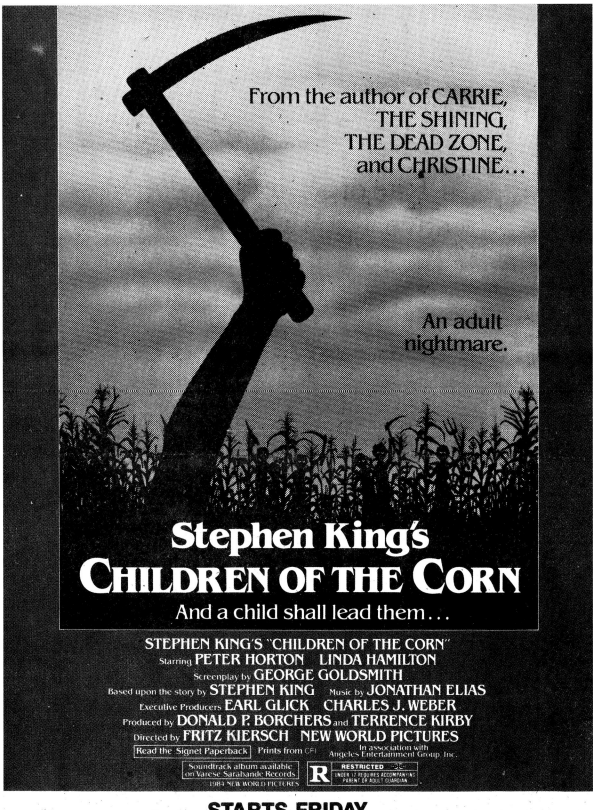

From the author of CARRIE,
THE SHINING,
THE DEAD ZONE,
and CHRISTINE...

An adult
nightmare.

Stephen King's
CHILDREN OF THE CORN
And a child shall lead them...

STEPHEN KING'S "CHILDREN OF THE CORN"
Starring PETER HORTON LINDA HAMILTON
Screenplay by GEORGE GOLDSMITH
Based upon the story by STEPHEN KING Music by JONATHAN ELIAS
Executive Producers EARL GLICK CHARLES J. WEBER
Produced by DONALD P. BORCHERS and TERRENCE KIRBY
Directed by FRITZ KIERSCH NEW WORLD PICTURES
Read the Signet Paperback Prints from CFI In association with
Angeles Entertainment Group, Inc.
Soundtrack album available
on Varese Sarabande Records R RESTRICTED
UNDER 17 REQUIRES ACCOMPANYING
PARENT OR ADULT GUARDIAN
1984 NEW WORLD PICTURES

STARTS FRIDAY

ON THE WEST SIDE
LOEWS STATE
BROADWAY AT 45TH STREET · 582-5070

ON THE EAST SIDE
LOEWS ORPHEUM
EAST 86TH STREET AT 3RD AVE · 289-4607

AND AT A THEATRE NEAR YOU

249

MORTUARY

By 1983, when *Mortuary* first opened, the slasher genre had started to fall out of favor, so Film Ventures International released two such movies with posters and ads disguising that side of their stories. *The House on Sorority Row* (see 1983) was promoted as a sexy thriller, while *Mortuary*, in which a young Bill Paxton plays the maniac, was sold in both its print marketing and trailer (a setpiece featuring Michael Berryman that doesn't appear in the movie itself) as a kind of back-from-the-dead opus.

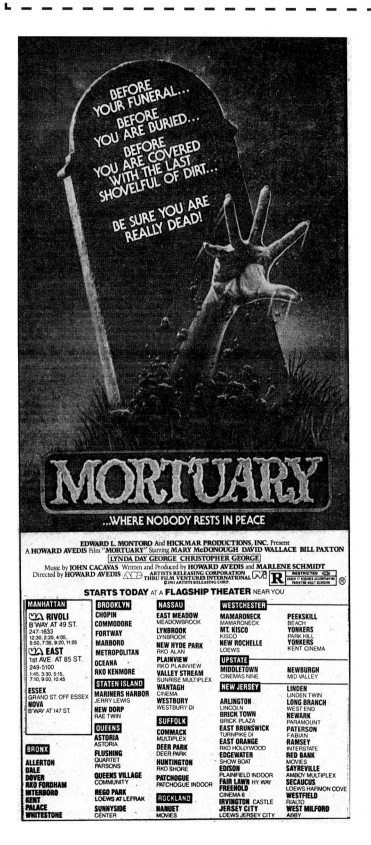

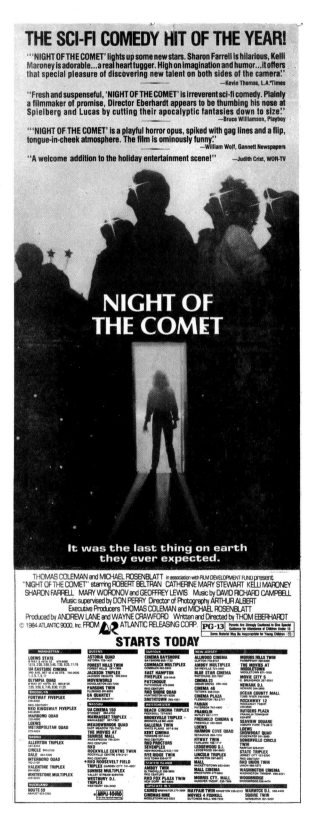

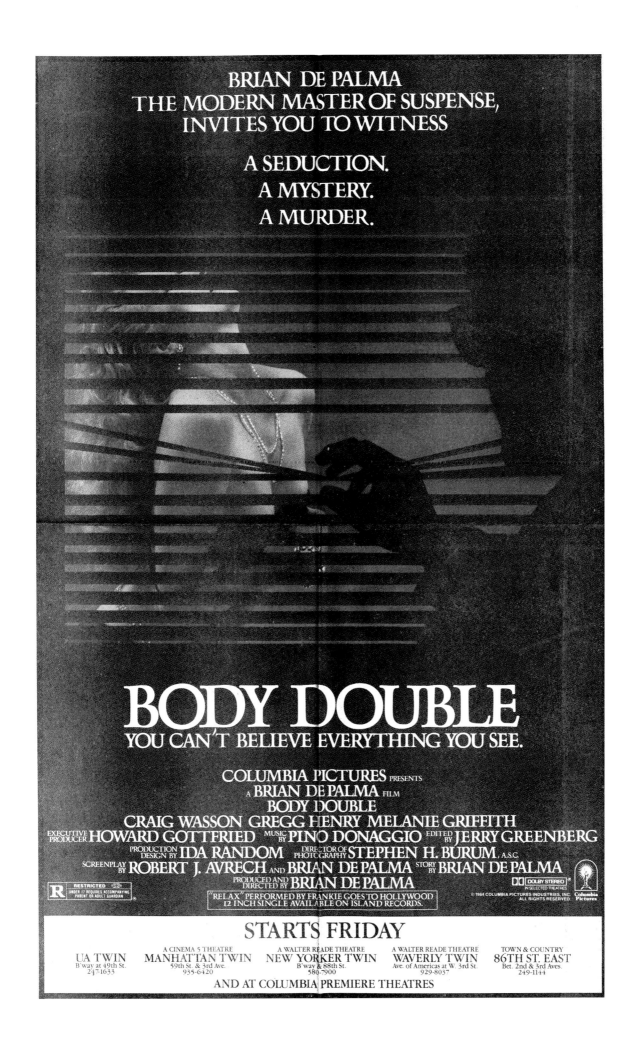

NIGHT SHADOWS

Originally titled *Mutant*, this was intended to be a major release from Film Ventures International, backed by a sizable ad campaign. But the once-robust distributor had run into financial trouble (due in part to the scuttled release of *Great White*, thanks to successful legal action brought by *Jaws* studio Universal), and the movie wound up tossed out in a smaller theatrical break with a last-minute name change to *Night Shadows*. (It retained the *Mutant* moniker on video.) Soon after, Film Ventures topper Edward L. Montoro disappeared with $1 million of the company's money, and it folded in 1985.

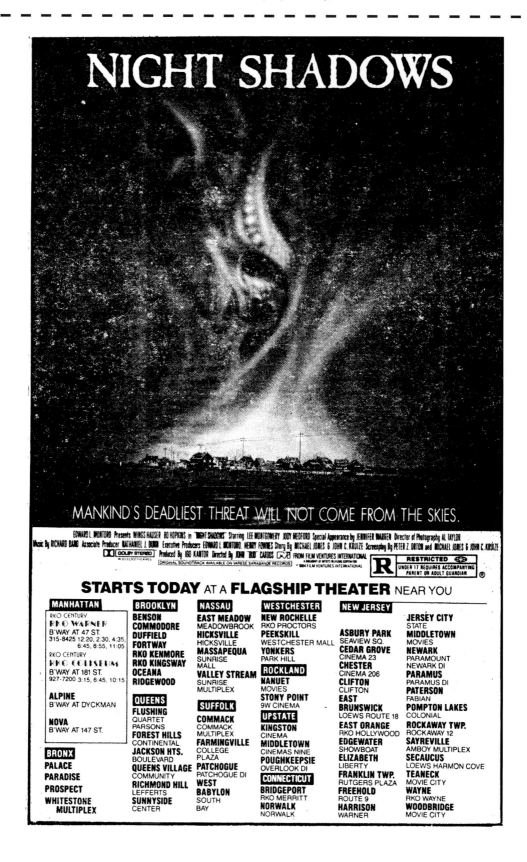

NINJA III: THE DOMINATION

The third of Cannon Films' swordsman sagas (after *Enter the Ninja* and *Revenge of the Ninja*) was advertised in print as essentially more of the same. Thus, some die-hard horror fans skipped a film that combined traditional action with horror tropes, as a young woman is possessed by the spirit of a vengeance-seeking ninja and must be exorcized. They also missed out on one of the great camp classics of the '80s, which has since been recognized as such by Cannon's fans.

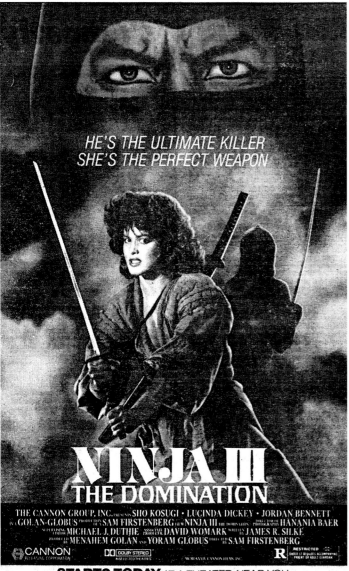

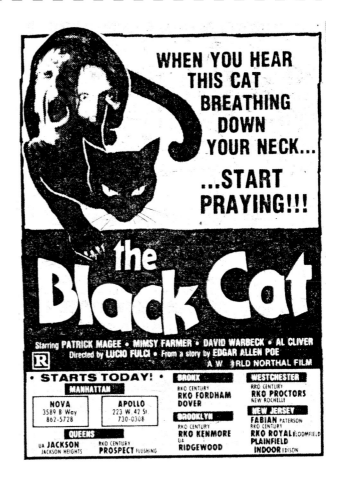

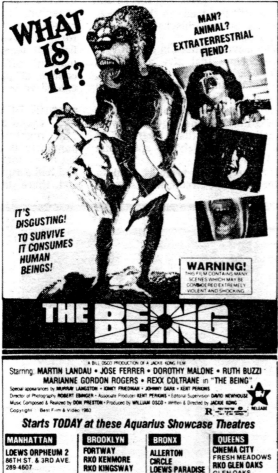

A NIGHTMARE ON ELM STREET

Wes Craven's film was initially known as *Nightmare on Elm Street*, without the *A*; the indefinite article was added prior to release. That's a tad ironic, considering there would be many subsequent nightmares on Elm Street after the movie turned out to be a surprise hit. It also scored well with a number of reviewers who had become weary of the more generic teen slasher flicks of the previous years.

"[T]here is more going on here than the usual chop-o-matic mentality associated with youth-oriented fright films."
— Michael McLeod, *The Cincinnati Enquirer*

"It is, Lord help us, a literate, clever, witty, imaginative horror film, just when, after the accumulated outrage of so many dreadful slasher items, the genre seemed as bankrupt as a 1929 savings and loan."
— STEPHEN HUNTER, *THE BALTIMORE SUN*

"*A Nightmare on Elm Street* owes most of its chills and suspenseful moments to its good special effects. Other than that, it doesn't offer much to dispel the image films like this foster, that teenagers are a foul-mouthed lot living from one sexual escapade to the next."
— Bill Kaufman, *New York Newsday*

"The whole premise of *Nightmare* is fascinating, and writer-director Wes Craven...is completely in control. ...[He] skillfully explores the borders between dream life and reality. Unfortunately, Craven's predilection for showing blatant, horrible violence offset what could have been a real contribution to the horror genre."
— Roxanne T. Mueller, *Cleveland Plain Dealer*

"Director Wes Craven...has wrought a shabby scare show, and one that wastes too much time dithering around between murders or threats of murders."
— Peter Stack, *San Francisco Chronicle*

IF NANCY DOESN'T WAKE UP SCREAMING
SHE WON'T WAKE UP AT ALL.

WES CRAVEN'S
A Nightmare
ON ELM STREET

NEW LINE CINEMA, MEDIA HOME ENTERTAINMENT, INC. and SMART EGG PICTURES Present
A ROBERT SHAYE Production • A WES CRAVEN Film • "A NIGHTMARE ON ELM STREET"
Starring JOHN SAXON • RONEE BLAKLEY • HEATHER LANGENKAMP • AMANDA WYSS • NICK CORRI • JOHNNY DEPP and ROBERT ENGLUND as Fred Krueger
Music by CHARLES BERNSTEIN • Director of Photography JACQUES HAITKIN • Editor RICK SHAINE • Executive Producers STANLEY DUDELSON and JOSEPH WOLF
Co-Producer SARA RISHER • Produced by ROBERT SHAYE • Written and Directed by WES CRAVEN FROM NEW LINE CINEMA

R RESTRICTED
UNDER 17 REQUIRES ACCOMPANYING
PARENT OR ADULT GUARDIAN

©New Line Cinema Corp. MCMLXXXIV

STARTS TODAY AT A **FLAGSHIP THEATER** NEAR YOU

255

FIVE ANGRY WOMEN / THE ALIEN FACTOR

I haven't been able to confirm whether either of these flicks made it to any New York City venues prior to this double bill, but it's inarguable that they were hardly "New Films" by this point. *The Alien Factor* was made in 1978, and *Five Angry Women* dated all the way back to 1974!

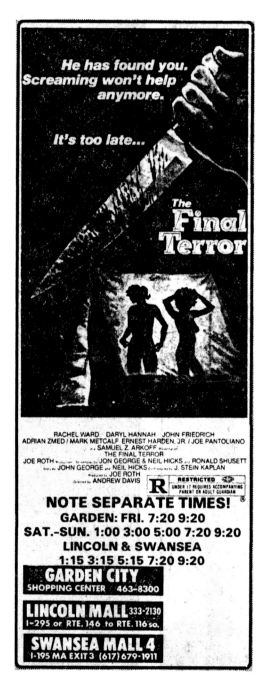

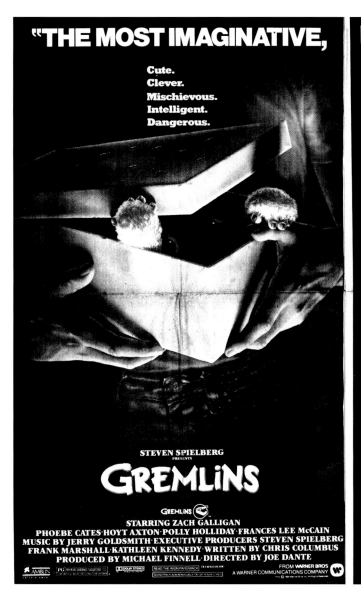

1984

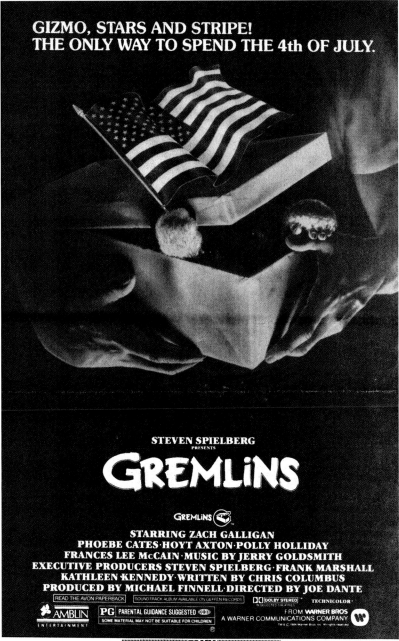

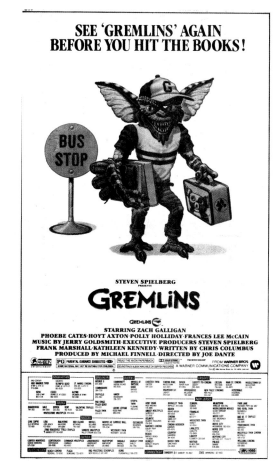
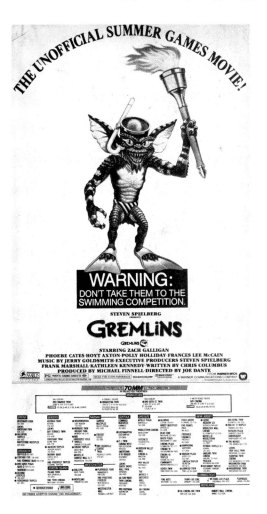

1985

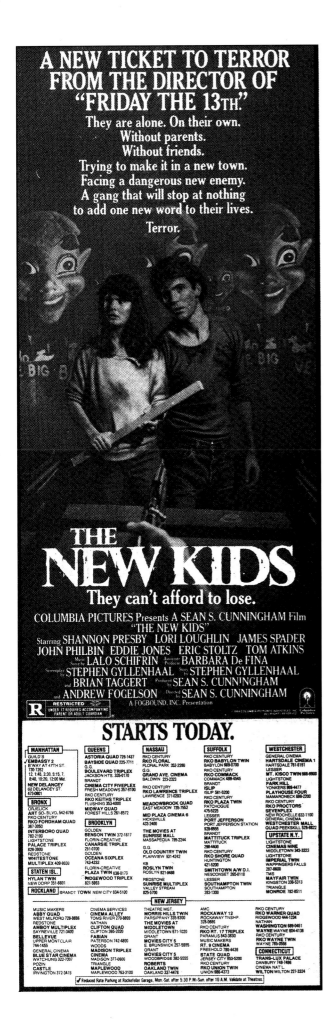

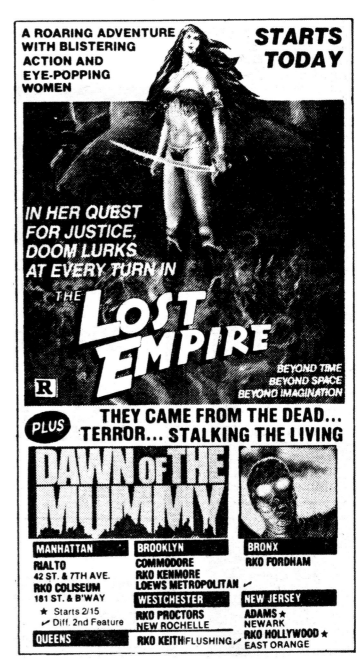

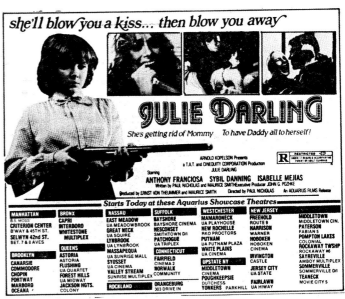

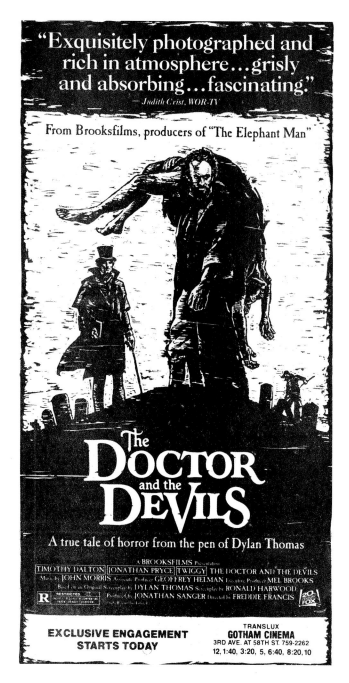

"Exquisitely photographed and rich in atmosphere...grisly and absorbing...fascinating."
— *Judith Crist, WOR-TV*

From Brooksfilms, producers of "The Elephant Man"

The DOCTOR and the DEVILS

A true tale of horror from the pen of Dylan Thomas

A BROOKSFILMS Presentation
TIMOTHY DALTON JONATHAN PRYCE TWIGGY THE DOCTOR AND THE DEVILS
Music by JOHN MORRIS Associate Producer GEOFFREY HELMAN Executive Producer MEL BROOKS
Based on an Original Screenplay by DYLAN THOMAS Screenplay by RONALD HARWOOD
Produced by JONATHAN SANGER Directed by FREDDIE FRANCIS

EXCLUSIVE ENGAGEMENT STARTS TODAY

TRANSLUX
GOTHAM CINEMA
3RD AVE. AT 58TH ST 759-2262
12, 1:40, 3:20, 5, 6:40, 8:20, 10

IT FELL FROM THE HEAVENS AND CREATED A HELL ON EARTH.

Sword of Heaven

TWE
TRANS WORLD ENTERTAINMENT
1985 TWE Prods. Inc.

STARTS TODAY AT A SELECTED THEATRE NEAR YOU

MANHATTAN	BROOKLYN	QUEENS	NEW JERSEY
UNITED ARTISTS TWIN	COLISEUM	QUEENS VILLAGE	NEWARK
B'WAY AT 49 ST. 247-1633	492-7707	COMMUNITY	PARAMOUNT
12:30, 2:30, 4:10, 5:55,	COMMODORE	465-4242	623-5030
7:45, 9:35, 11:25	384-7259		

DAY OF THE DEAD

Fans of *Night of the Living Dead* and *Dawn of the Dead* had been eagerly awaiting a closer to George A. Romero's trilogy for six years, and finally got it in summer 1985. United Film Distribution began the regional release in New York and a couple of other cities over July 4 weekend, and though initial box office was strong, *Day of the Dead* didn't become a breakout hit the way *Dawn* had. (In some areas, it didn't hit screens until *Return of the Living Dead* came along about a month later to provide undead competition.) Romero pared down his film due to budget concerns, and some critics missed both the scope and the satire of *Dawn*.

"Many in the audience will cringe and look away at the onslaught of blood and guts. But that's part of the fun, and the heads that move on their own, or the bodies that movie without heads are hideously charming examples of Grand Guignol."
— William Wolf, *Gannett News Service*

"*Day of the Dead*...has a less startling setting [than *Dawn*], since most of it takes place underground. But it still affords Mr. Romero the opportunity for intermittent philosophy and satire, without compromising his reputation as the grisliest guy around."
— Janet Maslin, *The New York Times*

"You might assume that it would be impossible to steal a scene from a zombie...but you haven't seen the overacting in this movie. The characters shout their lines from beginning to end, their temples pound with anger, and they use distracting Jamaican and Irish accents, until we are so busy listening to their endless dialogue that we lose interest in the movie they occupy."
— **ROGER EBERT, *CHICAGO SUN-TIMES***

"The zombies are no longer scary. They're Halloween camp. All those growling extras stalking around with their eyes and tongues missing look like they're just going through the paces to pay off their union insurance."
— Rex Reed, *New York Post*

First there was
"NIGHT of the LIVING DEAD"

then
"DAWN of the DEAD"

and now the darkest day of horror the world has ever known

GEORGE A. ROMERO'S

DAY
OF
THE
DEAD

United Film Distribution Company presents A Laurel Production
George A. Romero's "DAY OF THE DEAD"
Starring Lori Cardille, Terry Alexander, Joe Pilato, Richard Liberty
Production Design Cletus Anderson, Music by John Harrison, Director of Photography Michael Gornick
Makeup Special Effects Tom Savini, Co-Producer David Ball, Executive Producer Salah M. Hassanein
Produced by Richard P. Rubinstein, Written and Directed by George A. Romero

ORIGINAL SOUND TRACK AVAILABLE ON SATURN RECORDS & TAPES

Due to scenes of violence, which may be
considered shocking, no one under 17 admitted. © MCMLXXXV Dead Films, Inc.

STARTS WEDNESDAY

MANHATTAN

UA UNITED ARTISTS TWIN
B'WAY & 49TH ST.
247-1633

UA gemini
832-1670 64th St. & 2nd Ave.

GREENWICH PLAYHOUSE TWIN
12TH ST. AT 7TH AVE.
929-3350

GOLDEN
OLYMPIA QUAD
B'WAY AT 107TH ST.
865-8128

LESSER
ESSEX
GRAND ST. AT ESSEX
982-4455

AND AT A THEATRE NEAR YOU

Alien vampires have just landed from outer space...
in search of the one substance they need to survive...
TEENAGE BLOOD!

EVILS OF THE **NIGHT**

A SCIENCE FICTION
HORROR SHOCKER
FOR HALLOWEEN

MARS PRODUCTIONS PRESENTS "EVILS OF THE NIGHT"
Starring
ALDO RAY, JULIE NEWMAR, JOHN CARRADINE, TINA LOUISE and KARRIE EMERSON
Associate Producer JOAN KASHA Music ROBERT O. RAGLAND Written by PHILLIP CONNORS
Produced and Directed by MARDI RUSTAM [R] RESTRICTED Released by AQUARIUS RELEASING, INC. Color

Starts Today at these AQUARIUS SHOWCASE THEATRES

MANHATTAN	BROOKLYN	BRONX	NEW JERSEY	
CRITERION CENTER B'WAY AT 45TH ST.	**BENSON**	**ART**	**BLOOMFIELD** RKO ROYAL	**ROCKAWAY TWNSHP** ROCKAWAY
LIBERTY 42 ST. BET. 7 & 8 AVES.	**COLISEUM** **COMMODORE**	**DOVER** **INTERBORO**	**FAIR LAWN** HIGHWAY	**PARAMUS** PARAMUS DI
COSMO 118 ST., BET. LEX & 3	**DUFFIELD** **FORTWAY**	**KENT** **UA VALENTINE**	**HARRISON** WARNER	**SAYREVILLE** AMBOYS MULTIPLEX
ESSEX 275 GRAND ST.	**RKO KENMORE** **RKO KINGSWAY**	**WHITESTONE** **MULTIPLEX**	**IRVINGTON** CASTLE	**S. PLAINFIELD** MIDDLESEX
NOVA B'WAY AT 147TH	**OCEANA** **RIDGEWOOD**	**SUFFOLK**	**JERSEY CITY** UA STATE	**TEANECK** MOVIE CITY
QUEENS		**BABYLON** BABYLON	**MIDDLETOWN** MOVIES 7	**WAYNE** LOEWS 6
ASTORIA ASTORIA	**NASSAU**	**BRENTWOOD** BRENTWOOD	**NEWARK** PARAMOUNT	**WESTFIELD** UA RIALTO
FOREST HILLS MIDWAY	**E. MEADOW** MEADOWBROOK	**PATCHOGUE** SUNWAVE	**PATERSON** FABIAN	
FLUSHING QUARTET	**HICKSVILLE** HICKSVILLE	**COMMACK** COMMACK		**WESTCHESTER**
JACKSON HGTS JACKSON	**LYNBROOK** LYNBROOK	**MULTIPLEX**		**MAMARONECK** PLAYHOUSE
OZONE PARK CROSSBAY	**MASSAPEQUA** SUNRISE MALL	**CONNECTICUT**	**UPSTATE NY**	**NEW ROCHELLE** TOWN
STATEN ISLAND	**VALLEY STREAM** SUNRISE MULTIPLEX	**BRIDGEPORT** HIWAY	**NEWBURGH** MIDVALLEY	
ELTINGVILLE AMBOYS	**WESTBURY** WESTBURY MULTIPLEX	**BROOKFIELD** FINE ARTS	**WARWICK** WARWICK DI	**YONKERS** PARK HILL

RE-ANIMATOR

Back in the '80s, as we've seen, many critics typically derided horror movies featuring extreme bloodshed. That changed with Stuart Gordon's over-the-top H.P. Lovecraft adaptation, which won strong reviews for bringing ghoulish wit to its copious gore.

"Not since the heyday of Roger Corman, perhaps, have film makers had so much fun with an exploitation movie. ... Throughout, director Stuart Gordon dances on the edge of parody but never crosses it, and the actors follow his lead nicely."
— **Paul Attanasio**, *The Washington Post*

"The macabre fun lies in the film's emphasis on how much trouble all those flailing zombies become. ... *Re-Animator* plays like the kind of film George Romero has been trying to remake ever since *Night of the Living Dead*. A genre standout, its future as a midnight staple for the strong-of-stomach seems assured."
— **JAY CARR,**
THE BOSTON GLOBE

"By the end of the film, we are keenly aware that nothing of consequence has happened, but so what? We have been assaulted by a lurid imagination, amazed by unspeakable sights, blind-sided by the movie's curiously dry sense of humor."
— **Roger Ebert**, *Chicago Sun-Times*

"*Re-Animator* might be likened to a pie fight in a butcher shop, and if you don't like pie fights or butcher shops, you ought to steer clear. It's a mordant, witty, outrageous gross-out, an exercise in what might be called viscera slapstick. In other words, you either have to get with it or get out of it."
— **Stephen Hunter**, *The Baltimore Sun*

"It is hoped any other people who stumble into this film by mistake do so a long time after their last meal."
— **John A. Douglas**, *The Grand Rapids Press*

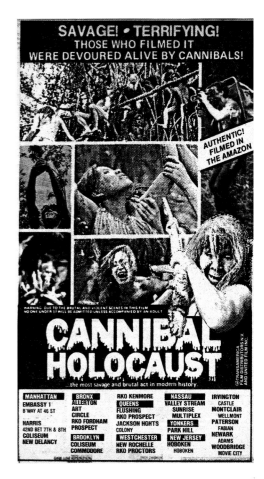
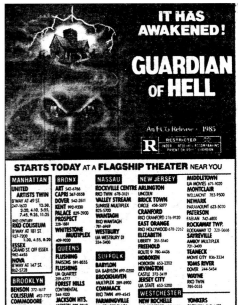

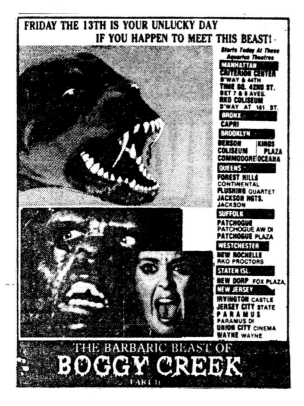

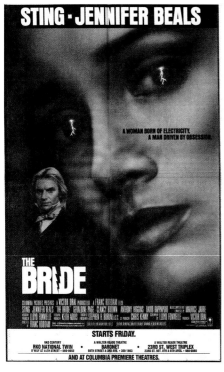

1985

THE MUTILATOR

By sword
By pick
By axe
Bye bye

WRITTEN, PRODUCED AND DIRECTED BY
BUDDY COOPER

STARRING

MATT MITLER FRANCES RAINES BILL HITCHCOCK
PAMELA WEDDLE COOPER RUTH MARTINEZ
MOREY LAMPLEY CONNIE ROGERS TRACE COOPER

ALSO
STARRING JACK CHATHAM SPECIAL
APPEARANCE BY BEN MOORE

DIRECTOR OF
PHOTOGRAPHY PETER SCHNALL LOCATION SOUND
RECORDING LARRY LOEWINGER

SOUND
EDITOR HUGHES WINBORNE SPECIAL MAKE UP
EFFECTS BY MARK SHOSTROM,

ANTHONY SHOWE, ED FERRELL MUSIC BY MICHAEL MINARD

DUE TO THE VIOLENT NATURE OF CERTAIN SCENES,
THIS MOTION PICTURE IS NOT INTENDED FOR
VIEWING BY THOSE UNDER 17 UNLESS ACCOMPANIED
BY A PARENT OR ADULT GUARDIAN.

CO-DIRECTOR JOHN DOUGLASS

ASSOCIATE
PRODUCER NEIL WHITFORD

OCEAN KING RELEASING © 1984 OK PRODUCTIONS

STARTS TODAY AT A **FLAGSHIP THEATER** NEAR YOU

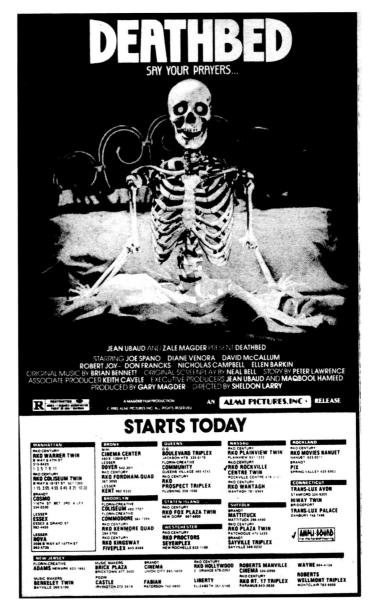

DEATHBED

SAY YOUR PRAYERS...

JEAN UBAUD AND ZALE MAGDER PRESENT DEATHBED
STARRING JOE SPANO DIANE VENORA DAVID McCALLUM
ROBERT JOY DON FRANCKS NICHOLAS CAMPBELL ELLEN BARKIN
ORIGINAL MUSIC BY BRIAN BENNETT ORIGINAL SCREENPLAY BY NEAL BELL STORY BY PETER LAWRENCE
ASSOCIATE PRODUCER KEITH CAVELE EXECUTIVE PRODUCERS JEAN UBAUD AND MAQBOOL HAMEED
PRODUCED BY GARY MAGDER DIRECTED BY SHELDON LARRY

A MAGDER FILM PRODUCTION
© 1985 ALMI PICTURES INC AL RIGHTS RESERVED AN ALMI PICTURES, INC. RELEASE

STARTS TODAY

THE TENANT IN ROOM 7 IS VERY SMALL, VERY TWISTED, AND VERY MAD

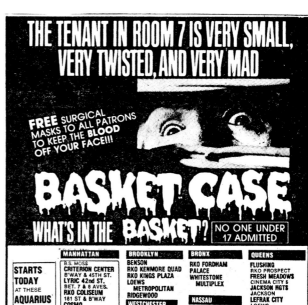

FREE SURGICAL MASKS TO ALL PATRONS TO KEEP THE **BLOOD** OFF YOUR FACE!!!

BASKET CASE

WHAT'S IN THE **BASKET**? NO ONE UNDER 17 ADMITTED

SILENT MADNESS

This latecomer to the slasher genre was shot in 3-D, and released as such to theaters — but not all of them. When I went to see it, the marquee stated that the film was in 3-D, but I didn't receive glasses, and the ticket girl explained that it wasn't being shown with the extra dimension. When I inquired why they were claiming the movie was in 3-D even though it wasn't, she clarified that it was a 3-D movie, they just weren't *showing* it in 3-D, and the conversation quickly took on the tone of a Monty Python sketch.

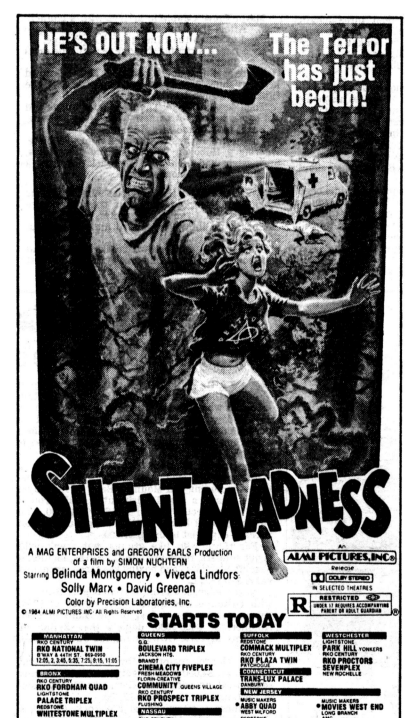

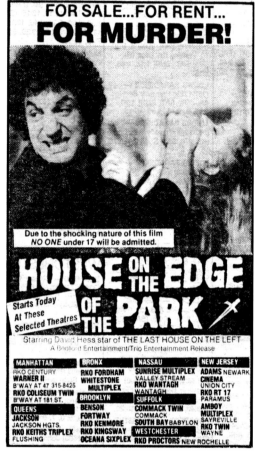

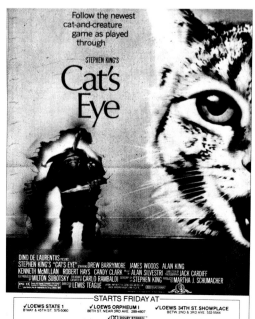

CREEPERS

When the edited and retitled American version of Dario Argento's *Phenomena* first hit theaters, the poster and ads featured teenage star Jennifer Connelly's intact visage. Box office was middling, and those materials were considered partially to blame because they lacked goriness, so Connelly's lovely face was messed up for subsequent releases.

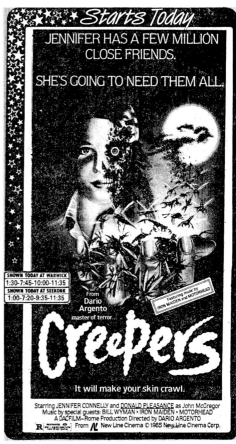

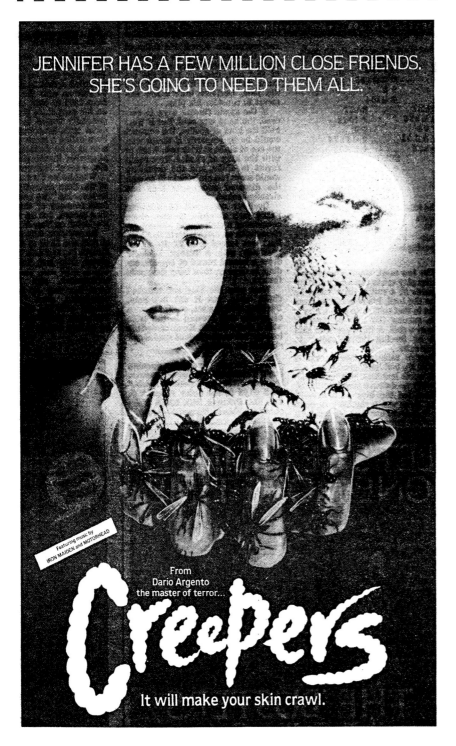

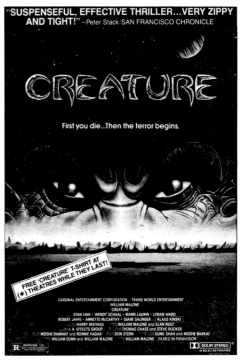

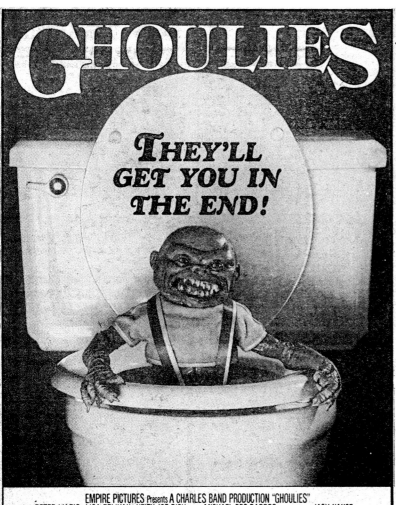

A ROCK BAND GIVES THEIR FINAL PERFORMANCE ON A HELL BOUND TRIP INTO THE OUTER REACHES OF HORROR!

NIGHT TRAIN TO TERROR

VISTO INTERNATIONAL INC. Presents
NIGHT TRAIN TO TERROR
Starring JOHN PHILLIP LAW · CAMERON MITCHELL · MARK LAWRENCE · CHARLES MOLL Executive Producer WILLIAM F. MESSERLI
Music Supervision RALPH IVES Produced and Directed by JAY SCHLOSSBERG-COHEN Associate Producer GENE RUGGIERO
Written by PHILLIP YORDAN Released and Distributed by VISTO INTERNATIONAL INC.

STARTS TODAY AT THESE **AQUARIUS SHOWCASE THEATRES**

a monster he can't control has taken over his soul!

Scream

RESTRICTED ® UNDER 17 REQUIRES ACCOMPANYING PARENT OR ADULT GUARDIAN

**Starts Today At These
Aquarius Showcase Theatres**

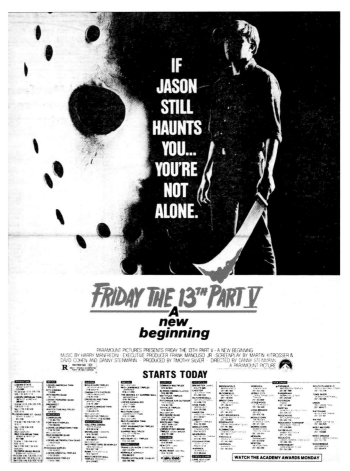

IF JASON STILL HAUNTS YOU... YOU'RE NOT ALONE.

FRIDAY THE 13TH PART V
A new beginning

PARAMOUNT PICTURES PRESENTS FRIDAY THE 13TH V - A NEW BEGINNING
MUSIC BY HARRY MANFREDINI · EXECUTIVE PRODUCER FRANK MANCUSO JR · SCREENPLAY BY MARTIN KITROSSER & DAVID COHEN AND DANNY STEINMANN · PRODUCED BY TIMOTHY SILVER · DIRECTED BY DANNY STEINMANN
A PARAMOUNT PICTURE

STARTS TODAY

WATCH THE ACADEMY AWARDS MONDAY

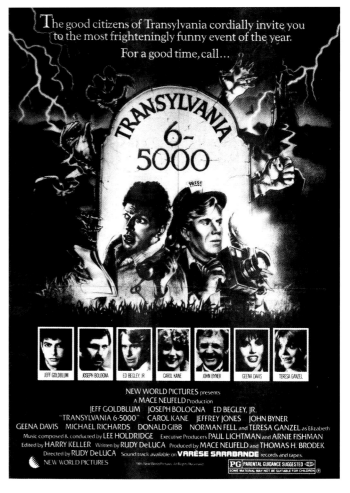

The good citizens of Transylvania cordially invite you to the most frighteningly funny event of the year.
For a good time, call...

TRANSYLVANIA 6-5000

JEFF GOLDBLUM · JOSEPH BOLOGNA · ED BEGLEY, JR. · CAROL KANE · JOHN BYNER · GEENA DAVIS · TERESA GANZEL

NEW WORLD PICTURES presents
A MACE NEUFELD Production
JEFF GOLDBLUM · JOSEPH BOLOGNA · ED BEGLEY, JR.
"TRANSYLVANIA 6-5000" · CAROL KANE · JEFFREY JONES · JOHN BYNER
GEENA DAVIS · MICHAEL RICHARDS · DONALD GIBB · NORMAN FELL and TERESA GANZEL as Elizabeth
Music composed & conducted by LEE HOLDRIDGE Executive Producers PAUL LICHTMAN and ARNIE FISHMAN
Edited by HARRY KELLER Written by RUDY DeLUCA Produced by MACE NEUFELD and THOMAS H. BRODEK
Directed by RUDY DeLUCA Sound track available on VARÈSE SARABANDE records and tapes.
NEW WORLD PICTURES

PG PARENTAL GUIDANCE SUGGESTED
SOME MATERIAL MAY NOT BE SUITABLE FOR CHILDREN

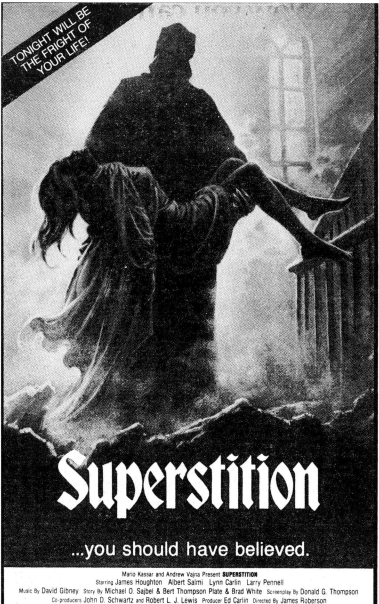

TONIGHT WILL BE THE FRIGHT OF YOUR LIFE!

Superstition

...you should have believed.

Mario Kassar and Andrew Vajna Present SUPERSTITION
Starring James Houghton Albert Salmi Lynn Carlin Larry Pennell
Music By David Gibney Story By Michael O. Sajbel & Bert Thompson Plate & Brad White Screenplay By Donald G. Thompson
Co-producers John D. Schwartz and Robert L. J. Lewis Producer Ed Carlin Directed by James Roberson
© 1984 ALMI PICTURES, INC. All Rights Reserved. AN ALMI PICTURES, INC. RELEASE DUE TO THE GRAPHIC NATURE OF THIS FILM NO ONE UNDER 17 WILL BE ADMITTED

STARTS TODAY

MANHATTAN
RKO NATIONAL TWIN
B'WAY & 44TH ST. 869-0950
12, 1:50, 3:40, 5:30, 7:25, 9:20, 11:10
RKO COLISEUM TWIN
B'WAY & 181ST ST. 927-2700
12, 3:40, 5:20, 7, 8:40, 10:20
RKO CENTURY
RKO 86TH ST. TWIN
86TH ST. & LEX. AVE 289-8900
1, 2:40, 4:20, 6, 7:40, 5:20, 11
LESSER
NOVA 862-5728
3689 B'WAY AT 147TH ST.
LESSER
ALPINE
DYCKMAN ST. & B'WAY 567-3547
BRANDT
COSMO
116TH ST. BET. 3RD. & LEX
534-0730
LESSER
ESSEX
ESSEX & GRAND ST
982-4455

BRONX
ORJELICK
ART SOUTHERN BLVD
ACORN
ALLERTON TRIPLEX
LIGHTSTONE
CIRCLE
LESSER
DOVER
RKO CENTURY
RKO FORDHAM QUAD
LESSER
KENT
LIGHTSTONE
PALACE TRIPLEX
LIGHTSTONE
PROSPECT
REDSTONE
WHITESTONE MULTIPLEX

BROOKLYN
GOLDEN
BENSON TWIN
BRANDT
CANARSIE TRIPLEX
ORJELICK
COLISEUM
FLORIN-CREATIVE
COMMODORE
GOLDEN
FORTWAY FIVEPLEX
RKO CENTURY
RKO KENMORE QUAD
RKO CENTURY
RKO KINGSWAY FIVEPLEX
LOEWS
METROPOLITAN
QUAD
GOLDEN
OCEANA SIXPLEX

QUEENS
G.G.
BOULEVARD TRIPLEX
JACKSON HTS.
BRANDT
CINEMA CITY FIVEPLEX
FRESH MEADOWS
FLORIN-CREATIVE
COMMUNITY
QUEENS VILLAGE
MAXI
HAVEN
WOODHAVEN
RKO CENTURY
RKO KEITHS TRIPLEX
FLUSHING
ABRAMS
LEFFERTS TRIPLEX
RICHMOND HILL
LOEWS LEFRAK CITY
TRIPLEX
REGO PARK
LIGHTSTONE
PARSONS TWIN
BRANDT
SURFSIDE TWIN CINEMA
ROCKAWAY PK.

NASSAU
RKO CENTURY
RKO FLORAL
FLORAL PARK
RKO CENTURY
RKO
GREEN ACRES TRIPLEX
VALLEY STREAM
RKO CENTURY
RKO LAWRENCE TRIPLEX
LAWRENCE
RKO CENTURY
LEVITTOWN TWIN
LEVITTOWN
RKO CENTURY
RKO PLAINVIEW TWIN
PLAINVIEW
G.G.
PORT WASHINGTON
TRIPLEX
RKO CENTURY
RKO
ROOSEVELT FIELD TRIPLEX
GARDEN CITY
RKO CENTURY
RKO WANTAGH
WANTAGH
BRANDT
WESTBURY D.I.
TRIPLEX
WESTBURY

STATEN ISLAND
AMBOY TWIN
ELTINGVILLE
RKO CENTURY
RKO FOX PLAZA TWIN
NEW DORP

WESTCHESTER
KENT CINEMA
YONKERS
LIGHTSTONE
PARK HILL
YONKERS
RKO CENTURY
RKO PROCTORS
SEVENPLEX
NEW ROCHELLE

SUFFOLK
RKO CENTURY
COMMACK MULTIPLEX
COMMACK
BRANDT
ISLIP ISLIP
RKO CENTURY
RKO PLAZA TWIN
PATCHOGUE
RKO CENTURY
RKO SHORE QUAD
HUNTINGTON
LIGHTSTONE
SOUTH BAY TRIO
W. BABYLON
BRANDT
SUFFOLK
RIVERHEAD

CONNECTICUT
TRANS-LUX AVON
STAMFORD
NUTMEG
CINEMA TWIN NORWALK
CINEMA NAT'L
COUNTY FAIRFIELD
TRANS-LUX
PALACE
DANBURY

UPSTATE N.Y.
ATM
CINEMA
MIDDLETOWN
ATM
DUTCHESS CINEMA
POUGHKEEPSIE
FLORIN-CREATIVE
LIBERTY TRIPLEX
LIBERTY
CATE
MID VALLEY CINEMA
NEWBURGH

ROCKLAND COUNTY
ATM
MALL NANUET
VENTURINI
9W CINEMA STONY POINT

NEW JERSEY
MUSIC MAKERS
ABBY QUAD
WEST MILFORD
REDSTONE
AMBOY MULTIPLEX
SAYREVILLE
TMA
ALLWOOD CINEMA
CLIFTON
POZIN
CASTLE IRVINGTON
BRANDT
CINEMA
UNION CITY
CINEMA TWIN
HOBOKEN
TRI-STATE
CINEMA 23
MONTAGUE
BRANDT
COMMUNITY MORRISTOWN
RKO CENTURY
RKO CRANFORD TWIN
CRANFORD
THEATRE MANAGEMENT
FABIAN PATERSON
RKO CENTURY
RKO HOLLYWOOD
E. ORANGE
REDSTONE
NEWARK D.I.
NEWARK
FLORIN-CREATIVE
PARAMOUNT
NEWARK
RKO CENTURY
RKO ROYAL TWIN
BLOOMFIELD
MUSIC MAKERS
RT. 9 CINEMA
FREEHOLD
RKO CENTURY
RKO RT. 17 TRIPLEX
PARAMUS
STATE QUAD JERSEY CITY
THEATRE MANAGEMENT
WASHINGTON TWNSHP.
CINEMA

1985

ONCE BITTEN

A clutch of comedies involving classic horror creatures hit theaters in mid to late 1985 — all of them pretty negligible. *Teen Wolf* rode the *Back to the Future* popularity of actor Michael J. Fox to good grosses, while *Transylvania 6-5000* and *Once Bitten* were less successful. Today, however, the latter is still remembered for featuring an early leading turn by an up-and-coming comic star, who even got a few positive notices for this weak vehicle.

"The many talents of Jim Carrey, the new-to-movies actor, consistently save *Once Bitten* from itself. Even when the script is almost awkwardly lacking in sharp humor, or the directing seems a little willy nilly, Carrey's adroit mixture of naivete and vampish menace is among the film's most appealing qualities."

— Peter Stack, *San Francisco Chronicle*

"The jokes are as dreadful as you'd imagine. ... There's no gore, no jolts, no horror-movie atmosphere at all – just the zillionth rehash of the horny teen-sex saga. ... Jim Carrey has a certain overbearing charm (if there's ever a call for another Jerry Lewis, he's your guy)."

— RICK LYMAN,
THE PHILADELPHIA INQUIRER

"Bend, fold and mutilate any comic possibilities in this teen sex and supernatural slapstick and you've got *Once Bitten* ... In every way, on every level, *Once Bitten* is beyond inept; it is numbing, enervated."

— Joseph Gelmis, *New York Newsday*

"Carrey has a certain goofy appeal, and he proves a surprisingly nimble dancer at the Halloween hop. ... As for the dialogue...it plays like an especially bad Las Vegas lounge act."

— Glenn Lovell, *San Jose Mercury News*

"Howard Storm directs *Once Bitten* as if he has spent the last 300 years in a coffin. Each scene, from the silly opening to the predictable ending, is telegraphed with all the subtlety of a bite on the neck."

— Michael Blowen, *The Boston Globe*

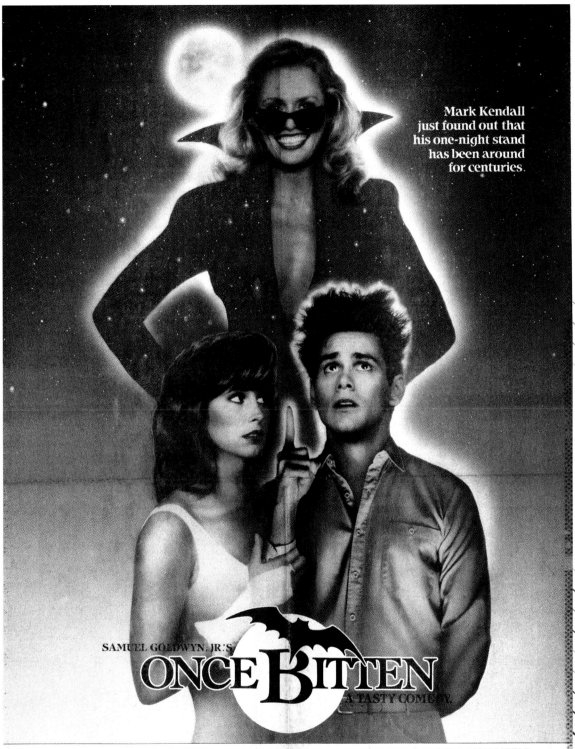

Mark Kendall just found out that his one-night stand has been around for centuries.

SAMUEL GOLDWYN, JR.'S

ONCE BITTEN

A TASTY COMEDY.

ONCE BITTEN Starring LAUREN HUTTON, JIM CARREY, KAREN KOPINS and CLEAVON LITTLE
Director of Photography ADAM GREENBERG Associate Producer RUSSELL THACHER
Executive Producer SAMUEL GOLDWYN, JR.
Screenplay by DAVID HINES & JEFFREY HAUSE and JONATHAN ROBERTS Story by DIMITRI VILLARD
Produced by DIMITRI VILLARD, ROBBY WALD and FRANK E. HILDEBRAND
Directed by HOWARD STORM

PG-13 PARENTS STRONGLY CAUTIONED
Some Material May be Inappropriate for Children Under 13 Original Soundtrack available on MCA/Curb Records

©1985 THE SAMUEL GOLDWYN COMPANY

STARTS TODAY

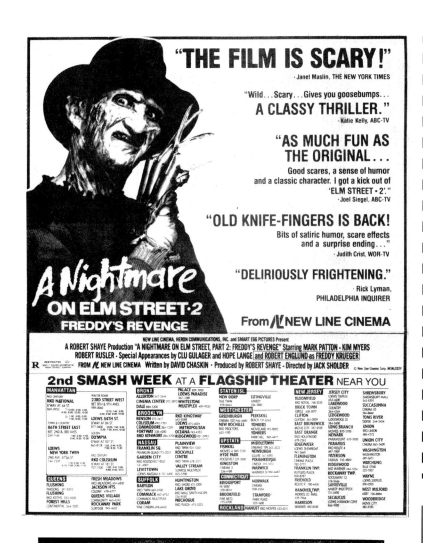

A NIGHTMARE ON ELM STREET 2: FREDDY'S REVENGE

Since *A Nightmare on Elm Street 2*'s release, many observers have picked up on the gay undercurrents running through several of its key scenes. This subtext seems obvious now, but it wasn't to critics at the time, some of whom actually liked it better than Wes Craven's original.

"Sequels rarely live up to the originals, but *Nightmare on Elm Street 2* surpasses the surprisingly good splatter film from which it stems. ... Like its predecessor, this sequel is juicily Freudian; that's why it's potent."
— Jay Carr, *The Boston Globe*

"It's a great opening sequence for a comic-horror film that erases the boundaries between waking and dreaming. It's also a sign that *Nightmare 2* is going to be a lot more fun than the gory original, thanks to director Jack Sholder's bizarre sense of humor."
— James Verniere, *Boston Herald*

"Not only are the nightmares major productions, but they worm their way into the picture until you can't tell where the dreamed horror ends and the real horror takes over. That's powerful picture-making, though it can inspire some resistance among those who wish to maintain their sanity."
— ARCHER WINSTEN, *NEW YORK POST*

"The original *Nightmare on Elm Street*, distasteful as it was, benefitted from the Boschian imagination of director Wes Craven. ... Jack Sholder, director of *Part 2*, is workmanlike, but that's all."
— Scott Cain, *The Atlanta Journal*

"[It's] as stomach-turning as might be expected, but it has a lot going for it: clever special effects, a good leading performance, and a villain so chatty he practically makes this a human-interest story."
— Janet Maslin, *The New York Times*

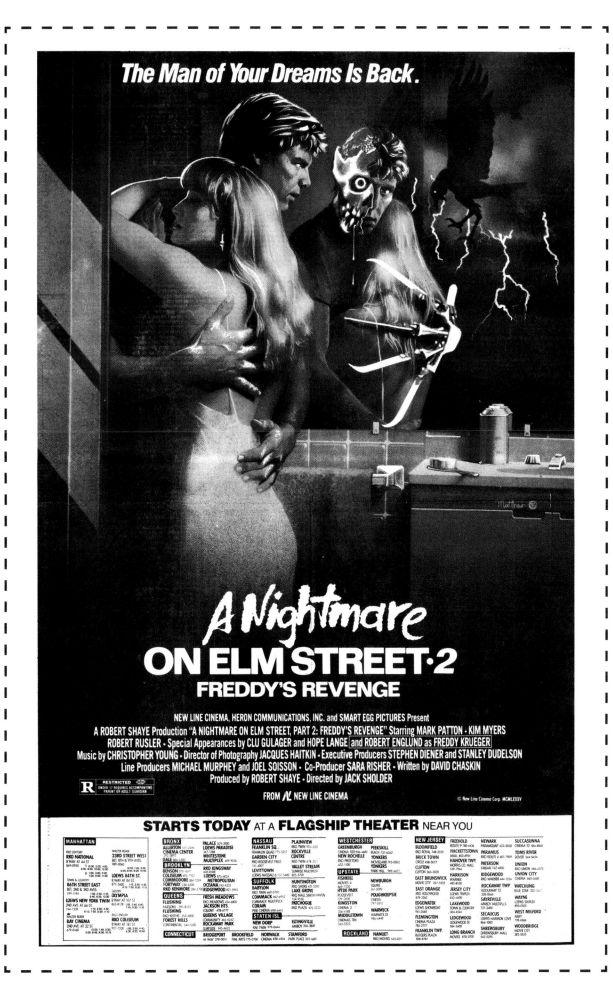

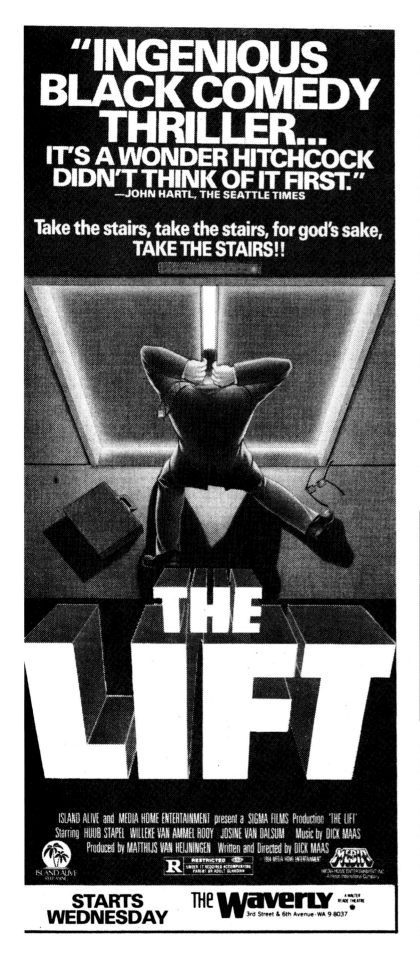

THE STUFF

The day *The Stuff* opened in New York in September 1985, Hurricane Gloria hit the city. Larry Cohen is quoted as having blamed the storm for interrupting newspaper delivery, preventing people from reading the favorable reviews his movie received. My personal recollection is that I went to see it in Manhattan that day, unimpeded by much in the way of wind and rain, despite the warnings. And while I quite enjoyed the film, the reviews, in New York and elsewhere, were mixed.

"This is a rich mine of horror and suspense, which writer-director Larry Cohen is digging to the bottom and beyond. ... The horror aspects of *The Stuff* is sufficiently gruesome, particularly when victims unhinge their jaws to spew it back up. Addicted horror fans could eat it up."

— Archer Winsten, *New York Post*

"The big problem with *The Stuff* is that it has a split personality. It is a comedy take-off on horror films, yet it is conveying a thoroughly serious message about irresponsible private greed and governmental supervision."

— Richard F. Shepard, *The New York Times*

"Like its title character, *The Stuff* has a tendency to bite off more than it can chew. ... Still, a surplus of good ideas is certainly preferable to a surfeit of them. *The Stuff* may, at heart, be all stuff and nonsense, but it's the right stuff and the right nonsense."

— ELEANOR RINGEL, *THE ATLANTA JOURNAL*

"*The Stuff* is a terrible, rotten, pointless and amateurish movie that has higher ideals. You gotta watch those higher ideals—they frequently turn turkey on you."

— Peter Stack, *San Francisco Chronicle*

"Cohen keeps the whole preposterous story afloat with a healthy dose of tongue-in-cheek humor and some cagy casting. ... Best yet, the film has Moriarty, an ingratiating, refreshingly low-voltage actor who almost single-handedly creates an engaging mood."

— Patrick Goldstein, *Los Angeles Times*

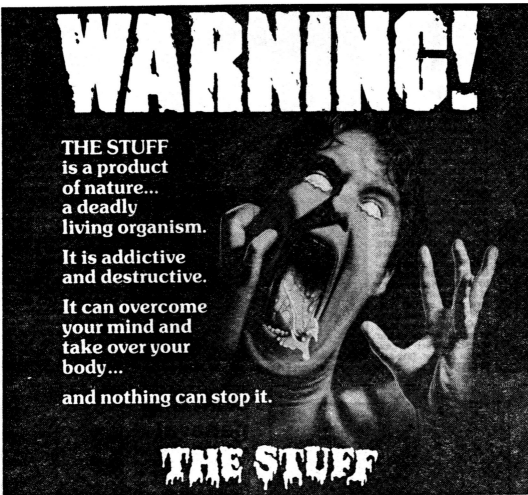

WARNING!

THE STUFF is a product of nature... a deadly living organism.

It is addictive and destructive.

It can overcome your mind and take over your body...

and nothing can stop it.

THE STUFF

New World Pictures presents A Larco Production A Larry Cohen Film "THE STUFF"
Starring MICHAEL MORIARTY ANDREA MARCOVICCI GARRETT MORRIS SCOTT BLOOM PAUL SORVINO as "Spears"
Guest Star DANNY AIELLO and PATRICK O'NEAL Director of Photography PAUL GLICKMAN Music by ANTHONY GUEFEN
Edited by ARMOND LEBOWITZ Executive Producer LARRY COHEN Associate Producer BARRY SHILS
R RESTRICTED UNDER 17 REQUIRES ACCOMPANYING PARENT OR ADULT GUARDIAN
Produced by PAUL KURTA Written and Directed by LARRY COHEN © 1985 New World Pictures. All rights reserved. NEW WORLD PICTURES

Starts Today at a Theatre Near You!

MANHATTAN

LOEWS ASTOR PLAZA	LOEWS ORPHEUM	GOLDEN QUAD	GOLDEN OLYMPIA QUAD
BROADWAY & 44TH STREET 869-8340	86TH STREET NEAR 3RD AVENUE 289-4607	34 WEST 13TH STREET 255-8801	BROADWAY AT 107TH STREET 865-8128
12:30, 2:15, 4, 5:45, 7:30, 9:15, 11	12:30, 2:15, 4, 5:45, 7:30, 9:15, 11	1:20, 3, 4:40, 6:15, 7:55, 9:30, 11:10	1:55, 3:35, 5:15, 6:55, 8:35, 10:15

BRONX
ALLERTON TRIPLEX 547-2444
LOEWS AMERICAN TWIN 828-3322
CINEMA CENTER 292-3893
INTERBORO QUAD 792-2100
LOEWS PARADISE QUAD 367-1288
WHITESTONE MULTIPLEX 409-9030

QUEENS
ASTORIA QUAD ASTORIA 726-1437
LOEWS BAY TERRACE TWIN BAYSIDE 428-4040
FOREST HILLS TWIN FOREST HILLS 261-7866
JACKSON TRIPLEX JACKSON HEIGHTS 335-0242
PARSONS QUAD FLUSHING 591-8555
RKO PROSPECT TRIPLEX FLUSHING 359-1050

BROOKLYN
BENSON TWIN 372-1617
CANARSIE TRIPLEX 251-0700
COMMODORE 384-7259
FORTWAY FIVEPLEX 238-4200
RKO KENMORE 284-5700
RKO KINGSWAY FIVEPLEX 645-8588
LOEWS METROPOLITAN QUAD 875-4024
OCEANA SIXPLEX 743-4333
RIDGEWOOD TRIPLEX 821-5993

NASSAU
LYNBROOK QUAD LYNBROOK 593-1033
THE MOVIES AT SUNRISE MALL MASSAPEQUA 795-2244
LOEWS NASSAU SIX LEVITTOWN 731-5400
RKO PLAINVIEW TWIN PLAINVIEW 931-1333
SQUIRE TRIPLEX GREAT NECK 466-2020
SUNRISE MULTIPLEX VALLEY STREAM 825-5700
WESTBURY TRIPLEX D.I. WESTBURY 334-3400

SUFFOLK
COMMACK MULTIPLEX COMMACK 462-6953
MOVIES AT CORAM CORAM 736-6200
MATTITUCK TRIPLEX MATTITUCK 298-4400
PATCHOGUE SUNRISE A/W D.I. PATCHOGUE 363-7200
PINE CINEMA QUAD CORAM 698-6442
LOEWS SOUTH SHORE MALL TWIN BAYSHORE 666-4000
LOEWS STONY BROOK TRIPLEX STONY BROOK 751-2300

WESTCHESTER
BEACH CINEMA QUAD PEEKSKILL 737-6262
BRONXVILLE TRIPLEX BRONXVILLE 961-4030
PARK HILL YONKERS 969-4477
TOWN NEW ROCHELLE 632-4000

UPSTATE
CINEMA TWIN CARMEL 225-6500
CINEMA TEN MIDDLETOWN 343-3323
HYDE PARK D.I. HYDE PARK 229-2000
KINGSTON TRIPLEX KINGSTON 336-6077
MID VALLEY TWIN NEWBURGH 561-9500
SBC CINESIX SOUTH HILLS MALL POUGHKEEPSIE 297-5512
WARWICK D.I. WARWICK 986-4440

ROCKLAND
PLAZA WEST HAVERSTRAW 947-2220
ROCKLAND D.I. MONSEY 356-4040

CONNECTICUT
CINEMA STAMFORD 324-3100
HIGHWAY BRIDGEPORT 378-0014
PALACE DANBURY 748-7496

NEW JERSEY

ABBY QUAD WEST MILFORD 728-8886
ADAMS NEWARK 623-1992
AMBOY MULTIPLEX SAYREVILLE 721-3400
CINEMA 10 QUAD SUCCASUNNA 584-8860
CIRCLE CINEMAS BRICKTOWN 458-5077
COLONIAL TWIN POMPTON LAKES 835-8789

COMMUNITY MORRISTOWN 445-1777
DOVER TWIN TOMS RIVER 244-5454
FABIAN FIVEPLEX PATERSON 742-4800
FAIRVIEW TWIN FAIRVIEW 941-2424
FIVE POINTS UNION 964-9633
LOEWS HARMON COVE QUAD SECAUCUS 866-1000

HOBOKEN TWIN HOBOKEN 653-2202
LOEWS JERSEY CITY TRIPLEX JERSEY CITY 653-4600
LEDGEWOOD D.I. LEDGEWOOD 584-5600
MIDDLEBROOK OAKHURST 493-2277
MOVIES WEST END LONG BRANCH 870-2700

THE MOVIES AT MIDDLETOWN MIDDLETOWN 671-1020
MOVIE CITY 5 WOODBRIDGE 382-5555
ROCKAWAY 12 ROCKAWAY TOWNSHIP 328-0666
ROBERTS CENTER BLOOMFIELD 748-7000
ROUTE 9 CINEMA FREEHOLD 780-4436

RKO ROUTE 17 TRIPLEX PARAMUS 843-3830
LOEWS ROUTE 18 TWIN E. BRUNSWICK 254-9000
LOEWS TROY HILLS TWIN PARSIPPANY 335-4600
LOEWS WAYNE SIX WAYNE 890-0505
WESTFIELD TWIN WESTFIELD 654-4720

277

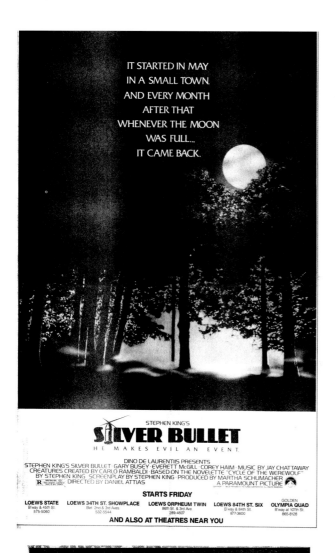

IT STARTED IN MAY
IN A SMALL TOWN,
AND EVERY MONTH
AFTER THAT
WHENEVER THE MOON
WAS FULL...
IT CAME BACK.

STEPHEN KING'S
SILVER BULLET
HE MAKES EVIL AN EVENT.

DINO DE LAURENTIIS PRESENTS
STEPHEN KING'S SILVER BULLET · GARY BUSEY · EVERETT McGILL · COREY HAIM · MUSIC BY JAY CHATTAWAY
CREATURES CREATED BY CARLO RAMBALDI · BASED ON THE NOVELETTE "CYCLE OF THE WEREWOLF"
BY STEPHEN KING · SCREENPLAY BY STEPHEN KING · PRODUCED BY MARTHA SCHUMACHER
DIRECTED BY DANIEL ATTIAS A PARAMOUNT PICTURE

STARTS FRIDAY

LOEWS STATE · LOEWS 34TH ST. SHOWPLACE · LOEWS ORPHEUM TWIN · LOEWS 84TH ST. SIX · GOLDEN OLYMPIA QUAD

AND ALSO AT THEATRES NEAR YOU

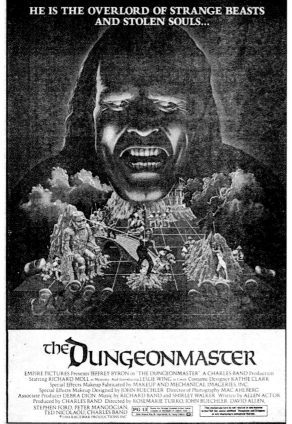

HE IS THE OVERLORD OF STRANGE BEASTS
AND STOLEN SOULS...

The DUNGEONMASTER

EMPIRE PICTURES Presents JEFFREY BYRON in "THE DUNGEONMASTER" A CHARLES BAND Production
Starring RICHARD MOLL as Mestema And Introducing LESLIE WING as Gwen Costume Designer KATHIE CLARK
Special Effects Makeup Fabricated by MAKEUP AND MECHANICAL IMAGERIES, INC.
Special Effects Makeup Designed by JOHN BUECHLER Director of Photography MAC AHLBERG
Associate Producer DEBRA DION Music by RICHARD BAND and SHIRLEY WALKER Written by ALLEN ACTOR
Produced by CHARLES BAND Directed by ROSEMARIE TURKO, JOHN BUECHLER, DAVID ALLEN,
STEPHEN FORD, PETER MANOOGIAN,
TED NICOLAOU, CHARLES BAND

THE RETURN OF THE LIVING DEAD

Re-Animator wasn't the only film to bring the deceased back to life with a sense of black humor. Dan O'Bannon's directorial debut, which grew out of a seriously intended follow-up to *Night of the Living Dead*, slipped into the late-summer-'85 movie scene and quickly won a following (outgrossing *Day of the Dead*). The overall critical response, on the other hand, wasn't as favorable as it was for Stuart Gordon's opus.

"The details are gruesomely graphic, the human statements of fear very expressive in today's profane epithet, and the pace of events is strictly pellmell. I don't know when corpses have been presented as impressively."

— Archer Winsten, *New York Post*

"The problem is it's difficult to spoof a spoof. Anyone who could take Romero's films seriously is too gullible to be turned loose in the world. But since this film is roughly three parts comedy and one part gore, it represents an improvement over Romero's record, which are considerably gorier."

— Mal Vincent, *The Virginian-Pilot*

"The whole point is excess, and O'Bannon's good at getting to that point. But the film is so clearly meant for giggles that it packs nowhere near the emotional punch of one of Romero's... ."

— BILL COSFORD,
THE MIAMI HERALD

"The acting is so bad that it's hard in most scenes to tell the walking dead from the supposedly living, and as an attempt to mingle horror with humor, O'Bannon's film is as hilarious as an autopsy."

— Desmond Ryan, *The Philadelphia Inquirer*

"This movie has enough sick, tasteless, yecch scenes to empty any theater – yet we are drawn into the plot by the sly, witty, little comic twists."

— Chuck Davis, *The Daily Oklahoman*

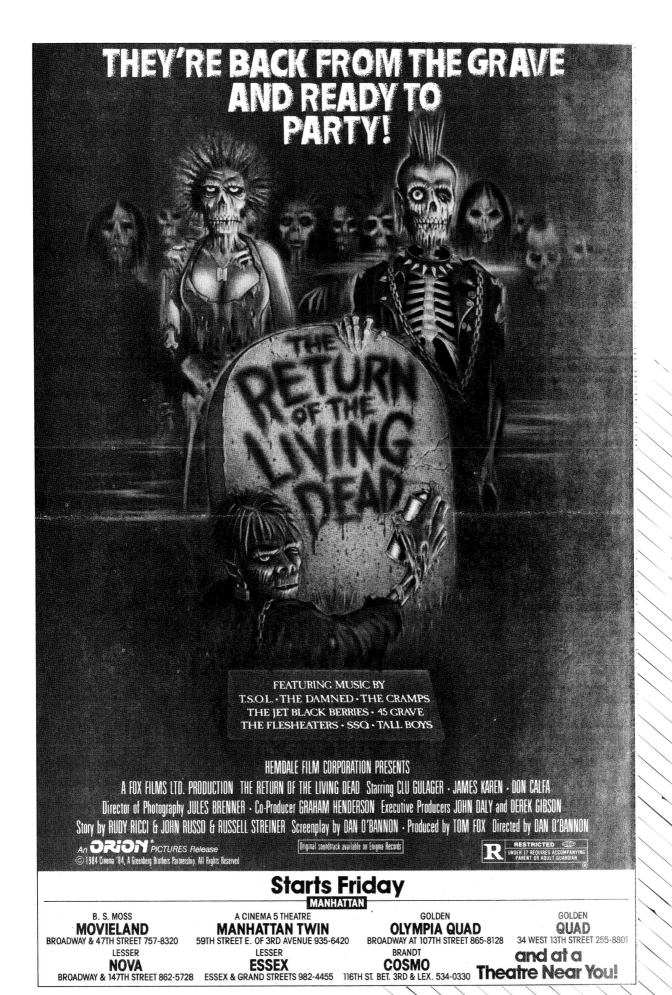

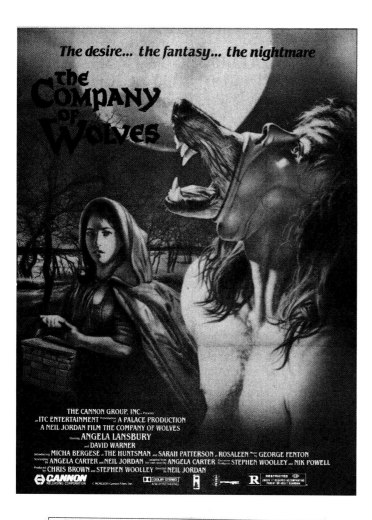

FRIGHT NIGHT

In a summer that had seen new offerings from Tobe Hooper (*Lifeforce*) and George A. Romero (*Day of the Dead*) disappoint at the box office, first-time director Tom Holland came along in August and delivered a sleeper hit with *Fright Night*. The highest-grossing original horror film of 1985 (surpassed in the genre only by *A Nightmare on Elm Street 2*), *Fright Night* is today considered a classic of the vampire genre, even if not all the critics saw it that way.

"...Tom Holland's writing and direction are less than weak; they're exasperating. He paints himself into corners constantly, then ignores them. No one says or does anything logical. No one is capable of normal human communication."
— Ed Blank, *The Pittsburgh Press*

"Though Mr. Holland's handling of his stars is successful enough to establish him as a newcomer with promise, his material here is uneven and often flat."
— Janet Maslin, *The New York Times*

"This film is a joke – a joke on the people responsible for every bad vampire movie made in the last 50 years. ... The film doesn't try to make the vampire idea believable; it simply tries to make it fun. And it succeeds wonderfully."
— TONY FRAZIER, *THE DAILY OKLAHOMAN*

"It's been a lot of years since we've had a real, visually scary vampire movie. To match the kind of stunning impact provided in the new *Fright Night*, you'd have to go way back to Lon Chaney."
— George Williams, *The Sacramento Bee*

"...[T]he best tongue-in-cheek chiller since Joe Dante's *The Howling*. And just as the Dante film revitalized the werewolf yarn, *Fright Night* gives the vampire melodrama a much-needed transfusion of humor and suspense."
— Glenn Lovell, *San Jose Mercury News*

SPECIAL ADVANCE PREVIEW TONIGHT.

There are some very good reasons to be afraid of the dark.

FRIGHT NIGHT

If you love being scared, it'll be the night of your life.

COLUMBIA PICTURES PRESENTS
A VISTAR FILMS PRODUCTION A TOM HOLLAND FILM
"FRIGHT NIGHT" CHRIS SARANDON WILLIAM RAGSDALE
AMANDA BEARSE STEPHEN GEOFFREYS AND RODDY McDOWALL
VISUAL EFFECTS BY RICHARD EDLUND, A.S.C. MUSIC BY BRAD FIEDEL PRODUCED BY HERB JAFFE
WRITTEN AND DIRECTED BY TOM HOLLAND

DELPHI

R RESTRICTED
UNDER 17 REQUIRES ACCOMPANYING
PARENT OR ADULT GUARDIAN

ORIGINAL MOTION PICTURE SOUNDTRACK ALBUM AVAILABLE ON CBS PRIVATE I RECORDS AND CASSETTES

READ THE TOR PAPERBACK

DOLBY STEREO
IN SELECTED THEATRES

©1985 COLUMBIA PICTURES INDUSTRIES, INC.
ALL RIGHTS RESERVED

1986

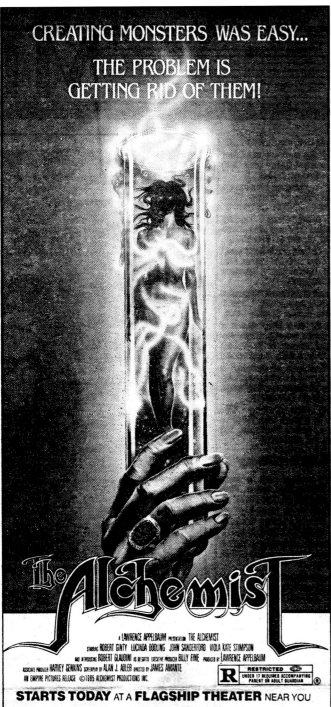

CREATING MONSTERS WAS EASY...
THE PROBLEM IS
GETTING RID OF THEM!

The ALCHEMIST

A LAWRENCE APPELBAUM PRESENTATION THE ALCHEMIST
STARRING ROBERT GINTY LUCINDA DOOLING JOHN SANDERFORD VIOLA KATE STIMPSON
AND INTRODUCING ROBERT GLAUDINI AS DELGATTO EXECUTIVE PRODUCER BILLY FINE PRODUCED BY LAWRENCE APPELBAUM
ASSOCIATE PRODUCER HARVEY GENKINS SCREENPLAY BY ALAN J. ADLER DIRECTED BY JAMES AMANTE
AN EMPIRE PICTURES RELEASE ©1985 ALCHEMIST PRODUCTIONS INC.

R RESTRICTED
UNDER 17 REQUIRES ACCOMPANYING
PARENT OR ADULT GUARDIAN

STARTS TODAY AT A FLAGSHIP THEATER NEAR YOU

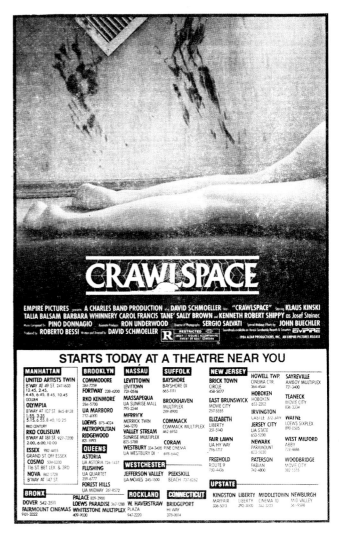

CRAWLSPACE

EMPIRE PICTURES PRESENTS A CHARLES BAND PRODUCTION OF A DAVID SCHMOELLER FILM "CRAWLSPACE" STARRING KLAUS KINSKI
TALIA BALSAM BARBARA WHINNERY CAROL FRANCIS TANE' SALLY BROWN AND KENNETH ROBERT SHIPPY AS JOSEF STEINER.
MUSIC COMPOSED BY PINO DONNAGIO ASSOCIATE PRODUCER RON UNDERWOOD DIRECTOR OF PHOTOGRAPHY SERGIO SALVATI SPECIAL MAKEUP EFFECTS BY JOHN BUECHLER
PRODUCED BY ROBERTO BESSI WRITTEN AND DIRECTED BY DAVID SCHMOELLER

R RESTRICTED
UNDER 17 REQUIRES ACCOMPANYING
PARENT OR ADULT GUARDIAN
1986 ALTAR PRODUCTIONS, INC. AN EMPIRE PICTURES RELEASE EMPIRE

STARTS TODAY AT A THEATRE NEAR YOU

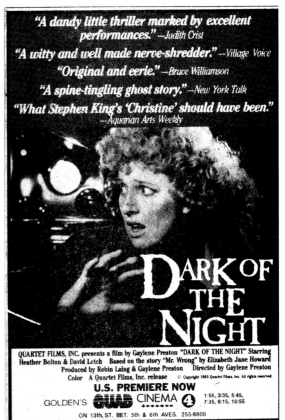

"A dandy little thriller marked by excellent performances." —Judith Crist

"A witty and well made nerve-shredder." —Village Voice

"Original and eerie." —Bruce Williamson

"A spine-tingling ghost story." —New York Talk

"What Stephen King's 'Christine' should have been." —Aquarian Arts Weekly

DARK OF THE NIGHT

QUARTET FILMS, INC. PRESENTS A FILM BY GAYLENE PRESTON "DARK OF THE NIGHT" STARRING
Heather Bolton & David Letch Based on the story "Mr. Wrong" by Elizabeth Jane Howard
Produced by Robin Laing & Gaylene Preston Directed by Gaylene Preston
Color A Quartet Films, Inc. release © Copyright 1985 Quartet Films, Inc. All rights reserved.

U.S. PREMIERE NOW
GOLDEN'S QUAD CINEMA 4
ON 13th ST. BET. 5th & 6th AVES. 255-8800
1:55, 3:35, 5:45,
7:35, 9:15, 10:55

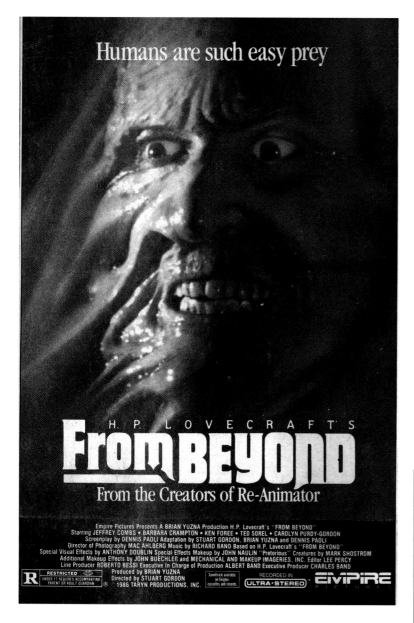

Humans are such easy prey

H.P. LOVECRAFT'S

FromBEYOND

From the Creators of Re-Animator

Empire Pictures Presents A BRIAN YUZNA Production H.P. Lovecraft's "FROM BEYOND"
Starring JEFFREY COMBS • BARBARA CRAMPTON • KEN FOREE • TED SOREL • CAROLYN PURDY-GORDON
Screenplay by DENNIS PAOLI Adaptation by STUART GORDON, BRIAN YUZNA and DENNIS PAOLI
Director of Photography MAC AHLBERG Music by RICHARD BAND Based on H.P. Lovecraft's "FROM BEYOND"
Special Visual Effects by ANTHONY DOUBLIN Special Effects Makeup by JOHN NAULIN "Pretorious" Creatures by MARK SHOSTROM
Additional Makeup Effects by JOHN BUECHLER and MECHANICAL AND MAKEUP IMAGERIES, INC. Editor LEE PERCY
Line Producer ROBERTO BESSI Executive In Charge of Production ALBERT BAND Executive Producer CHARLES BAND
Produced by BRIAN YUZNA
Directed by STUART GORDON
© 1986 TARYN PRODUCTIONS, INC.

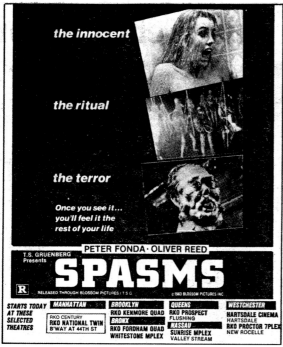

the innocent

the ritual

the terror

Once you see it...
you'll feel it the
rest of your life

PETER FONDA • OLIVER REED

T.S. GRUENBERG
Presents

SPASMS

RELEASED THROUGH BLOSSOM PICTURES / T S G © 1983 BLOSSOM PICTURES INC

STARTS TODAY AT THESE SELECTED THEATRES

MANHATTAN	BROOKLYN	QUEENS	WESTCHESTER
RKO CENTURY RKO NATIONAL TWIN B'WAY AT 44TH ST	RKO KENMORE QUAD	RKO PROSPECT FLUSHING	HARTSDALE CINEMA HARTSDALE
BRONX	RKO FORDHAM QUAD WHITESTONE MPLEX	NASSAU SUNRISE MPLEX VALLEY STREAM	RKO PROCTOR 7PLEX NEW ROCELLE

APRIL FOOL'S DAY

As Paramount Pictures and producer Frank Mancuso Jr. continued to crank out *Friday the 13th* sequels, they also decided to take a humorous approach to youth slashing. While played straight, *April Fool's Day*, as befits the title, injects a prankish sense of comedy into the genre. Some fans and critics found it a refreshing break from the formula, while others were not as receptive.

"I went to see this movie April 1, figuring somehow it would be more appropriate on April Fools' Day than otherwise. I suspect, however, that the acting and screenplay would be just as bad any day of the year."
— Eric E. Harrison, *Arkansas Democrat*

"In general the picture moves fast under the directorial guidance of Fred Walton, sounds reasonable in the script of Danilo Bach. If you can use a killer-thriller suspense pick-me-up, this could be what the therapist ordered."
— Archer Winsten, *New York Post*

"Much of the first half of *April Fool's Day* is funny in a campy, low-budget kind of way. But when attention must necessarily be turned to danger and suspense, the film goes soft. We also begin to miss the laughs. ... But at least it is a departure from the gross violence and utter stupidity of the *Friday* films."
— PATRICK TAGGART, *AUSTIN AMERICAN-STATESMAN*

"The movie could have used more sex and violence. You read it here first. A call for increased violence in a horror film, and a plea for extra sex."
— Peter Stack, *San Francisco Chronicle*

"More obnoxious even than a film with a cheap, lazy fraud at its center is a film that tries to pass off the fraud as a fiendishly clever plot device. ... You've seen whoopee cushions with more integrity."
— Jay Maeder, *New York Daily News*

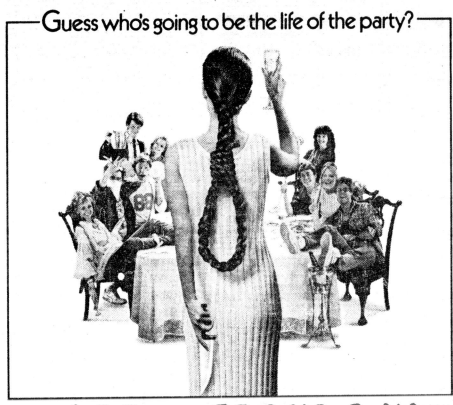

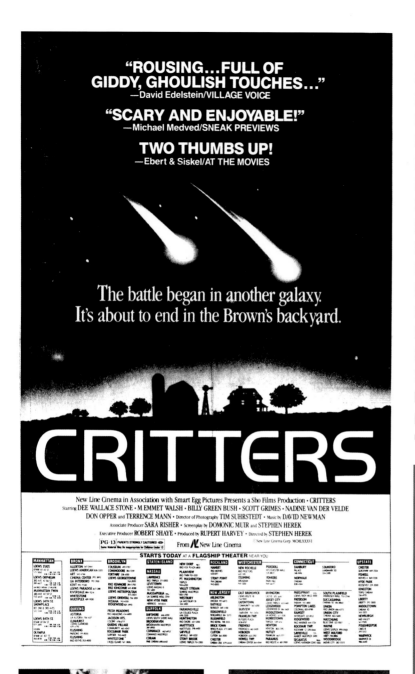

"ROUSING...FULL OF GIDDY, GHOULISH TOUCHES..."
—David Edelstein/VILLAGE VOICE

"SCARY AND ENJOYABLE!"
—Michael Medved/SNEAK PREVIEWS

TWO THUMBS UP!
—Ebert & Siskel/AT THE MOVIES

The battle began in another galaxy.
It's about to end in the Brown's backyard.

CRITTERS

New Line Cinema in Association with Smart Egg Pictures Presents a Sho Films Production · CRITTERS
Starring DEE WALLACE STONE · M. EMMET WALSH · BILLY GREEN BUSH · SCOTT GRIMES · NADINE VAN DER VELDE
DON OPPER and TERRENCE MANN · Director of Photography TIM SUHRSTEDT · Music by DAVID NEWMAN
Associate Producer SARA RISHER · Screenplay by DOMONIC MUIR and STEPHEN HEREK
Executive Producer ROBERT SHAYE · Produced by RUPERT HARVEY · Directed by STEPHEN HEREK
PG-13 PARENTS STRONGLY CAUTIONED From ∧∨ New Line Cinema

CRITTERS

Having launched a hit franchise with *A Nightmare on Elm Street*, New Line Cinema moved from the supernatural to science fiction, jumping on the mini-monster bandwagon that got rolling with *Gremlins*. Initial ads sold the overall sci-fi veneer before the distributor decided to full on reveal the hungry creatures after the first week. And a number of critics ate it up.

"Movie theaters are full of clones of box-office hits, but with *Critters* the gene splicing experiment is a success. No tired retread here. This mutation has a soul."
— Jerry Bokamper, *Arkansas Gazette*

"[W]riter/director Stephen Herek could use a little of [Joe] Dante's go-for-broke flair: *Critters* never pushes itself enough to be a real shout-it-from-the-rooftops sleeper. Still, even if it does play it safe, the movie is well-played and unexpectedly entertaining."
— Eleanor Ringel, *The Atlanta Journal*

"*Critters* is one of the smoothest fake-Spielberg pastiche movies so far. The director and co-writer, Stephen Herek, has turned in a noteworthy audition film. ... Of course, when you consider the big picture, smoothness isn't everything. Originality isn't a bad quality, either."
— DAVID CHUTE,
LOS ANGELES HERALD EXAMINER

"The mixture of sitcom and gore is too cruel for my tastes. ... It's all meant to be a romp. But it's unsatisfying, unsettling – like switching channels back and forth from a family comedy to a gory space-monster flick."
— Joseph Gelmis, *New York Newsday*

"What a pleasant sense of humor *Critters* has and it is this attribute that is most responsible for making this playfully scary film more satisfying than most of the other items on the monsters-from-outer-space-come-to-Earth-and-try-to-kill-everybody menu."
— Rick Kogan, *Chicago Tribune*

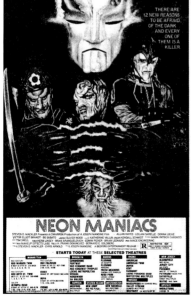

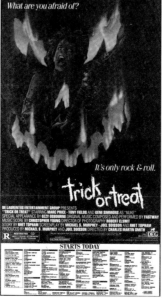

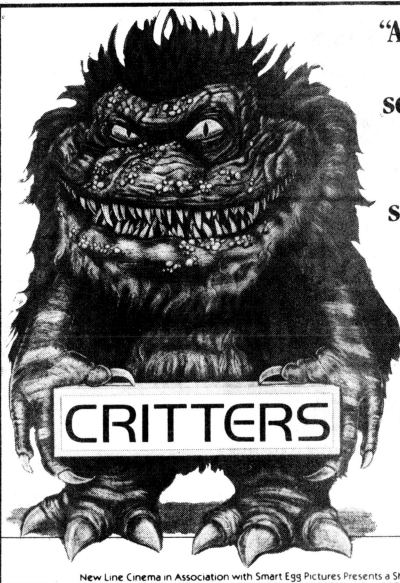

"A thoroughly enjoyable sci-fi thriller."
—Pia Lindstrom/NBC-TV

"A funny science fiction horror film."
Both thumbs up!
—Ebert & Siskel/ AT THE MOVIES

"Scary and enjoyable!"
—Michael Medved/ SNEAK PREVIEWS

New Line Cinema in Association with Smart Egg Pictures Presents a Sho Films Production
CRITTERS • Starring DEE WALLACE STONE • M. EMMET WALSH • BILLY GREEN BUSH • SCOTT GRIMES • NADINE VAN DER VELDE
DON OPPER AND TERRENCE MANN • Director of Photography TIM SUHRSTEDT • Music by DAVID NEWMAN
Associate Producer SARA RISHER • Screenplay by DOMONIC MUIR and STEPHEN HEREK
Executive Producer ROBERT SHAYE • Produced by RUPERT HARVEY • Directed by STEPHEN HEREK

From ⋀ New Line Cinema

© New Line Cinema Corp. MCMLXXXVI

PG-13 PARENTS STRONGLY CAUTIONED ⟨⟩
Some Material May Be Inappropriate for Children Under 13

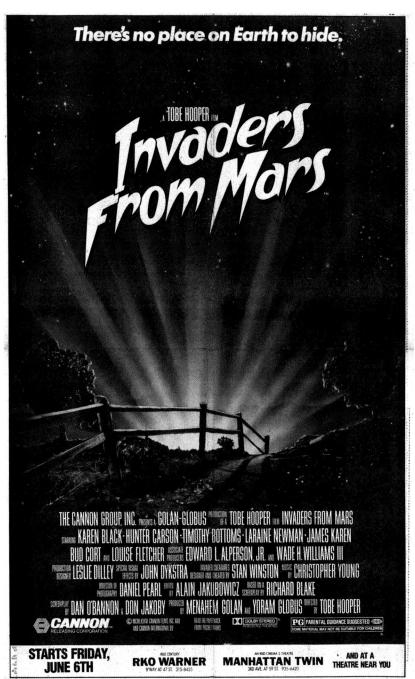

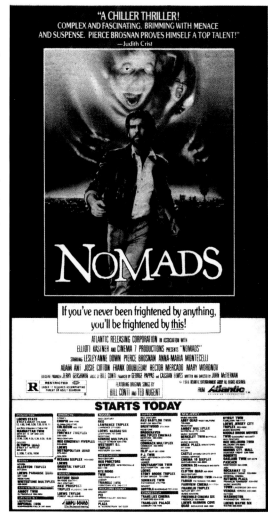

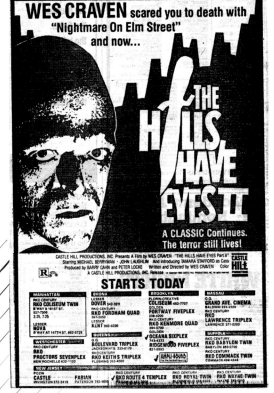

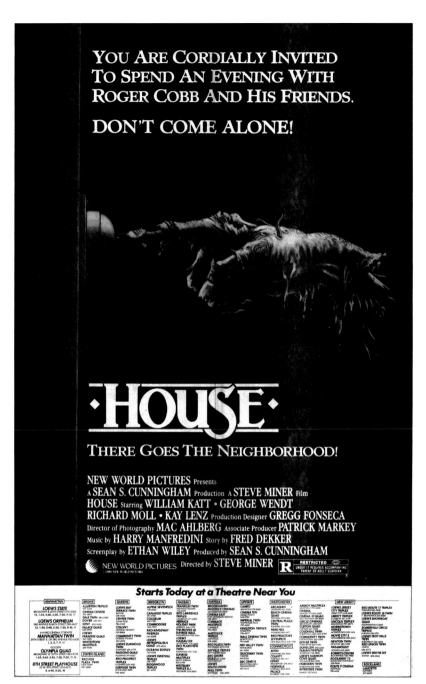

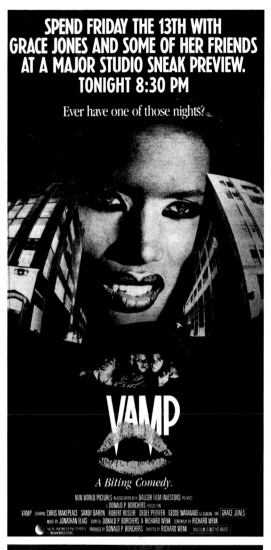

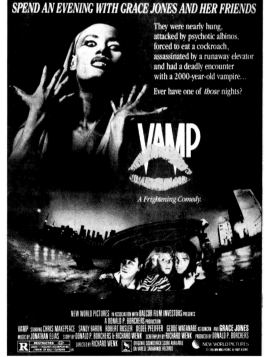

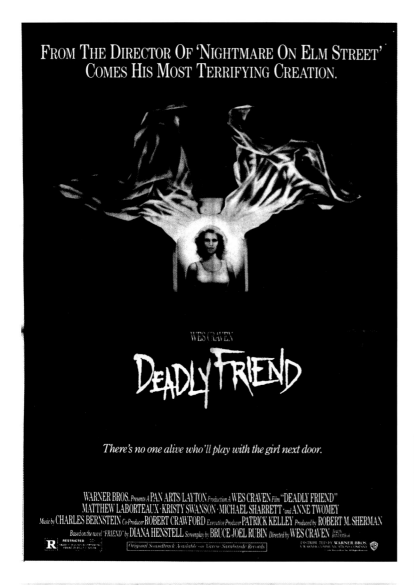

FROM THE DIRECTOR OF 'NIGHTMARE ON ELM STREET'
COMES HIS MOST TERRIFYING CREATION.

WES CRAVEN

DEADLY FRIEND

There's no one alive who'll play with the girl next door.

WARNER BROS. Presents A PAN ARTS·LAYTON Production A WES CRAVEN Film "DEADLY FRIEND"
MATTHEW LABORTEAUX · KRISTY SWANSON · MICHAEL SHARRETT and ANNE TWOMEY
Music by CHARLES BERNSTEIN Co-Producer ROBERT CRAWFORD Executive Producer PATRICK KELLEY Produced by ROBERT M. SHERMAN
Based on the novel "FRIEND" by DIANA HENSTELL Screenplay by BRUCE JOEL RUBIN Directed by WES CRAVEN

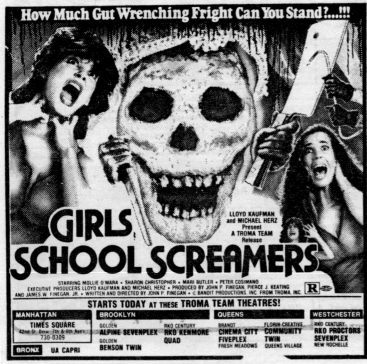

How Much Gut Wrenching Fright Can You Stand?...!!!

GIRLS
SCHOOL SCREAMERS

LLOYD KAUFMAN
and MICHAEL HERZ
Present
A TROMA TEAM
Release

STARRING MOLLIE O'MARA · SHARON CHRISTOPHER · MARI BUTLER · PETER COSIMANO
EXECUTIVE PRODUCERS LLOYD KAUFMAN AND MICHAEL HERZ · PRODUCED BY JOHN P. FINEGAN, PIERCE J. KEATING
AND JAMES W. FINEGAN, JR. · WRITTEN AND DIRECTED BY JOHN P. FINEGAN · C BANDIT PRODUCTIONS, INC. FROM TROMA, INC.

STARTS TODAY AT THESE TROMA TEAM THEATRES!

MANHATTAN	BROOKLYN		QUEENS		WESTCHESTER
TIMES SQUARE 42nd St. Btw. 7th & 8th Ave's 730-0309	GOLDEN ALPINE SEVENPLEX	RKO CENTURY RKO KENMORE QUAD	BRANDT CINEMA CITY FIVEPLEX FRESH MEADOWS	FLORIN-CREATIVE COMMUNITY TWIN QUEENS VILLAGE	RKO CENTURY RKO PROCTORS SEVENPLEX NEW ROCHELLE
BRONX UA CAPRI	GOLDEN BENSON TWIN				

DEMONS

In the 1980s, U.S. theatrical exposure of Dario Argento's films was spotty at best: *Inferno* barely made it to any big screens, *Tenebrae* was butchered and given a marginal release as *Unsane*, and *Opera* was abandoned by Stateside distributor Orion Pictures. With the exception of *Creepers/Phenomena* (1985), the only Argento movie of the decade to receive a decent amount of bookings – and, unlike *Creepers*, to go out uncut and unrated – was this one, which he produced and co-wrote (Lamberto Bava directed). It even managed to score praise from a couple of critics.

"[Bava and Argento] have created a horror film *that is actually scary*. Mr. Bava evokes fear and doom from his demons not just by an endless parade of elaborate – and excellently crafted – special effects, but by presenting a claustrophobic, darkly lit set that entraps not only the cast, but the audience, also."
— *The Washington Times*, author unknown

"...*Demons* isn't half as scary or convincing as [*Night of the Living Dead*], yet young Italian director Lamberto Bava shares with Romero...the gift of projecting a chilling apocalyptic vision with a terrific sense of style If there's not much content – and even less logic – in *Demons*, there is a helluva lot of form."
— KEVIN THOMAS, *LOS ANGELES TIMES*

"*Demons* is a *Purple Rose of Cairo* for the dimwitted and bloodthirsty. ... [It] is the movie equivalent of a fingernail on a blackboard."
— Carrie Rickey, *The Philadelphia Inquirer*

"Take no solace in the fact that, unlike the patrons portrayed in the movie, those wandering in to see this horror show will be safe. Merely sitting through *Demons* is punishment enough."
— William Wolf, *Gannett News Service*

"It's useless to complain about characterization in a movie like this, but *Demons* is particularly aggravating."
— Scott Cain, *The Atlanta Journal*

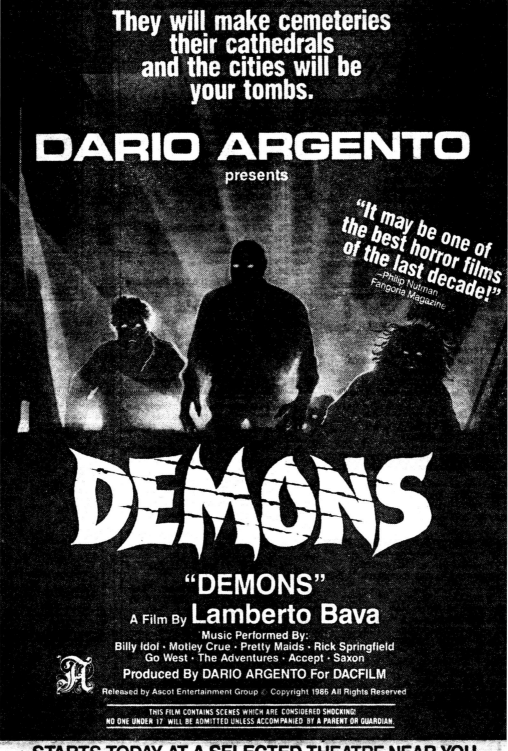

They will make cemeteries
their cathedrals
and the cities will be
your tombs.

DARIO ARGENTO
presents

"It may be one of the best horror films of the last decade!"
—Philip Nutman
Fangoria Magazine

DEMONS

"DEMONS"

A Film By **Lamberto Bava**

Music Performed By:
Billy Idol · Motley Crue · Pretty Maids · Rick Springfield
Go West · The Adventures · Accept · Saxon

Produced By DARIO ARGENTO For DACFILM

Released by Ascot Entertainment Group © Copyright 1986 All Rights Reserved

THIS FILM CONTAINS SCENES WHICH ARE CONSIDERED SHOCKING!
NO ONE UNDER 17 WILL BE ADMITTED UNLESS ACCOMPANIED BY A PARENT OR GUARDIAN.

STARTS TODAY AT A SELECTED THEATRE NEAR YOU

CHOPPING MALL

Security robots rampage through a shopping mall, terrorizing trapped teens, in a film that was aptly known as *Killbots* up until shortly before its release. For whatever reason, it was decided that hi-tech horror wouldn't sell, so the title was changed and any hint of the robo threat was left out of the poster and newspaper ads, in favor of a gnarled hand suspiciously resembling the one seen earlier in 1986 in the marketing materials for *House*.

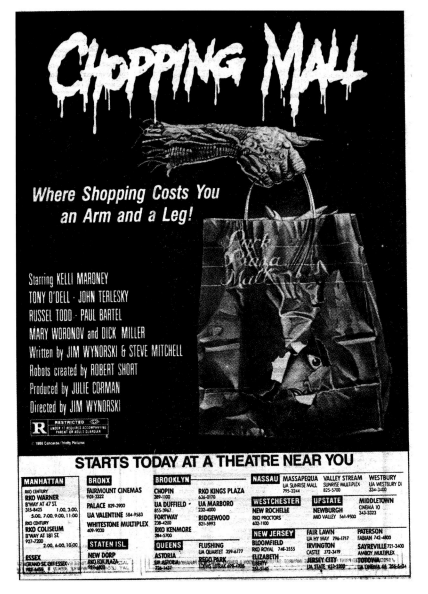

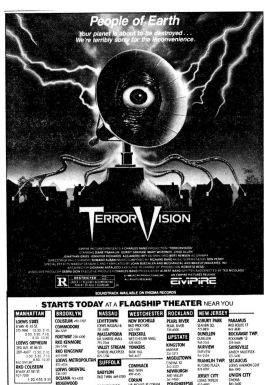

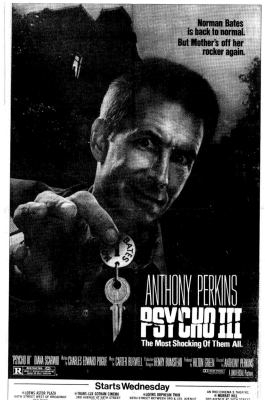

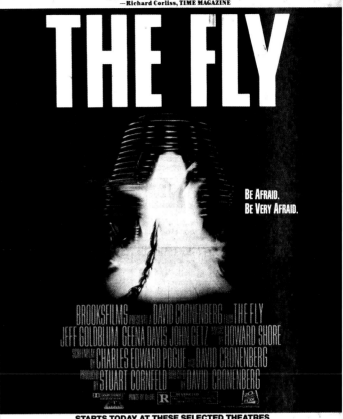

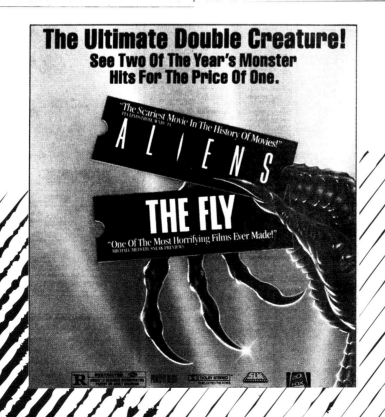

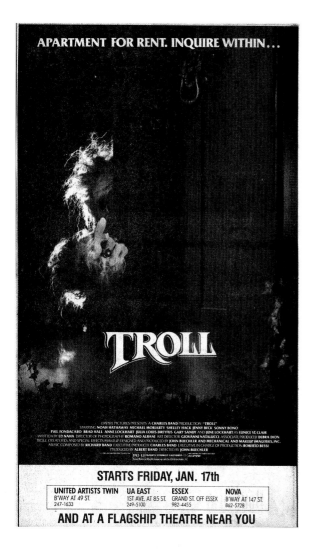

APARTMENT FOR RENT. INQUIRE WITHIN...

TROLL

EMPIRE PICTURES PRESENTS A CHARLES BAND PRODUCTION "TROLL"
STARRING NOAH HATHAWAY MICHAEL MORIARTY SHELLEY HACK JENNY BECK SONNY BONO
PHIL FONDACARO BRAD HALL ANNE LOCKHART JULIA LOUIS-DREYFUS GARY SANDY AND JUNE LOCKHART AS EUNICE ST. CLAIR
WRITTEN BY ED NAHA DIRECTOR OF PHOTOGRAPHY ROMANO ALBANI ART DIRECTOR GIOVANNI NATALUCCI ASSOCIATE PRODUCER DEBRA DION
TROLL CREATURES AND SPECIAL EFFECTS MAKEUP DESIGNED AND PRODUCED BY JOHN BUECHLER AND MECHANICAL AND MAKEUP IMAGERIES, INC.
MUSIC COMPOSED BY RICHARD BAND EXECUTIVE PRODUCER CHARLES BAND EXECUTIVE IN CHARGE OF PRODUCTION ROBERTO BESSI
PRODUCED BY ALBERT BAND DIRECTED BY JOHN BUECHLER

STARTS FRIDAY, JAN. 17th

UNITED ARTISTS TWIN	UA EAST	ESSEX	NOVA
B'WAY AT 49 ST. 247-1633	1ST AVE. AT 85 ST. 249-5100	GRAND ST. OFF ESSEX 982-4455	B'WAY AT 147 ST. 862-5728

AND AT A FLAGSHIP THEATRE NEAR YOU

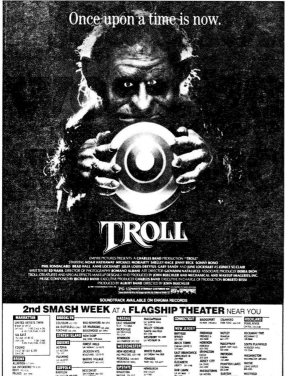

Once upon a time is now.

TROLL

EMPIRE PICTURES PRESENTS A CHARLES BAND PRODUCTION "TROLL"
STARRING NOAH HATHAWAY MICHAEL MORIARTY SHELLEY HACK JENNY BECK SONNY BONO
PHIL FONDACARO BRAD HALL ANNE LOCKHART JULIA LOUIS-DREYFUS GARY SANDY AND JUNE LOCKHART AS EUNICE ST. CLAIR
WRITTEN BY ED NAHA DIRECTOR OF PHOTOGRAPHY ROMANO ALBANI ART DIRECTOR GIOVANNI NATALUCCI ASSOCIATE PRODUCER DEBRA DION
TROLL CREATURES AND SPECIAL EFFECTS MAKEUP DESIGNED AND PRODUCED BY JOHN BUECHLER AND MECHANICAL AND MAKEUP IMAGERIES, INC.
MUSIC COMPOSED BY RICHARD BAND EXECUTIVE PRODUCER CHARLES BAND EXECUTIVE IN CHARGE OF PRODUCTION ROBERTO BESSI
PRODUCED BY ALBERT BAND DIRECTED BY JOHN BUECHLER

SOUNDTRACK AVAILABLE ON ENIGMA RECORDS

2nd SMASH WEEK AT A **FLAGSHIP THEATER** NEAR YOU

FRIDAY THE 13TH PART VI: JASON LIVES

By the time the sixth in Paramount Pictures' slaughter series arrived in July 1986, you could pretty much rerun the reviews of previous entries with the new title inserted, as they were almost all dismissive or worse. Then, for *Friday the 13th Part VI*, writer-director Tom McLoughlin bestowed a new slickness and sense of humor upon the franchise, and a few — if only a few — critics actually responded.

"What distinguishes *Friday the 13th Part VI* is its humor. ... The movie is very pretty (except for the gore) and very well photographed. ... Tom McLoughlin...[has] done a very slick job."
— Stephen M. Silverman, *New York Post*

"Tom McLoughlin...never lets the humor get in the way of car chases, beheadings, mutilations, stranglings, and revolting mayhem. ... But, of its kind, Number Six is a lot of bloody fun."
— *Detroit Free Press*, author unknown

"Jason's new director and screenwriter, Tom McLoughlin, tries to liven up the formula with traces of humor, and acknowledges the film's cult status with some self-directed irony. ... But despite a few lighter touches, the film is still a gory waste of time."
— Caryn James, *The New York Times*

"McLoughlin knows what Jason fans require and splatters the movie in blood, severed heads, and all of the ghoulish frills that are supposed to add up to what's loosely classified as entertainment. ... Critiquing these films is almost irrelevant. When the supposed treat comes pure and simple from watching bodies dismembered, how can you say a movie is good?"
—WILLIAM WOLF, *GANNETT NEWS SERVICE*

"*Friday the 13th Part VI*, like the previous five installments, is a real crowd-sleazer. ... At one point during this picture... I was reminded of kindergarten sadism."
—Carrie Rickey, *The Philadelphia Inquirer*

"The humor is welcome, some of the camera work inventive. And the young actors...are cute or lively (at least until Jason shows up). McLoughlin actually shows promise as a film maker. But eventually the movie, like its hero, lumbers back into its sadistic, unbreakable routine."
—Michael Wilmington, *Los Angeles Times*

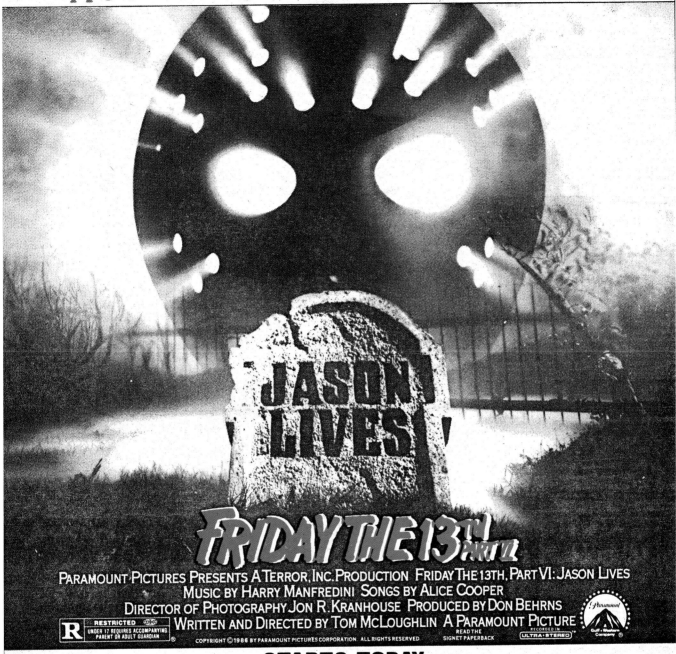

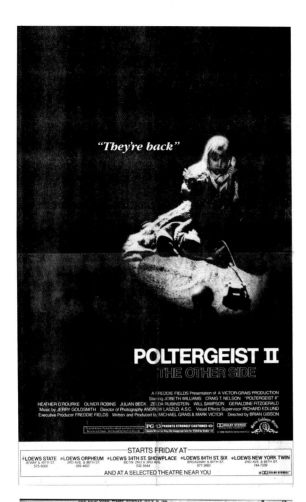

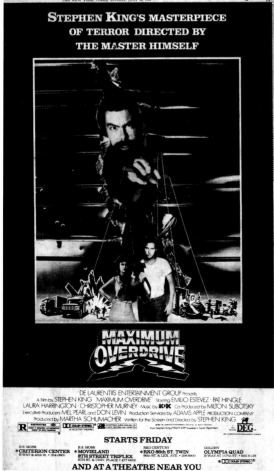

THE HITCHER

Both the posters/ads and the trailer did a good job of conveying *The Hitcher's promise* of road movie terror. When I saw it opening weekend in one of Times Square's biggest theaters, the packed audience reacted with screams and applause. Yet the movie was a box-office flop, destined to find its following on video. And like many cult films, it thrilled some critics and horrified others in the wrong way.

"*The Hitcher* unfolds with the awful, nightmare logic of all top-notch psychological thrillers. It is rooted in reality, but a reality gone horribly awry – and it introduces, in the form of Rutger Hauer's satanic hitchhiker, one of the most fully imagined and genuinely troubling villains of recent years."

— Rick Lyman, *The Philadelphia Inquirer*

"Relentlessly malevolent – a sick, cruel, extraordinarily vicious film that is so remarkably well done it even gets away with existential noodlings that might otherwise have skittered perilously close to the goofy."

— JAY MAEDER,
NEW YORK DAILY NEWS

"[A] nauseating thriller that reaches down from the screen and defies you to stay in the theater to see what desecration of the human body it will present next."

— Gene Siskel, *Chicago Tribune*

"[O]n its own terms, this movie is diseased and corrupt. I would have admired it more if it had found the courage to acknowledge the real relationship it was portraying between Howell and Rutger, but no: It prefers to disguise itself as a violent thriller, and on that level it is reprehensible."

— Roger Ebert, *Chicago Sun-Times*

"*The Hitcher*, grotesquely violent as it is, might well turn out to be director Robert Harmon's *Sugarland Express*... It has the look, feel and finish of a born-to-the-camera film-maker... As the personification of pure evil, Dutch actor Rutger Hauer is simply brilliant."

— *The Des Moines Register*, author unknown

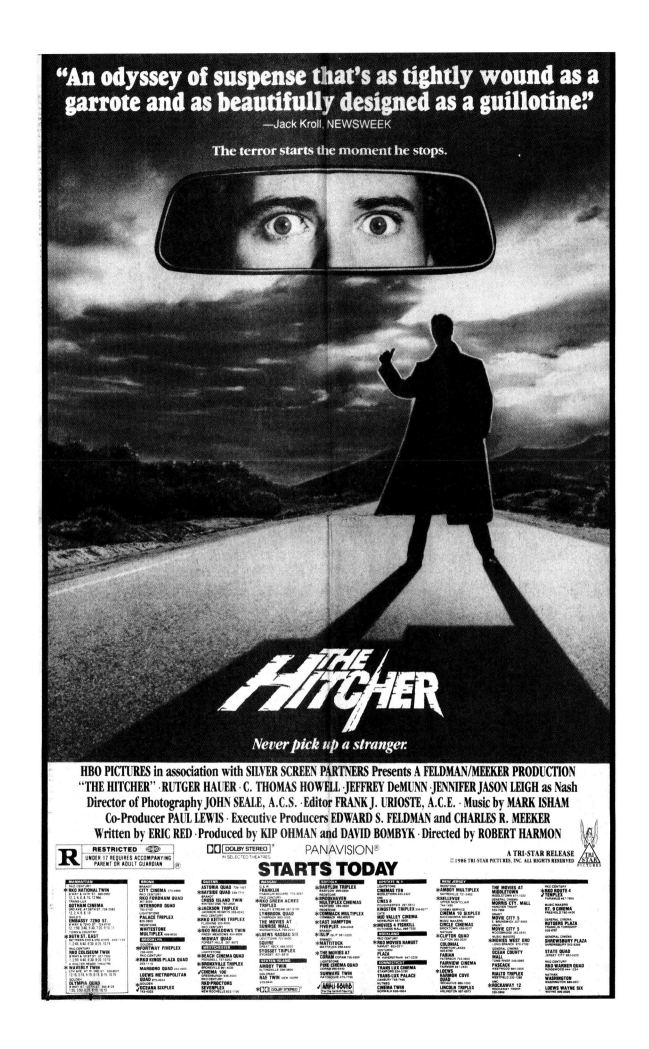

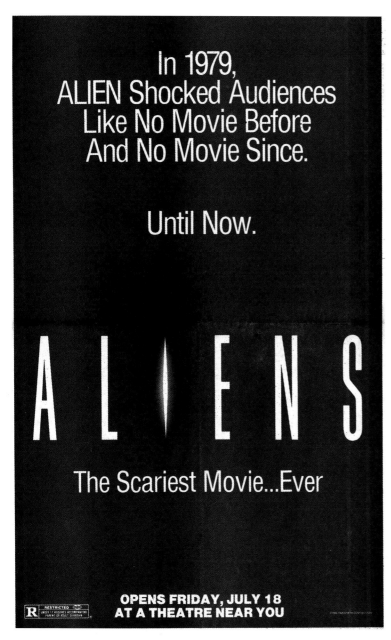

In 1979,
ALIEN Shocked Audiences
Like No Movie Before
And No Movie Since.

Until Now.

ALIENS

The Scariest Movie...Ever

OPENS FRIDAY, JULY 18
AT A THEATRE NEAR YOU

NIGHT OF THE CREEPS

In New York City, *Night of the Creeps* opened the same Friday as *The Texas Chainsaw Massacre 2*. But the choice of which film to catch first was obvious: I had to get my hands on one of those "anti-Creep Prevention Masks." (It turned out to be a paper surgical mask with the movie's logo printed on it, and I still have it to this day.) What I also got, to my surprise, was a wonderfully witty and entertaining homage to every kind of horror and science fiction subgenre there is. At the time, though, it didn't gather much of an audience, even after a change of title (to *Homecoming Night*) and ad campaign in other cities.

"The director-writer, Fred Dekker, understands the rules of making horror films. ... What he doesn't understand is how to get you from one scene of graphic gore to the next – and make you believe it. ... There are too many holes in the plot and there is much too much left unexplained."

— Dan Aquilante, *New York Post*

"[B]eyond its obviously derivative inspiration, the film shows a fair ability to create suspense, build tension, and achieve respectable performances. When the action becomes silly, which it does now and then...Mr. Dekker is adept at saving his film from total absurdity by a dash of humor."

— Nina Darnton, *The New York Times*

"While its science-fiction foundation is extremely flimsy and derivative, the film has a certain quiet wit that is neither mechanical nor campy."

— RICHARD FREEDMAN,
GANNETT NEWS SERVICE

"[I]ts attempt to cross a slasher movie with a monster movie, and produce a spoof of both, is good only for a few gross-out effects and one great giggle. ... Unfortunately, Dekker invested more effort in references than on characters."

— Tom Shales, *The Washington Post*
(reviewed as *Homecoming Night*)

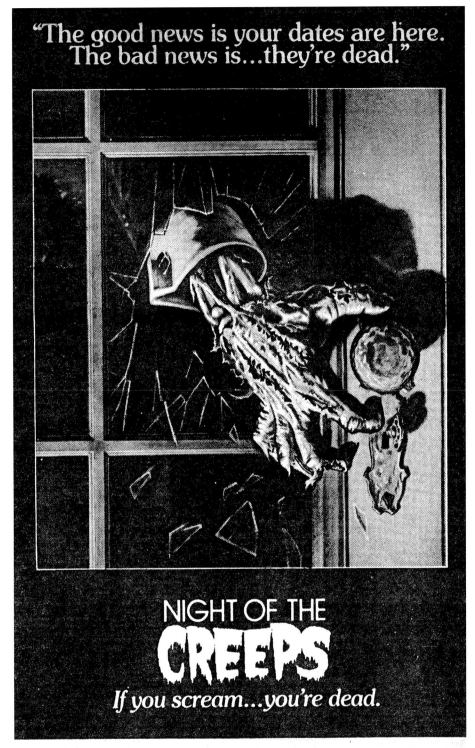

"The good news is your dates are here.
The bad news is...they're dead."

NIGHT OF THE
CREEPS

If you scream...you're dead.

TRI-STAR PICTURES PRESENTS
A CHARLES GORDON PRODUCTION A FRED DEKKER FILM
'NIGHT OF THE CREEPS' JASON LIVELY STEVE MARSHALL JILL WHITLOW
And TOM ATKINS as Detective Cameron Music by BARRY DeVORZON
Executive Producer WILLIAM FINNEGAN Produced by CHARLES GORDON
Written and Directed by FRED DEKKER

A TRI-STAR RELEASE
©1986 Tri-Star Pictures, Inc.
All Rights Reserved.

STARTS TODAY

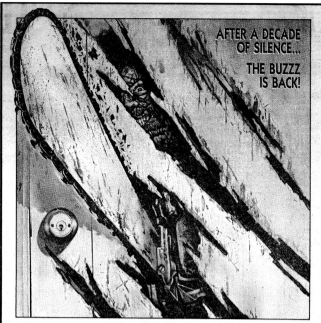

THE TEXAS CHAINSAW MASSACRE 2

The first ad for Tobe Hooper's sequel pitched the horror content, which was considerably more explicit than in the first *Chainsaw*, while the second design, with its aping of the *Breakfast Club* ensemble poster, reflected the film's satirical side. But *Chainsaw 2* just couldn't win at the box office, or with most critics of the day, who objected either to the humor or to the gore.

"[It] will strike you either as completely repulsive or irresistibly demented, depending on your tolerance for make-believe carnage and cannibal-style chili. ... [It] takes exploitation beyond the limits of bad taste right into a realm of the criminally insane. I suppose that's the whole point."

— **James Verniere,** *Boston Herald*

"The *Howard the Duck* of horror films. ... Poor Tobe Hooper has literally fouled his own nest, making a mockery of the one movie for which he may be remembered."

— **Eleanor Ringel,** *The Atlanta Journal*

"[T]here's some nice photography and production design; screenwriter L.M. Kit Carson lends some Texas texture and funny lines.. ... But mostly, *Texas Chainsaw Massacre 2* is straight blood and guts."

— **Paul Attanasio,** *The Washington Post*

"If you don't like slasher movies, you won't like *Saw 2* – it's too gruesome. And if you do like slasher movies, you won't like *Saw 2* either – it's too funny."

— **JAMI BERNARD,**
NEW YORK POST

"This is a fan of *The Texas Chainsaw Massacre* talking. But the sequel to the 1974 classic is as unoriginal as sin and as unappetizing as chili con carnage. ... In the unredeemably disgusting sequel, nothing is left to the imagination."

— **Carrie Rickey,** *The Philadelphia Inquirer*

"...Hooper and Carson seem to be self-consciously trying to produce a cult film rather than making a good movie and then hoping for the best. Also they try to give *The Texas Chainsaw Massacre 2* a little humor and satire, which would be all right, except very little of what they do is funny."

— **John A. Douglas,** *The Grand Rapids Press*

AFTER A DECADE
OF SILENCE...

THE BUZZZ
IS BACK.

A TOBE HOOPER FILM

THE TEXAS CHAINSAW MASSACRE PART 2

He was 98 lbs. of solid nerd until he became...

A LLOYD KAUFMAN / MICHAEL HERZ PRODUCTION

THE TOXIC AVENGER

The first Super-Hero...from New Jersey!

Starring ANDREE MARANDA · MITCHELL COHEN · PAT RYAN, JR. · JENNIFER BABTIST · ROBERT PRICHARD · CINDY MANION · GARY SCHNEIDER · MARK TORGL · Directors of Photography JAMES LONDON and LLOYD KAUFMAN · Written by JOE RITTER · Edited by RICHARD HAINES · Associate Producer STUART STRUTIN · Music Consultant MARC KATZ **R RESTRICTED** · Directed by MICHAEL HERZ and SAMUEL WEIL · Produced by LLOYD KAUFMAN and MICHAEL HERZ · From TROMA INC. · © TROMA SALES CORP THE H'H CO

NOW PLAYING AT THESE TROMA TEAM THEATRES IN MANHATTAN

RKO CENTURY
RKO WARNER TWIN
BROADWAY & 47TH ST.

RKO CENTURY
RKO COLISEUM TWIN
BROADWAY & 181ST ST.

AND AT THEATRES EVERYWHERE!

From the producers of "THE TOXIC AVENGER"
CELEBRATE THE HOLIDAYS WITH AMERICA'S #1 SCI-FI-ACTION-TERROR-COMEDY!
Readin'...Writin' and Radiation!

A LLOYD KAUFMAN MICHAEL HERZ PRODUCTION

CLASS OF NUKE'EM HIGH

Starring JANELLE BRADY · GILBERT BRENTON · ROBERT PRICHARD · R.L. RYAN · JAMES NUGENT VERNON · BRAD DUNKER · GARY SCHNEIDER · THEO COHAN · Associate Producer STUART STRUTIN · Executive Producer JAMES TREADWELL · Produced by LLOYD KAUFMAN and MICHAEL HERZ · Directed by RICHARD W. HAINES and SAMUEL WEIL · Released by TROMA, INC · ©TNT CO TROMA, INC MCMLXXXVI

THE TOXIC AVENGER

Fans of Troma's trendsetting exercise in bad taste are familiar with the poster design used in the later newspaper ads. Yet when the movie debuted in New York in April 1986, it was promoted with different art that gave it slasher undertones. Perhaps they felt this was a more effective sell to the general horror audience, but in any case, it was the midnight crowds who really supported *Toxic Avenger* and made it the center of the Troma universe. Needless to say, the reviews were mixed between those who enjoyed the film in spite of its lowbrow quality, and those who disdained it for the same reason.

"If a lot of it is bad, it's redeemed by two qualities: humor and audacity. The humor sometimes palls, but the audacity stays as ripe and toxic as a New Jersey dump site."
— Michael Wilmington, Los Angeles Times

"There may be a mindless audience for it. If so, so much the worse for all of us. ... It marks a new low in tasteless sex and violence."
— Archer Winsten, *New York Post*

"*The Toxic Avenger* is a thoroughly disgusting, puerile, and sneakily funny combination of soft-core porn, gory horror flick, and sendup of superhero movies. It is a perfect film if somebody has already checked out the cassette of *Attack of the Killer Tomatoes* and you just can't stand seeing *Rocky Horror Picture Show* even one more time."
— HARPER BARNES, *ST. LOUIS POST-DISPATCH*

"*The Toxic Avenger* is a perfect example of what happens when a clever idea falls into the hands of tasteless, untalented people."
— Dudley Saunders, *Louisville Courier-Journal*

"Anyone who is not looking for intellectual enlightenment, moral or spiritual uplift, physical beauty, expensive production values, refined acting, incisive writing or smooth direction, will love *The Toxic Avenger*. ... This is, surely, a midnight cult movie in the making."
— Scott Cain, *The Atlanta Journal*

1987

FISHING WAS NEVER LIKE THIS!

Lloyd Kaufman and Michael Herz
present A Troma Team Release
A David Herbert Production
of a James Mallon Film

BLOOD HOOK

YOU CAN'T WORM YOUR WAY OUT

R ⬤ From TROMA, INC.

STARTS TODAY
at these TROMA TEAM THEATRES!

MANHATTAN	NEW JERSEY
LIBERTY 42nd Street 42nd St. Betw. 7th & 8th Aves. 730-0332	**CINEMA** UNION CITY
	FABIAN PATERSON
	LIBERTY ELIZABETH

| **BRONX** **FAIRMONT** | |

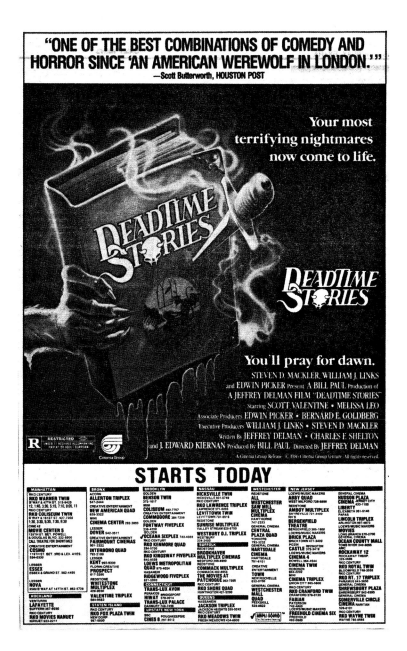

"ONE OF THE BEST COMBINATIONS OF COMEDY AND
HORROR SINCE 'AN AMERICAN WEREWOLF IN LONDON.'"
—Scott Butterworth, HOUSTON POST

Your most
terrifying nightmares
now come to life.

DEADTIME STORIES

You'll pray for dawn.

STEVEN D. MACKLER, WILLIAM J. LINKS
and EDWIN PICKER Present A BILL PAUL Production of
A JEFFREY DELMAN Film "DEADTIME STORIES"
Starring SCOTT VALENTINE • MELISSA LEO
Associate Producers EDWIN PICKER • BERNARD E. GOLDBERG
Executive Producers WILLIAM J. LINKS • STEVEN D. MACKLER
Written By JEFFREY DELMAN • CHARLES F. SHELTON
and J. EDWARD KIERNAN Produced By BILL PAUL Directed By JEFFREY DELMAN
A Cinema Group Release © 1986 Cinema Group Venture. All rights reserved.

R RESTRICTED

STARTS TODAY

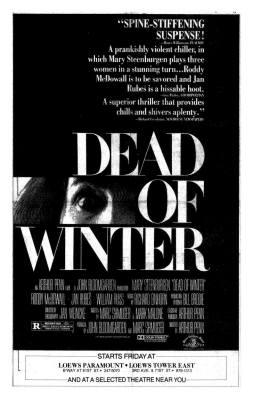

"SPINE-STIFFENING
SUSPENSE!"
—Bruce Williamson, PLAYBOY

A prankishly violent chiller, in
which Mary Steenburgen plays three
women in a stunning turn...Roddy
McDowall is to be savored and Jan
Rubes is a hissable hoot.
A superior thriller that provides
chills and shivers aplenty."
—Richard Freedman, NEWHOUSE NEWSPAPERS

DEAD OF WINTER

AN ARTHUR PENN Film A JOHN BLOOMGARDEN PRODUCTION MARY STEENBURGEN "DEAD OF WINTER"
RODDY McDOWALL • JAN RUBES • WILLIAM RUSS Music RICHARD EINHORN Produced by BILL BRODIE
Director of Photography JAN WEINCKE Written by MARC SHMUGER and MARK MALONE Executive Producer ARTHUR PENN
Produced by JOHN BLOOMGARDEN and MARC SHMUGER Directed by ARTHUR PENN

R RESTRICTED DOLBY STEREO

STARTS FRIDAY AT
LOEWS PARAMOUNT • LOEWS TOWER EAST
B'WAY AT 61ST ST. • 247-5070 3RD AVE. & 71ST ST. • 879-1313
AND AT A SELECTED THEATRE NEAR YOU

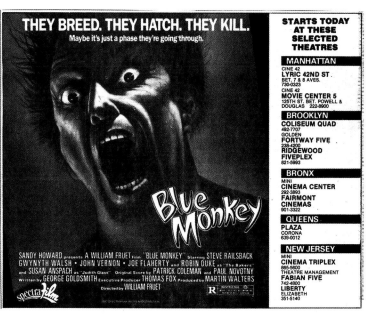

THEY BREED. THEY HATCH. THEY KILL.
Maybe it's just a phase they're going through.

Blue Monkey

SANDY HOWARD presents A WILLIAM FRUET Film "BLUE MONKEY" Starring STEVE RAILSBACK
GWYNYTH WALSH • JOHN VERNON • JOE FLAHERTY and ROBIN DUKE as "The Bakers"
and SUSAN ANSPACH as "Judith Glass" Original Score by PATRICK COLEMAN and PAUL NOVOTNY
Written by GEORGE GOLDSMITH Executive Producer THOMAS FOX Produced by MARTIN WALTERS
Directed by WILLIAM FRUET

SPECTRAFILM R RESTRICTED

305

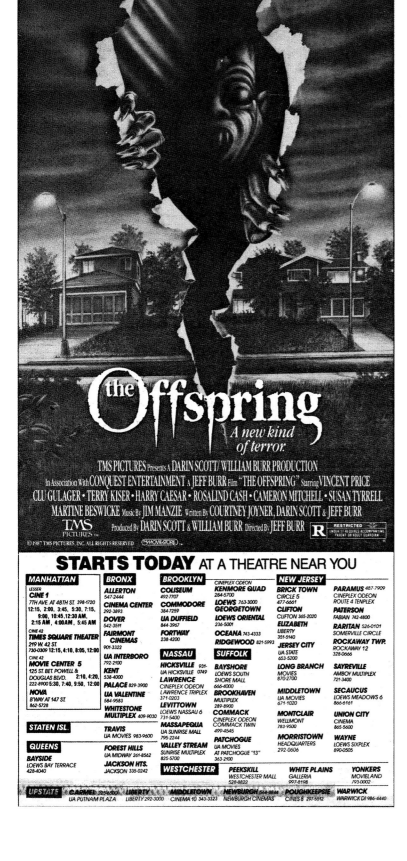

The birth of your worst nightmare.

the OFFSPRING
A new kind of terror.

TMS PICTURES Presents A DARIN SCOTT/WILLIAM BURR PRODUCTION
In Association With CONQUEST ENTERTAINMENT A JEFF BURR Film "THE OFFSPRING" Starring VINCENT PRICE
CLU GULAGER • TERRY KISER • HARRY CAESAR • ROSALIND CASH • CAMERON MITCHELL • SUSAN TYRRELL
MARTINE BESWICKE Music By JIM MANZIE Written By COURTNEY JOYNER, DARIN SCOTT & JEFF BURR
TMS PICTURES Produced By DARIN SCOTT & WILLIAM BURR Directed By JEFF BURR
© 1987 TMS PICTURES, INC. ALL RIGHTS RESERVED ™MOVIESTORE

R RESTRICTED UNDER 17 REQUIRES ACCOMPANYING PARENT OR ADULT GUARDIAN

STARTS TODAY AT A THEATRE NEAR YOU

MANHATTAN
LESSER
CINE 1
7TH AVE. AT 48TH ST. 398-1720
12:15, 2:00, 3:45, 5:30, 7:15,
9:00, 10:45,12:30 AM,
2:15 AM, 4:00AM, 5:45 AM
CINE 42
TIMES SQUARE THEATER
219 W 42 ST.
730-0309 12:15, 4:10, 8:05, 12:00
CINE 42
MOVIE CENTER 5
125 ST. BET POWELL &
DOUGLAS BLVD. 2:10, 4:20,
222-8900 5:30, 7:40, 9:50, 12:00
NOVA
B'WAY AT 147 ST.
862-5728

STATEN ISL.
TRAVIS
UA MOVIES 983-9600

QUEENS
BAYSIDE
LOEWS BAY TERRACE
428-4040

BRONX
ALLERTON
547-2444
CINEMA CENTER
292-3893
DOVER
542-3511
FAIRMONT
CINEMAS
901-3322
UA INTERBORO
792-2100
KENT
538-4000
PALACE 829-3900
UA VALENTINE
584-9583
WHITESTONE
MULTIPLEX 409-9030

FOREST HILLS
UA MIDWAY 261-8562
JACKSON HTS.
JACKSON 335-0242

BROOKLYN
COLISEUM
492-7707
COMMODORE
384-7259
UA DUFFIELD
844-3967
FORTWAY
238-4200

NASSAU
HICKSVILLE 931-
UA HICKSVILLE 0749
LAWRENCE
CINEPLEX ODEON
LAWRENCE TRIPLEX
371-0203
LEVITTOWN
LOEWS NASSAU 6
731-5400
MASSAPEQUA
UA SUNRISE MALL
795-2244
VALLEY STREAM
SUNRISE MULTIPLEX
825-5700

CINEPLEX ODEON
KENMORE QUAD
284-5700
LOEWS 763-3000
GEORGETOWN
LOEWS ORIENTAL
236-5001
OCEANA 743-4333
RIDGEWOOD 821-5993

SUFFOLK
BAYSHORE
LOEWS SOUTH
SHORE MALL
666-4000
BROOKHAVEN
MULTIPLEX
289-8900
COMMACK
CINEPLEX ODEON
COMMACK TWIN
499-4545
PATCHOGUE
UA MOVIES
AT PATCHOGUE "13"
363-2100

WESTCHESTER
PEEKSKILL
WESTCHESTER MALL
528-8822

NEW JERSEY
BRICK TOWN
CIRCLE 5
477-6661
CLIFTON
CLIFTON 365-2020
ELIZABETH
LIBERTY
351-5140
JERSEY CITY
UA STATE
653-5200
LONG BRANCH
MOVIES
870-2700
MIDDLETOWN
UA MOVIES
671-1020
MONTCLAIR
WELLMONT
783-9500
MORRISTOWN
HEADQUARTERS
292-0606

WHITE PLAINS
GALLERIA
997-8198

PARAMUS 487-7909
CINEPLEX ODEON
ROUTE 4 TENPLEX
PATERSON
FABIAN 742-4800
RARITAN 526-0101
SOMERVILLE CIRCLE
ROCKAWAY TWP.
ROCKAWAY 12
328-0666
SAYREVILLE
AMBOY MULTIPLEX
721-3400
SECAUCUS
LOEWS MEADOWS 6
866-6161
UNION CITY
CINEMA
865-5600
WAYNE
LOEWS SIXPLEX
890-0505

YONKERS
MOVIELAND
793-0002

UPSTATE CARMEL 225-6500
UA PUTNAM PLAZA
LIBERTY
LIBERTY 292-3000
MIDDLETOWN
CINEMA 10 343-3323
NEWBURGH 564-8844
NEWBURGH CINEMAS
POUGHKEEPSIE
CINES 8 297-5512
WARWICK
WARWICK DI 986-4440

EVIL DEAD II

There was no way to cut Sam Raimi's sequel for an R rating, and DeLaurentiis Entertainment Group couldn't release an unrated film, so the Rosebud Releasing division was established solely to get *Evil Dead II* into theaters. The poster/ad image is pretty softcore considering how wild and crazy the farcical gore becomes in the movie itself, but *Evil Dead II* got a boost from a number of critics, who overall gave it higher marks than its predecessor.

❝*With Evil Dead II*, [the filmmakers] prove that their first horror film...was no fluke. These guys know how to entertain... The film should attract notice for its sense of humour and ingenuity even from those who are not fans of the horror genre.❞
— Anne Marie Biondo, *The Detroit News*

❝*Evil Dead II* never lets up, continually introducing new characters and adding new thrills and chills right up to the last frame. As a film maker, Raimi is a dynamo who knows how to make a movie as cinematic as possible.❞
— KEVIN THOMAS, *LOS ANGELES TIMES*

❝...for those who relish fantastical horror and appreciate its deliberate absurdity, the execution is skillful enough and the tone is playful enough to make this audacious little film a must-see.❞
— Bruce Westbrook, *Houston Chronicle*

❝*Evil Dead II* has astonishing surprises, abundant humor, nifty special effects, and relentless tension. There are problems. The movie ends on an unsatisfying note... The acting is weak. The sets are cheap... Judge for yourself. That is, if you're up to it.❞
— Hal Boedeker, *The Miami Herald*

❝If you go in for this sort of thing, rest assured Raimi hasn't lost his touch for the grotesque. If anything, he's refined it. The result is a relentless, non-stop nightmare of primordial dread that boasts an elegant albeit disgusting single-mindedness.❞
— Deborah J. Kunk, *Los Angeles Herald Examiner*

1987

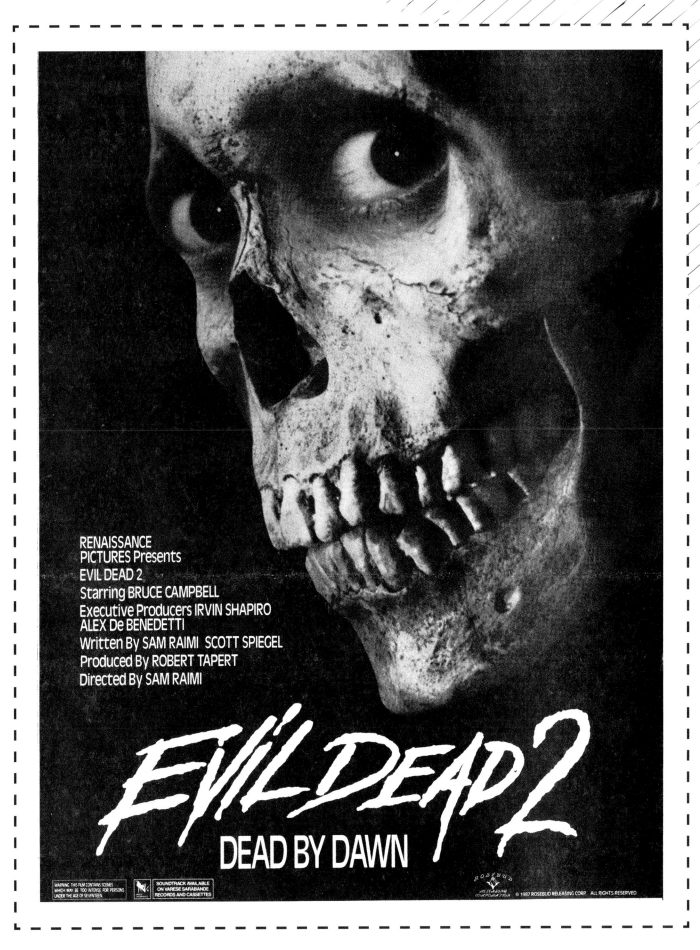

RENAISSANCE
PICTURES Presents
EVIL DEAD 2
Starring BRUCE CAMPBELL
Executive Producers IRVIN SHAPIRO
ALEX De BENEDETTI
Written By SAM RAIMI SCOTT SPIEGEL
Produced By ROBERT TAPERT
Directed By SAM RAIMI

EVIL DEAD 2
DEAD BY DAWN

TIME MAGAZINE —. Just when you thought it was safe to go back in the water, marine biologists have charted some capricious changes in the feeding habits of sharks. In the past two years, sharks have repeatedly attacked the new 1-in. fiber-optic telephone cable off the Canary Islands.

Marine biologists accompanying the repair teams have also discovered previously unknown species of fish. But they still do not know why the new cable is so appealing. The favored theory: sharks attack the lines after detecting faint electric fields that trigger a feeding reflex.

SAN FRANCISCO (AP) — For a 20-year-old scuba diver the fictional horror of "Jaws" became real and deadly when a great white shark closed its mouth around his right leg.

"It was simply a feeling of possible doom—that it was totally out of my hands," the bearded young man recalled.

"If he wanted to eat me, he could eat me and I knew that." The injured diver was in surgery for three hours as doctors mended several small arteries, a lanced nerve and ripped flesh. The doctors also found three of the shark's teeth lodged in his leg.

By Tuesday, he was wearing one of the teeth on a chain around his neck.

SANTA ROSA, Calif. — Scientists believe that most attacks take place while humans are on or near the surface, the same location that marine mammals fall victim to great whites. The scientists believe that humans are attacked at the surface because they are breathing or resting with their heads above the water and are therefore unable to anticipate the charge coming from below.

White sharks do prey upon whales. In 1928, a single white shark was seen feeding near shore upon a floating grey whale carcass in California.

CARMEL, Calif. — A fireman was diving in Monastery Cov... December at one... popular divin... when he was... great whi... courage... gone... says h... the wate...

Five of 40 sh... attack victims ...ve died... ...ia and Oregon. ...at the deaths ...sive blood loss ...mption by the

...een attacks upon ...ce occur- ...Pacific.

...dequate ...nce other ...dy system" ...ost ...lves ...he

CORPUS CHRISTI, Tex., - haps as many as a thousa... more migrating sharks con... off this Gulf Coast resort tod... the second day, driving ba... from the 85-degree wate... creating a scene that man... reminded them of the m... picture "Jaws."

But... an employee of the Na... Park Service at the Padre I... resort area just south of her... that she had not seen panic a... the swimmers there, "just... amazement."

"There've always been sh... around," she said, "but ne... such amounts."

© New York Times Co. June 3, 1977

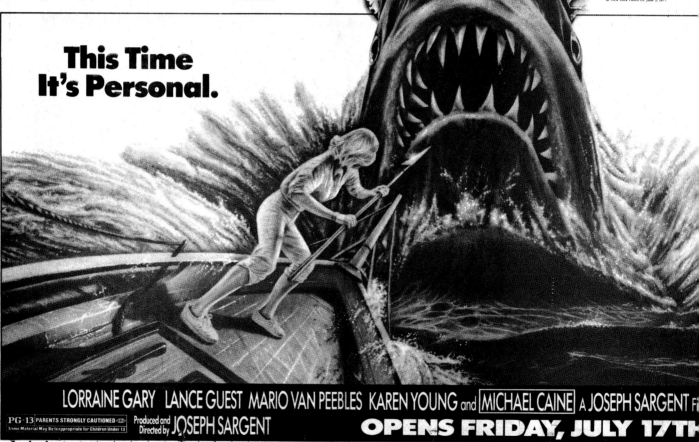

This Time It's Personal.

LORRAINE GARY LANCE GUEST MARIO VAN PEEBLES KAREN YOUNG and MICHAEL CAINE A JOSEPH SARGENT F...

PG-13 PARENTS STRONGLY CAUTIONED
Some Material May Be Inappropriate for Children Under 13

Produced and Directed by JOSEPH SARGENT

OPENS FRIDAY, JULY 17TH

...E — The largest great white ...ver captured was in 1945. It ... feet, 3 inches long and ...d 7302 pounds. But larger ...have since been sited in the ...at are up to 24 feet long.

...tooth shape of large white ...s provides a cutting and ...g ability which is well-suited ...ing upon large, thick-skinned ...alian prey.

...e prey is sited, the shark ...ascends and at close range ...one of a variety of feeding ...s according to prey size and ...e.

PETALUMA, Calif. — An experienced diver scouting for abalone near Point Reyes, Calif. was diving without scuba gear, as is required for abalone collectors in northern Calif., and came to the surface to catch his breath. He never saw the shark until the creature had grabbed him around the middle and headed downward.

As the shark shook him and ripped into his flesh, the diver gripped on a steel abalone tool and, as the struggle continued, he reached behind him and banged the shark on the head. The attack ended and the shark disappeared. The diver surfaced and was hauled aboard by companions, alive but wounded.

SAN FRANCISCO — In the last month, two more episodes have added to the reputation of the triangle, which is bounded by Point Reyes, the Farallon Islands and Monterey Bay. In September, a surfer was decapitated by a great white shark off the San Mateo County coast; and this month an abalone diver was attacked and badly mauled while bobbing on the surface near Point Reyes. A shark warning was issued last weekend to bathers at Stinson Beach in northern Marin County after another great white was spotted offshore.

The two episodes brought the total number of great white attacks to 40 since records were first kept in the 1920's.

OREGON — Five of 40 shark attack victims have died in California and Oregon. It is significant that the deaths resulted from massive blood loss rather than consumption by sharks. Part of the reason is that it is typical for white sharks to attack with one massive bite, then wait for five to ten minutes until its victim has bled to death before attempting to consume it.

Sharks most commonly attack feet and legs, followed by arms and hands, and then torso. Of three recorded human white shark attack victims in Chile, two were taken mid-torso and the third on the foot.

NEW JERSEY — In twelve days, four people were killed by sharks along a 60-mile stretch of New Jersey coastline. One victim was taken within 50 feet off shore.

MONTEREY BAY — In early 1987, two white sharks were seen eating a whale. The Dept. of Fish and Game subsequently called a shark alert, warning employees to stay out of the water.

Most great white shark attacks have occurred without warning, from behind the victim, as if the shark were stalking prey.

SAN FRANCISCO (AP) — Two weeks ago, a fisherman caught a great white shark weighing a ton. Last Sunday, a great white caught a fisherman. Last week, as experts pondered the persistent presence of sharks along the Northern California coast, area residents wondered just how many of the monsters are out there.

Experts are guessing that the number of great white sharks in the area is increasing and will continue to do so.

"The worst is yet to come," say shark experts. "We can only see it as an increasing phenomenon that has not reached its zenith yet."

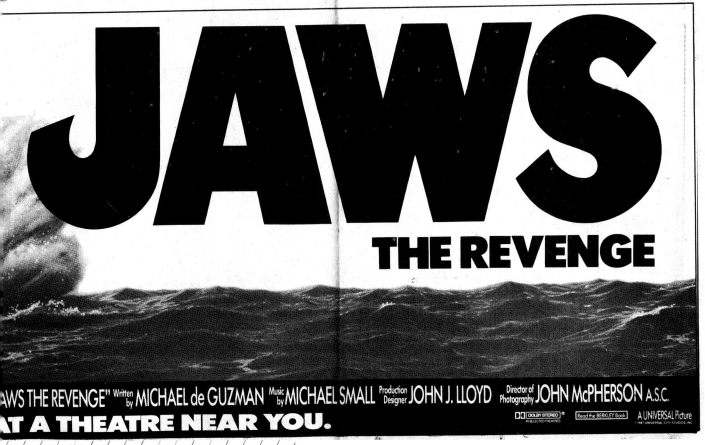

...AWS THE REVENGE" Written by MICHAEL de GUZMAN Music by MICHAEL SMALL Production Designer JOHN J. LLOYD Director of Photography JOHN McPHERSON A.S.C.

...T A THEATRE NEAR YOU.

DOLBY STEREO IN SELECTED THEATRES · Read the BERKLEY Book · A UNIVERSAL Picture © 1987 UNIVERSAL CITY STUDIOS, INC.

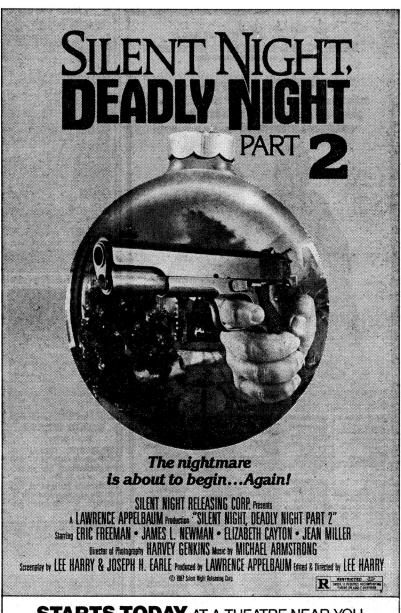

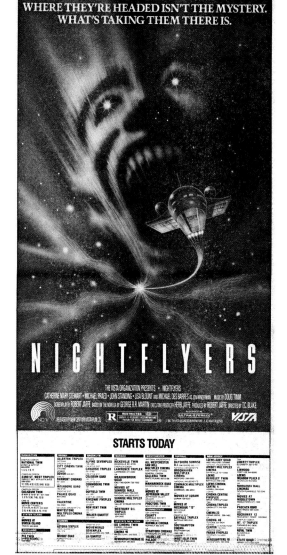

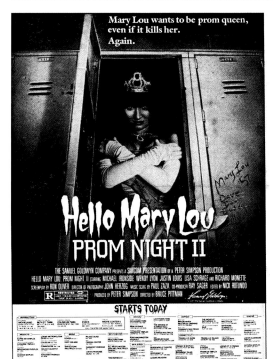

MUNCHIES

Jumping on the *Gremlins* bandwagon (and hiring the film's editor, Bettina a.k.a. Tina Hirsch, to direct), Roger Corman's Concorde Pictures tried to give *Munchies* cred by recalling one of Corman's horror/comedy classics of the 1960s. The advertising materials also blatantly knocked off the crimson-clad, long-legged poster image of the 1984 hit Gene Wilder comedy *The Woman in Red*. The film itself lived up to neither of these "inspirations," and subsequent *Munchie* movies were kid-oriented and featured a different creature voiced by Dom DeLuise and Howard Hesseman.

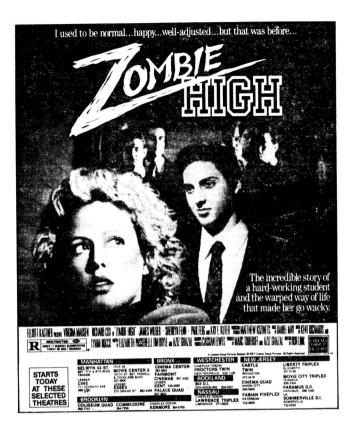

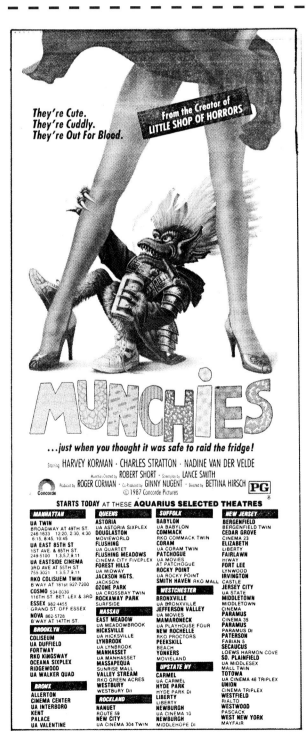

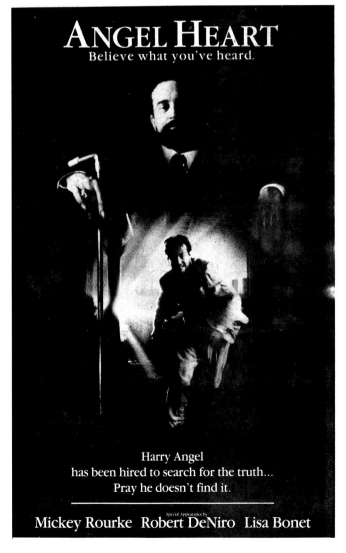

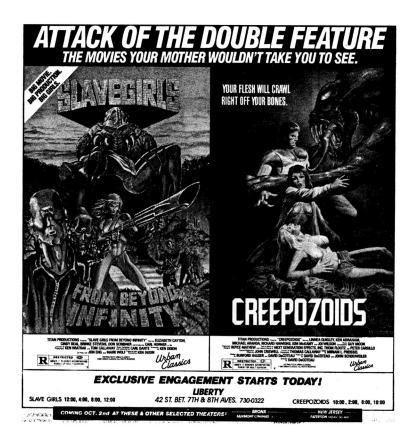

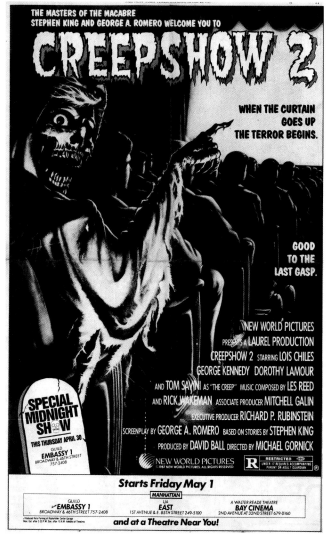

HELLRAISER

The striking visage of Doug Bradley's lead Cenobite was the focus of *Hellraiser*'s print campaign — though it's often forgotten that he was nameless in Clive Barker's directorial debut, and was only dubbed "Pinhead" for *Hellbound: Hellraiser II* (1988). Some strong reviews also helped Barker's movie to become a franchise-launching success.

"The secret of Barker's success is that he plays gruesome, funhouse effects against convincing performances and a fascinating, suspenseful story."
— Malcolm L. Johnson, *Hartford Courant*

"From the slime to the ridiculous—that is, from the special effects to the sexually oriented plot—*Hellraiser* is a horror film slanted for adults... Writer-director Clive Barker is adept at keeping it moving at a fast pace. And the demons are menacing and ably evoke visceral fear."
— Carole Kass, *Richmond Times-Dispatch*

"Barker does a fine job of sustaining an urgent mood of uneasy dread between the bursts of full-bore gore. And, even more impressively, he manages to make the relationship between Julia and Frank crackle with an appalling eroticism."
— Joe Leydon, *The Houston Post*

"...beneath its slippery red surface, the Barker picture drills to the quick of more identifiable horrors: family estrangement, pressurized emotional states, and servitude to desire... [It] resists overplaying and surmounts its own flaws well enough to suggest that Barker might become as important to film as he has become to genre fiction."
— MICHAEL H. PRICE,
FORT WORTH STAR-TELEGRAM

"*Hellraiser* is intelligent and brutally imaginative—but it's definitely not tasteful or low-key. It's less an ultra-literate horror film than a violently self-conscious one."
— Michael Wilmington, *Los Angeles Times*

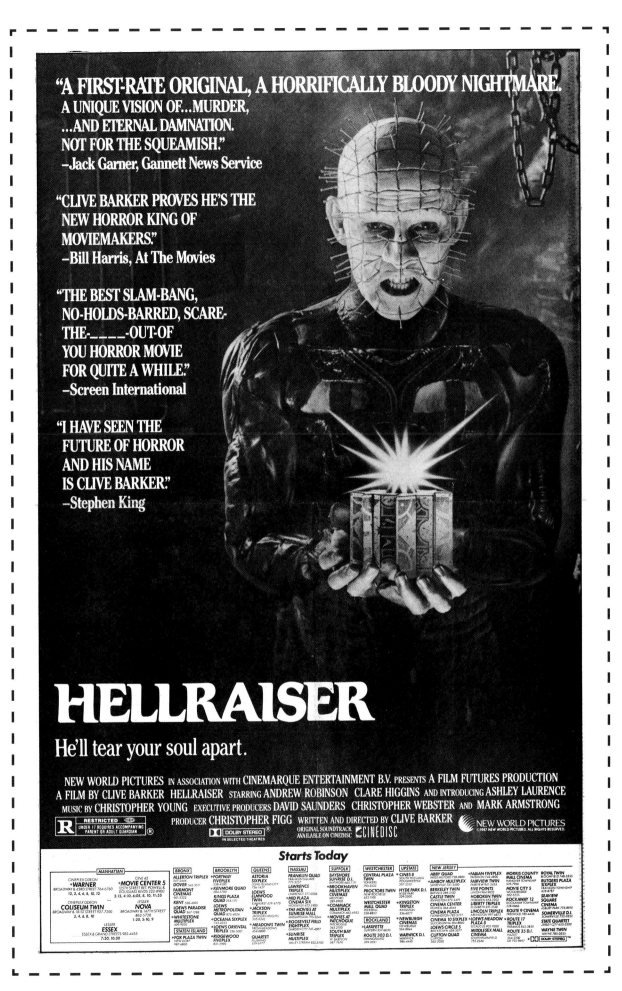

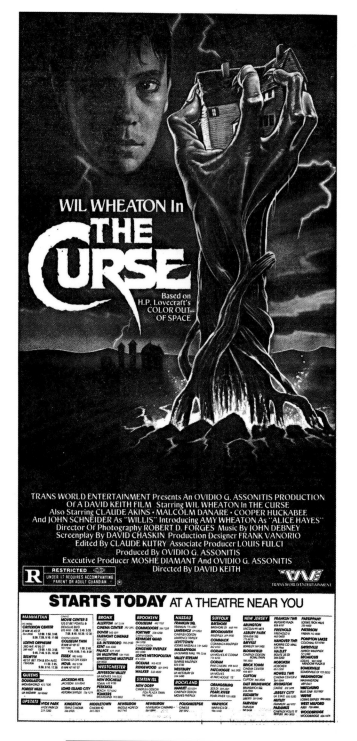

NEAR DARK

After a series of costly box-office failures, DeLaurentiis Entertainment Group was ailing by the time it sent *Near Dark* to theaters in October 1987, and wasn't able to give Kathryn Bigelow's stylish vampire/road movie the bookings or promotion it deserved. The marketing team went for a horrific hard sell in the print campaign, eschewing any attention to the film's other nuances, yet (even after *The Lost Boys*, which similarly updated bloodsucker lore to high-grossing effect earlier in the year) a number of strong reviews couldn't help it at the box office.

"*Near Dark* is remarkable—obviously a small genre movie but one with more ideas, political ideas, than most big movies have... Bigelow's visual compositions are crisp and eerie, wonderfully pictorial... *Near Dark* obviously isn't a movie for everyone. But who cares about everyone?"

— Joe Baltake, *The Sacramento Bee*

"Director and co-writer Kathryn Bigelow [uses] a winning combination of humor, style, and outright gore... The movie is an acquired taste, to be sure. It also is one worth sampling."

— Tim Carman, *The Houston Post*

"Almost from its first frame, *Near Dark* pulses with the kind of energy and style that announces a distinctive new directing talent. By the end, it's confirmed: Kathryn Bigelow is the real thing."

— Marshall Fine, *Gannett News Service*

"The movie does everything *The Lost Boys* was too witless to do: It lets you feel, for a minute, what a high it might be to be undead, powerful, and meaner than hell. It gives you a little release. And it doesn't insult you."

— CRAIG SELIGMAN,
SAN FRANCISCO EXAMINER

"Surprisingly, relationships are exactly what hold together *Near Dark*, a well-acted, highly original country-and-western vampire movie... The director, Kathryn Bigelow, gets solid, no-nonsense performances out of her entire cast."

— *The Seattle Times*, author unknown

EROTIC, BIZARRE, EXOTIC!

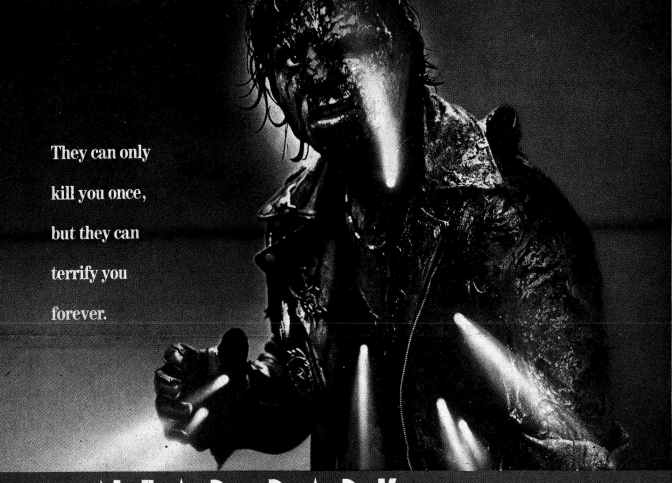

They can only
kill you once,
but they can
terrify you
forever.

NEAR DARK ...pray for daylight

F/M ENTERTAINMENT Presents A FELDMAN/MEEKER Production
"NEAR DARK" Starring ADRIAN PASDAR · JENNY WRIGHT · LANCE HENRIKSEN · BILL PAXTON
JENETTE GOLDSTEIN and TIM THOMERSON as Loy Music By TANGERINE DREAM · Film Editor HOWARD SMITH
Director of Photography ADAM GREENBERG · Executive Producers EDWARD S. FELDMAN and CHARLES R. MEEKER
Co-Producer ERIC RED · Produced By STEVEN-CHARLES JAFFE Written By ERIC RED & KATHRYN BIGELOW
Directed By KATHRYN BIGELOW

RESTRICTED
UNDER 17 REQUIRES ACCOMPANYING
PARENT OR ADULT GUARDIAN

RECORDED IN
ULTRA•STEREO ®

ORIGINAL MOTION PICTURE SOUNDTRACK AVAILABLE ON VARESE
SARABANDE RECORDS, CASSETTES AND COMPACT DISCS.

A DEG
RELEASE DEG
DE LAURENTIIS ENTERTAINMENT GROUP
© 1987 DE LAURENTIIS ENTERTAINMENT GROUP INC. ALL RIGHTS RESERVED

STARTS FRIDAY
AT A THEATRE NEAR YOU

315

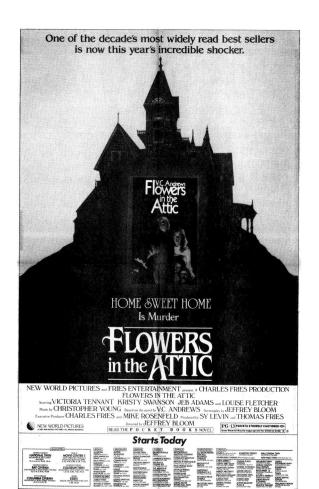

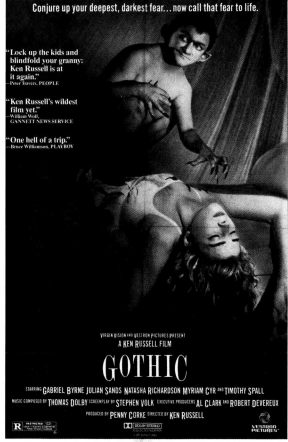

When you open the door to the unknown, there's no telling who will drop in... or who will drop dead.

WITCHBOARD

CINEMA GROUP presents A PARAGON ARTS INTERNATIONAL PRODUCTION "WITCHBOARD"
Starring TODD ALLEN · TAWNY KITAEN · STEPHEN NICHOLS · Co-starring KATHLEEN WILHOITE · BURKE BYRNES With Special Appearance by ROSE MARIE
Executive Producer WALTER S. JOSTEN Produced by GERALD GEOFFRAY · Supervising Producer RON MITCHELL · Associate Producer ROLAND CARROLL
Director of Photography ROY H. WAGNER Written and Directed by KEVIN S. TENNEY

STARTS TODAY

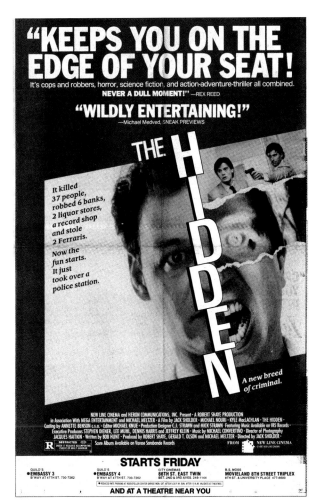

"KEEPS YOU ON THE EDGE OF YOUR SEAT!

It's cops and robbers, horror, science fiction, and action-adventure-thriller all combined.
NEVER A DULL MOMENT!" —REX REED

"WILDLY ENTERTAINING!"
—Michael Medved, SNEAK PREVIEWS

THE HIDDEN

It killed 37 people, robbed 6 banks, 2 liquor stores, a record shop and stole 2 Ferraris.

Now the fun starts. It just took over a police station.

A new breed of criminal.

NEW LINE CINEMA and HERON COMMUNICATIONS, INC. Present · A ROBERT SHAYE PRODUCTION
In Association With MEGA ENTERTAINMENT and MICHAEL MELTZER · A Film by JACK SHOLDER · MICHAEL NOURI · KYLE MacLACHLAN · THE HIDDEN ·
Casting by ANNETTE BENSON c.s.a. · Editor MICHAEL KNUE · Production Designer C.J. STRAWN and MICK STRAWN · Featuring Music Available on IRS Records ·
Executive Producers STEPHEN DIENER, LEE MUHL, DENNIS HARRIS and JEFFREY KLEIN · Music by MICHAEL CONVERTINO · Director of Photography
JACQUES HAITKIN · Written by BOB HUNT · Produced by ROBERT SHAYE, GERALD T. OLSON and MICHAEL MELTZER · Directed by JACK SHOLDER
FROM NEW LINE CINEMA

Score Album Available on Varese Sarabande Records

STARTS FRIDAY

GUILD'S ●EMBASSY 3 · GUILD'S ●EMBASSY 4 · CITY CINEMAS 86TH ST. EAST TWIN · B.S. MOSS MOVIELAND 8TH STREET TRIPLEX

AND AT A THEATRE NEAR YOU

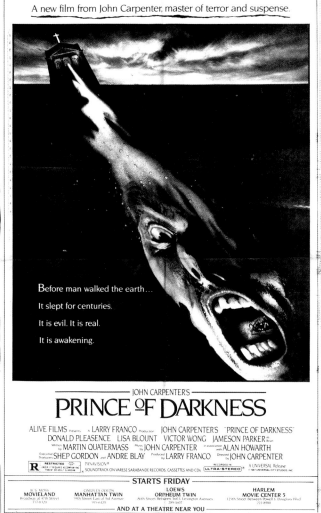

A new film from John Carpenter, master of terror and suspense.

Before man walked the earth...
It slept for centuries.
It is evil. It is real.
It is awakening.

JOHN CARPENTER'S
PRINCE OF DARKNESS

ALIVE FILMS Presents · A LARRY FRANCO Production · JOHN CARPENTER'S "PRINCE OF DARKNESS"
DONALD PLEASENCE · LISA BLOUNT · VICTOR WONG · JAMESON PARKER
Written by MARTIN QUATERMASS · Music by JOHN CARPENTER in association with ALAN HOWARTH
Executive Producers SHEP GORDON and ANDRE BLAY · Produced by LARRY FRANCO · Directed by JOHN CARPENTER
SOUNDTRACK ON VARESE SARABANDE RECORDS, CASSETTES AND CDs · ULTRA-STEREO · A UNIVERSAL Release

STARTS FRIDAY

B.S. MOSS MOVIELAND Broadway at 47th Street · CINEPLEX ODEON MANHATTAN TWIN 59th Street East of 3rd Avenue · LOEWS ORPHEUM TWIN 86th Street Between 2nd & Lexington Avenues · HARLEM MOVIE CENTER 5 125th Street Between Powell & Douglass Blvd

AND AT A THEATRE NEAR YOU

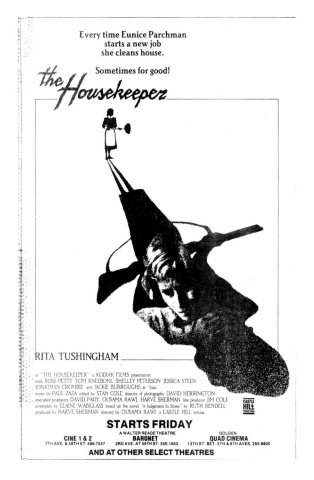

Every time Eunice Parchman starts a new job she cleans house.
Sometimes for good!

the Housekeeper

RITA TUSHINGHAM

in "THE HOUSEKEEPER" a KODIAK FILMS presentation
with ROSS PETTY · TOM KNEEBONE · SHELLEY PETERSON · JESSICA STEEN
JONATHAN CROMBIE · and JACKIE BURROUGHS as "Joan"
music by PAUL ZAZA · edited by STAN COLE · director of photography DAVID HERRINGTON
executive producers DAVID PADY, OUSAMA RAWI, HARVE SHERMAN · line producer JIM COLE
screenplay by ELAINE WAISGLASS · based on the novel "A Judgement In Stone" by RUTH RENDELL
produced by HARVE SHERMAN · directed by OUSAMA RAWI · a CASTLE HILL release

STARTS FRIDAY
A WALTER READE THEATRE
CINE 1 & 2 7TH AVE. & 48TH ST. 489-7547 · BARONET 3RD AVE. AT 59TH ST. 355-1663 · GOLDEN QUAD CINEMA 13TH ST. BET. 5TH & 6TH AVES. 255-8800

AND AT OTHER SELECT THEATRES

317

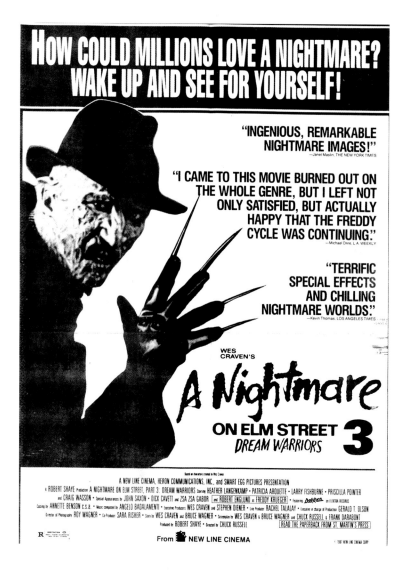

A NIGHTMARE ON ELM STREET 3: DREAM WARRIORS

After the platform releases of the previous two Freddy Krueger adventures, New Line gave *A Nightmare on Elm Street 3* the series' first wide, 1000-plus-theater break in February 1987, firmly establishing Freddy as a box-office monster. There were enough positive reviews for New Line to quote them in the ads, even as not all critics found the film sufficiently dreamy.

"Spectacular special effects and devilishly creative predicaments make this third *Elm Street* entertaining for even the least fervent of Freddy's followers."

— Christopher Tricarico,
Los Angeles Herald Examiner

"...*Nightmare 3*...is full of consistently inventive imagery... When you add a neat subplot about Freddy's birth...you've got a genre film a cut above the others."

— James Verniere, *Boston Herald*

"...*A Nightmare on Elm Street 3* has to work a little harder to get the job done. It does, though, offering good scares, excellent special effects, brisk pacing, a nicely unsettling atmosphere and, best of all, a philosophical point of view that raises it above the usual slash-and-hack horror film."

— John Wooley, *Tulsa World*

"*A Nightmare on Elm Street 3* is a dismal succession of such macabre episodes, rendered the more repulsive by the harsh truth that teenage suicide is a pressing and growing national problem."

— Desmond Ryan, *The Philadelphia Inquirer*

"The effects this time are more skillful and gruesome than ever. The direction, now that originator Wes Craven has retired from the helm, is merely gruesome. Scripts remain a problem... On the plus side, Freddy has been endowed with a measure of wit."

— BILL COSFORD,
THE MIAMI HERALD

319

THE STEPFATHER

New Century/Vista had a gem of a psychological suspense shocker with *The Stepfather*, but had trouble marketing it. Beginning in early 1987, the distributor tried different campaigns in different cities, and couldn't find the right one to sell a movie that focused on a teen heroine, yet was more adult in its terror tactics than your run-of-the-mill slasher fare. In New York, critic David Edelstein of alt-weekly *The Village Voice* raved about *The Stepfather* early on, and pressured New Century/Vista in print to open the film in New York. When it finally arrived in May, the campaign emphasized the recognition the film had received... still to no box-office avail, sadly, leaving it to find its audience on video.

"The best horror movies begin with the simplest of premises—and *The Stepfather* has a doozy... Donald Westlake...and director Joseph Ruben never miss an opportunity to turn up the heat, deftly preying on our deepest fears of a stranger taking our father's place."
— Patrick Goldstein, *Los Angeles Times*

"*The Stepfather* is a nearly perfect work of popular entertainment. A thriller about a psychopathic killer, it is absolutely terrifying. At the same time it is a highly personal work, the expression of a gifted individual."
— DAVE KEHR, *CHICAGO TRIBUNE*

"...a suspense film cum domestic horror movie that is a good deal better than any of the slew of conventional thrillers that have been glutting movie screens... What makes *The Stepfather* so good is the originality of writer Donald Westlake's characterization of Jerry Blake... All the acting is good here, but O'Quinn is extraordinary as the killer."
— Michael Healy, *The Denver Post*

"I won't call it a masterpiece, because you'll gripe if it doesn't turn out to be *Citizen Kane* or something safe like that. For sheer originality, energy of imagination, and total conviction of the storyteller's impulse, though, no picture in recent months is the equal of a little item called *The Stepfather*."
— Randolph Man, *Santa Fe New Mexican*

321

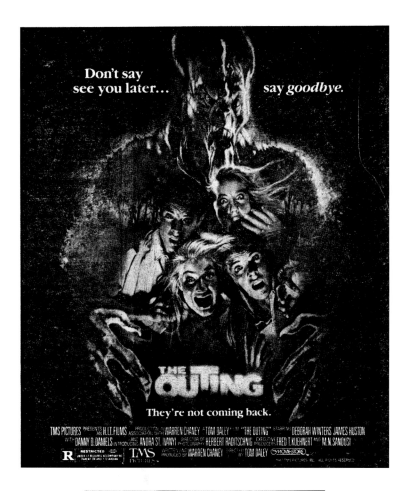

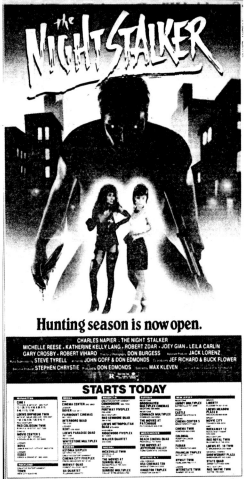

STREET TRASH

The 8th Street Playhouse is best known in cult movie history for being New York City's longtime home of *The Rocky Horror Picture Show* and its most fervent midnight fans, but that was far from the only oddball flick to grace its screen. Another one was *Street Trash*, which Jim Muro expanded from his same-titled short film in collaboration with School of Visual Arts film teacher Roy Frumkes. A true New York horror movie, it's interesting to see that this love-it-or-hate-it flick received more of the latter reaction from Manhattan reviewers, while finding admirers in Boston.

"It belongs to an ill-intentioned genre of low-budget movie that serves only to disgust, not to challenge complacency, further a plot or shed light on the human condition ... There's necrophilia. There's slime. There are sick sound effects. There's something for everyone. Except me."

— Jami Bernard, *New York Post*

"*Street Trash*...is the stuff that civil-libertarian nightmares are made of. It claims no redeeming social value, and you don't have to be a Supreme Court nominee to question whether the Founders could have foreseen anything like it when they wrote the First Amendment."

— WALTER GOODMAN,
THE NEW YORK TIMES

"[It] easily outstrips [*The Toxic Avenger*] both in creative gore and in humor. ... For those who have a strong stomach and a skewed sense of humor, *Street Trash* is brash exploitation fun."

— Betsy Sherman, *The Boston Globe*

"Good exploitation movies are hard to find these days ... Well, Jim Muro's *Street Trash* is the real thing. ... It's an unabashedly lewd and crude movie, and it's a howl. ... Muro also has taken the care to make *Street Trash* look like a more generously budgeted film."

— Paul Sherman, *Boston Herald*

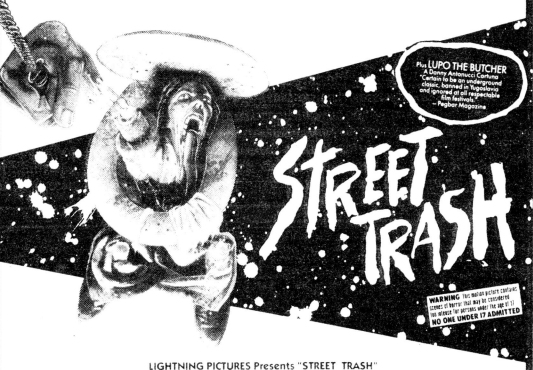

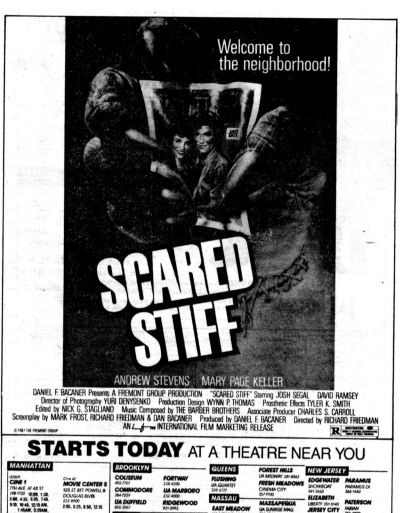

Welcome to the neighborhood!

SCARED STIFF

ANDREW STEVENS MARY PAGE KELLER

DANIEL F. BACANER Presents A FREMONT GROUP PRODUCTION "SCARED STIFF" Starring JOSH SEGAL DAVID RAMSEY
Director of Photography YURI DENYSENKO Production Design WYNN P. THOMAS Prosthetic Effects TYLER K. SMITH
Edited by NICK G. STAGLIANO Music Composed by THE BARBER BROTHERS Associate Producer CHARLES S. CARROLL
Screenplay by MARK FROST, RICHARD FRIEDMAN & DAN BACANER Produced by DANIEL F. BACANER Directed by RICHARD FRIEDMAN
© 1987 THE FREMONT GROUP AN International FILM MARKETING RELEASE

STARTS TODAY AT A THEATRE NEAR YOU

MANHATTAN

LOESER
CINE 1
7TH AVE AT 48 ST
398-1720 12:00, 1:30,
3:00, 4:35, 6:05, 7:40,
9:10, 10:40, 12:15 AM,
1:45AM, 3:20AM,
4:50AM, 6:20AM

CINE 42 #1
42 ST BET 7TH
& 8TH AVES.
221-1992 11:40, 2:55,
6:00, 9:10, 12:20

Cine 42
MOVIE CENTER 5
125 ST. BET. POWELL &
DOUGLAS BLVD.
222-8900
2:05, 5:25, 8:50, 12:15

ESSEX
GRAND ST OFF ESSEX
982-4455

BROOKLYN

COLISEUM
492-7707

COMMODORE
384-7259

UA DUFFIELD
855-3967

BRONX

CINEMA CENTER
292-3893

DOVER 542-3511

FAIRMONT
CINEMAS 901-3322

FORTWAY
238-4200

UA MARBORO
232-4000

RIDGEWOOD
821-5993

KENT
538-4000

PALACE
829-3900

UA VALENTINE

RED APPLE

QUEENS

FLUSHING
UA QUARTET
359-6777

NASSAU

EAST MEADOW
UA MEADOWBROOK
735-7552

HICKSVILLE
UA HICKSVILLE 931-0749

SUFFOLK

BABYLON
UA BABYLON

FOREST HILLS
UA MIDWAY 281-8562

FRESH MEADOWS
CINEMA CITY
357-9100

MASSAPEQUA
UA SUNRISE MALL
795-2244

WESTBURY
UA WESTBURY DI
334-3400

PATCHOGUE
UA MOVIES
AT PATCHOGUE 12
363-2100

NEW JERSEY

EDGEWATER
SHOWBOAT
941-3660

ELIZABETH
LIBERTY 351-5140

JERSEY CITY
UA STATE
653-5200

NUTLEY
FRANKLIN
667-1777

NEWBURGH
NEWBURGH
CINEMAS
564-8844

PARAMUS
PARAMUS DI
368-1440

PATERSON
FABIAN
742-4800

UNION CITY
CINEMA
865-5600

POUGHKEEPSE
CINES 8
297-5512

WESTCHESTER JEFFERSON VALLEY
UA MOVIES 245-0220

PEEKSKILL
BEACH 738-8262

YONKERS
MOVIELAND 793-0002

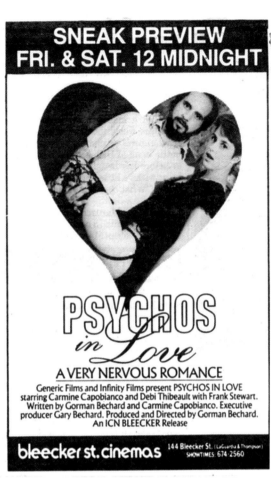

SNEAK PREVIEW
FRI. & SAT. 12 MIDNIGHT

PSYCHOS in Love

A VERY NERVOUS ROMANCE

Generic Films and Infinity Films present PSYCHOS IN LOVE
starring Carmine Capobianco and Debi Thibeault with Frank Stewart.
Written by Gorman Bechard and Carmine Capobianco. Executive
producer Gary Bechard. Produced and Directed by Gorman Bechard.
An ICN BLEECKER Release

bleecker st. cinemas 144 Bleecker St. (LaGuardia & Thompson)
SHOWTIMES: 674-2560

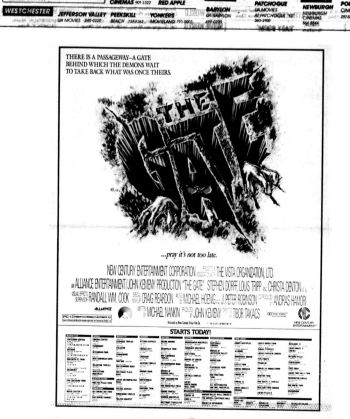

THERE IS A PASSAGEWAY—A GATE
BEHIND WHICH THE DEMONS WAIT
TO TAKE BACK WHAT WAS ONCE THEIRS.

THE GATE

...pray it's not too late.

NEW CENTURY ENTERTAINMENT CORPORATION THE VISTA ORGANIZATION, LTD.

AN ALLIANCE ENTERTAINMENT/JOHN KEMENY PRODUCTION "THE GATE" STEPHEN DORFF, LOUIS TRIPP & CHRISTA DENTON
VISUAL EFFECTS SUPERVISOR RANDALL WM. COOK SPECIAL EFFECTS CRAIG REARDON MUSIC MICHAEL HOENIG J. PETER ROBINSON ANDRAS HAMORI
WRITTEN BY MICHAEL NANKIN PRODUCED BY JOHN KEMENY DIRECTED BY TIBOR TAKACS

PG-13

STARTS TODAY!!

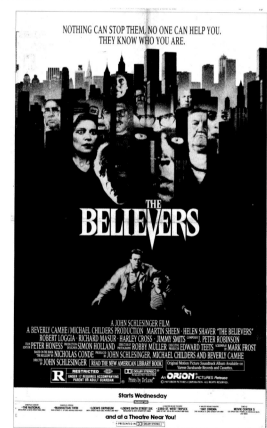

NOTHING CAN STOP THEM, NO ONE CAN HELP YOU.
THEY KNOW WHO YOU ARE.

THE BELIEVERS

A JOHN SCHLESINGER FILM
A BEVERLY CAMHE/MICHAEL CHILDERS PRODUCTION MARTIN SHEEN · HELEN SHAVER "THE BELIEVERS"
ROBERT LOGGIA · RICHARD MASUR · HARLEY CROSS · JIMMY SMITS COMPOSER J. PETER ROBINSON
EDITOR PETER HONESS DESIGNER SIMON HOLLAND PHOTOGRAPHY ROBBY MÜLLER PRODUCER EDWARD TEETS SCREENPLAY MARK FROST
BASED ON THE BOOK "THE RELIGION" BY NICHOLAS CONDE PRODUCED BY JOHN SCHLESINGER, MICHAEL CHILDERS AND BEVERLY CAMHE
DIRECTED BY JOHN SCHLESINGER READ THE NEW AMERICAN LIBRARY BOOK Original Motion Picture Soundtrack Album Available on Varese Sarabande Records and Cassettes.

R RESTRICTED DOLBY STEREO Prints by DeLuxe An ORION PICTURES Release

Starts Wednesday

MANHATTAN
"THE NATIONAL "MANHATTAN TWIN LOEWS ORPHEUM "LOEWS 84TH STREET SIX "23RD ST. WEST TRIPLEX BAY CINEMA MOVIE CENTER 5

and at a Theatre Near You!

PRESENTED IN DOLBY STEREO

1987

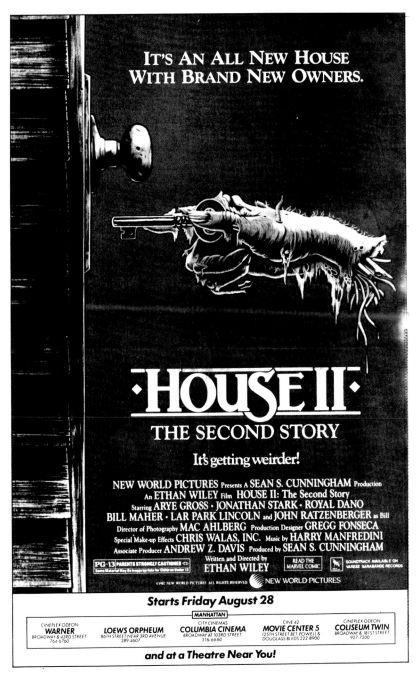

IT'S AN ALL NEW HOUSE
WITH BRAND NEW OWNERS.

·HOUSE II·
THE SECOND STORY

It's getting weirder!

NEW WORLD PICTURES Presents A SEAN S. CUNNINGHAM Production
An ETHAN WILEY Film HOUSE II: The Second Story
Starring ARYE GROSS · JONATHAN STARK · ROYAL DANO
BILL MAHER · LAR PARK LINCOLN and JOHN RATZENBERGER as Bill
Director of Photography MAC AHLBERG Production Designer GREGG FONSECA
Special Make-up Effects CHRIS WALAS, INC. Music by HARRY MANFREDINI
Associate Producer ANDREW Z. DAVIS Produced by SEAN S. CUNNINGHAM
Written and Directed by ETHAN WILEY

PG-13 PARENTS STRONGLY CAUTIONED · READ THE MARVEL COMIC · SOUNDTRACK AVAILABLE ON VARESE SARABANDE RECORDS

©1987 NEW WORLD PICTURES ALL RIGHTS RESERVED ▪ NEW WORLD PICTURES

Starts Friday August 28

MANHATTAN				
CINEPLEX ODEON **WARNER** BROADWAY & 43RD STREET 764-6760	**LOEWS ORPHEUM** 86TH STREET NEAR 3RD AVENUE 289-4607	CITY CINEMAS **COLUMBIA CINEMA** BROADWAY AT 103RD STREET 316-6060	CINE 42 **MOVIE CENTER 5** 125TH STREET BET POWELL & DOUGLASS BLVDS 222-8900	CINEPLEX ODEON **COLISEUM TWIN** BROADWAY & 181ST STREET 927-7200

and at a Theatre Near You!

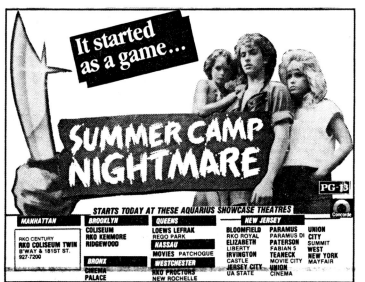

It started as a game...

SUMMER CAMP NIGHTMARE

PG-13

STARTS TODAY AT THESE AQUARIUS SHOWCASE THEATRES

MANHATTAN	BROOKLYN	QUEENS	NEW JERSEY		
RKO CENTURY **RKO COLISEUM TWIN** B'WAY & 181ST ST. 927-7200	**COLISEUM** RKO KENMORE RIDGEWOOD	**LOEWS LEFRAK** REGO PARK	**BLOOMFIELD** RKO ROYAL	**PARAMUS** PARAMUS DI	**UNION** CITY
		NASSAU	**ELIZABETH** LIBERTY	**PATERSON** FABIAN 5	**SUMMIT** WEST
		MOVIES PATCHOGUE	**IRVINGTON** CASTLE	**TEANECK** MOVIE CITY	**NEW YORK** MAYFAIR
	BRONX	*WESTCHESTER*	**JERSEY CITY** UA STATE	**UNION** CINEMA	
	CINEMA PALACE	RKO PROCTORS NEW ROCHELLE			

Concorde

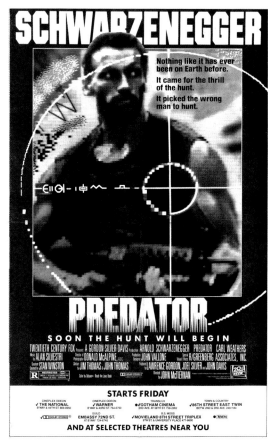

SCHWARZENEGGER

Nothing like it has ever been on Earth before.
It came for the thrill of the hunt.
It picked the wrong man to hunt.

PREDATOR

SOON THE HUNT WILL BEGIN

TWENTIETH CENTURY FOX Presents A GORDON-SILVER-DAVIS Production A ARNOLD SCHWARZENEGGER PREDATOR CARL WEATHERS
Music by ALAN SILVESTRI Director of Photography DONALD McALPINE, A.S.C. Production Designer JOHN VALLONE Visual Effects R/GREENBERG ASSOCIATES, INC.
Created by STAN WINSTON Written by JIM THOMAS & JOHN THOMAS Produced by LAWRENCE GORDON, JOEL SILVER & JOHN DAVIS Directed by JOHN McTIERNAN

R RESTRICTED ▪ Color by Deluxe® Read the Jove Book ▪ [DOLBY STEREO] ▪ 20th CENTURY FOX

STARTS FRIDAY

CINEPLEX ODEON ✓ THE NATIONAL B'WAY & 44TH ST. 869-0950	CINEPLEX ODEON ✓ WARNER B'WAY & 43RD ST. 764-6760	TRAMS/LUX ✓ GOTHAM CINEMA 3RD AVE. AT 58TH ST. 759-2262	TOWN & COUNTRY ✓ 86TH STREET EAST TWIN BETW. 2ND & 3RD AVE. 249-7144
✓ [DOLBY STEREO] GUILD EMBASSY 72ND ST. AT B'WAY 724-6745	B.S. MOSS MOVIELAND 8TH STREET TRIPLEX 8TH ST. & UNIVERSITY PLACE 477-6600	✓ 70MM	

AND AT SELECTED THEATRES NEAR YOU

THE "HOWLING" TERROR CONTINUES!

HOWLING III

BANCANNIA ENTERTAINMENT Presents A PHILIPPE MORA FILM A CHARLES WATERSTREET/PHILIPPE MORA Production
"HOWLING III" Starring BARRY OTTO · IMOGEN ANNESLEY · MAX FAIRCHILD
LEIGH BIOLOS · DASHA BLAHOVA · RALPH COTTERILL as Professor Sharp · BARRY HUMPHRIES
Special Effects by BOB McCARRON · Music by ALLAN ZAVOD Screenplay and Storyline by PHILIPPE MORA
Based on the book, The Howling III by GARY BRANDNER Executive Producers EDWARD SIMONS, STEVE LANE and ROBERT PRINGLE
Co-Produced by GILDA BARACCHI Produced by CHARLES WATERSTREET and PHILIPPE MORA Directed by PHILIPPE MORA
1987 BANCANNIA HOLDINGS PTY. LTD. A SQUARE PICTURES RELEASE

PG-13 PARENTS STRONGLY CAUTIONED ▪ Some Material May Be Inappropriate for Children Under 13

1988

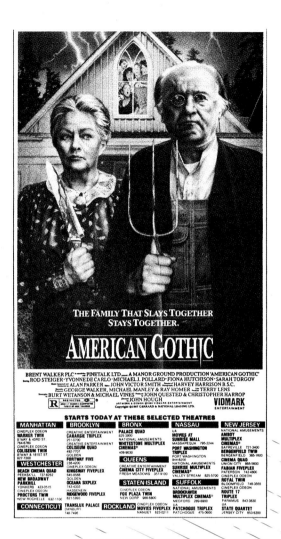
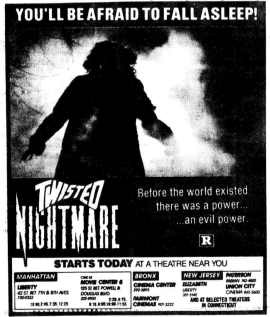

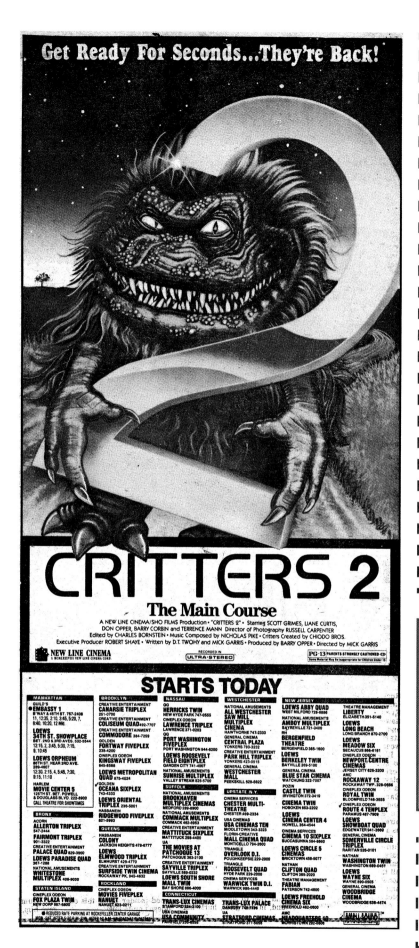

ELVIRA, MISTRESS OF THE DARK

The "hostess with the mostest" found her fame making fun of cheesy B-horror and sci-fi flicks on TV. So when she busted out in her first feature film vehicle, some could see the unkind reviews it received as a case of the shoe being on the other foot (to use what is perhaps not the most appropriate anatomical analogy). Still, a few critics found the flick fulfilling.

"Call it T*he Attack of the Killer Tomato* (unlike the film classic *Tomatoes*, although there are a lot of round objects bouncing around here). ... *Elvira, Mistress of the Dark* flaunts enough broad jokes and self-deprecating humor to emerge a vivid delight."
— Mary Voelz Chandler, *Rocky Mountain News*

"Elvira's smart mouth and slinky silhouette may not seem to be quite a sturdy-enough foundation on which to build a whole feature film. But she brings off the trick with quite a bit of campy charm."
— Michael Healy, *Los Angeles Daily News*

"She's fun, a Transylvania Valley Girl grown up into the Queen of the Bs, but after 96 minutes you may start thinking more fondly about those '50s and '60s camp classics she's usually interspersed with."
— Richard Harrington, *The Washington Post*

"While Elvira does a decently indecent job of fleshing out her terror-TV persona, and the movie maintains an essentially amiable, throwaway tone, most of the comedy here is cut as low as El's ubiquitous black dress."
— PHANTOM OF THE MOVIES, *NEW YORK DAILY NEWS*

"Now I'm certainly no prude, and I'm not going to knock a movie just because of a bunch of raunchy jokes (I even chuckled at a few). But when they're a movie's sole reason for existence, which is the case here, I take objection."
— V.A. Musetto, *New York Post*

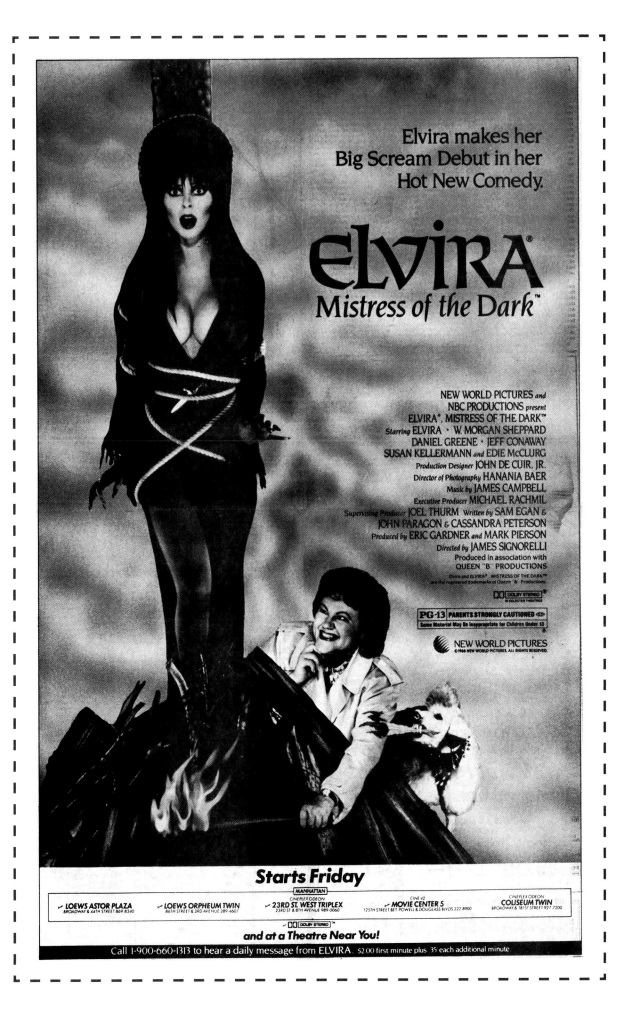

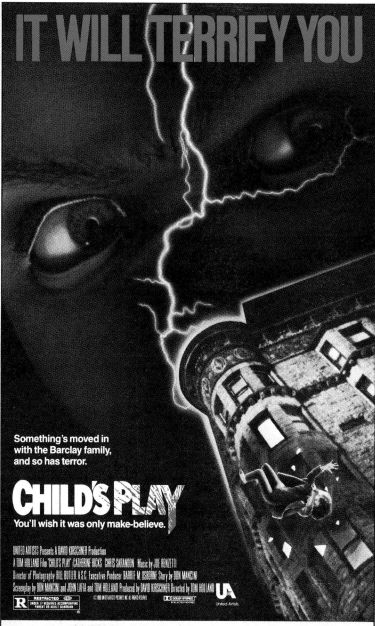

CHILD'S PLAY

As we've seen previously in this book, several horror films had secondary ads created for their ongoing releases on Halloween or Friday the 13th. *Child's Play* opened in early November 1988, and so missed out on an All Hallow's tie-in, though MGM was able to exploit the Thanksgiving holiday later in the month when the movie proved to have box-office legs. It also won favor with some of its critics.

"*Child's Play* is a cheerfully energetic horror film of the slam-bang school, but slicker and more clever than most. ... [I]t is well made, contains effective performances, and has succeeded in creating a truly malevolent doll. Chucky is one mean SOB."

— Roger Ebert, *Chicago Sun-Times*

"An enterprising but ultimately overwrought thriller. ... The film has its inspired moments before it goes over the top with cheap child-in-peril sequences."

— Gene Siskel, *Chicago Tribune*

"Originality is not the point of *Child's Play*. ... It's the deft wit and swift editing that keep us off guard, no matter how predictable the plot. ... [The film] is a fitting successor to the classic television horror stories it takes off from. As Rod Serling did in *Twilight Zone*, Mr. Holland treats his audience intelligently."

— CARYN JAMES,
THE NEW YORK TIMES

"Unfortunately, *Child's Play* gets a little ugly at the end, not only because the finale seems a rehash of virtually every shock movie of the last 10 years, but because it involved the very realistic terrorizing of a 6-year-old."

— Richard Harrington, *The Washington Post*

"Director Tom Holland...stages most of the mayhem in the kind of wonderfully gothic apartment house where you keep expecting to run into *Rosemary's Baby*. ... [The movie] slickly walks the line between horror and humor."

— Jay Carr, *The Boston Globe*

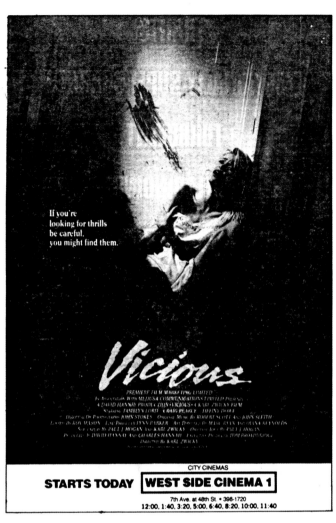

If you're
looking for thrills
be careful,
you might find them.

Vicious

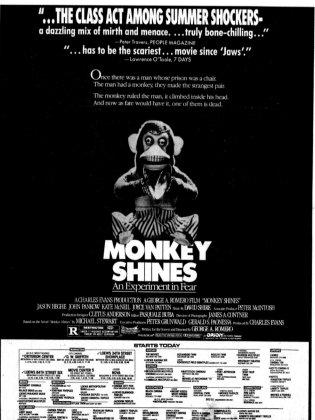

"...THE CLASS ACT AMONG SUMMER SHOCKERS-
a dazzling mix of mirth and menace. ...truly bone-chilling..."
—Peter Travers, PEOPLE MAGAZINE

"...has to be the scariest... movie since 'Jaws'."
—Lawrence O'Toole, 7 DAYS

Once there was a man whose prison was a chair.
The man had a monkey, they made the strangest pair.

The monkey ruled the man, it climbed inside his head.
And now as fate would have it, one of them is dead.

MONKEY SHINES
An Experiment in Fear

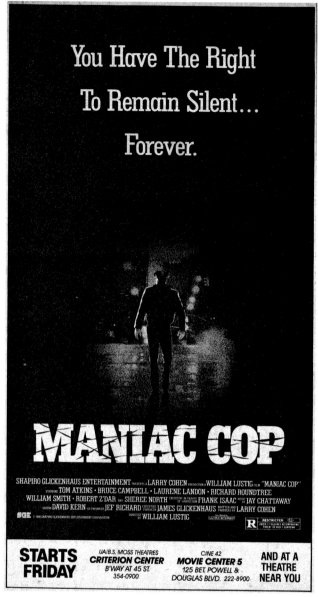

You Have The Right
To Remain Silent...
Forever.

MANIAC COP

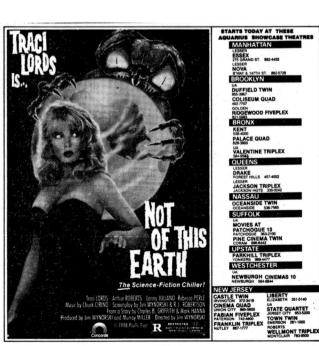

TRACI LORDS Is...

NOT OF THIS EARTH
The Science-Fiction Chiller!

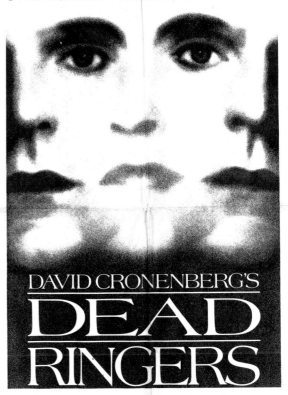
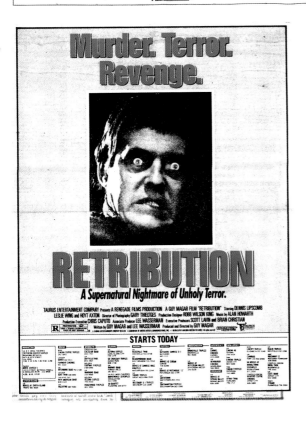
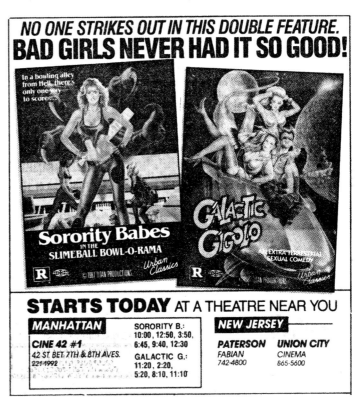
333

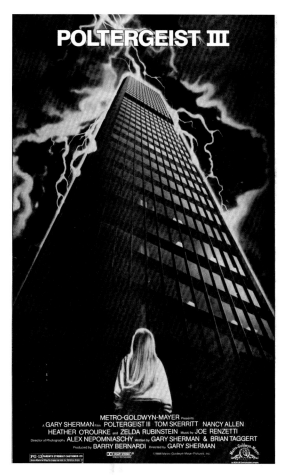

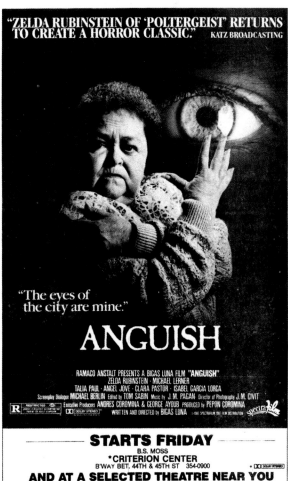

HELLBOUND: HELLRAISER II

When the sequel to Clive Barker's grisly hit arrived in theaters in December 1988, part of the promotion included the giving away of T-shirts bearing the movie's title in glow-in-the-dark letters. This led a *Variety* wise guy to note that this was not a time of year when many people walked around at night wearing T-shirts. Nonetheless, *Hellbound: Hellraiser II* won a lot of favor with fans, though not so much with reviewers.

"*Hellbound: Hellraiser II* is an offensively inept sequel to the 1987 Clive Barker film. ... But *Hellbound*, which was originally tagged with an X rating by the Motion Picture Association of America, should not be condemned for being 'splatter porn.' It should be condemned for being stupid."

— James Verniere, *Boston Herald*

"As sheer spectacle, *Hellraiser II* certainly rivets, once you get past the idiocies of plot and performance. A great deal of perverse imagination has been lavished on the Bosch-like vistas; it lives up to its promise to show you those things you've never seen before, while ripping your soul apart."

— Stephen Hunter, *The Baltimore Sun*

"Clearly, Mr. Barker's affinities are with these creatures, who promise pleasure and deliver only pain. ... And beyond some explicit, hyper-surreal gore...the Cenobites are the only imaginative things in *Hellbound*."

— STEVE DOLLAR,
THE ATLANTA JOURNAL

"*Hellbound* is a worthy successor to last year's grisly but effective *Hellraiser*, which means it basically offers more of the same: silly mysticism, creepy characters and barrels of blood... [T]he four Cenobites frighten effectively on both conscious and subconscious levels."

— David Kronke, *Dallas Times Herald*

"Barker is on board only as executive producer this time, and his unsettling presence is missed. ... It's more of an action/adventure picture this time around, if still an exceptionally grisly one, and hardcore Barker enthusiasts may bemoan the switch in tone."

— Chris Willman, *Los Angeles Times*

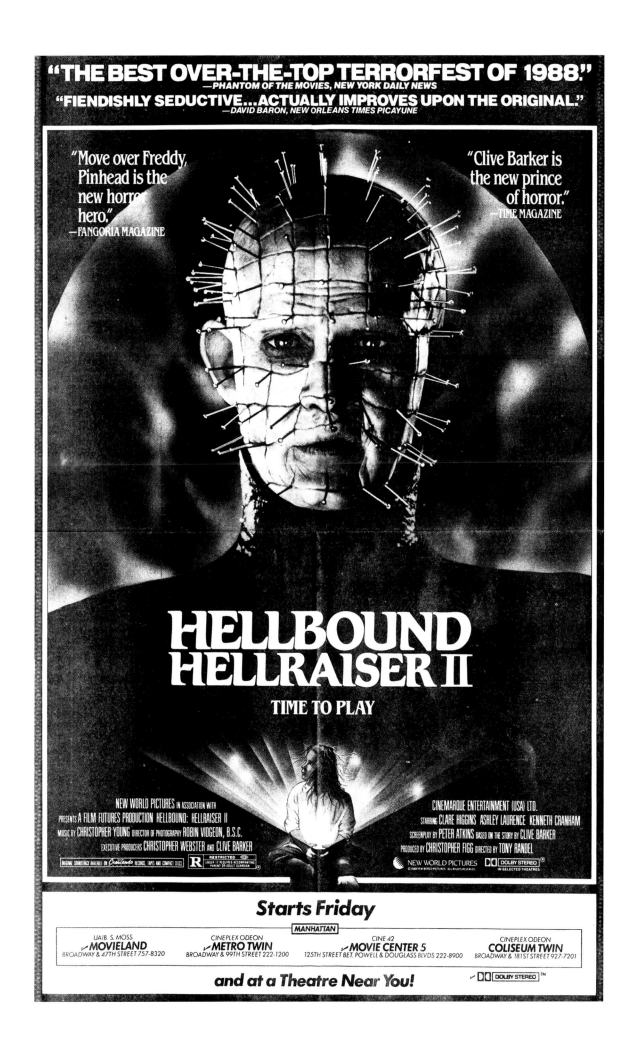

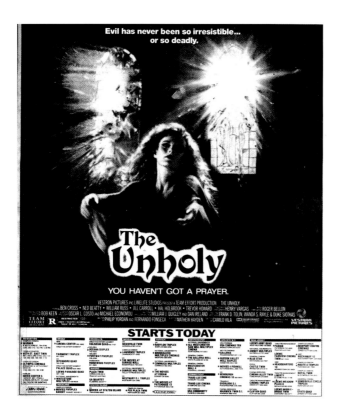

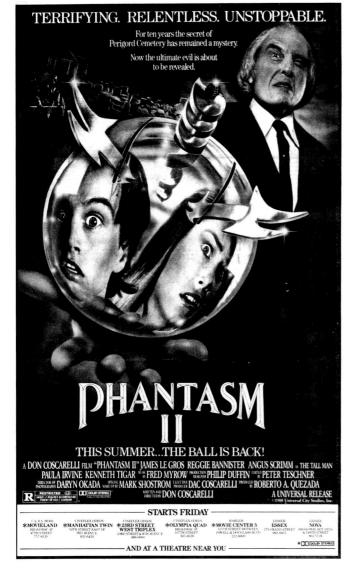

The filmmaking debut of the Chiodo Brothers special effects team, *Killer Klowns* didn't receive the release it warranted, nor did many critics pay attention to it. It's noteworthy, though, that the few who did write it up gave props to the qualities that would later make it a video favorite.

"The story's freshness is matched by nifty execution and fairly witty gags. ... A certain Mr. Herman should have stuck with the Chiodos and dumped director Randal Kleiser. Comparing the two summer circus entertainments my opinion is: Give *Big Top Pee-wee* the hook and send in the Klowns."

— Kathy Huffhines, *Detroit Free Press*

"*Killer Klowns from Outer Space* is (and please don't die laughing when I say this) a swell spoof of those long-gone but not forgotten movies. And with a clever twist. ... [It's] so off-handed and unpretentious, and such fun to watch, that you just don't care [about its flaws]."

— V.A. MUSETTO, *NEW YORK POST*

"...[T]his offbeat, black-comic homage to '50s 'monster movies' demonstrates both above-average technical skill and large dollops of imagination. ... While budget constraints occasionally show, they're more than offset by the rush of creativity fiendishly and cleverly at work."

— Leonard Klady, *Los Angeles Times*

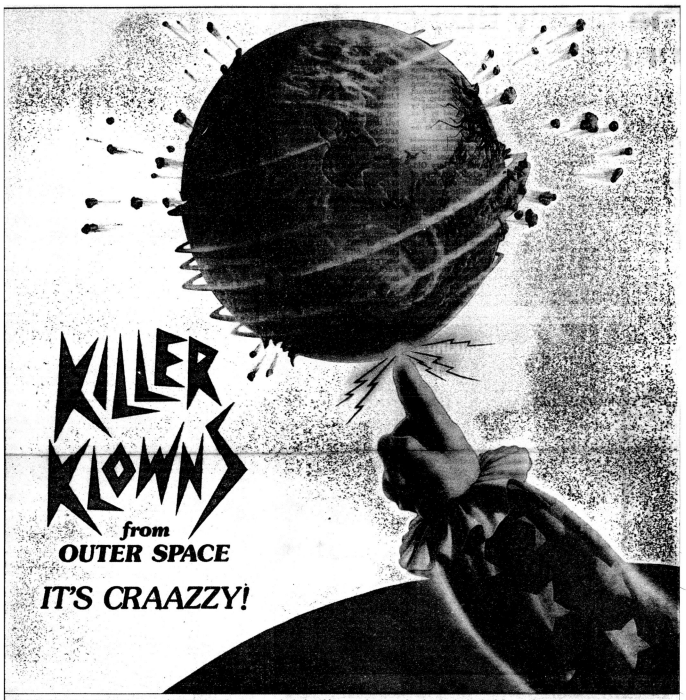

KILLER KLOWNS
from OUTER SPACE
IT'S CRAAZZY!

TRANS WORLD ENTERTAINMENT Presents A SARLUI/DIAMANT Presentation of A CHIODO BROS. Production "KILLER KLOWNS FROM OUTER SPACE" Starring GRANT CRAMER • SUZANNE SNYDER JOHN ALLEN NELSON • ROYAL DANO and JOHN VERNON as Officer Mooney MUSIC BY JOHN MASSARI SPECIAL VISUAL EFFECTS BY FANTASY II FILM EFFECTS ASSOCIATE PRODUCER J. LICHAUCO DIRECTOR OF PHOTOGRAPHY ALFRED TAYLOR A.S.C. EXECUTIVE PRODUCERS PAUL MASON and HELEN SARLUI-TUCKER WRITTEN BY CHARLES CHIODO & STEPHEN CHIODO PRODUCED BY EDWARD CHIODO • STEPHEN CHIODO & CHARLES CHIODO

PG-13 PARENTS STRONGLY CAUTIONED
Some Material May Be Inappropriate for Children Under 13

DOLBY STEREO
IN SELECTED THEATRES

DIRECTED BY STEPHEN CHIODO

Title Song "KILLER KLOWNS FROM OUTER SPACE" Performed by THE DICKIES Available on "Enigma Records"

TRANS WORLD ENTERTAINMENT
© 1988 TRANS WORLD ENTERTAINMENT. All Rights Reserved.

STARTS TODAY AT A THEATRE NEAR YOU

MANHATTAN
CINEPLEX ODEON
WARNER TWIN
B'WAY AT 43 ST.
764-6760 1:00, 3:00, 5:00,
7:00, 9:00, 11:00
ESSEX
GRAND ST. OFF ESSEX
982-4455

BRONX
CINEMA CENTER
292-3893
DOVER 542-3511
FAIRMONT CINEMAS
901-3322
KENT 538-4000
PALACE
829-3900

BROOKLYN
ALPINE
748-4200
CANARSIE
251-0700
COLISEUM
492-7707
COMMODORE
384-7259

QUEENS
FRESH MEADOWS
CINEMA CITY 357-9100
UPSTATE
MONTICELLO
MALL 794-2600
NEW PALTZ
NEW PALTZ 255-1110

SUFFOLK
MATTITUCK
MATTITUCK 298-4400
WESTCHESTER
PEEKSKILL 528-8822
WESTCHESTER MALL
YONKERS
PARK HILL 969-4477

NEW JERSEY
BELLE MEADE
HILLSBORO
359-4480
EAST BRUNSWICK
MOVIE CITY
257-5555

HOWELL TWP.
CINEMA CENTER 4
364-4544
LINDEN
LINDEN QUAD
925-9787
NUTLEY
FRANKLIN
667-1777

PATERSON
FABIAN
742-4800
UNION CITY
CINEMA
865-5600
WOODBRIDGE
MOVIE CITY
382-5555

THE SEVENTH SIGN & THE BLOB

In 1988, Tri-Star Pictures tried promoting a couple of its fright features by running a series of teaser ads in the days leading up to their releases. Sadly for the distributor, this approach didn't help the fortunes of either *The Blob* or *The Seventh Sign*, and after the initial disappointing business of the former, the studio resorted to a campy campaign keyed to one of the snarkier reviews.

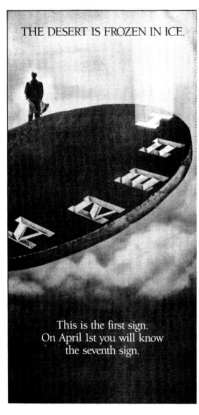

THE DESERT IS FROZEN IN ICE.

This is the first sign.
On April 1st you will know
the seventh sign.

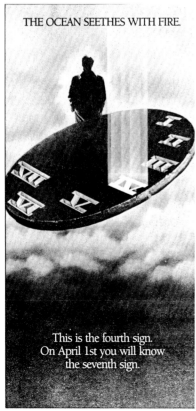

THE OCEAN SEETHES WITH FIRE.

This is the fourth sign.
On April 1st you will know
the seventh sign.

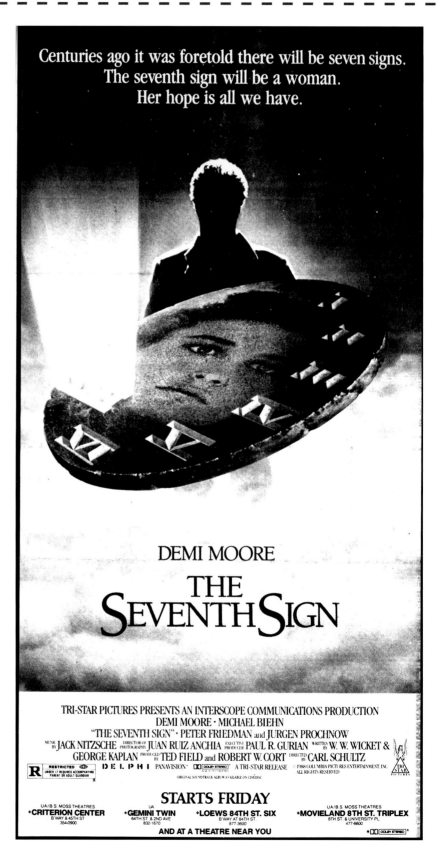

Centuries ago it was foretold there will be seven signs.
The seventh sign will be a woman.
Her hope is all we have.

DEMI MOORE

THE Seventh Sign

TRI-STAR PICTURES PRESENTS AN INTERSCOPE COMMUNICATIONS PRODUCTION
DEMI MOORE · MICHAEL BIEHN
"THE SEVENTH SIGN" · PETER FRIEDMAN and JURGEN PROCHNOW
MUSIC BY JACK NITZSCHE DIRECTOR OF PHOTOGRAPHY JUAN RUIZ ANCHIA EXECUTIVE PRODUCER PAUL R. GURIAN WRITTEN BY W. W. WICKET &
GEORGE KAPLAN PRODUCED BY TED FIELD and ROBERT W. CORT DIRECTED BY CARL SCHULTZ
R RESTRICTED UNDER 17 REQUIRES ACCOMPANYING PARENT OR ADULT GUARDIAN DELPHI PANAVISION · DOLBY STEREO® · A TRI-STAR RELEASE ©1988 COLUMBIA PICTURES ENTERTAINMENT, INC. ALL RIGHTS RESERVED
ORIGINAL SOUNDTRACK ALBUM AVAILABLE ON CINEDISC

STARTS FRIDAY

UA/B.S. MOSS THEATRES
+CRITERION CENTER
B'WAY & 45TH ST.
354-0900

UA
+GEMINI TWIN
64TH ST. & 2ND AVE.
832-1670

+LOEWS 84TH ST. SIX
B'WAY AT 84TH ST.
877-3600

UA/B.S. MOSS THEATRES
+MOVIELAND 8TH ST. TRIPLEX
8TH ST. & UNIVERSITY PL.
477-6600

AND AT A THEATRE NEAR YOU

1988

If it had a
face,
you could
look it
in the eye.

If it had a
heart,
you could
kill it.

If it had a
body,
you could
shoot it.

If it had a
mind,
you could
reason
with it.

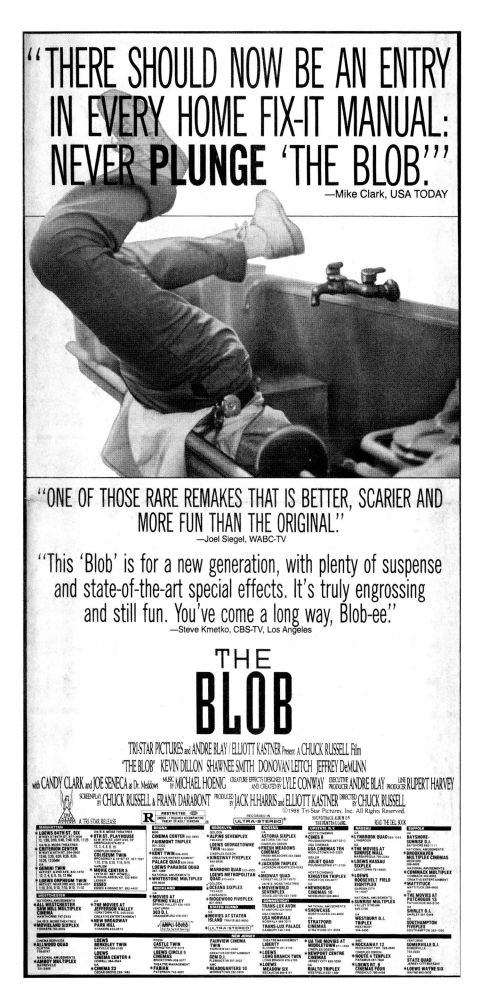

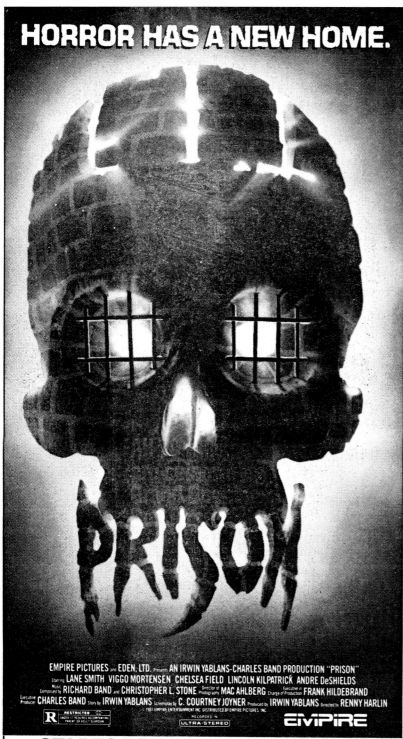

1988

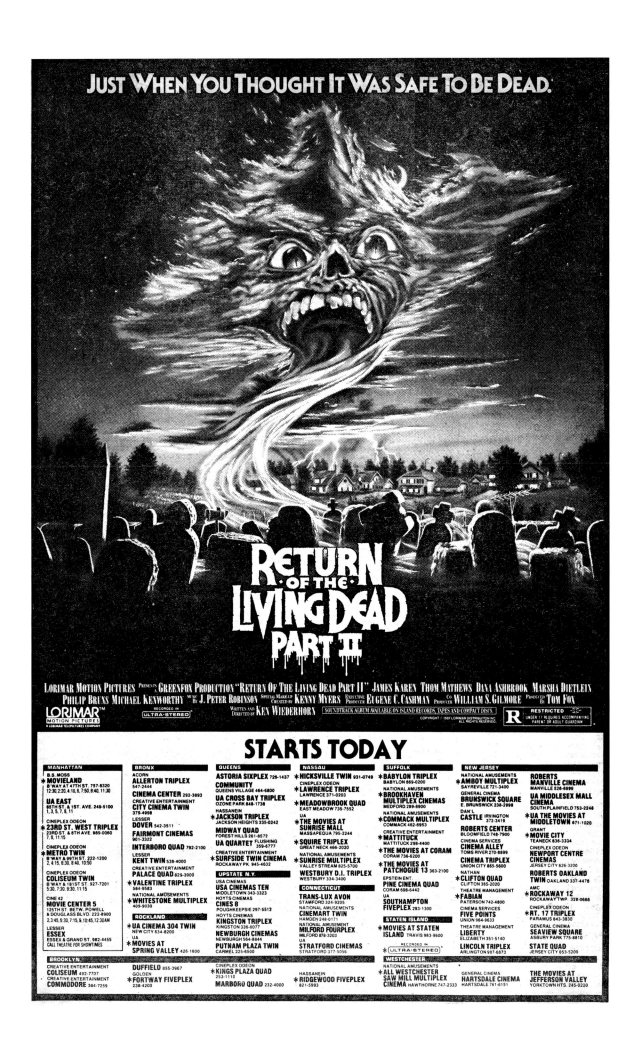

341

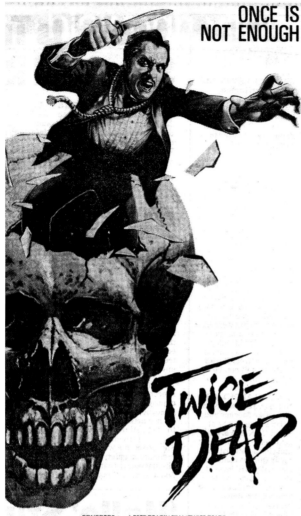

ONCE IS NOT ENOUGH

TWICE DEAD

CONCORDE presents A BERT DRAGIN FILM "TWICE DEAD" Starring TOM BREZNAHAN · JILL WHITLOW · JONATHAN CHAPIN · CHRISTOPHER BURGARD and TODD BRIDGES as PETIE Cinematography by ZORAN HOCHSTATTER Music Composed by DAVID BERGEAUD Screenplay by BERT DRAGIN and ROBERT McDONNELL Produced by GUY LOUTHAN and ROBERT McDONNELL Directed by BERT DRAGIN © 1988 T.D. PRODUCTIONS

CYNTHIA'S GOT A GRAVE PROBLEM!
13 years ago, something terrifying almost killed her.
Now it's come back to finish the job.

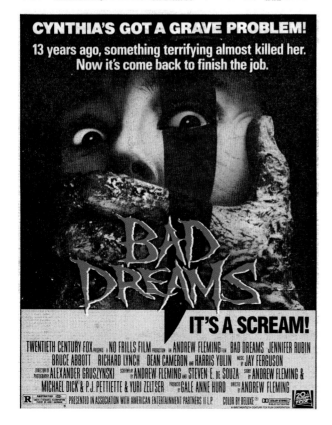

BAD DREAMS

IT'S A SCREAM!

TWENTIETH CENTURY FOX presents A NO FRILLS FILM production AN ANDREW FLEMING FILM "BAD DREAMS" JENNIFER RUBIN BRUCE ABBOTT RICHARD LYNCH DEAN CAMERON and HARRIS YULIN MUSIC by JAY FERGUSON DIRECTOR OF PHOTOGRAPHY ALEXANDER GRUSZYNSKI SCREENPLAY by ANDREW FLEMING and STEVEN E. DE SOUZA STORY by ANDREW FLEMING & MICHAEL DICK & P.J. PETTIETTE & YURI ZELTSER PRODUCED by GALE ANNE HURD DIRECTED by ANDREW FLEMING COLOR BY DELUXE PRESENTED IN ASSOCIATION WITH AMERICAN ENTERTAINMENT PARTNERS II L.P. © 1988 TWENTIETH CENTURY FOX FILM CORPORATION

THEY LIVE

This was the second low-budget feature Carpenter made for Alive Films and Universal Pictures, following the previous year's *Prince of Darkness*. Neither film won much critical approval, with *Prince* being almost, ahem, universally panned. Both went on to be more positively reassessed in later years, particularly *They Live*, which is now recognized as a juicy combo of science fiction, horror, and spiky political satire. At the time, a few reviewers appreciated its sociopolitical statements.

❝*They Live* is a junkheap, but it's scrappy and inventive, and it casts a spell. ... [Carpenter is] back where he started now, making cheapies clean and fast, and the return has revitalized him.❞
— David Edelstein, *New York Post*

❝Since Mr. Carpenter seems to be trying to make a real point here, the flatness of *They Live* is doubly disappointing. So is its crazy inconsistency, since the film stops trying to abide ever by its own game plan after a while.❞
— Janet Maslin, *The New York Times*

❝The plot for *They Live* is full of black holes, the acting is wretched, the effects are second-rate. In fact, the whole thing is so preposterous it makes *V* look like *Masterpiece Theater*.❞
— Richard Harrington, *The Washington Post*

❝...Carpenter is skillful enough not to let his soapbox get in the way of the entertainment. Reaganomics may be the obvious point of comparison here, but *They Live* is also engaging as a simple fable of haves vs. have-nots.❞
— Julie Hinds, *The Detroit News*

❝*They Live* is the looniest movie of the season and also one of the most engaging. For director John Carpenter...the new movie represents his most radical turning. It's his first explicitly – and indeed, even feverishly – political film. ... [It's] loose, funky, happily self-indulgent.❞
— Dave Kehr, *Chicago Tribune*

❝*They Live* has cult favorite written all over it, and part of the reason is the way it regenerates the cheap, juicy, surprisingly potent sci-fi of the 1950s. ... As sci-fi horror comedy, They Live, with its wake-up call to the world, is in a class with *Terminator* and *RoboCop*, even though its hero doesn't sport bionic biceps.❞
— JAY CARR,
THE BOSTON GLOBE

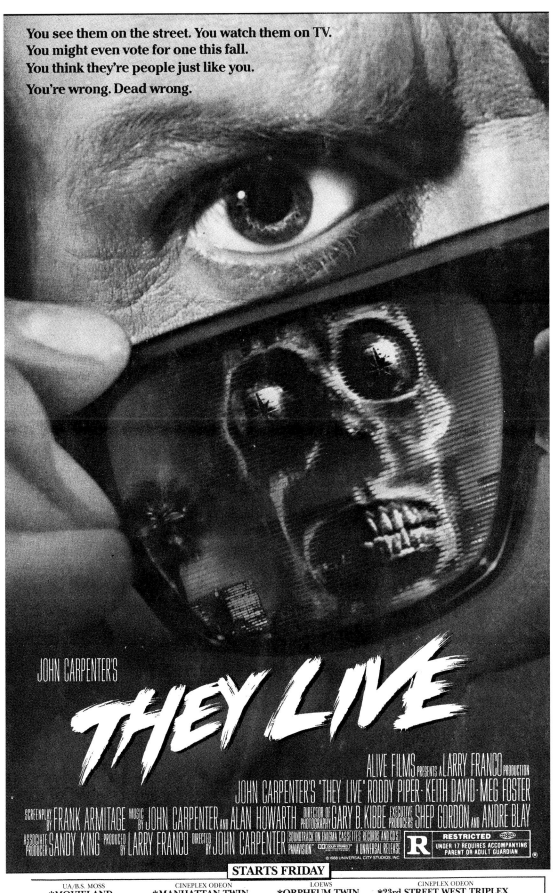

You see them on the street. You watch them on TV.
You might even vote for one this fall.
You think they're people just like you.

You're wrong. Dead wrong.

JOHN CARPENTER'S

THEY LIVE

ALIVE FILMS PRESENTS A LARRY FRANCO PRODUCTION
JOHN CARPENTER'S "THEY LIVE" RODDY PIPER · KEITH DAVID · MEG FOSTER
SCREENPLAY BY FRANK ARMITAGE MUSIC BY JOHN CARPENTER AND ALAN HOWARTH DIRECTOR OF PHOTOGRAPHY GARY B. KIBBE EXECUTIVE PRODUCERS SHEP GORDON AND ANDRE BLAY
ASSOCIATE PRODUCER SANDY KING PRODUCED BY LARRY FRANCO DIRECTED BY JOHN CARPENTER SOUNDTRACK ON ENIGMA CASSETTES RECORDS AND CD'S PANAVISION® DOLBY STEREO A UNIVERSAL RELEASE

R RESTRICTED
UNDER 17 REQUIRES ACCOMPANYING
PARENT OR ADULT GUARDIAN

©1988 UNIVERSAL CITY STUDIOS, INC.

STARTS FRIDAY

343

THE NEST

The poster for Concorde Pictures' insects-amok movie, depicting a huge cockroach overpowering a scantily clad woman, is quite a grabber (if typically exaggerated — the film's bugs are normal-sized, albeit flesh-hungry). For some reason, though, the ad Concorde chose for the New York market was cheesy in more ways than one. And in at least one other city, *The Nest* ad simply reused the graphic from producer Roger Corman's earlier *Humanoids from the Deep*.

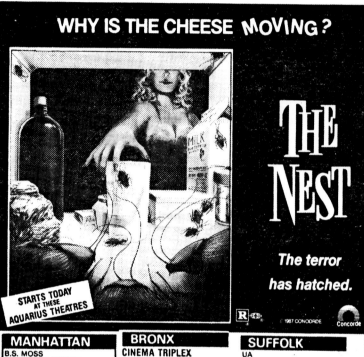

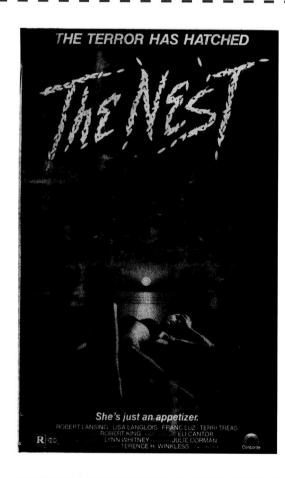

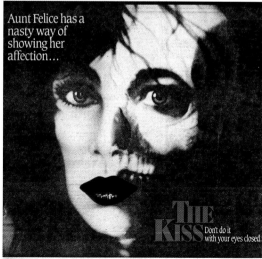

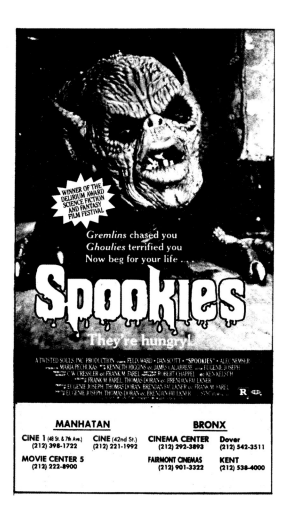

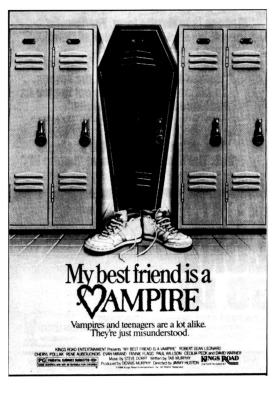

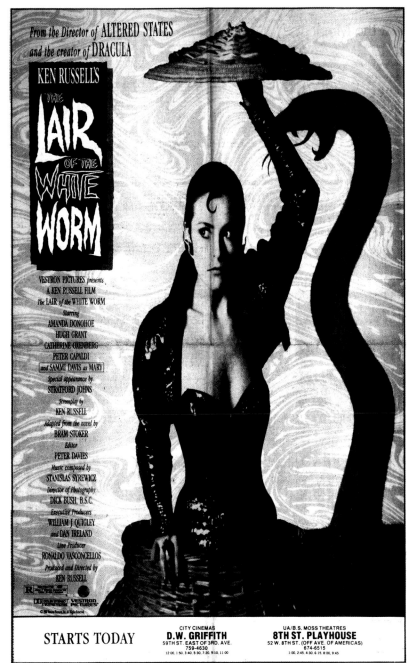

BRAIN DAMAGE, JACK'S BACK & WHITE OF THE EYE

The short-lived Palisades Entertainment handled a few of 1988's more interesting horror/thriller films, but didn't do such a hot job of promoting them. *Brain Damage*, arguably the best movie in Frank Henenlotter's filmography, was dumped into only a handful of theaters, and the images chosen to feature on the ads for Rowdy Herrington's *Jack's Back* and Donald Cammell's *White of the Eye* weren't the type to send potential audiences running to the theaters. Small wonder that the company was defunct before the end of the decade.

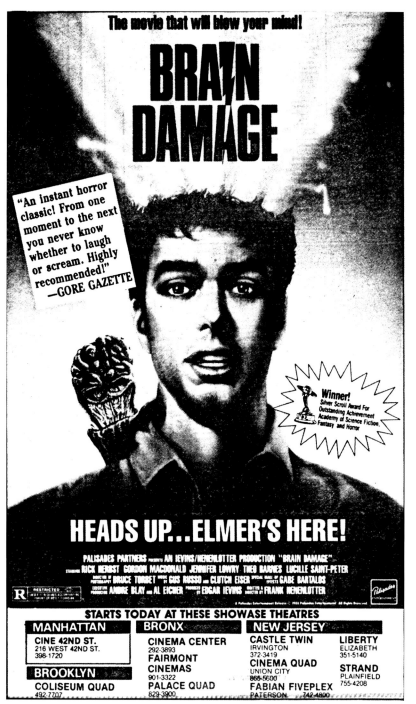

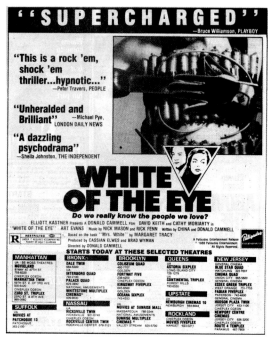

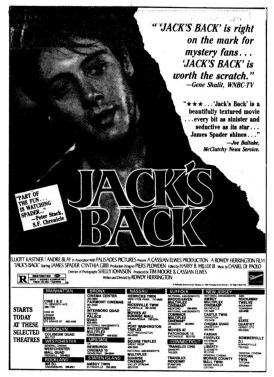

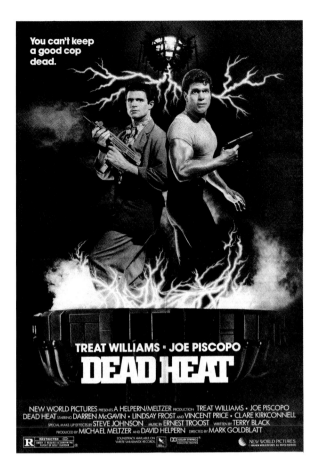

You can't keep a good cop dead.

TREAT WILLIAMS • JOE PISCOPO
DEAD HEAT

NEW WORLD PICTURES PRESENTS A HELPERN/MELTZER PRODUCTION TREAT WILLIAMS • JOE PISCOPO DEAD HEAT STARRING DARREN McGAVIN • LINDSAY FROST AND VINCENT PRICE • CLARE KIRKCONNELL SPECIAL MAKE-UP EFFECTS BY STEVE JOHNSON MUSIC BY ERNEST TROOST WRITTEN BY TERRY BLACK PRODUCED BY MICHAEL MELTZER AND DAVID HELPERN DIRECTED BY MARK GOLDBLATT

FROM THE PRODUCER OF DEADTIME STORIES...

The **Rejuvenator**

The Fountain Of Youth For The Living Dead.

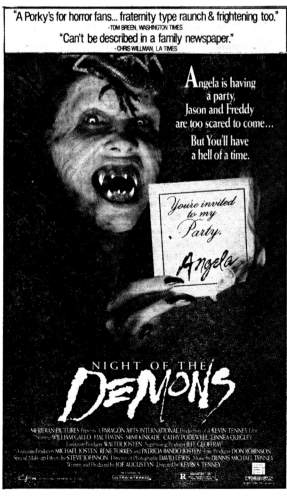

"A Porky's for horror fans... fraternity type raunch & frightening too."
-TOM BREEN, WASHINGTON TIMES

"Can't be described in a family newspaper."
-CHRIS WILLMAN, LA TIMES

Angela is having a party. Jason and Freddy are too scared to come... But You'll have a hell of a time.

You're invited to my Party. Angela

NIGHT OF THE
DEMONS

MERIDIAN PICTURES PRESENTS A PARAGON ARTS INTERNATIONAL PRODUCTION A KEVIN TENNEY FILM STARRING WILLIAM GALLO • HAL HAVINS • MIMI KINKADE • CATHY PODEWELL • LINNEA QUIGLEY EXECUTIVE PRODUCER WALTER JOSTEN SUPERVISING PRODUCER JEFF GEOFFRAY ASSOCIATE PRODUCERS MICHAEL JOSTEN, RENE TORRES AND PATRICIA RANDO JOSTEN LINE PRODUCER DON ROBINSON SPECIAL MAKE-UP EFFECTS BY STEVE JOHNSON DIRECTOR OF PHOTOGRAPHY DAVID LEWIS MUSIC BY DENNIS MICHAEL TENNEY WRITTEN AND PRODUCED BY JOE AUGUSTYN DIRECTED BY KEVIN S. TENNEY

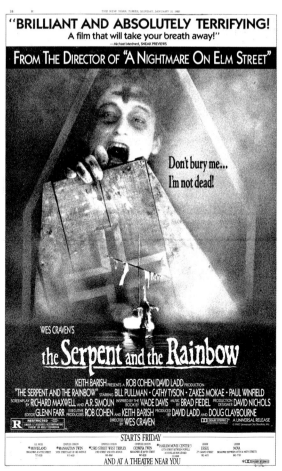

"BRILLIANT AND ABSOLUTELY TERRIFYING!
A film that will take your breath away!"
—Michael Medved, SNEAK PREVIEWS

FROM THE DIRECTOR OF "A NIGHTMARE ON ELM STREET"

Don't bury me...
I'm not dead!

WES CRAVEN'S
the **Serpent** and the **Rainbow**

KEITH BARISH PRESENTS A ROB COHEN/DAVID LADD PRODUCTION "THE SERPENT AND THE RAINBOW" STARRING BILL PULLMAN • CATHY TYSON • ZAKES MOKAE • PAUL WINFIELD SCREENPLAY BY RICHARD MAXWELL AND A.R. SIMOUN INSPIRED BY THE BOOK BY WADE DAVIS MUSIC BY BRAD FIEDEL PRODUCTION DESIGNER DAVID NICHOLS EDITOR GLENN FARR EXECUTIVE PRODUCERS ROB COHEN AND KEITH BARISH PRODUCED BY DAVID LADD AND DOUG CLAYBOURNE DIRECTED BY WES CRAVEN A UNIVERSAL RELEASE

STARTS FRIDAY

AND AT A THEATRE NEAR YOU

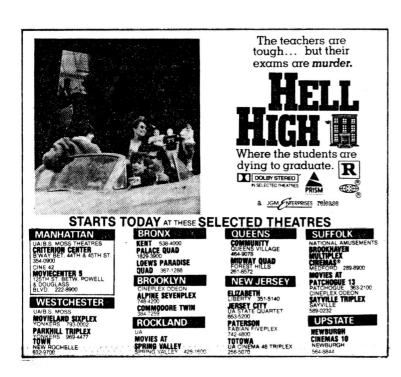

The teachers are tough... but their exams are *murder.*

HELL HIGH

Where the students are dying to graduate.

DOLBY STEREO
IN SELECTED THEATRES

R

PRISM

a JGM Enterprises release

STARTS TODAY AT THESE SELECTED THEATRES

MANHATTAN
UA/B.S. MOSS THEATRES
CRITERION CENTER
B'WAY BET. 44TH & 45TH ST.
354-0900
CINE 42
MOVIECENTER 5
125TH ST. BETW. POWELL
& DOUGLASS
BLVD. 222-8900

WESTCHESTER
UA/B.S. MOSS
MOVIELAND SIXPLEX
YONKERS 793-0002
PARKHILL TRIPLEX
YONKERS 969-4477
TOWN
NEW ROCHELLE
632-9700

BRONX
KENT 538-4000
PALACE QUAD
1829-3900
LOEWS PARADISE
QUAD 367-1288

BROOKLYN
CINEPLEX ODEON
ALPINE SEVENPLEX
748-4200
COMMODORE TWIN
384-7259

ROCKLAND
UA
MOVIES AT
SPRING VALLEY
SPRING VALLEY 425-1600

QUEENS
COMMUNITY
QUEENS VILLAGE
464-9078
MIDWAY QUAD
FOREST HILLS
261-8572

NEW JERSEY
ELIZABETH
LIBERTY 351-5140
JERSEY CITY
UA STATE QUARTET
653-5200
PATERSON
FABIAN FIVEPLEX
742-4800
TOTOWA
UA CINEMA 46 TRIPLEX
256-5070

SUFFOLK
NATIONAL AMUSEMENTS
BROOKHAVEN
MULTIPLEX
CINEMAS®
MEDFORD 289-8900
MOVIES AT
PATCHOGUE 13
PATCHOGUE 363-2100
CINEPLEX ODEON
SAYVILLE TRIPLEX
SAYVILLE
589-0232

UPSTATE
NEWBURGH
CINEMAS 10
NEWBURGH
564-8844

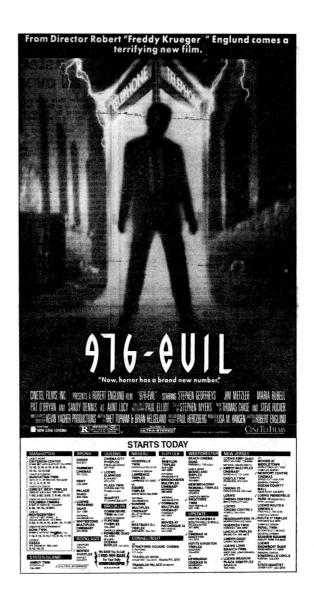

From Director Robert "Freddy Krueger" Englund comes a terrifying new film.

976-EVIL

"Now, horror has a brand new number."

CINETEL FILMS, INC. PRESENTS A ROBERT ENGLUND FILM "976-EVIL" STARRING STEPHEN GEOFFREYS, JIM METZLER, MARIA RUBELL, PAT O'BRYAN AND SANDY DENNIS AS AUNT LUCY PHOTOGRAPHY PAUL ELLIOT MUSIC THOMAS CHASE AND STEVE RUCKER SCREENPLAY STEPHEN MYERS CREATURES CREATED KEVIN YAGHER PRODUCTIONS WRITTEN RHET TOPHAM & BRIAN HELGELAND PRODUCED PAUL HERTZBERG LISA M. HANSEN DIRECTED ROBERT ENGLUND

NEW LINE CINEMA
R
ULTRA-STEREO
CINETEL FILMS

STARTS TODAY

MANHATTAN
UA/B.S. MOSS
CRITERION CENTER
B'WAY BET. 44TH & 45TH ST. 354-0900
12, 2, 4, 6, 8, 10, 10:10, 12:10 AM
CINEPLEX ODEON
MANHATTAN TWIN
59TH ST. E. OF 3RD AVE. 755-5100
12, 2, 4, 6, 8, 10
CINEPLEX ODEON
23RD ST. WEST TRIPLEX
23RD ST. & 8TH AVE. 989-0060
1:05, 3:05, 5:05, 7, 9:45, 10:25
CREATIVE ENTERTAINMENT
COLUMBIA CINEMA
B'WAY AT 103RD ST. 316-6690
8:30, 10:15, 12 MID
CINE 42
MOVIECENTER 5
125TH ST. BET. POWELL &
DOUGLAS BLVD. 222-8900
2:30, 4:15, 6:10, 8:05, 10, 11:55
CREATIVE ENTERTAINMENT
NOVA TWIN
B'WAY & 147TH ST. 862-5728
1:15, 3:15, 5:15, 7:15, 9:15, 11:15
LESSER
ESSEX
375 GRAND ST. 982-4455
8:10, 9:40, 10:15

STATEN ISLAND
UA
AMBOY TWIN
ELTINGVILLE
356-5800

BRONX
UA
DOVER
543-3511
UA
FAIRMONT
CINEMAS
901-3322
UA
KENT
538-4000
UA
PALACE
QUAD
829-3900
UA
LOEWS
PARADISE
QUAD
367-1288
NATIONAL
AMUSEMENTS
WHITESTONE
MULTIPLEX
CINEMAS®
409-9030

ROCKLAND
CINEPLEX
ODEON
MOVIES
NANUET
FIVEPLEX
623-2011

QUEENS
UA
CINEMA CITY
FIVEPLEX
FRESH MEADOWS
357-9100
UA
LOEWS
ELMWOOD
ELMHURST
429-4770
UA
PLAZA TWIN
CORONA 898-7722
(Open on ror)
CINEPLEX ODEON
COMMODORE
TWIN 384-7259
NATIONAL AMUSEMENTS
FORTWAY
MULTIPLEX
238-4200
CINEPLEX ODEON
RIDGEWOOD QUAD
821-5993

BROOKLYN
UA
SQUARE
TRIPLEX
FLUSHING 359-6777
NATIONAL
AMUSEMENTS
MULTIPLEX
CINEMAS®
VALLEY STREAM
825-5700

NASSAU
UA
HICKSVILLE
TWIN
HICKSVILLE 931-0749
CINEPLEX ODEON
LAWRENCE
TRIPLEX
471-4771

SUFFOLK
UA
BABYLON
TRIPLEX
BABYLON
669-3200
NATIONAL
AMUSEMENTS
BROOKHAVEN
MULTIPLEX
CINEMAS®
MEDFORD
289-8900
NATIONAL
AMUSEMENTS
MOVIES AT
PATCHOGUE 13
PATCHOGUE
363-2100
UA
WESTBURY D.I.
WESTBURY 334-1111

CONNECTICUT
STRATFORD SQUARE CINEMA
375-1663
TRANSLUX AVON
STAMFORD 324-8021 Starts Fri. 3/31
TRANSLUX PALACE DANBURY
748-7496

WESTCHESTER
UA
BEACH CINEMA
PEEKSKILL 737-6262
NATIONAL AMUSEMENTS
AMBOY MULTIPLEX
SAYREVILLE 721-3400
UA
MOVIELAND
SIXPLEX
YONKERS
793-0002
UA
NEW BROADWAY
PARKHILL TRIPLEX
YONKERS
423-0513
CINEPLEX ODEON
PROCTORS
NEW ROCHELLE 632-1100
UA
HOYTS CINEMA 8
SOUTH HILLS MALL
POUGHKEEPSIE 297-8661
UA
CINEMAS 10
NEWBURGH
564-8844

UPSTATE
UA
HOYTS CINEMA 8
SOUTH HILLS MALL
POUGHKEEPSIE 297-8661
UA
HOYTS KINGSTON
TRIPLEX
KINGSTON
336-6500
UA
NEWBURGH
CINEMAS 10
NEWBURGH
564-8844

NEW JERSEY
NATIONAL AMUSEMENTS
MOVIES AT
MIDDLETOWN
MIDDLETOWN 671-1020
CINEPLEX ODEON
NEWPORT CENTRE
CINEMAS
JERSEY CITY 626-3301
GENERAL CINEMA
OCEAN COUNTY
MALL
TOMS RIVER 240-6093
UA
LOEWS RIDGEFIELD
PARK 943-4565
UA
LOEWS
CINEMA CENTER 5
BRICKTOWN 477-4461
UA
LOEWS
ROUTE-9
FREEHOLD 780-4436
CINEPLEX ODEON
HOBOKEN TWIN
HOBOKEN 963-2993
UA
LINCOLN TRIPLEX
ARLINGTON 997-6873
UA
LOEWS LONG
BRANCH TWIN
WEST END, LONG BRANCH
229-8600
UA
LOEWS MEADOW
PLAZA EIGHTPLEX
SECAUCUS
902-5200
UA
MOVIES AT
MIDDLETOWN
UA
ROYAL TWIN
BLOOMFIELD 748-3553
GENERAL CINEMA
SEAVIEW SQUARE
ASBURY PARK 775-6810
UA
LOEWS
SOMERVILLE CIRCLE
CINEMAS
SOMERVILLE 725-9192
UA
STATE QUARTET
JERSEY CITY 653-5200
UA
ROUTE 17 TRIPLEX
PARAMUS 843-3850

We DARE You to Call
1-900-909-DARE
For Your Daily
HOROSCOPES

ULTRA-STEREO

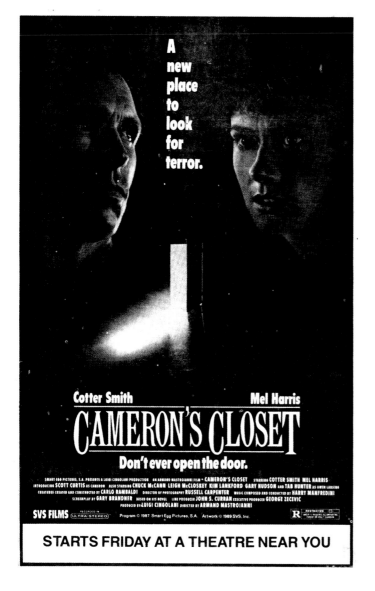

A new place to look for terror.

Cotter Smith · Mel Harris

CAMERON'S CLOSET

Don't ever open the door.

SMART EGG PICTURES, S.A. PRESENTS A LUIGI CINGOLANI PRODUCTION AN ARMAND MASTROIANNI FILM "CAMERON'S CLOSET" STARRING COTTER SMITH MEL HARRIS INTRODUCING SCOTT CURTIS AS CAMERON ALSO CHUCK McCANN LEIGH McCLOSKEY KIM LANKFORD GARY HUDSON AND TAB HUNTER AS OWEN LANSING CREATURES CREATED AND CONSTRUCTED BY CARLO RAMBALDI DIRECTOR OF PHOTOGRAPHY RUSSELL CARPENTER MUSIC COMPOSED AND CONDUCTED BY HARRY MANFREDINI SCREENPLAY BY GARY BRANDNER BASED ON HIS NOVEL LINE PRODUCER JOHN S. CURRAN EXECUTIVE PRODUCER GEORGE ZECEVIC PRODUCED BY LUIGI CINGOLANI DIRECTED BY ARMAND MASTROIANNI

SVS FILMS
RECORDED IN
ULTRA-STEREO
Program © 1987 Smart Egg Pictures, S.A. Artwork © 1989 SVS, Inc.
R RESTRICTED

STARTS FRIDAY AT A THEATRE NEAR YOU

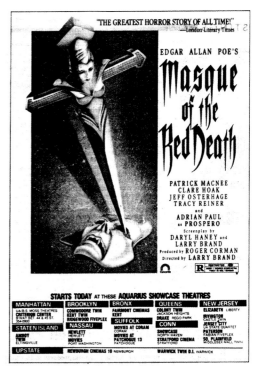

"THE GREATEST HORROR STORY OF ALL TIME!"
—London Literary Times

EDGAR ALLAN POE'S

Masque of the Red Death

PATRICK MACNEE
CLARE HOAK
JEFF OSTERHAGE
TRACY REINER
and
ADRIAN PAUL
AS PROSPERO

Screenplay by
DARYL HANEY and
LARRY BRAND
Produced by ROGER CORMAN
Directed by LARRY BRAND

R RESTRICTED

STARTS TODAY AT THESE AQUARIUS SHOWCASE THEATRES

MANHATTAN
UA/B.S. MOSS THEATRES
CRITERION CENTER
B'WAY BET. 44 & 45 ST.
354-0900

STATEN ISLAND
AMBOY
TWIN
ELTINGVILLE

UPSTATE

BROOKLYN
COMMODORE TWIN
KENT TWIN
RIDGEWOOD FIVEPLEX

NASSAU
HEWLETT
HEWLETT

NEWBURGH CINEMAS 10 NEWBURGH

BRONX
FAIRMONT CINEMAS
KENT

SUFFOLK
MOVIES AT CORAM
CORAM
MOVIES AT
PATCHOGUE 13
PATCHOGUE

QUEENS
COLONY TWIN
JACKSON HEIGHTS
DRAKE REGO PARK

CONN
SHOWCASE
NORTH HAVEN
STRATFORD CINEMA
STRATFORD

WARWICK TWIN D.I. WARWICK

NEW JERSEY
ELIZABETH LIBERTY
IRVINGTON
CASTLE TWIN
JERSEY CITY
UA STATE QUARTET
PATERSON
FABIAN FIVEPLEX
SO. PLAINFIELD
MIDDLESEX MALL TWIN

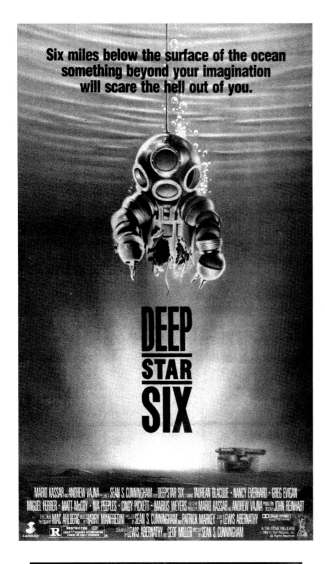

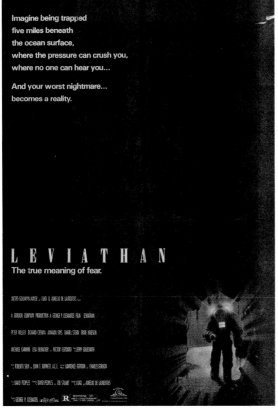

DEEPSTAR SIX, LEVIATHAN & DEAD CALM

The year of the aquatic horror film proved to be 1989. Likely inspired by the impending release of James Cameron's *The Abyss*, underwater creature features, Sean S. Cunningham's *DeepStar Six* and George Pan Cosmatos' *Leviathan*, arrived in January and March respectively, but neither made waves critically or at the box office. Then, in April, the Australian-made *Dead Calm* set sail, and while it didn't do any better financially, its reviews helped launch the Hollywood careers of director Phillip Noyce (*Blind Fury, The Saint, Salt*) and star Nicole Kidman.

"In *Dead Calm*, the most ferocious deep-sea terrorfest since the original *Jaws*, director Phillip Noyce dispenses with the gimmickry of leviathans and slithering submarine aliens. Instead, the Australian filmmaker has created a monster more frighteningly real than any special effects wizardry could conjure up: a human being."

— Steven Rea, *The Philadelphia Inquirer*

"[I]t's both a pretty good reason for not going near the water and a pretty good reason for going to the theater. But it also has one thing that most other critics won't tell you about or won't confess a fondness for. It has a really neat movie death."

— Stephen Hunter, *The Baltimore Sun*

"*Dead Calm*...would qualify as a beautifully made movie in any genre. It is well-paced, suspenseful, brilliantly acted and directed with great flair."

— Mike McGrady, *New York Newsday*

"From the opening scene of *Dead Calm*, a sense of menace pervades... In many ways, *Dead Calm* feels like a movie from 30 or 40 years ago, down to its final twist. That's meant as a compliment in a year that has produced far too many copycats, and far too many movies that rely on soundtracks and samurai editing designed for viewers with short attention spans."

— **BARBARA VANCHERI,**
PITTSBURGH POST-GAZETTE

"*Dead Calm* is an unsettling hybrid of escapist suspense and the kind of pure trash that depends on dead babies and murdered dogs for effect. ... [The] pace is so flaccid that Hughie and Rae might be playing a sinister game of hide-and-seek."

— Caryn James, *The New York Times*

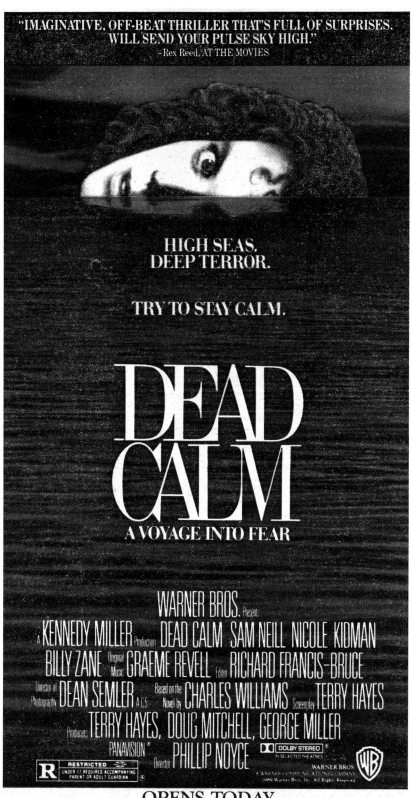

"IMAGINATIVE, OFF-BEAT THRILLER THAT'S FULL OF SURPRISES.
WILL SEND YOUR PULSE SKY HIGH."
– Rex Reed, AT THE MOVIES

HIGH SEAS.
DEEP TERROR.

TRY TO STAY CALM.

DEAD CALM
A VOYAGE INTO FEAR

WARNER BROS. Present

A KENNEDY MILLER Production DEAD CALM SAM NEILL NICOLE KIDMAN
BILLY ZANE Original Music GRAEME REVELL Editor RICHARD FRANCIS-BRUCE
Director of Photography DEAN SEMLER A.C.S. Based on the Novel by CHARLES WILLIAMS Screenplay TERRY HAYES
Producers TERRY HAYES, DOUG MITCHELL, GEORGE MILLER
PANAVISION® Director PHILLIP NOYCE DOLBY STEREO IN SELECTED THEATRES WB

R RESTRICTED
UNDER 17 REQUIRES ACCOMPANYING
PARENT OR ADULT GUARDIAN
WARNER BROS
A WARNER COMMUNICATIONS COMPANY
1989 Warner Bros. Inc. All Rights Reserved

OPENS TODAY

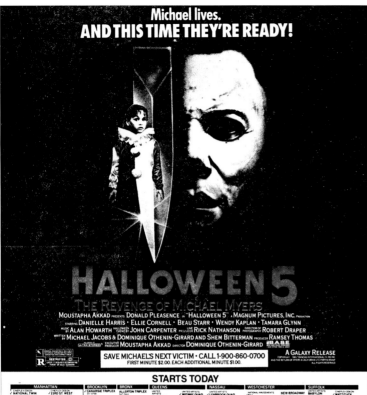

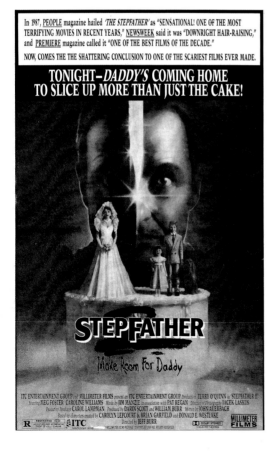

PARENTS

Despite Vestron Video's success as a purveyor of horror fare, its theatrical division Vestron Pictures never quite clicked as a supplier of big screen genre features. It came closest with *The Lair of the White Worm* (1988), one of a few Ken Russell pictures it backed (along with *Gothic* and *The Rainbow*), and another oddity in its lineup was this stylish, shivery comedy marking the directorial debut of actor Bob Balaban. Its story of a little boy in the 1950s who realizes his folks are cannibals has earned a cult following, though back then it was not for all tastes.

"The laughs and screams come hard on each other's heels, barely leaving the viewer time to breathe. First-time director Bob Balaban has seamlessly blended horror and comedy in this ghoulishly funny film."
— Marshall Fine, *Gannett News Service*

"The actors play this lunacy straight, which takes the film a long way. ... *Parents* is not worth going out of your way to see. But its slight, silly satisfactions will probably look bigger on video, especially if you're in a mindless, undemanding mood."
— CARYN JAMES,
THE NEW YORK TIMES

"*Parents* combines several biting comic ideas and some meaty performances that might have cooked up nicely into a zesty stew of tastelessness. ... Unhappily, director Bob Balaban butchers the job with his nouvelle cinema techniques."
— Malcolm L. Johnson, *Hartford Courant*

"The plot is less interesting than the stylized manner in which the movie is made. ... Bob Balaban...comes through his first directing assignment with gourmet style, and first-time screenwriter Christopher Hawthorne's script has deliciously gross appeal."
— *The Indianapolis Star*, author unknown

"Takes over where 'BLUE VELVET' left off."
— Ken Russell

PARENTS

A NEW NAME FOR TERROR.

A VESTRON PICTURES PRESENTATION IN ASSOCIATION WITH GREAT AMERICAN FILMS LIMITED PARTNERSHIP A BOB BALABAN FILM "PARENTS"

RANDY QUAID MARY BETH HURT SANDY DENNIS

EXECUTIVE PRODUCERS
MITCHELL CANNOLD AND STEVEN REUTHER EXECUTIVE IN CHARGE OF PRODUCTION DORI BERINSTEIN WASSERMAN EDITOR BILL PANKOW MUSIC BY JONATHAN ELIAS

WRITTEN BY
CHRISTOPHER HAWTHORNE PRODUCED BY BONNIE PALEF DIRECTED BY BOB BALABAN

R RESTRICTED
UNDER 17 REQUIRES ACCOMPANYING
PARENT OR ADULT GUARDIAN

© 1988 VESTRON PICTURES INC. ALL RIGHTS RESERVED

DOLBY STEREO
IN SELECTED THEATRES

 VESTRON PICTURES

─ STARTS FRIDAY ─

UA/B.S. MOSS
✓CRITERION CENTER
B'WAY BET. 44TH & 45TH ST.
354-0900

UA
✓EASTSIDE CINEMA
3RD AVE AT 55TH ST.
755-3020

UA/B.S. MOSS
✓8TH STREET PLAYHOUSE
52 W. 8TH ST.
674-6515

─AND AT SPECIALLY SELECTED THEATRES─

353

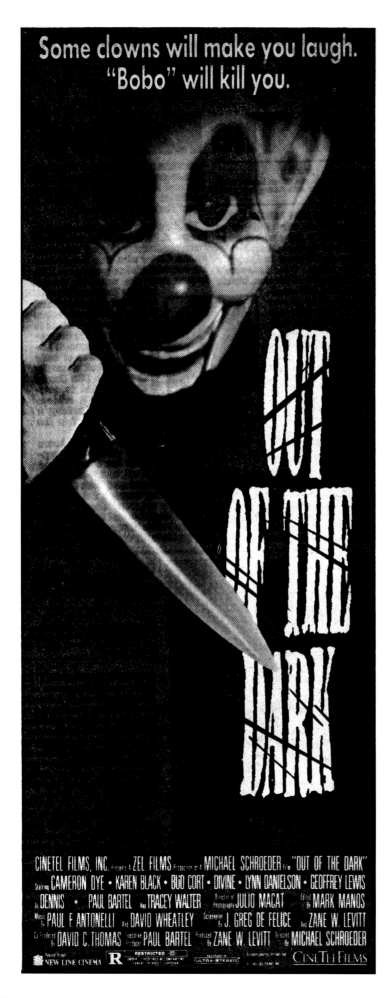

Some clowns will make you laugh. "Bobo" will kill you.

OUT OF THE DARK

CINETEL FILMS, INC. presents A ZEL FILMS Production of A MICHAEL SCHROEDER Film "OUT OF THE DARK" Starring CAMERON DYE • KAREN BLACK • BUD CORT • DIVINE • LYNN DANIELSON • GEOFFREY LEWIS as DENNIS • PAUL BARTEL And TRACEY WALTER Photography by JULIO MACAT Edited by MARK MANOS Music by PAUL F ANTONELLI And DAVID WHEATLEY Screenplay by J. GREG DE FELICE and ZANE W. LEVITT Co-Produced by DAVID C. THOMAS Executive Producer PAUL BARTEL Produced by ZANE W. LEVITT Directed by MICHAEL SCHROEDER

NEW LINE CINEMA R RESTRICTED ULTRA-STEREO CINETEL FILMS

PET SEMATARY

As well received critically as some of the 1980s' Stephen King scare pictures were, none of the author's adaptations had been major financial hits since 1976's *Carrie*. That changed with the film version of what many (including King himself) considered his most disturbing novel, which was originally to be helmed by George A. Romero before being turned over to Mary Lambert. The grosses were high, even though critics' opinions of the movie largely were not.

"[W]hile it doesn't hold a candle to Stanley Kubrick's adaptation of *The Shining*, it moves along at a merry, grisly clip under the direction of Mary Lambert."
— Richard Freedman, *Newark Star-Ledger*

"*Pet Sematary* ultimately emerges as a sick, tasteless, but not entirely successful attempt to exploit common familiar fears. The flick undermines its more original aspects by gradually descending into just another maelstrom of monster-kid clichés."
— Phantom of the Movies, *New York Daily News*

"*Pet Sematary*, based on one of King's better novels, is smoothly made and watchable, but it's totally impersonal. The story itself is almost unbearably traumatic. ... But the movie...bobs along the surface with cheap, pop-up scares and zombielike acting."
— David Edelstein, *New York Post*

"*Pet Sematary* finds Stephen King at his farthest out, never more simultaneously compelling and repelling, but there is no denying that in Mary Lambert he has a director who can go the distance and make the contradiction work."
— KEVIN THOMAS, *LOS ANGELES TIMES*

"You've got to have an awful good reason for pulling the incredible morose stunts that Lambert and King pull in this movie. *Pet Sematary* doesn't have a good enough reason. As a horror movie, it fails because it gives up on the kind of terror that comes from a good story and opts for the easy, slasher-flick ending."
— Gary Thompson, *Philadelphia Daily News*

1989

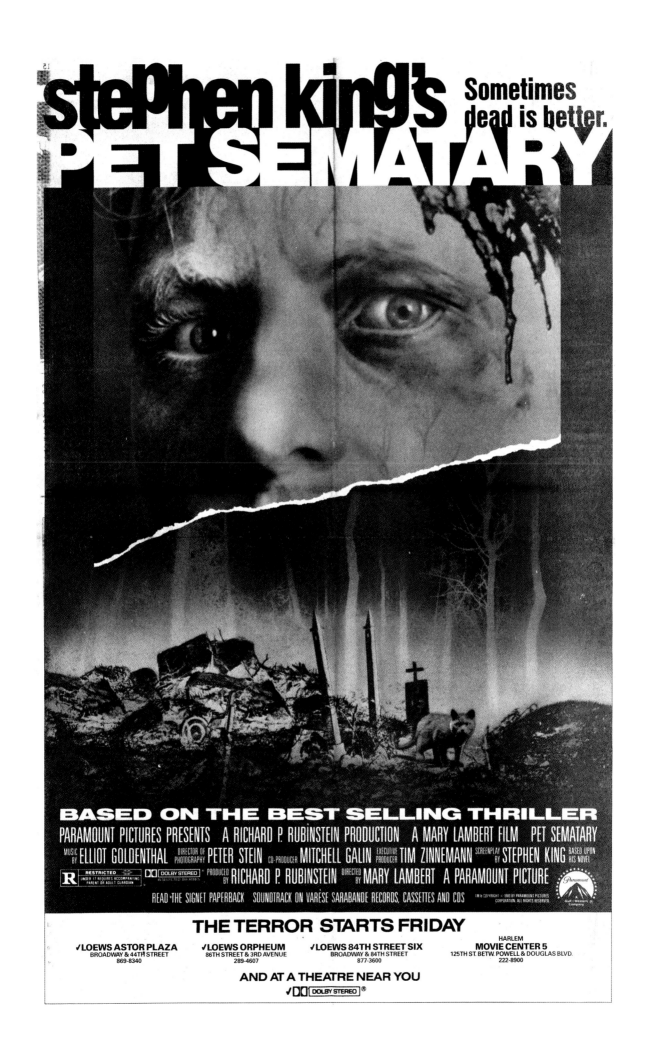

THE TOXIC AVENGER PART II & III

When the Troma Team set out to sequelize their popular *The Toxic Avenger*, they shot it as one film that was later split up into two. *Toxic Avenger Part II* opened in New York in April and *Part III* followed in November, both releases featuring in-person appearances by Toxie himself — one of them, anyway. John Altamura initially played the deformed superhero but was fired fairly early in production, with Ron Fazio taking over the role and accompanying the movie at Manhattan venues.

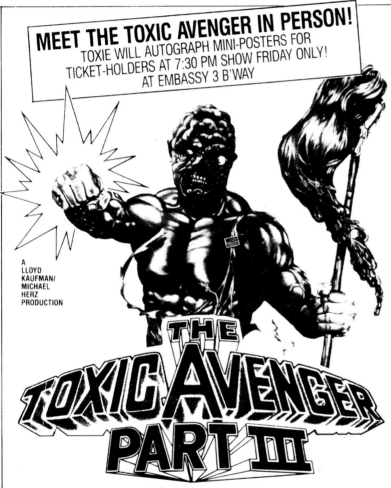

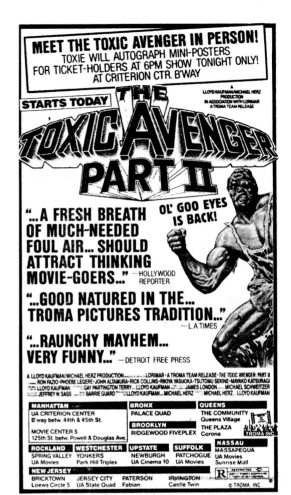

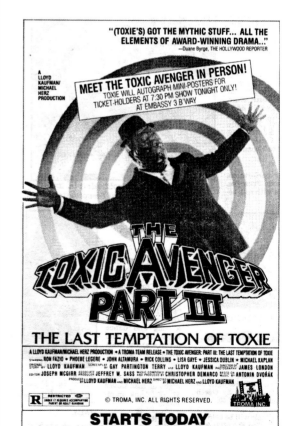

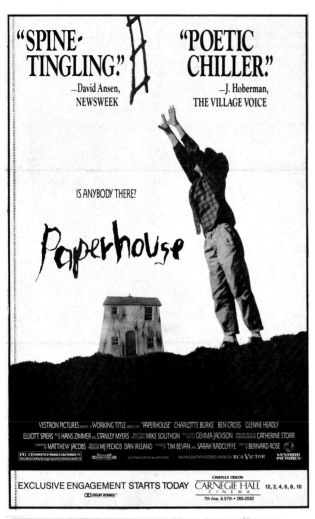

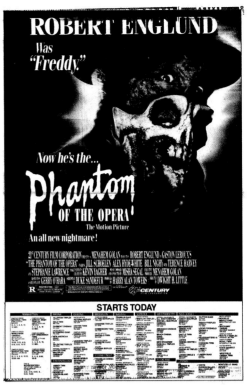

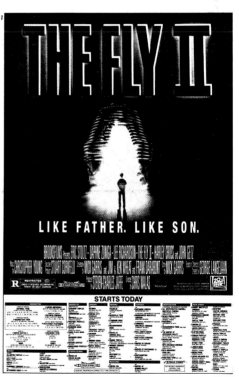

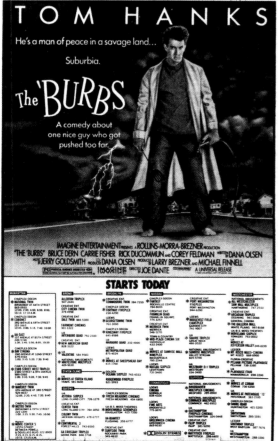

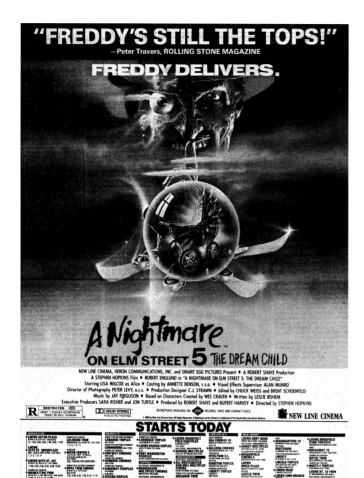

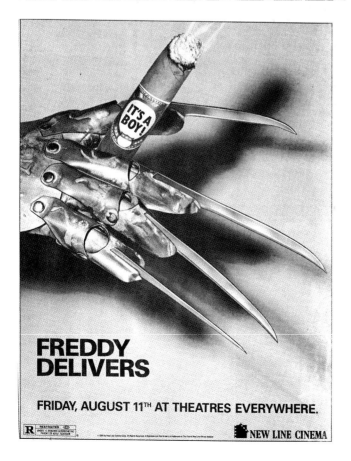

SHOCKER

Following the success of *A Nightmare on Elm Street* (1984), Wes Craven directed *Deadly Friend* (1986), a much-tampered-with film greeted with poor reviews and box office, and *The Serpent and the Rainbow* (1988), which did much better in both categories. Having signed away the sequel and merchandising rights to *Nightmare* and Freddy Krueger as part of his deal to make that film, Craven created a new monster: *Shocker*'s Horace Pinker. One of several electrocuted villains to return from their executions around the same time (see also 1988's *Prison* and this year's *The Horror Show*, etc.), Pinker just didn't catch on the way Freddy had, with audiences or most critics.

"In a way, the movie is brilliant, but it's clearly put together for people who adore the tricks and gambits of horror movies over the past 60 years, and who are willing to see them scrambled and trampled."

— Howie Movshovitz, *The Denver Post*

"With its freewheeling mixture of gore, surrealism, and Freud, it will do almost anything to grab attention. ... If the movie's metaphors are as obvious and as portentous as the heavy metal music that punctuates the action, *Shocker* at least has the feel of a movie that was fun to make."

— STEPHEN HOLDEN,
THE NEW YORK TIMES

"The most shocking thing about Wes Craven's new horror thriller is how ridiculous it is. ... Maybe Mr. Craven secretly craves a farcical assignment. There must be some reason *Shocker* ends up resembling a misplaced segment from *Amazon Women on the Moon*."

— Gary Arnold, *The Washington Times*

"Craven has technique to burn—much to the exasperation of those who wish he would deploy it on more challenging material. *Shocker* is proof that when it comes to putting a charge into this kind of current event, behind-the-camera talent is almost irrelevant."

— Desmond Ryan, *The Philadelphia Inquirer*

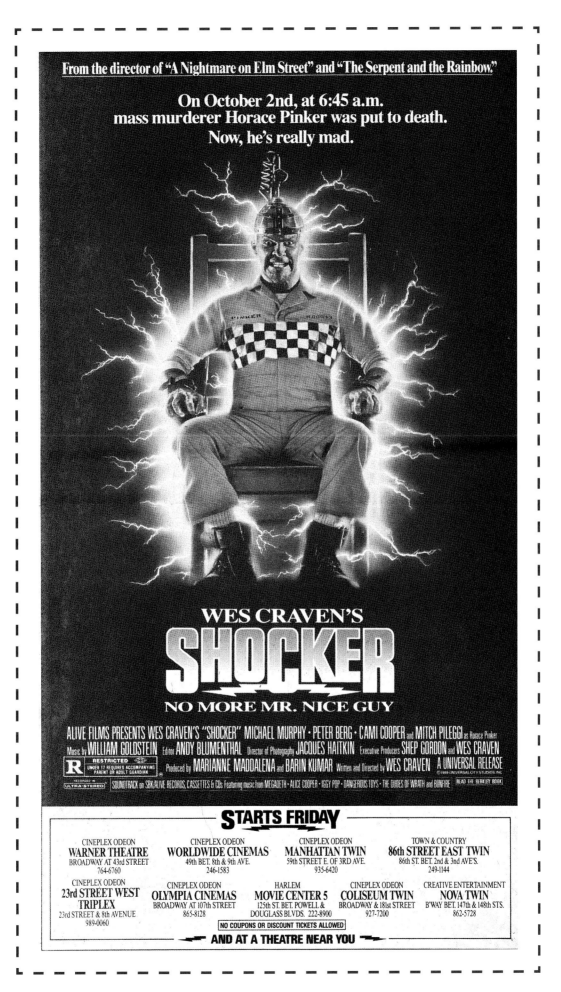

FRIDAY THE 13TH PART VIII: JASON TAKES MANHATTAN

When Jason Voorhees finally departed his usual Crystal Lake environs for a more populated area, Paramount initially came up with a perfect advertising campaign that desecrated a very familiar NYC promotional image. When the New York City Tourism Board objected, Paramount switched to more traditional art for *Friday the 13th Part VIII*. The attendant publicity, however, failed to translate to box office — especially once word got around that Jason only spends a small amount of the film's running time in Manhattan, and most of that footage is clearly shot in Vancouver.

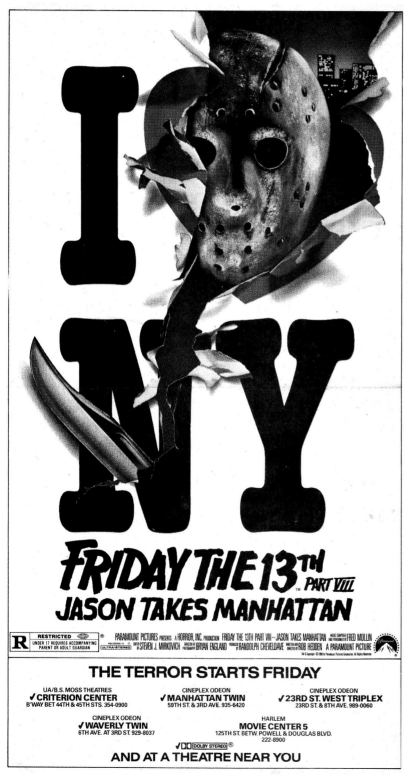

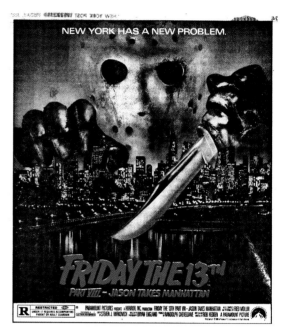

1989

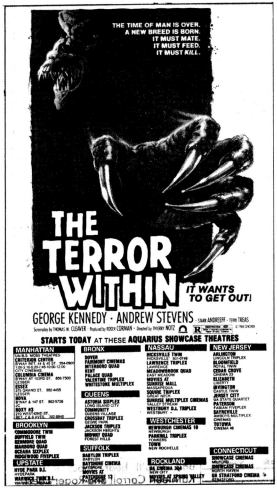

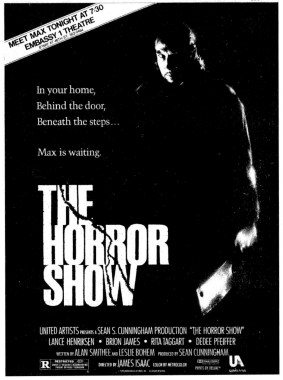

SATURDAY THE 14TH STRIKES BACK

The promise of a sequel to the limp horror/comedy *Saturday the 14th* (1982) wasn't terribly enticing, even if no less than famed macabre cartoonist Gahan Wilson had been enlisted to create the ad art. But even those who might have wanted to catch the film in the New York area were out of luck, as although it was advertised to give the illusion it was receiving a release, it didn't actually play any theaters there!

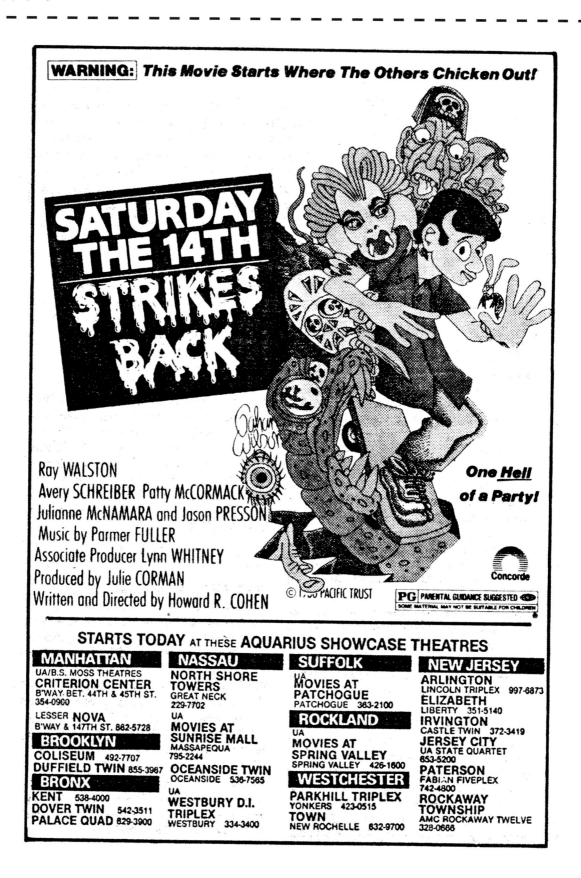

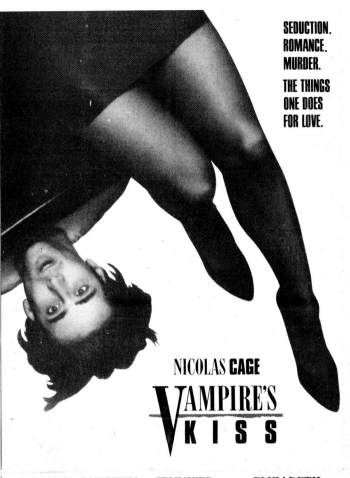

SEDUCTION.
ROMANCE.
MURDER.

THE THINGS
ONE DOES
FOR LOVE.

NICOLAS CAGE
VAMPIRE'S
KISS

MARIA CONCHITA JENNIFER AND ELIZABETH
ALONSO BEALS ASHLEY

JOHN DALY and DEREK GIBSON Present for † HEMDALE FILM CORPORATION
A MAGELLAN PICTURES Production NICOLAS CAGE 🦇 "VAMPIRE'S KISS"
MARIA CONCHITA ALONSO JENNIFER BEALS and ELIZABETH ASHLEY ♥ Written by JOSEPH MINION
Produced by BARRY SHILS ☠ and BARBARA ZITWER ⚕ Directed by ROBERT BIERMAN PANAVISION® HEMDALE
A MAJOR INDEPENDENT

AMERICA'S FAVORITE SUPER HERO IS BACK IN *ACTION!*

"A CROSS BETWEEN 'LITTLE SHOP OF HORRORS' AND 'THE INCREDIBLE HULK'
WITH A LIGHT SPRITZ OF 'HAIRSPRAY.'"
—David Denby, GLAMOUR

THE RETURN OF
SWAMP THING

STARRING
LOUIS JOURDAN HEATHER LOCKLEAR

LIGHTYEAR ENTERTAINMENT presents a BENJAMIN MELNIKER—MICHAEL E. USLAN PRODUCTION of a JIM WYNORSKI film
THE RETURN OF SWAMP THING
starring LOUIS JOURDAN HEATHER LOCKLEAR SARAH DOUGLAS and DICK DUROCK as SWAMP THING
music by CHUCK CIRINO edited by LESLIE ROSENTHAL production designer ROBB WILSON KING director of photography ZORAN HOCHSTATTER
executive producers TOM KUHN and CHARLES MITCHELL written by DEREK SPENCER and GRANT MORRIS
produced by BENJAMIN MELNIKER and MICHAEL E. USLAN directed by JIM WYNORSKI
A FILM FROM
MILLIMETER FILMS

Some Talk.
Some Listen.
Some Die.

PARTY
LINE

SVS FILMS WESTWIND

STARTS TODAY

MANHATTAN
CITY CINEMAS
WEST SIDE CINEMA
7TH AVE. BET. 47TH & 48TH ST. 398-1720
12, 1:40, 3:20, 5, 6:40, 8:20, 10, 11:40

BROOKLYN
CINEPLEX ODEON
KENMORE CINEMAS
284-5700

NEW JERSEY
THEATRE MANAGEMENT
FABIAN
PATERSON 742-4800

HOW CAN A DEAD MAN TOUCH YOU?

I, MADMAN

TRANS WORLD ENTERTAINMENT presents a SARLUI DIAMANT production a TIBOR TAKACS film
I, MADMAN starring JENNY WRIGHT · CLAYTON ROHNER
music MICHAEL HOENIG special effects PATTI MEADE creature effects RANDALL WILLIAM COOK
editor MARCUS MANTON director of photography BRIAN ENGLAND executive producers PAUL MASON · HELEN SARLUI-TUCKER
written by DAVID CHASKIN produced by RAFAEL EISENMAN directed by TIBOR TAKACS

STARTS TODAY AT A THEATRE NEAR YOU

MICHAEL GINGOLD

Michael Gingold first began reproducing newspaper ads for 1980s horror films in the pages of his Xerox fanzine *Scareaphanalia*, which he wrote and self-published for nearly a decade. While still in college, he began contributing capsule reviews to the annual book *Movies on TV and Videocassette*, and later did the same for *The Blockbuster Video Guide*. He also wrote full-length reviews for CineBooks' annual *The Motion Picture Guide*, many of which now appear at the *TV Guide* on-line movie database.

In 1988, during his junior year, Michael began writing for *Fangoria* magazine, then joined the staff in 1990. He spent 26 years there, moving up quickly from associate editor to managing editor, and eventually editor-in-chief, while also serving as an editor and writer for Fangoria.com as well as sister publication *GoreZone* and many one-shot publications. He rejoined *Fangoria* for its fall 2018 resurrection, and has written for many other publications and websites, among them *Rue Morgue*, *Birth.Movies.Death*, *Time Out New York*, *MovieMaker*, *Scream* and *Delirium*.

Michael has directed documentaries and featurettes for numerous Blu-rays, including the award-winning *Twisted Tale: The Unmaking of "Spookies"* (Vinegar Syndrome), and written liner notes for many disc releases, including lengthy essays for Anchor Bay and Shout! Factory's award-winning *Halloween: The Complete Collection* and Shout!'s *Friday the 13th Collection*. He has appeared in documentaries such as David Gregory's *Lost Soul: The Doomed Journey of Richard Stanley's "Island of Dr. Moreau"* and taken part in DVD/Blu-ray audio commentaries including *The Dead Zone* and *The Stepfather* (Shout! Factory) and the *42nd Street Forever* series (Synapse Films).

In addition to 1984 Publishing's *Ad Nauseam* and *Ad Astra* books, Michael is the author of *The FrightFest Guide to Monster Movies* (FAB Press) and *Shark Movie Mania* (Rue Morgue), and contributed to *Yuletide Terror: Christmas Horror on Film and Television* (Spectacular Optical). Among his screenplays are *Shadow: Dead Riot* for Fever Dreams, *Leeches!* for Rapid Heart Pictures and the upcoming *Damnation* for director Dante Tomaselli. He has served on juries for festivals like Montreal's Fantasia, The Boston Underground Film Festival and Ithaca International Fantastic Film Festival.

Thanks to Chris Poggiali, William Wilson and the staff of The New York Public Library for the Performing Arts.

INDEX

AD NAUSEAM: NEWSPRINT NIGHTMARES FROM THE '70S AND '80S

Copyright © 2021 by Michael Gingold

WRITER: Michael Gingold

EDITOR: Dave Alexander / Matthew Chojnacki

ART DIRECTION & LAYOUT DESIGN: Shane Lewis / Desiree Lewis

COVER "ZOMBIE HAND" ILLUSTRATION: Kyle Crawford

COPY EDITOR: Marie Maude Polychuck

PUBLISHER: Matthew Chojnacki

Published by 1984 Publishing. All rights reserved.

LIBRARY OF CONGRESS CONTROL NUMBER: 2021936419

ISBN: 978-1-948221-18-4

1984 Publishing logo is © and ™ of 1984 Publishing, LLC. Rue Morgue logo is © and ™ of Marrs Media, Inc.

All images are from the personal collection of Michael Gingold.

Printed and bound in PRC

1984 PUBLISHING
Cleveland, Ohio / USA
1984Publishing.com
info@1984Publishing.com

RUE MORGUE
Toronto, Ontario / Canada
Rue-Morgue.com
info@Rue-Morgue.com

CHILE — The largest great white shark ever captured was in 1945. It was 21 feet, 3 inches long and weighed 7302 pounds. But larger sharks have since been sited in the U.S. that are up to 24 feet long.

The tooth shape of large white sharks provides a cutting and gouging ability which is well-suited for feeding upon large, thick-skinned mammalian prey.

Once prey is sited, the shark rapidly ascends and at close range begins one of a variety of feeding patterns according to prey size and posture.

PETALUMA, Calif. — An experienced diver scouting for abalone near Point Reyes, Calif. was diving without scuba gear, as is required for abalone collectors in northern Calif., and came to the surface to catch his breath. He never saw the shark until the creature had grabbed him around the middle and headed downward.

As the shark shook him and ripped into his flesh, the diver gripped on a steel abalone tool and, as the struggle continued, he reached behind him and banged the shark on the head. The attack ended and the shark disappeared. The diver surfaced and was hauled aboard by companions, alive but wounded.

SAN FRANCISCO — In the month, two more episodes ha added to the reputation of triangle, which is bounded by P Reyes, the Farallon Islands a Monterey Bay. In September surfer was decapitated by a gr white shark off the San Ma County coast; and this month abalone diver was attacked a badly mauled while bobbing on surface near Point Reyes. A sh warning was issued last weekend bathers at Stinson Beach in north Marin County after another gr white was spotted offshore.

The two episodes brought total number of great white atta to 40 since records were first kep the 1920's.